The Neo-Impressionists

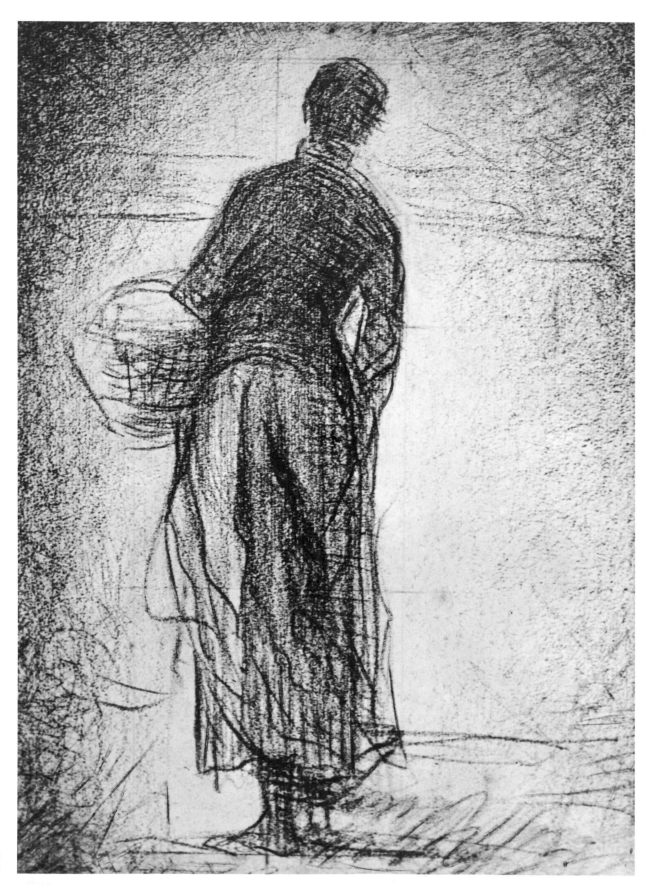

Georges Seurat
Woman Carrying a Basket

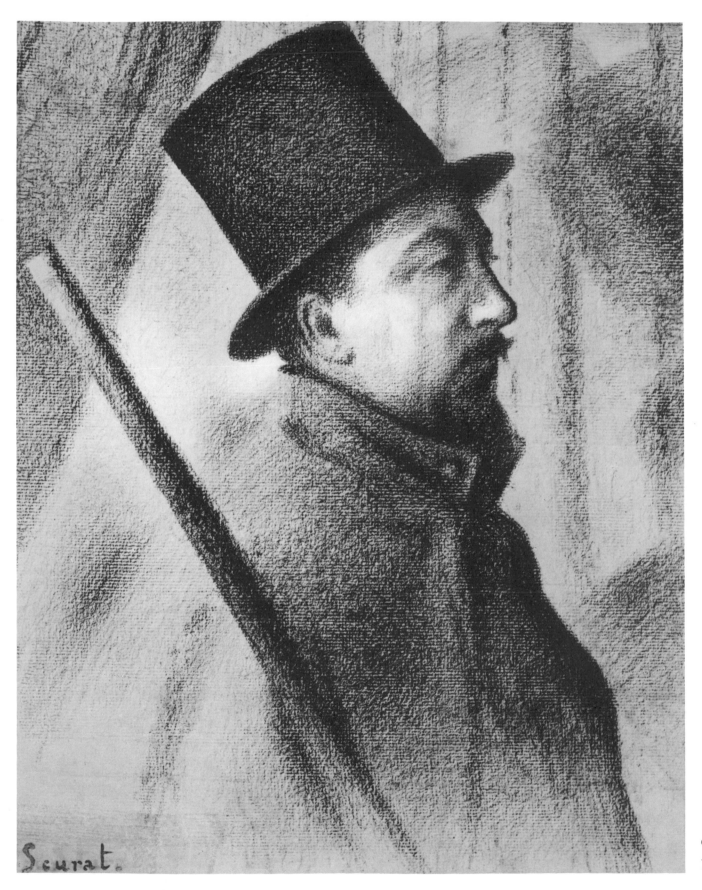

Georges Seurat
Portrait of Paul Signac
1889–90

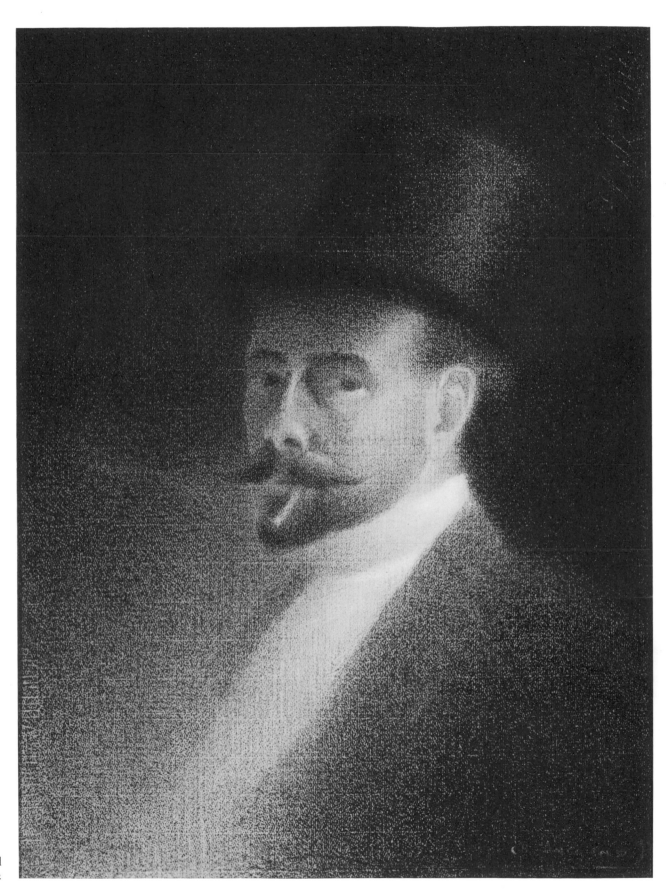

Charles Angrand
Self-portrait 1892

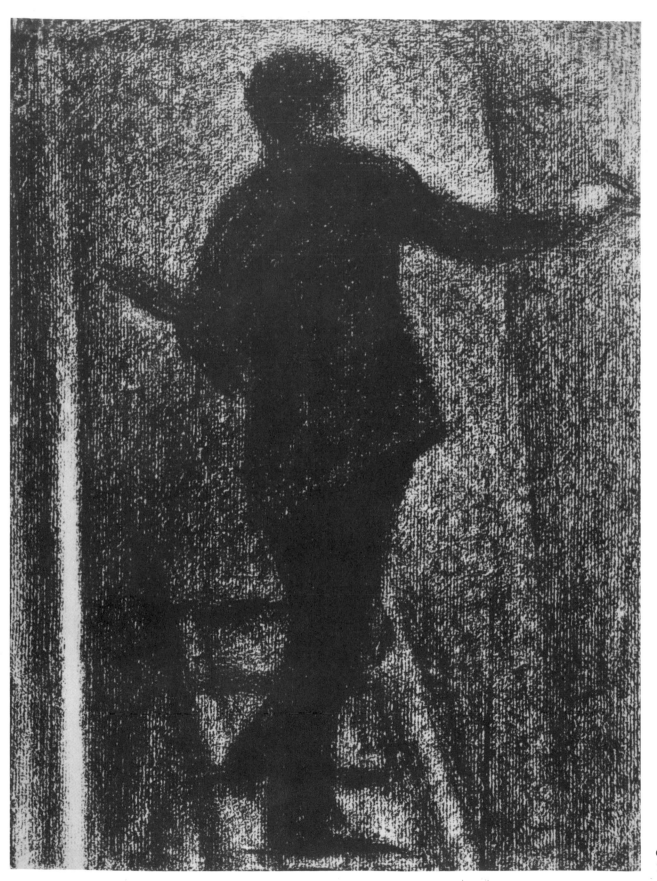

Georges Seurat
The Painter at Work c. 1884

THE NEO IMPRESSIONISTS

edited by Jean Sutter

with contributions by

Robert L. Herbert
Isabelle Compin
Pierre Angrand
Lily Bazalgette
Alan Fern
Pierre Eberhart
Francine-Claire Legrand
Henri Thévenin
Marie-Jeanne Chartrain-Hebbelinck

New York Graphic Society Ltd.
Greenwich, Connecticut

Translated from the French
by Chantal Deliss

First published in Great Britain in 1970
by Thames and Hudson Ltd, London

English translation © *1970 Thames and Hudson Ltd, London,*
and New York Graphic Society Ltd, Greenwich, Connecticut
© *1970 by Bibliothèque des Arts, Lausanne, and Editions*
Ides et Calendes, Neuchâtel, Switzerland

Artistic rights:
Spadem and Adagp, Paris, and Cosmopress, Geneva

Printed and bound in Switzerland

International Standard Book Number 0-8212-0224-3
Library of Congress Catalog Card Number 70-126029

Contents

Georges Seurat *Sketch* 1877–78 Conté crayon

Introduction

This is what Thadée Natanson, in his book *Peints à leur tour* (1948), wrote about the school of Seurat: 'Should what is still referred to as pointillism be turned into a kind of faith, then surely Delacroix and the impressionist painters would be the prophets, Seurat the Messiah, while Paul Signac would be Saint Paul, since it was he who evolved and set down the precepts. This School of painting – and indeed it was a School and, as such, one of the very few in existence in the nineteenth century – owes him its appellation of neo-impressionism as well as the name "divisionism" which describes its theories more accurately.'

The neo-impressionist painters analysed in this book are those who, attracted by Georges Seurat's technique, followed in his footsteps until 1891, the year of his death. They all knew him personally, discussed theories of painting with him, and gave him their total allegiance.

Many critics of the time tried to analyse Seurat's technique: Félix Fénéon, for instance, frequently described neo-impressionist techniques, and even went so far as to devote a whole issue of *Hommes d'Aujourd'hui* in June 1890 to Signac and his work. He was not the only writer to analyse in detail the principles of the School. From the articles published at the time, one can single out also Alphonse Germain, a reputable critic who published a rather more intelligible article than Fénéon in September 1891, in a special number of *La Plume* devoted entirely to the new School.

Later, in 1899, Paul Signac published in the *Revue Blanche* his book *D'Eugène Delacroix au néo-impressionisme,* setting out in detail the history of the movement and of its theories.

Nowadays, of course, art historians take a different view of the essence of neo-impressionism. In this book, the chapter entitled 'Seurat's Theories', by Professor Robert L. Herbert, constitutes an exposition and criticism of the School's beginnings, as seen through the works of its pioneers.

The need for a book of this kind has been felt for several years; although it does not claim to be a history of neo-impressionism, it does attempt to establish as accurately as possible the various roles of its principal adherents. Various excellent books on Seurat have been published, such as John Rewald's (1946) on the painter and his works, the descriptive catalogues of his paintings by Henri Dorra and John Rewald (1958), the comprehensive catalogue of the artist's drawings and paintings by de Hauke and Brame (1962), a study and criticism of Seurat's drawings by Robert L. Herbert (1962), and a study of his art and theories by W. I. Homer (1964).

Although there is an excellent catalogue (1963) of paintings by Henri-Edmond Cross, compiled by Mlle Isabelle Compin, far less has been written about the other painters of this school; a few are mentioned in John Rewald's *Post-Impressionism from Van Gogh to Gauguin* (1956, etc.). The study of Signac by Lucie Cousturier (1922), and A. Tabarant's biography (1928) of Maximilien Luce, are now wholly unobtainable, and the catalogues mentioned earlier are now prohibitively expensive to buy. The only two publications on Signac to have been reprinted are George Besson's (1935 and 1950).

The neo-impressionists succeeded mostly because, as well as Seurat, they included a group of great painters, such as Henri Edmond Cross, Paul Signac, Charles Angrand and Maximilien Luce, who still count among the most important artists of the nineteenth century. Nor should one underestimate Albert Dubois-Pillet, Henri Delavallée, Hippolyte Petitjean or Lucien Pissarro. Of the experiments within the School, Louis Hayet's still deserve great interest, and, while such painters as Cavallo-Péduzzi and Léo Gausson lacked perseverance and consistency, they nevertheless played an important, if brief, role.

It may seem surprising that Camille Pissarro has not been allocated a chapter of his own in this book, considering that his authority was so essential to Seurat's and Signac's works, but this impressionist painter, with his

sensitive, impulsive and enthusiastic temperament, soon abandoned not only his young friends but also their school, which he later denounced on several occasions. Furthermore, so much literature of quality has already been produced on Camille Pissarro that it would have been senseless to add yet another study of his well-known career. In the present book, Mr Alan Fern does, in fact, deal with him indirectly, through the works of his son Lucien Pissarro.

At a very early date, and thanks mostly to the group of Les Vingt in Brussels, the neo-impressionists gained wide recognition outside France. Les Vingt were at that time struggling in Belgium to seek recognition for the most avant-garde works in painting, music and literature. They at once supported the neo-impressionist movement, and its theories rapidly spread among and around them. One day, Félix Fénéon asked Seurat for a list of the members of Les Vingt whom he considered to be his followers ; he gave the following nine names, which therefore deserve a mention : Anna Boch, Frantz Charlet, Alfred William Finch, Georges Lemmen, Dario de Regoyos, Jan Toorop, Théo van Rysselberghe, Henry van de Velde and Guillaume Vogels.

A thorough study of the neo-impressionists, which I hope someone will one day undertake, should include the second generation painters who became active after 1891 such as Lucie Cousturier, Jeanne Selmersheim-Desgranges, Jeanne Droz, Antoine de La Rochefoucauld, Achille Laugé, Henri Person, E. Fer and Carlos Reymond, who were all followers of the school and of its precepts.

Robert L. Herbert's writing on the occasion of the fine exhibition which he organized at the Solomon R. Guggenheim Museum, New York (*Neo-Impressionism*, 1968) covers the influence of neo-impressionism abroad. Fortunato Bellonzi has published a very comprehensive study of the school's influence in Italy (*Il divisionismo nella pittura italiana*, Milan 1967). Such publications are likely to increase in number, and will contribute to the understanding of 'optical painting', which has played such an important part in the evolution of modern art.

Jean Sutter

Georges Seurat *Seated Man* 1877–78 Conté crayon

Georges Seurat 1859–1891

Georges-Pierre Seurat was born in Paris on 2 December 1859, on the first floor of 60 rue de Bondy, in the tenth Arrondissement. His parents were Antoine Seurat (1815–91) and Ernestine Faivre (1828–99). His father had retired three years earlier after having made a good deal of money as a *huissier*, a court official at the Public Tribunal of the Seine in La Villette, then an independent commune north of Paris.

His family were farmers in Dosnon (Aube), in the dry province of Champagne. Mme Seurat's mother came from an old Parisian family called Veillard, and there had been sculptors in her family as far back as 1750. Her Faivre grandfather originated from the Jura and had been a jeweller in rue de la Barillerie, and later in rue Saint-Julien-le-Pauvre.

Georges Seurat was the third child in a family of four. A boy, Emile, was born in 1846, followed by a daughter, Berthe, in 1847; another boy, Gabriel, was born in 1863 but died at the age of five. The family belonged to the rich middle class, and the Seurats settled in 1862 in a comfortable apartment at 110 boulevard de Magenta, a newly-built quarter in the tenth Arrondissement. Emile Seurat, a playwright of little achievement, lived all his life on his private income. Marie-Berthe married Léon Appert, a professional engineer who became a well-known glassmaker.

Nothing is known about Seurat's schooling except the fact, which he disclosed himself, that he went to high school. From a very early age, he came into contact with art through one of his uncles, Paul Haumonté-Faivre (1821–69), who owned at 48 avenue des Ternes a large and very prosperous fancy goods store, 'Au Père de Famille'. Paul Haumonté was artistically inclined, and often used to paint or draw, taking his nephew Georges, not yet ten years old, with him on his artistic expeditions. Seurat's predisposition to drawing was thus encouraged. When Seurat was fifteen, his parents enrolled him at a specialized evening school of drawing at 17 rue des Petits-Hôtels, near the family house. There Seurat learned to draw during 1875, 1876 and 1877. He made the acquaintance of another student, Edmond Aman-Jean, who was to be his lifelong friend.

The director and principal teacher of the school of drawing was a sculptor, Justin Lequien (1821–82). The school, run on vocational lines, trained artists and craftsmen for various industrial trades. It was the precursor of the famous Ecole Bernard Palissy.

It is thought that, after 1876, Seurat also took lessons at the Ecole des Beaux-Arts. In 1878, he successfully took the entrance examination, at the same time as Aman-Jean, then worked for two years in the studio of Henri Lehmann, a pupil and admirer of Ingres, who taught a classical style of painting. Lehmann encouraged good composition, insisted on accurate line drawing, and demanded from his pupils clear outlines. Seurat was a very average art student, and his school results were not impressive. He made friends with some of the other students, including Ernest Laurent, Osbert, Séon and Cavallo-Péduzzi.

In 1879, Aman-Jean and Seurat rented a studio at 32, rue de l'Arbalète, where they both worked intensively, often joined by Laurent. In May 1879, they visited the fourth exhibition of the impressionists in avenue de l'Opéra. This exhibition was dominated by the works of Pissarro, Degas and Monet, which made a deep impression on the three painters.

As a student at the Beaux-Arts, Seurat was dispensed from the usual four years' military service. He enlisted for his one-year 'volunteer service' in October 1879 and was posted to the 119th Infantry Regiment in Brest. He was stationed there for the whole year, during which he filled two sketchbooks, mostly with street scenes and sketches of military life. He appears to have spent a great deal of time in January and February 1880 reading David Sutter's articles on *Les Phénomènes de la Vision*, published in *L'Art*.

On his return to Paris on 8 November 1880, he rented a tiny apartment at 19 rue de Chabrol, not far from his

parents' house, where he was to paint his most important works.

For about two years, his life was divided between work, reflection and frequent trips to the outskirts of Paris with his friend Aman-Jean, who, like himself, had given up attending the Beaux-Arts. They travelled around the country together, and went to the Valois: Ermenonville, Châlis, Survilliers, Mortefontaine, Barbizon. They drew and painted in what was then countryside at Saint-Ouen and Aubervilliers.

Back in Paris, Seurat concentrated on studying Delacroix's technique, and in 1881 he wrote – the only writing in his life – three essays on the works of Delacroix, which he had studied at great length. That same year, he and Aman-Jean went on holiday to Pontaubert in Burgundy, where they stayed for two months. This was the only really carefree period in Seurat's life. The two friends swam together on sunny days, and went to village dances.

Seurat attained artistic maturity at an early age. Soon the Brest sketchbooks were discarded. He found his own style as early as the end of 1881, and particularly during the summer of 1882. His drawings already showed deep originality and that skilful finish which he was to master more and more completely, without affecting the basic meaning of his work.

The ambition of young painters of the period was to exhibit their works at the annual official Salon des Artistes Français, and to be awarded a prize which represented the credentials of an accomplished painter. The importance of academic art was such that it was essential for a painter to be officially recognized as one of the 'French artists' before being accepted by the public. In March 1881, Aman-Jean sent in some of his works to the Salon, and one of his charcoal drawings was accepted. At the 1882 Salon, one of his paintings was accepted, as were one painting and one wax crayon drawing by Laurent. Seurat had not yet succeeded in exhibiting any of his works.

In 1883 the three friends submitted several works. Seurat sent in two drawings, the portrait of his mother embroidering and the portrait of Aman-Jean; the jury accepted only the latter. Aman-Jean had two works admitted, and Laurent only one. Aman-Jean received a third-class medal and Laurent an honourable mention. Two of the three articles published in *Le Moniteur des Arts* about the drawings in the exhibition mention Seurat's. In the words of Jules Pick: 'an excellent portrait, perfectly and accurately drawn'. Roger Marx, the critic, wrote: 'an excellent chiaroscuro study, a drawing

of talent, not the work of a beginner'. Seurat thus did not pass unnoticed when he first came into the public view.

No doubt many discussions took place between Seurat and his friends on the problem of expressing as much light as possible on the canvas, and this can be seen in Laurent's paintings. In 1883, at a competition for the decoration of the Town Hall at Saint-Maur-des-Fossés, Laurent sent in a design based on the concept of the division of tones. Puvis de Chavannes who saw it by chance, was most interested and enquired after the name of the artist. This was probably how Seurat and Aman-Jean made the acquaintance of Puvis; they were to become his collaborators when he worked on his own large mural compositions.

Since the spring of 1883, Seurat had been giving thought to a large composition, three metres (ten feet) long and two metres high, representing the leisure moments of Parisians along the banks of the Seine. This led to numerous drawings and *croquetons*, preliminary oil sketches, with frequent visits to the island of La Grande Jatte, between the Asnières and Courbevoie bridges, where many Parisians spent their Sundays.

Seurat completed *Bathing at Asnières* by March 1884, and sent it to the Salon, but it was refused. That year, the reaction from the rejected painters was particularly violent. For several years, groups of painters and sculptors had tried to conduct an organized fight against the dictatorial institution which the official Salon had become. A group emerged from a recently founded society, the Société des Jeunes Artistes, which, since 1882, had successfully organized two exhibitions under the aegis of Victor Hugo. This new group now took the lead in the rebellion and, in April, meetings held at the Café Marengo led to the founding of the Groupe des Artistes Indépendants. The District Prefect allowed them the use of a shed in the Cour des Tuileries, where they opened an exhibition on 15 May to show the works of some 450 painters, among them Seurat with his *Bathing at Asnières*. But the Groupe des Artistes Indépendants was a disorganized collection of people, and its future was doomed. Within the Groupe itself, some members joined forces to try and establish the society on a firm base and ensure its future. The reorganization, begun by a senior member, Odilon Redon, was taken over by an unknown captain of the Republican Guard in Paris, Albert Dubois-Pillet, a Sunday painter who loved art, and whose work had been rejected by the Salon for four years. Like the other painters, he had enthusiastically joined the Groupe des Artistes Indépendants, and now, under his impulse, things began to take shape.

 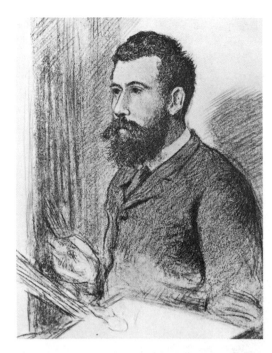

Georges Seurat, *c.* 1888 Maximilien Luce *Seurat* 1890 Maximilien Luce *Seurat* 1890

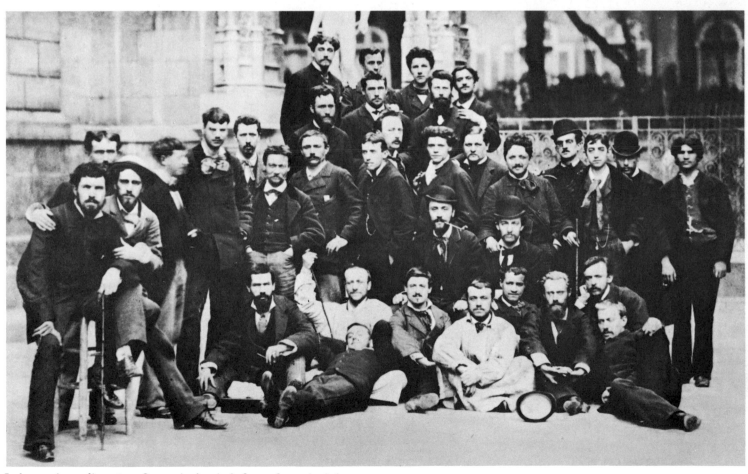

Lehmann's studio, 1890. Seurat is the sixth figure from the left

On 4 June 1884, the Société des Artistes Indépendants was officially founded, with Dubois-Pillet as its active organizer. He collected around him some hundred artists who recognized his valuable qualities and were to trust him implicitly. Seurat was among them: he remained loyal to the Société until his death, and always took part in its activities.

The Société held an exhibition from 10 December 1884 to 20 January 1885 in the Pavillon de la Ville de Paris, in the Champs-Elysées, which included the works of 139 painters. It was a financial failure and the Société found itself owing 2300 francs when the exhibition closed. The press critics had been mostly unfavourable, although the more perceptive of them had rightly grouped together some of the painters such as Dubois-Pillet, Charles Angrand, Georges Seurat, Paul Signac, Henri Edmond Cross, Armand Guillaumin and Emile Schuffenecker: the same painters who, gathering around Seurat, were to adopt his style of painting and contribute to the founding of the school of neo-impressionism. Seurat had exhibited *Bathing at Asnières*, which had again attracted notice, as well as *croquetons* of the island of La Grande Jatte, where he had been working since 1883.

Since May 1884, Seurat had been actively working at a new composition, larger even than *Bathing at Asnières*, with La Grande Jatte as subject. In spite of debts, the members of the Société held great hopes that there would be another exhibition in March 1885. Seurat's *Sunday Afternoon on the Island of La Grande Jatte* was ready to be shown, but the exhibition did not materialize. In spite of his disappointment, Seurat did not lose faith in the resourceful Dubois-Pillet, who had powerful political connections, and who, through Freemasonry, enjoyed anonymous backing.

At the end of 1884, Seurat went with a group of loyal friends to see the journalist and writer Robert Caze, who had played a prominent part during the Commune rising in 1870, and had been granted an amnesty in 1880. Caze was a friend also of Edmond de Goncourt. Every Monday night, he entertained painters and writers in his apartment at 13 rue Condorcet. Camille and Lucien Pissarro, Seurat, Signac, Armand Guillaumin and Jules Vidal, among others, were usually there. One evening, Pissarro brought Cézanne with him. The habitués among writers included, sometimes, Goncourt, and, more often, Joris Karl Huysmans, as well as a whole group of young poets, graduates from the Lycée Fontanes led by Rodolphe Darzens and Jean Ajalbert. Pierre Quillard, René Ghil, Ephraïm Mickhaël, Paul Adam and Henri de Régnier were also regular visitors, as well as P. V. Stock, the publisher.

It was in this atmosphere that Seurat found himself in 1885 at the head of the avant-garde movement. He was living amongst painters who had become, thanks to Dubois-Pillet, a coherent group, capable of organizing their own exhibitions. Seurat made many friends, in both older and younger generations. He enjoyed the friendship of Dubois-Pillet, Signac, Angrand, Lucien Pissarro and Hayet and could rely on the support of Camille Pissarro, Guillaumin and Edgar Degas. He was also acquainted with the progressive young writers of Robert Caze's circle, and of the Lutèce group, as well as with Paul Adam and the Darzens-Ajalbert group where symbolism was very much becoming the topical subject. He met great intellectuals such as Teodor de Wyzewa and Edouard Dujardin, whose conversation fascinated him; although he rarely spoke, he would listen eagerly to the ideas which were to have such a deep influence on intellectual life in France under the Third Republic.

During the summer of 1885, Seurat stayed in Grandcamp, a small seaport on the English Channel, where he painted remarkable seascapes. He still spent a great deal of his time thinking about first principles, and it was during this period that his conception of tone separation

Georges Seurat *Man with bottle* 1877

Georges Seurat *Two sketchbook pages* 1880

became clear to him. Back in Paris, he took up again his painting of La Grande Jatte, but this time in a far more 'pointillist' style, a monumental task which was to take him six or seven months.

Since January 1886, Dubois-Pillet had been thinking about another exhibition to be held in August and September. What was to be the eighth impressionist exhibition was organized and financed jointly by Eugène Manet (Berthe Morisot's husband) and Degas. The latter rented an empty apartment at 1 rue Laffitte above the famous restaurant La Maison-Dorée. Degas deleted the word 'impressionist' from the name of the exhibition, simply calling it he 'Eighth Exhibition of Paintings'. It was held from 15 May to 15 June. Renoir and Monet were not included in the group, but Seurat, Signac and Lucien Pissarro were. Other artists who took part in the exhibition were Berthe Morisot, Mary Cassatt, Marie Bracquemond, Camille Pissarro, Félix Bracquemond, Victor Vignon, Federigo Zandomeneghi, Guillaumin and Degas.

On 31 March, a painful event occurred for Dubois-Pillet and his friends : Robert Caze died from wounds sustained six weeks earlier in a duel against Charles Vigné.

The exhibition opened on the date planned. Seurat's La Grande Jatte created a sensation and aroused strong reactions. Some people sneered at it but the more perspicacious who had already admired Bathing at Asnières were aware of the importance of this latest work. The press in general virtually ignored the exhibition, and most of the critics did not even mention Seurat's name. However, the friends he had made since the previous year were active on his behalf. Paul Adam, in the Revue Contemporaine, and Jean Ajalbert, in the Revue Moderne, both wrote long articles drawing attention to the painter and his works. And so, in spite of the financial loss due to lack of attendance, the eighth exhibition did eventually awaken public interest in Seurat and in neo-impressionism.

All the artists who were preoccupied with the problem of applying science in art, and who favoured artistic revolution, now grouped themselves together. Seurat made the acquaintance of Félix Fénéon and of other critics, such as Arsène Alexandre, Gustave Kahn, Jules Christophe and Paul Alexis, who became his loyal admirers. He also met Charles Henry, whose aesthetic studies were to influence Seurat deeply.

Another important fact was that the Belgian poet Emile Verhaeren, very impressed by La Grande Jatte, introduced the painting to his friends Théo van Rysselberghe, a painter, and Octave Maus, a lawyer, who were at the head of Les Vingt, an avant-garde group of painters and musicians in Brussels. They immediately decided to invite Seurat to their next exhibition in February 1887.

In order to understand this enthusiasm for La Grande Jatte, one must try to feel the psychological atmosphere of the period. It was generally believed at that time that a manner and a technique of painting could be devised which would be definitive. Many thought that Seurat's method might well provide the solution sought by all artists, whether they were impressionists, symbolists or even syntheticists-to-be like Gauguin.

In July and August 1886, Seurat stayed at Honfleur, where he worked relentlessly, to return to Paris in time for the Salon des Indépendants which opened on 26 August. There he exhibited ten works, including La Grande Jatte as well as paintings of Grandcamp, Honfleur and the outskirts of Paris. In November, Emile Verhaeren came to visit him at his studio, bought a painting of Honfleur and invited him to the next exhibition of Les Vingt.

The year 1886 had, in fact, been very profitable : the success of La Grande Jatte both in France and in Belgium had established his reputation with the avant-garde artists and with his literary friends. During the same year, he and Dubois-Pillet had experimented on integrating a frame closely with its painting, and Seurat had tried using the same colour tones for both.

In the autumn he started work on a large canvas, The Models. In November and December, he exhibited two paintings in Nantes.

On 2 February 1887, Seurat, accompanied by Signac who had become his firm friend, went to Brussels for the opening of the Salon des Vingt, where seven of his paintings were hanging : La Grande Jatte, two canvases of Grandcamp and four of Honfleur. At this exhibition, Emile Verhaeren bought his second Seurat, The Hospice and the Lighthouse at Honfleur, and a Brussels hotelier by the name of Van Cutsem bought Beach at Le Bas-Butin for 300 francs.

This was the period of Seurat's close friendship with Camille Pissarro ; at the beginning of 1887 the two painters were seeing each other almost every day. The older painter was entranced by his young friend.

On his return from Brussels in February, Seurat was having lunch in a cheap restaurant at 43 avenue de Clichy, near La Fourche, when he met Van Gogh who had managed to persuade the restaurant owner to exhibit modern paintings under the huge glass roof. A short time later, Seurat went with Aman-Jean to Van Gogh's apartment at 54 rue Lepic. To the two friends' question as to how a painting should be begun, Van Gogh replied :

'In the same way as a fruit grows, from the kernel.'

As the Société's finances were in a better state, the 1887 Salon des Indépendants took place from 26 March until 3 May. Apart from six paintings of Honfleur and twelve sketches, Seurat exhibited sketches for his *Models* and *Bridge at Courbevoie*.

He spent that summer in Paris in order to carry out a short period of military service and went on working actively at *The Models*, at the same time trying to complete another large canvas, the *Circus Parade*. Both paintings were finished at the same time.

This particular year had also been of great importance to Seurat: although *La Grande Jatte* had caused controversy in Brussels, some ten Belgian painters had been converted to his technique. Théo van Rysselberghe took the initiative and was soon followed by others including Georges Lemmen, Alfred William Finch and Henry van de Velde.

In January 1888, Seurat exhibited at the same time as Edouard Manet, Camille Pissarro, Dario de Regoyos, Jean-François Raffaëlli, Paul Helleu, Berthe Morisot, Louis Anquetin, Cross and Signac in the premises of the *Revue Indépendante*, which was then run by his friends Edouard Dujardin and Félix Fénéon.

At the beginning of March, at a charity sale, works by Camille Pissarro, Dubois-Pillet, Cross, Signac and Seurat were put to auction. Seurat's beautiful drawing *Eden-Concert*, touched up in gouache and coloured inks, was sold for 17.85 francs (including commission) to Théo van Gogh. The Pissarro fetched 75 francs, the Cross 14 francs, the Signac 27 francs, the Dubois-Pillet 120 francs. Seurat and his friends indeed stood very low in the public appreciation at that time.

That year, the Indépendants took place from 22 March to 3 May, and Seurat showed his two large paintings, *The Models* and *Circus Parade*, together with eight drawings. The exhibition was a great success and, from then on, the Société was firmly established.

In the spring, Seurat went back to La Grande Jatte, often accompanied by Angrand, one of his most faithful friends. There they worked assiduously and completed some fine paintings.

In July and August 1888, the Dutch engravers' club organized in Amsterdam its second Salon, designed to cover the evolution of the engraver's art during the nineteenth century. French artists were represented by Camille Corot, Théodore Rousseau, Jean-François Millet, Félix Buhot, Auguste Lançon, J.-L. Brown, Camille Pissarro, Jean-Louis Forain, Odilon Redon, Degas and Rafaëlli, as well as Lucien Pissarro and Seurat who were the two youngest painters of the group. Théo van Gogh was one of the organizers, and he lent to the exhibition the drawing by Seurat which he had bought in March.

In August and September, Seurat stayed in Port-en-Bessin, a small seaport on the Channel coast. An incident in August caused the first serious rift within the group of neo-impressionists. On 13 August, Arsène Alexandre published in the daily newspaper *Paris* an article on the neo-impressionists which described Seurat as 'the man of great achievements who is in some danger of having the paternity of his own theory wrested from him by ill-informed critics or unscrupulous colleagues'. The touchy Signac took the article as an insult to him, especially as Alexandre added, on the subject of the Group's precepts: 'They have spoilt some great talents, painters like Angrand and Signac.'

Signac warned Camille Pissarro that he would demand an explanation from Seurat, whom he suspected of having instigated these insinuations. Seurat calmed him down and avoided a breach, but, nevertheless, the dissension grew between them.

Pissarro took this opportunity to break away completely from the neo-impressionist group, and this move marked the end of the harmonious spirit of enthusiasm which had prevailed in 1886. Although other painters, such as Cross and Achille Petitjean, were to adopt more closely the theories of optical painting, Seurat thus once more stood alone in his convictions.

In February 1889, he was invited to the Salon des Vingt in Brussels and sent in twelve works including *The Models*, two paintings of La Grande Jatte completed the previous year, and six canvases of Port-en-Bessin.

It is believed that it was a short time after his return from Belgium that he embarked on a liaison with Madeleine Knoblock, a twenty-year-old model who was a close friend of Emilie Etiembre, who posed for Degas' jockeys. In June, he stayed at Le Crotoy, where he painted a few canvases, but he soon returned to Paris. When he began to live with Madeleine, Seurat abandoned many of his friends and no longer went to their meetings. Although he still helped occasionally at the Indépendants, he had stopped seeing Aman-Jean regularly. One day, Dubois-Pillet anxiously asked Signac what had happened to Seurat, as he had not seen him for so long.

At the Indépendants, during the whole of September, he exhibited two paintings of Le Crotoy and six of Port-en-Bessin.

By the time the Indépendants closed, Madeleine Knoblock was over five months pregnant, and in October 1889, Seurat gave up his studio at 128*bis* bou-

levard de Clichy to move secretly with her to a studio measuring about five metres (seventeen feet) square, in a quiet courtyard off the passage de l'Elysée-des-Beaux-Arts. His secret was so carefully guarded that neither his relatives nor his closest friends suspected his liaison.

He had completed in that year two important paintings: a *café-concert* scene entitled *Chahut* and a portrait of his mistress, *Young Woman powdering herself*. Early in 1890 he conceived another large composition, *The Circus*.

Madeleine gave birth to a son in Seurat's studio at four o'clock in the morning of 16 February 1890. Seurat immediately acknowledged him legally and gave him his own Christian names in reverse, Pierre Georges. The birth of the child remained as close a secret as the liaison.

About that time, not only had Seurat's own friendships cooled but the neo-impressionist group had lost a great deal of its solidarity. Félix Fénéon, who was, in all but name, editor-in-chief of the avant-garde periodical *Hommes d'Aujourd'hui*, decided to devote several issues to his friends among contemporary writers and painters, and, more particularly, to the adepts of optical painting. At the beginning of March, Georges Lecomte published an article on Camille Pissarro, with a portrait of him by Lucien. Perhaps through ignorance, the text minimized Seurat's role in the founding of neo-impressionism, and the painter protested to Félix Fénéon and Georges Lecomte. The latter, in his article on the Indépendants published in the 29 March issue of *Art et Critique*, wrote a more impartial account of the truth.

That year, the Indépendants opened on 20 March with eleven of Seurat's paintings, including *Chahut* and *Young Woman powdering herself*. The critics were not favourable and there was a definite atmosphere of distaste towards neo-impressionism.

While the exhibition was on, the issue of *Les Hommes d'Aujourd'hui* devoted to Seurat came out, written by Jules Christophe and with a portrait of the painter by Luce. Apart from inaccuracies in the details of the artist's life and family, the technical points, which had been checked by Seurat, were correct and the history of optical painting accurate. All Seurat's friends were mentioned: Pissarro, Signac, Fénéon, etc.

In the middle of June, *Les Hommes d'Aujourd'hui* published its number on Signac by Félix Fénéon, with a portrait by Seurat. This document showed how upset the old friendships were by this time. It seems incredible that Seurat's name is not even mentioned once in this otherwise comprehensive analysis of optical painting. Seurat and his friends were astounded, and Seurat, after destroying many drafts, wrote Fénéon a letter setting out the true facts on the origin of his method. Fénéon tried to justify himself but his attitude remained strange. These upheavals created an uneasy atmosphere within the group. The year 1890 was to be a landmark in many respects. Seurat's isolation became complete in that year. He spent his usual seaside holiday at Gravelines on the North Sea coast.

At the beginning of 1891, Madeleine Knoblock was again expecting a child. Seurat was working as relentlessly as ever at *The Circus*. On 2 February he attended a literary dinner given in honour of symbolism and of Jean Moréas, in particular, who had just published *Le Pèlerin de l'Absolu* with great success. There were more than one hundred guests with, among them, Gauguin, Redon, Signac, Félicien Rops and William Bouguereau, as well as all Seurat's literary friends, from Jean Ajalbert to Henri Régnier, and from Félix Fénéon to Arsène Alexandre.

Les Vingt, who were holding their exhibition on 7 February in Brussels, again invited Seurat, who sent in his *Chahut* as well as two paintings of Le Crotoy and four of Gravelines.

The seventh Indépendants was to take place that year from 19 March to 27 April. Seurat, as usual actively engaged in the organization of the exhibition, dealt himself with the hanging of the paintings at the show. Five of his own works, including the barely completed *The Circus*, were exhibited.

Palm Sunday was on 22 March. On the following Thursday, Seurat suddenly felt very ill; and on Good Friday morning he visited his mother, in the boulevard Magenta, supported by a friend and accompanied by Madeleine Knoblock and their young son Pierre-Georges. Mme Seurat heard for the first time of her son's liaison, of the existence of a child and of the renewed pregnancy of his mistress. Seurat, struck by a fatal type of diphtheria, died on Easter Sunday, 29 March, at six in the morning.

Appearance and Character

Seurat was a very strongly-built man. His military recruitment papers gave the following description of him: Brown hair and eyebrows, brown eyes, average forehead, prominent nose, average mouth, round chin, oval face, height 1 m 76 (5 ft 10½ in.), no distinguishing marks.

Here is how his friends described him:

Signac: 'Seurat was a very handsome man, an athletic "grenadier", with a beard.'

Henri Jaudin: 'Seurat, that tall handsome boy, very quiet, a little sad.'

Aman-Jean: 'Physically, he resembled the Donatello *Saint George* now at the Bargello Museum in Florence, and previously in a niche of Or San Michele. He was handsome.'

Angrand: 'He was good-looking, with his straight nose, wide forehead, heavy eyelids and his handsome beard, dark brown with tawny highlights. His whole bearing expressed calmness. He had style.'

Gustave Kahn: 'He was tall and well-proportioned. His dark, abundant beard and thick, slightly curly hair gave him the face of one of those mitred Assyrian priests one sees on bas-relief. His large eyes, extraordinarily calm normally, narrowed and became mere luminous spots under blinking lashes whenever he painted or looked at subjects.'

Teodor de Wyzewa: 'His height, long beard and open gaze reminded me of one of those Italian Renaissance masters who, like him, strong and yet contemptuous of their strength, advanced steadily towards their ideals.'

R. Carabin, the sculptor: 'He was an apostle and looked like Christ. He was a reserved and very quiet man.'

Gustave Kahn: 'His appearance almost gave an impression of coldness, in his very dark blue or black clothes with the look of symmetry and neatness which made Degas call him once in a moment of ill humour "the notary". Seurat was kind and impulsive by nature. He normally remained silent in a crowd of people but, when among his close friends, he would talk at great length about art, its aims and techniques. Then, the slight colouring of his cheeks denoted his excitement, and he would discourse without drawing breath, comparing the progress made by painting and music respectively and seeking to find unity between his own efforts and those of the contemporary poets and musicians.'

Teodor de Wyzewa: 'From the very first day of our acquaintance, I realized that his was a soul belonging to the past. He lived free from the disenchantment which nowadays affects artists. He believed in the importance of theories, in the absolute value of methods and in the future of revolutions. I was overjoyed to find, in a corner of Montmartre, a specimen of a race which I thought extinct, the race of painters who practise their own theories and combine orderly minds with unselfconscious fantasy. Indeed, I felt very acutely the affinity between Seurat and Leonardo, Dürer and Poussin. I never tired of listening to him describing his future experiments in their order of importance and the number of years he would need for them. He never tired, either, of talking to me on the subject.'

Jules Christophe: 'Like Maximilien Robespierre, Georges Seurat believed in what he said – although he rarely spoke – and, therefore, in what he did. He was a taciturn, persevering and pure man. Not only did he attribute hieratic austerity to human beings, but to him Nature possessed the sleep-inducing calm of ecstasy. This explained the feelings expressed in his landscapes of Lower Normandy, Picardy, and Seine.'

Emile Verhaeren: 'To hear Seurat explain and reveal himself in front of his latest painting was to be led by his sincerity and overcome by his persuasion. Calmly, with restrained gestures and looking at you the whole time, he would, in a slow, monotone, almost professorial, voice describe to you the results of his experiments and the clear convictions which he called "the basis". Then he would ask you for your opinion, challenge you and wait for a sign indicating that he had been understood; all this with great modesty, almost diffidence, and yet his self-pride was evident. He never attempted to destroy in his friends their admiration for someone else's work, even though he might not share their taste; one felt his modesty and lack of envy. He never complained, either, about the success of others, even though that success was his by right.'

Arsène Alexandre: 'His vocation was to experiment for ever, to be engulfed by his passion, and to be haunted by new ideas which sometimes drove him to work throughout the night. Life had, in fact, affected Seurat and made him as he was: withdrawn, taciturn, secretive even with his most loyal friends. To this poor young man, life as he had made it for himself was a heavy burden, and art, in his dreamed ideal, was an exhausting exercise.'

Seurat was very reserved and taciturn, even with his family. He was, however, very affectionate and loyal. He never missed family celebrations and faithfully observed traditions. Although friction frequently arose among his colleagues, he never quarrelled with anyone.

Significantly, although his friendship with Aman-Jean lasted sixteen years and was the deepest of his life, Aman-Jean recounted that he never knew that Seurat had a sister, or which school Seurat had attended, and had never visited the Seurat family house; in fact, it was not until Seurat's death that he met Mme Seurat.

Seurat was loyal, and kept in close touch with his student friends at the Beaux-Arts. He went from time to time to Osbert's reunions, and, after 1887, attended the annual dinners of old students of the Lehmann studio.

His physical strength and balanced personality inspired Vincent van Gogh to write with sad envy to his brother Théo in January 1890: 'I have often thought that had I been blessed, two years ago, with the calm temperament of Seurat, for instance, I would have been able to survive.'

His personality was summed up by a poet, Henri de Régnier, in a poem to Seurat included in his *Vestigia Flammae* (1920). Whenever Félix Fénéon was asked to give a description of Seurat he would refer the questioner to these lines:

'Seurat, an ardent and lofty soul was in you. I remember. You were grave, calm and gentle, taciturn, knowing how much mere words can waste of one's substance in idle noise. You listened in a deliberate silence that your eyes belied. But if your art came into question, your eyes would flash, for you had within you, slowly nurtured, the obstinate, overriding determination of an innovator, the obstinacy which makes a great artist.

'You were a serious, good, simple, courteous man, who resembled nothing so much as the Sunday strollers who come from Montrouge or the Place Blanche and take the horse bus to the Bois, when they walk, alone or in twos and threes, to the islands of Puteaux or La Grande Jatte....

'You seemed no more than another passer-by; but you carried them all away in your mind, and in the silence of your studio, in grim, determined labour, you constructed, with lines and dots of colour, those great paintings in which colour and light are united in a unique and logical way, and which, whether *Circus, Bathers* or *Parade* or *Chahut*, show in their swirling skirts and half-naked figures, in the precision of their optical mixing, a splendour which is modern and hieratic.'

Jean Sutter

Seurat's Theories

Georges Seurat was born in the setting which was least propitious to the growth of a revolutionary.... Around him, all the people with whom he came into contact were respecters of conventions and prejudices, of the truths which had had their day – and he went and adopted new truths, ideas which seemed senseless because they had still not been explored. He devoted his life to them, and consumed his spirit.[1]

Arsène Alexandre

Seurat was one of those rare artists who make conservatism into a vehicle for revolutionary change. The stereotype of the romantic artist is so persuasive that we look with surprise on the simple facts of his life: a middle-class, conservative family; conventional schooling in a municipal school and the Ecole des Beaux-Arts; absorption in manuals and textbooks by writers who stressed codified rules of art, liberally dosed with moral injunctions.

The moralizing and didactic quality in Seurat's formation should be emphasized, because it was in perfect harmony with the most intimate qualities of his style. Before he was twenty-two years old he had annotated the writings of Charles Blanc, Eugène Delacroix, Eugène Chevreul, Ogden Rood and David Sutter, and it is significant that he copied out statements that praised qualities of decisiveness, clarity, firmness, and scientific exactitude. These qualities are the very mark of his temperament, and stamp all aspects of his life and work. Even his letters to his friends have a telegraphic terseness that reminds us of the epigrams and peremptory declarations of the scientists he read. After the early period, he continued to choose writings that emphasized the same characteristics. His devotion to Charles Henry from 1886 onward was made the easier when he read such phrases as 'To say "science" is to say "liberty"', which recalled his youthful study of Charles Blanc: 'To say "proportion" is to say "liberty"'.[2] When both he and Gauguin copied a Turkish manuscript by Vehbi Zunbal-Zadé,[3] Gauguin made it into a vehicle of mystery and anti-Western enchantment, but Seurat seems to have been drawn to such echoes of Rood and Sutter as 'precision of contour is the prerogative of the hand which is unweakened by any infirmity of will.'

As a model for his life, Seurat chose Delacroix. He took extracts from his writings, he annotated his paintings, and he read Charles Blanc's essay about him. Blanc stressed not just Delacroix's careful mixtures of colours, and his quasi-scientific knowledge, but also a manner of living that Seurat emulated. Delacroix, Blanc wrote, lived 'withdrawn upon himself, silent and solitary, inventing, drawing, painting without pause, keeping his door bolted in order to be undisturbed in his fever.'[4] And from Delacroix's letters, Seurat copied:

'Sterility is not only a tragedy for art, it is also a stain on the artist's talent. Any work from a man who is not prolific necessarily bears the stamp of tiredness. One can only hope to have followers if one offers, as a model, large and numerous paintings.'[5]

By copying this passage from Delacroix, Seurat made clear his ambition to form a school (and he was indeed productive; although he died aged thirty-one, he left behind about 240 paintings and several hundred drawings). The mission to which he called himself had more than one result, which we might summarize under three headings:

1. *The celebration of the power of pure colour.* This was urged upon him by Rood and Chevreul who, despite their conservative aesthetic, advocated the elimination of sullied and dull pigment mixtures, and by Charles Blanc, who claimed for Delacroix the accomplishment of this aim. Seurat's notes on Delacroix's paintings confirm this basic goal, which Seurat placed at the centre of his life's work, 'the purity of the spectral element being the keystone of my technique' (Appendix A).

2. *The expressive power of line, colour and value.* Charles Blanc made Seurat familiar, from the earliest days, with the theories of Humbert de Superville, which permeate

his *Grammaire*. These state the relationship of upward-moving lines with gaiety, downward lines with sadness, and horizontal lines with calm. To such ideas, Charles Henry brought intensive scientific study, incorporating not only line but also colour and black-and-white. They seem to supplant colour theory as Seurat's guiding interest after 1886.

3. *The reform of impressionism and of the Beaux-Arts tradition*. Possessed as he was by an instinct for absolute clarity, Seurat regarded impressionism as too indecisive. He learned much about pure colour from Monet, Renoir and Pissarro, but he superimposed over these practical lessons his all-pervasive sense of strong, classicizing structure. This had been ingrained in him in school, and also in his readings. 'The want of good, decided, and approximately accurate drawing', wrote Rood, 'is one of the most common causes that ruin the colour of paintings.'[6] At the same time, Seurat reclaimed for modern art the tradition of Ingres, Poussin and classical art by infusing it with new life, inspired by his contact with the impressionists and his realization that modern life must be celebrated with modern techniques and expressed with contemporary subjects.

It is this intersection, in Seurat, of a conservatism of instinct and of training with the most positive contemporary currents which defines his art. It is this synthesis of quasi-scientific theories, in the realm of idea, and of geometric essences of structure, in the realm of colour and form, which is the miracle we admire.

Colour theory

Charles Blanc's *Grammaire des arts du dessin*, which Seurat began reading in 1876, states the principal ideas and theories that the young artist was later to build upon. In fact, his subsequent readings were either confirmations or scientific extensions of what Blanc says in his eclectic summations. Referring both to Chevreul and to Delacroix, Blanc constructs a theory of optical mixing (*mélange optique*) by which separate touches of pigment will tend to form more pure and vibrant colours in the observer's eye than would be formed by the more traditional mixing of pigments on the palette. Blanc drew his guiding principles on optical mixing from Chevreul and emphasized the chemist's vocabulary, 'analogy of opposites, analogy of like things', words which Seurat took in turn for his famous statement *L'Esthétique* (Appendix B).

It was through Blanc that Seurat learned of Chevreul.

The maxims he copied[7] stress the relative quality of colour, the way in which adjacent hues affect one another, particularly the effects of contrast of hue and of light and dark. Among them are these :

'To apply colour to a canvas involves not merely colouring that part of the canvas but colouring the surrounding areas with the complementary colour. White applied next to a colour enhances the value ; it is as if one removed from the colour the white light which weakens its intensity.... Grey applied next to a colour makes the colour seem more brilliant, and at the same time the grey is tinted with the complementary tone of the adjacent colour..., A darker colour next to a different lighter colour results in a higher value of the former and a lower value of the latter, independently of the mixing of the complementaries.'

It was also through Blanc that Seurat learned of Delacroix's use of optical mixing, small strokes of separate hues which would combine to form a new colour in the eye.[8] Give or take the size of the strokes, however, and the observer's distance, and the strokes could fail to mix and instead provoke a 'vibration' to which Blanc gave special praise. Seurat imitated Blanc's analyses by taking colour notes on paintings by Delacroix which he sought out in dealers' shops.[9] In particular he seemed attracted to Delacroix's use of colour opposites in one area to form rich greys, his use of separate strokes of pure paint, and his juxtaposition of areas of contrasting hues.

At the same time, he was reading extensively in Delacroix's own writings, and matching them against the actual pictures. On one set of his notes after the paintings, he cited a passage from Piron's book,[10] and elsewhere he copied Delacroix's own comments on colour.[11] From Blanc and from these studies generally, he recognized in Delacroix his ideal, and wrote on his sheet of colour notes after his paintings : 'This is the strictest application of scientific principles seen through the medium of a personality.'

Parts of Delacroix's journal which Seurat copied express puzzlement over the failure of certain natural effects of blue and yellow to produce green. It was here that the most significant of Seurat's scientific readings intervened to provide an explanation, and to set the artist on the way toward his mature colour theory. He read Ogden Rood's *Théorie Scientifique des Couleurs* (originally *Modern Chromatics*, New York, 1879) when it appeared in 1881, as his letter informs us (Appendix A), and Rood's chief lesson was the separation of colour-light from colour-pigment. Delacroix's puzzlement was

Georges Seurat *Houses and Garden* 1882

owing to his confusion of the two. Blue and yellow pigments make green, but blue and yellow light make a pale grey. Rood must have struck Seurat with all the force of a scientific revelation; he took Chevreul's and Blanc's empirical theories in which pigment and light are confused, and gave them a correct and thorough reworking. Actually, although Rood made some original scientific contributions, his book is essentially a great work of popular science, which incorporated the latest scientific findings of Helmholtz, Maxwell and many others.

Rood was himself an amateur painter, and his approach to colour science was an attractive one from the artist's point of view. He had a long section recommending that the artist make very free colour sketches in large strokes on small surfaces, just as Seurat did in his *croquetons*. He offered scientific evidence for the distrust of earth tones and black which Seurat was absorbing in any case from Delacroix's practice. He cited from John Ruskin and others to prove the desirability of optical mixing, to which Seurat was already attuned, and he gave both elegant explanations of its effects and practical examples of its occurrence in art and nature. From Dove he drew lessons for the explanation of the lustre created by the use of small strokes of different colours, and, like Blanc, he lavished praise on the special effects caused by this vibration of hues when they fail to mix completely in the observer's eye. Throughout the book, he showed a

marked preference for the use of colour opposites, incorporating Chevreul's principal rules and predilections. He also echoed Seurat's early training by his aesthetic attitudes, which are clearly of the familiar classicizing kind, holding forth the virtues of decisiveness, clear structure and idealized form.

Rood, therefore, stood as a remarkable confirmation and bringing up to date of the several sources Seurat was familiar with : Blanc, Delacroix and Chevreul. In an age of positivism, son of a successful middle-class broker, brother-in-law of an engineer and manufacturer, Seurat was the exemplar of the artist who finds inspiration in the science of his era, as Professor Meyer Schapiro has so brilliantly shown.[12]

At the same time Seurat's painting, like that of any artist, was a compound of many factors, not all of which are susceptible of ready exegesis. Published materials that he read are a primary source for the study of his ideas and his life, but they cannot really explain his art. We know, for example, that despite his early study of Delacroix and Rood, he shed earth colours only very gradually, from 1882 to 1884. We must not assume that he could 'apply' lessons in colour theory without testing them in the actual process of painting, and, equally important, in the course of studying other artists. He read Rood in 1881, but it was only in 1885 that he began a systematic application of optical mixing. In the intervening years, events took place in his art for which the paintings themselves are the only evidence.

In 1881 and 1882, Seurat's oil paintings were still in the Barbizon tradition. True to the Beaux-Arts, he had first mastered drawing at school; in the period after his military service, he signed and dated drawings of complete artistic maturity. But in painting, he postponed his

Georges Seurat *Men Sleeping and Monkeys* 1880

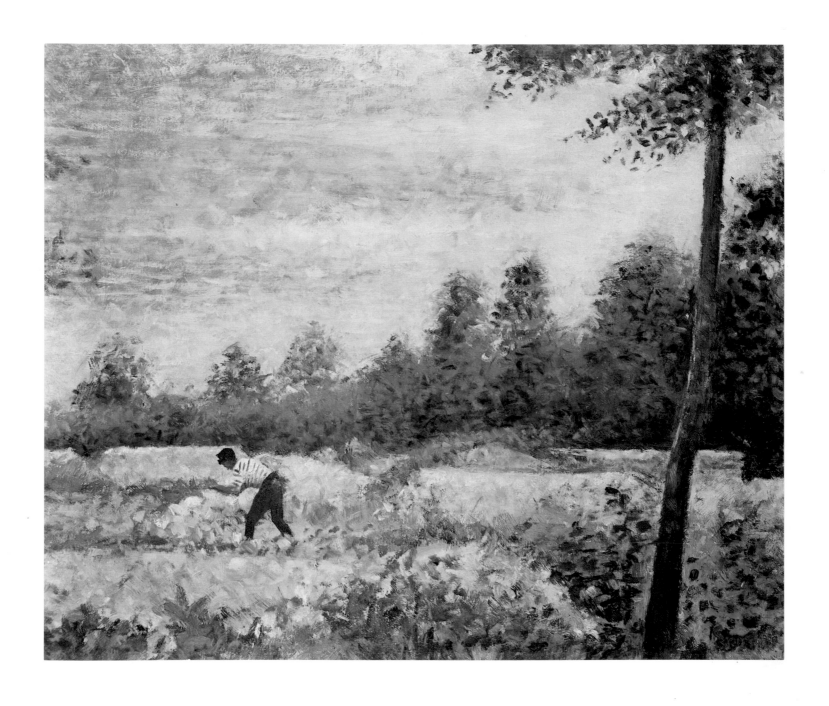

Georges Seurat *Stonebreaker at Montfermeil* 1882

maturity and gave himself over almost exclusively to sketches. His palette was close to that of Delacroix and the Barbizon painters, and his subjects were landscape and peasant scenes. Forms were rendered in a blocky simplicity which embodied both the monumentality of Millet and the geometric idealization of the classicizing tradition passed on to him by his school training, and by Chevreul, Blanc and Rood. He must have seen impressionist pictures by this time, but only Pissarro – significantly the most 'Barbizon' of the impressionists – had any effect on him.

By 1883, in the preparatory studies for his first mural-scale canvas, *Bathing at Asnières*, Seurat showed a sudden awareness of impressionism. Several panels exist which are veritable essays in the manner of Monet, Manet, Renoir and Pissarro. His palette brightened, specific effects of light were more often exploited, and his subjects moved from Barbizon countryside to impressionist river-bank and suburb. In fact, for all the significance of his readings, one feels that it was impressionism which provided the ultimate key to the unlocking of pure colour-light which the young artist had been seeking.

When *Bathing at Asnières* was shown at the first exhibition of the Indépendants in 1884, it was recognized as having a dual character. The homely subject – ordinary boys and men along the industrialized Seine north of Paris – and the light, fresh and broken tones of the surface, were modern and familiar: in the Goncourts' *Renée Mauperin*, for example, there is a famous scene of swimming by the industrial banks of the Seine, and any number of impressionist pictures showed bathers relaxing along the river. The figures, however, were different in character, and so was the geometric structure superimposed over the landscape. The boys and men, in immobile poses, have the permanence and monumentality of classical relief sculpture, and the solidity of the landscape rhythms joins with them to create a modern arcadia, transplanted from the classical tradition. It was a meeting of opposites, giving to impressionism the permanence of older traditions and to these, the revivification of the new predilection for bright, outdoor colour.

Seurat met the young Paul Signac at the founding of the Indépendants in 1884, and Signac's devotion to impressionism seems to have helped Seurat to take the final steps away from the pre-impressionist palette. Furthermore, Signac, whose ebullience contrasted with Seurat's native taciturnity, introduced Seurat to impressionist painters like Guillaumin and Pissarro, and by 1885, to the young symbolist writers like Robert Caze, Gustave Kahn and others. Although he retained his friendships with Aman-Jean, Séon and other fellow-students, Seurat was now pulled away from the Beaux-Arts milieu to the most radical artistic society of Paris. He appeared to them as an emissary of the correct, middle-class world. They were probably unaware of the degree to which their society helped commit him to a construction of *la vie moderne*.

Aided by this new exposure to contemporary painting and literature, Seurat finally shed earth colours in 1884, and rural subjects do not seem to have survived that year, either. In the spring and summer he undertook the first of many studies for his *Sunday Afternoon at the Island of La Grande Jatte*, another monumental remaking of a common impressionist theme. During the genesis of the picture, including the summer of 1885 painting seascapes at Grandcamp, his brushwork became progressively finer until, over a dense *paille haché*, he began to apply rather systematic tiny strokes. When shown at the eighth and last impressionist exhibition in May 1886, *La Grande Jatte* was instantly greeted as a fundamental reform of impressionism. Seurat's rational temperament and Beaux-Arts training had finally joined impressionism in its own precincts, and since the elder Pissarro, his son Lucien, and Signac also painted in the new manner, a reformist movement was indeed at hand.

The chief impulsion behind neo-impressionism (as Félix Fénéon named it in 1886) was that fundamental urge towards structural discipline which we have noted in Seurat's youth, but which merged with the strong current of positivist science to incorporate the aspirations of other painters as well. Pissarro was proud to call himself one of the *impressionnistes scientifiques*, and he found that he was offended by Monet's brushwork. 'It's stale', he remarked; and the connoisseur 'must be offended by the disorder which results from the romantic fancy which is not, for all the artist's talent, in accord with our age.'[13]

The colour theory embodied in *La Grande Jatte* became that of neo-impressionism, and, although there was considerable variation in the colours used by the painters (Seurat's own palette later became lighter and simpler), the underlying theory was then fully established. It was best summarized by Fénéon in a number of essays published in the symbolist journals from 1886 onward.[14]

First, there was the local colour: for example, the bright green of sunlit grass and the dark green of shaded grass. The local colour was allowed to dominate in most cases and to form a stable structure of relatively few large areas of colour.

In direct sunlight, the local colour receives a heavy

dosage of yellow-orange, conceived of as the proper expression in pigment of the sun's action. To the local green of the grass in our example will be added strokes of several pure yellows and oranges, which represent particles of sunlight reflected from the surface without being altered by absorption. Local colour and pure sunlight are usually the only ones present under the full impact of the sun, all other reactions being obliterated. (The orange would also express something else: it is the colour-opposite of the adjacent blues which are strong in the shaded areas of grass nearby.)

In shadow, sunlight is only indirect and hence weaker, permitting many more colour reactions. The local colour of grass will be green, but now blue will be in evidence also, as the pervasive colour of indirect light which is being reflected from the surface. There will be some sparse orange, representing stray particles of sunlight, but more important will be a new range of colours indicating light that has been partly absorbed before being reflected back to our eye. These will usually be reds and purples (the latter also a result of the reds mixing with the blues), because, surprisingly enough, green vegetation has a good deal of red, although we see it only in shadow or at sunset. Depending upon the natural surface to be painted, the partly-absorbed hues will vary enormously.

Thus far, then, we have local colour, reflected sunlight, and partly absorbed light. There are two remaining catagories: light reflected from an adjacent area, and the action of complementary colours. In the former case, a red dress might reflect some of itself on the green grass, or the green might bounce up to the dress. Actually Seurat seldom exploited this phenomenon, although Pissarro often did, as Fénéon pointed out. Such differences show that theory cannot explain all aspects of practice.

The play of complementary colour is the remaining feature of neo-impressionist colour theory, and the key to its nature. Chevreul's famous concepts of 'simultaneous contrast' and 'successive contrast' find their place here. Simultaneous contrast means that two colour-areas placed side by side will tend to exaggerate their differences, and, if complementaries, they will acquire an unusual brilliance. (If complementaries are interwoven in small strokes, however, they neutralize one another to form a grey.) Successive contrast means that one colour-area will fatigue the eye after a moment and induce an after-image or surrounding halo of the colour-opposite. Hence the orange of sunlit grass and the blue of shaded grass in our example exist not only in their own right, as already explained, but also as one another's complementary. The sunlit orange provokes blue as a result of 'successive contrast', and the blue produces the orange. Such reactions are strongest toward the edges of colour-areas. In the example, the oranges would be most intense next to the shaded grass, and the blue, next to that zone of orange.

One should mention also another aspect of the theory, namely 'irradiation': when two areas of unequal lightness are juxtaposed, the lighter will seem still lighter at the edge, and the darker, still darker. The light-dark strips of contrast coincide with the bands of colour-opposites to produce the omnipresent haloes and *umbrae* of neo-impressionist pictures.

Whether found only at the edges where two areas meet ('successive contrast') or in the juxtaposition of entire areas of opposed colour ('simultaneous contrast'), this balance of opposites is that which distinguishes neo-impressionism so readily from impressionism. Camille Pissarro, for the record, remained an impressionist at heart even when using much of the neo-impressionist technique, because he sought the harmony of similar tones, not opposites. This is why he usually showered one area with the local colour of the adjacent area, not its complementary. As a result, he tended to blend two areas together, instead of separating them as did Seurat and Signac.

The most conspicuous instance of blending, rather than opposition, which Seurat and Signac permitted, was the mixing on the palette of two adjacent colours on Rood's colour-wheel. Yellow could be mixed with green, for example, or with orange, but not with blue or red. To the person who mistakenly believes that Seurat or the others used only the three primary colours, or even the six major ones, this comes perhaps as a surprise. This erroneous view persists in the face of ready documentation and the evidence of the pictures themselves.[15] When he wanted a green or an orange, Seurat used them fresh from the tube (and several different greens and oranges at that); he did not compose them with dots of yellow and blue, or red and yellow. At its simplest, late in his career, his palette had nine colours, and each could be mixed with its neighbours to produce eighteen pigment mixtures – and each of the eighteen could be mixed with white to any degree. What is true is that when Seurat wanted a green, he first used several greens to give a vibration within the local colour, then would also add yellows and blues to supplement the basic tone. The yellows and blues do not form green, as the mistaken view has it, because the eye sees them separately; but they make our mind think of yellow-green and blue-green, the ultimate vibration which the artist sought.

The division of the colours and the use of small touches of paint were supposed to lead to optical mixing, which Blanc and Rood had discussed extensively. When two or more pigments were mixed together on the palette, they produced a dull result. The same pigments, according to the theory, if placed in separate strokes, would 'mix' in the eye to form new hues. In practice, optical mixing seldom occurs in Seurat's work, because one sees the separate colours even at a distance. This is why his first step was to apply in broad criss-cross strokes a substantial layer of local colour. Underlying the small surface touches, and showing between them, this layer is really responsible for 'resultant' hues. In the shaded grass of *La Grande Jatte*, for instance, Seurat first brushed in several different greens and blue-greens. It is these, stemming from Delacroix and impressionist practice, which make us read the dominant colour, although we also see the fine, interlaced strokes of varied colour on the surface.

It was not real optical mixing, but what Blanc and Fénéon called 'vibration', that Seurat and the neo-impressionists sought. The eye struggles toward a resolution of the several colours, but stops short of a final, single result. In so doing, it is subjected to a vibration of coloured particles in which their separate identities are

Georges Seurat *The White Horse* 1881–84 Conté crayon

Georges Seurat *Sketchbook page* 1880

preserved, but intensely activated by the texture and by interaction with the other colours. 'The effect referred to takes place when different colours are placed side by side in lines or dots, and then viewed at such a distance that the blending is more or less accomplished by the eye of the beholder. Under these circumstances the tints mix on the retina, and produce new colours, which are identical with those that are obtained by the method of revolving discs.... If the coloured lines or dots are quite distant from the eye, the mixture is of course perfect, and presents nothing remarkable in its appearance; but before this distance is reached there is a stage in which the colours are blended, although somewhat imperfectly, so that the surface seems to flicker or glimmer – an effect that no doubt arises from a faint perception from time to time of its constituents. This communicates a soft and particular brilliancy to the surface, and gives it a certain

appearance of transparency; we seem to see into it and below it.'[16]

The shimmering, multicoloured surfaces have a curious depth and richness; Rood cited Dove's concept of lustre as an explanation. Seen closely, the touches of pigment vary greatly in size and placement, and by following the contours of the represented images, they have an architectural role. We are normally less aware of this, however, and more conscious of the relative uniformity of stroke. To the degree that the coloured touches of paint can induce a sense of colour-light actively forming itself in front of our eyes, the brushwork has to be nearly uniform, the more to resemble pure light-particles. Were the touches to vary much in size they would seem to belong to the object being represented, as in traditional painting, and not to the autonomous colour-light process.

There are other reasons for the tapestry of small and

separate touches of pigment. Theory aside, it is evident that they permitted extremely subtle variations of colour, serving Seurat's wish to express extraordinary nuances of hue. One could add a colour, or change its gradation, by the application of another set of touches. Contrast a traditional painting, in which added touches must be patiently adapted to the underlying formation of pigment.

Not only were the strokes of paint separate, they were also applied over a previously dry layer. This prevented the direct merging of two colours, accomplishing two aims at once: the demand of theory to separate the colours, and the wish to avoid an interchange of their chemical constituents which, in traditional painting, often leads to actual alteration of colour. Furthermore, the small strokes dried evenly, unlike other methods (Van Gogh's, for example), in which tension between the dry outer surface and the molten interior of thick strokes caused them to crack.

The evenly dotted surfaces of Seurat's pictures, the colour theory he espoused, his predilection for harmonies

32 Georges Seurat *Three Women*, 1885–86 Conté crayon

Georges Seurat *Study for 'La Grande Jatte'* 1884–85

of contrast, and his engineer's expression of ordered structure, all came together in the remarkable integrity of his vibrating surfaces. The regular rhythm of his small touches of paint embodied his anti-impressionism for, to use Fénéon's expressions, 'this uniform and nearly abstract execution' left no room for the irregular 'trails of impasto' or the 'dexterity of touch' associated with impressionism. One of the virtues of Seurat's colloidal texture was its ability to preserve the definite contours of his geometric style, which large and uneven strokes would have destroyed.

And yet for all the apparent order Seurat established, for all the seeming rigidity of his compositions, how remarkably tense and active are his flickering, shimmering surfaces. The colours do not settle into readily grasped, easily named tones. They dance and flutter before our eyes, forcing us to an intense visual activity. This straining of the eye, this actual work which the observer is required to do, endows Seurat's structural order with a sense of process, of life-action.

Ogden Rood cited Ruskin on just this quality of vibrating colour touches, and one wonders if Seurat took

inspiration from it when he read in 1881: 'Ruskin, speaking of gradation of colour, says: "You will find in practice that brilliancy of hue and vigour of light, and even the aspect of transparency in shade, are essentially dependent on this character alone; hardness, coldness, and opacity resulting far more from *equality* of colour than from nature of colour." In another place [*Elements of Drawing*, 1857] the same author, in giving advice to a beginner, says: "And it does not matter how small the touch of colour may be, though not larger than the smallest pin's head, if one part of it is not darker than the rest, it is a bad touch; for it is not merely because the natural fact is so that your colour should be gradated; the preciousness and pleasantness of colour depends more on this than on any other of its qualities, for gradation is to colours just what curvature is to lines, both being felt to be beautiful by the pure instinct of every human mind, and both, considered as types, expressing the law of gradual change and progress in the human soul itself."[17]

The expressive power of line, colour and value

Seurat's 'L'Esthétique' (Appendix B) stresses the emotional nature of the essential components of painting: colour, line and black-and-white. Bright colours, upward-moving lines and light tones induce gaiety, as one example. What are the origins of these associations?

Charles Blanc again stands at the beginning of Seurat's theories. Writing about Delacroix, he comments on the Romantic master's attention to the 'moral' qualities of colour, by which he meant the appropriateness of certain colours and combinations of colour to specific moods: 'Eugène Delacroix had not only mastered the mathematical rules of colour; he understood its moral harmonies, and he understood better than anyone its dramatic language.'[18]

Hence a battle scene would be built upon strongly opposing hues of intense saturation, but an Entombment would be shown in a harmony of sombre tones. This ability of colour to project mood is later referred to by both Fénéon and Signac (*D'Eugène Delacroix au néo-impressionnisme*) as a 'moral' quality, in apparent deference to Blanc's terminology.

The emotional significance of line was given far greater prominence in Blanc's *Grammaire* than that of colour. In almost every section of his book, he refers to the theories of Humbert de Superville, whose *Essai sur les signes inconditionnels dans l'Art* (Leiden 1827) brought together the traditional ideas on this subject. Blanc reproduces Superville's famous three faces whose schematic lines symbolize his themes: upward-slanting for gaiety, horizontal for calmness, downward-slanting for sadness. Blanc returns to these diagrammatic faces repeatedly, and gives extended analyses of the ideas they signify. For example, he reproduces the 'calm' face to begin his section 'L'Architecture monumentale en plate-bande exprime les idées de calme, de fatalité et de durée', and insists on the fact that the four little horizontal lines (eyes, nose and mouth) suffice to project the feelings of calm, fatality and duration without further details. He then cites Egyptian architecture, with its flat horizontal planes and lines, as the archetypal example.

Years after he first read Blanc's *Grammaire*, Seurat sketched Superville's three faces on a scrap of paper (private collection, Paris), which also has a drawing for the background of *Circus Parade* (Metropolitan Museum, New York). The conspicuous horizontals of the painting, and its occasional downward-slanting lines, express a melancholy that is combined with a sense of absolute monumentality. The only prototype for this radical painting is Egyptian art; and, in fact, Blanc's engravings after Egyptian architecture are curiously close to the structure of *Circus Parade*, whose mood of 'calm, fatality and duration' embodies a perfect linking of style and idea.

On this same invaluable scrap of paper are citations from another book, *Introduction à une Esthétique scientifique* (1885) by Charles Henry. Seurat had met Henry at the last impressionist exhibition in May 1886. He was a brilliant young scientist, author already of many books although only Seurat's age. He was a contributor to many symbolist reviews and an intimate friend of Gustave Kahn and Félix Fénéon, who were among Seurat's chief defenders. *Introduction à une Esthétique scientifique* must have struck Seurat with a force like that of Rood's book in 1881. Just as Rood gave scientific evidence for the empirical colour theories of Chevreul and Delacroix, Henry returned to Humbert de Superville and Blanc, and placed a scientific base underneath their rather general ideas.

Calling on his knowledge of aesthetics and mathematics, and on his own physiological experiments, Henry dealt with the extensive evidence linking human emotions – normally unconscious but sometimes conscious – with directions of movement. Feelings of gaiety and excitement are expressed by actual or implied movement to the upper right, such as a right-handed person waving to attract attention. These movements Henry called 'dynamogenic', and are related to pleasure and the release of

energy. One only has to think of the natural movement upward and to the right, that is, clockwise, when one grinds a pencil sharpener or coffee mill, and how uncomfortable it is to reverse the movement. Movements down and to the left express dejection or fatigue, and Henry called them 'inhibitory'. They are related to pain, and to the conservation of energy. In experiments at which Fénéon and others were present, Henry showed not only that red, yellow and the warm colours are dynamogenic and the cold colours inhibitory, but also that there is an intimate association with direction. For example, a person wearing yellow or red glasses, asked to copy a given diagram, will unconsciously shift elements of the design to the right or upward.

In subsequent publications (especially *Cercle chromatique* of 1888), Henry carried his theories further, and thoroughly integrated line, colour and value. He constructed a graduated wheel on which the location of the colours and the angles of incidence, or distances between them, corresponded to dynamogenics and inhibition, and he applied numerical schemata to guarantee combinations which would be effective. That Seurat was familiar with these later writings, as well as *Introduction à une Esthétique scientifique*, seems certain, and we know that Signac collaborated directly with Henry in producing posters and diagrams for his books.

Two features of Henry's theories should be emphasized because of their relevance to Seurat and to the whole development of modern art. These are *movement*, the dynamic component, and *line as abstraction*, the schematic component.

Movement is central, because the physiological basis for Henry's ideas resides in the demonstrable fact that human reaction to any event or thought must involve actual physical or mental (and secretly kinesthetic) motion. If no such movement occurs, there is no reaction at all, no cognizance of outer change, and the organism continues as it was. Here is where theories of continuity and discontinuity are moulded to his purposes by Henry, and also where he could bring scientific evidence to bear. For if our reactions to the spectra of events are subtle and hard to define, at least the actual movements which document these reactions, because they occur in the field of human physiology, can be charted. Lines of a work of art, in this fashion, embody the movement of the artist who made them, and the observer's eye recapitulates this movement since it actually scans the surface. Additionally, the lines will induce secondary, unconscious reactions according to their dynamogenic or inhibitory directions.

From motion of the eye to interior reactions, then, the human being undergoes movement in order to comprehend. This feature of Henry's concepts must have been especially congenial to Seurat, and perhaps contributed to the increasing liveliness of his later style. Contemporaries who knew Seurat cited Henry when commenting on *Chahut* (Rijksmuseum Kröller-Müller, Otterlo) and *The Circus* (Musée du Louvre), whose upward-moving lines express the bustle and gaiety of their subjects. The very active rhythms of Seurat's late pictures contrast sharply with the monumentality of *Bathing at Asnières* and *La Grande Jatte*. Admittedly, Henry's concept intends to be a universal one, applying equally well to calm as to excitatory compositions, but he was so much the son of his period that his writings are marked by a constant invocation of dynamic movement, as though one could hear in the background the churning rhythms of the machine age (in *La Revue Blanche* in 1894, Henry published wonderful articles on bicycling, whose illustrations look forward to futurism and cubism). In Seurat's late paintings, the movement of the darting lines is given added vigour by the movement of our eyes as we react to the shimmer and vibration of the divided colour.

Line as abstraction is the other especially significant feature of Henry's theories. On the little sheet already referred to, which has Superville's three faces and the background of *Circus Parade*, Seurat copied these words from *Introduction à une Esthétique scientifique*: *ligne – abstraction – direction*. With the economy we would expect of him, Seurat had condensed this sentence (p. 7): 'But a little reflection soon shows that a line is an abstraction: it is the synthesis of the two parallel and opposite directions in which it could be drawn. The reality is direction.'

A line is the cipher of a given movement in a certain direction, the mark of an action. How congenial to an artist such a definition is! It points to his role in forming an image, whereas the non-artist, the observer, will usually accept the lines, not as the abstraction of the artist's movements, but as the evocation of an image. For Seurat as for Henry, the basic building-blocks of a work of art – the touch of colour and the line – are given a remarkable autonomy, a power to express feelings almost alone, almost independently of the objects they conjure up. This is why Seurat's 'L'Esthétique' is devoid of all reference to subject matter, and refers only to abstract structural components as vessels of feeling.

With such ideas we are truly on the threshold of the twentieth century. Purely abstract art requires one to believe that line and colour can be vehicles for emotional expression, since there is no imagery to help. It was

Seurat's generation which took the penultimate step toward this position. 'M. Seurat', wrote Fénéon, 'well knows that a line, independently of its topographical role, possesses a measurable abstract value.'[19]

Two other pieces of evidence can be brought to bear on this same heading. In his youthful reading of Charles Blanc, Seurat had already absorbed the idea of line being an abstraction. In his *Grammaire*, Blanc had remarked on the expressive power of the most radically simple lines, 'these abstract lines', as he calls them, and he reproduced schematic drawings which Seurat later put on the same sheet with his citation from Henry, *ligne – abstraction – direction*.

A second juxtaposition can be made to show how pervasive this proto-abstract concept was, for it was by no means limited to Seurat. The symbolists, among whom he counted many friends and associates, had a parallel concept which they readily transferred to painting. Teodor de Wyzewa wrote : 'The need to express emotions through art very soon forced painters to go beyond the bounds of realistic representation of sensation.... Colour and line, under the influence of habit, had acquired, like words, an emotional importance independent of the actual objects they were meant to represent.... These colours and contours, and these phrases, from having been mere illustrations of visual experiences, now became bound to inner emotions.... They were emotional signs, like syllables in poetry or notes in music. Some painters... thus used colour and line in order to achieve a symphonic composition, ignoring the visual subject to be represented.'[20] Wyzewa was not thinking of Seurat, but, more probably, of Renoir and Monet ; but his view, common

Georges Seurat *The Seine from La Grande Jatte* c.1888

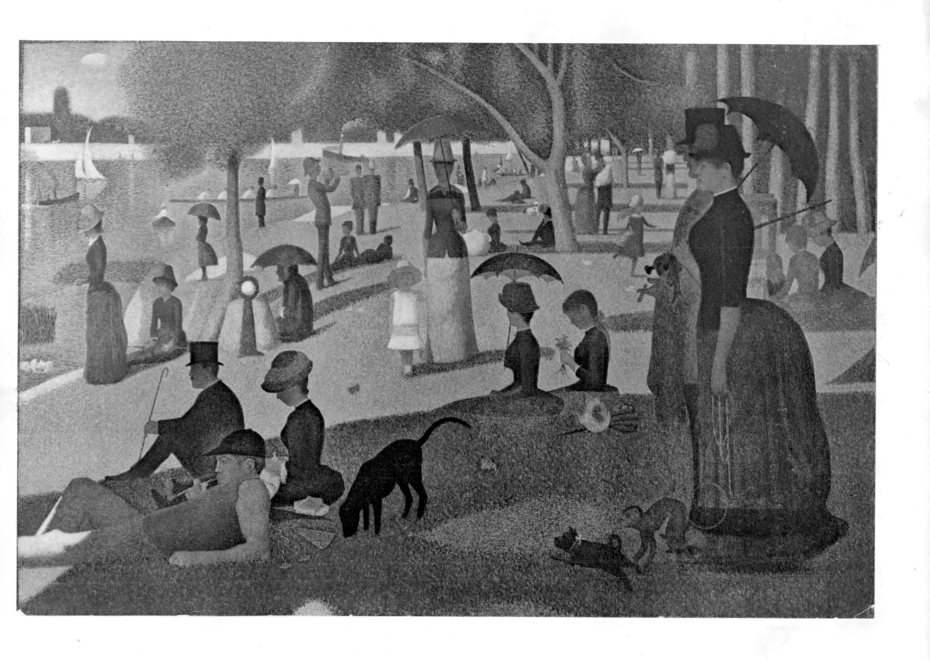

Georges Seurat *A Sunday Afternoon at the Island of La Grande Jatte* 1884–86

to the symbolists, could be applied to Gauguin or Van Gogh as well, and generally to most advanced painters of the end of the century.

A word of caution is needed, however, lest we believe that Seurat and the post-impressionists were already abstractionists in our sense of the word. Like the symbolists, their choice of images reveals definite patterns of preference. What has mattered thus far in the present discussion is the degree to which the formal elements of art were given a new autonomy, but all these artists wished to express themselves through the images they borrowed from the natural world. They meant to draw away from nature, to *abstract* in its precise meaning, by disdaining conventional imitation in order to celebrate the condensed essence of forms and movements. The newly distilled forms they regarded as superior to mere imitation because they more readily stood for the dominance of the artist's mind over the stuff of nature. It was therefore easy for them to emphasize the instruments by which this dominance, this near-independence, was asserted.

The reform of impressionism

In 1886, when *La Grande Jatte* won Seurat instant notoriety, impressionism was losing its always fragile identity. Manet had died in 1883. Cézanne had long been creating his own art in near-isolation in the South of France, and was as yet known to very few. Although Monet and Degas were continuing along their creative paths, Renoir had veered suddenly towards the classicizing tradition and was in the midst of his *période aigre*, a most notable parallel to Seurat's development. Pissarro had been converted to neo-impressionism and was one of the dissidents in the last impressionist exhibition in May.

By 1891, when Seurat died aged thirty-one, painting in Paris had passed from impressionism to Art Nouveau. The evolution of his own style from *La Grande Jatte* to *Chahut* and *The Circus* is an indication of Seurat's essential contribution to this radical transformation. In the last months of this five-year period, Van Gogh and Gauguin had come to sudden prominence, and their work, along with that of younger artists, consummated the abrupt shift away from impressionism. This evolution was seconded by the exactly contemporary rise of the Symbolists, who effected a similar change in poetry.

From 1886, the year in which both movements were born, neo-impressionists and symbolists shared friendships. In the symbolist press, the neo-impressionists were given first place for about five years, until the force of both movements began to flow into the sands of the 1890s. The last five years of Seurat's life are documented in articles written for the most part by men who knew him, and to whom he gave synopses of his ideas: Fénéon, Kahn, Verhaeren, Adam, Antoine, Christophe and others. The final elements for a study of Seurat's concepts will be provided by this body of writing, which we must place next to Seurat's early readings. What we will discover is this: Seurat's youthful training had incorporated already, to a marked degree, the values and attitudes later central to symbolism.

We should recall first how thoroughly Seurat established a set of artistic values utterly foreign to contemporary impressionism. His training at the municipal school and at the Ecole des Beaux-Arts emphasized drawing from classical sculpture, from Ingres and from Poussin, as a way of attaining a standard by which to judge natural form. Already evident in drawings dated 1877, when he was only seventeen, is a penchant for clear, simplified outline and flat geometric shape. His principal reading in the same period, Blanc's *Grammaire*, stressed the relationship between classicizing form and the values of permanence, and established them in opposition to the hedonistic naturalism of impressionism.

In the opening chapter of the *Grammaire*, Blanc made this clear: 'The artist's task is to bring back among us the ideal, to reveal to us the pristine beauty of objects, to unveil their quality of permanence, their pure essence. Art should define and illuminate to the mind what nature presents in a muddled and obscure form [like impressionism!].... In the artist's hand, the secondary element, time, will stand still and beauty will acquire permanence.... Were the changing elements of time allowed to interfere, beauty, which embodies immortality and God, would become a prey to our transitory feelings.'

Blanc's constant attention to laws of harmonic order was seconded by Chevreul and Rood, who share much the same outlook, and even more so by David Sutter, whose essays Seurat 'meditated', as he tells us himself, in 1880 (Appendix A).[21] Sutter's ideas are very much like Blanc's, but more rigidly construed (however, both men were liberals within the Beaux-Arts tradition, and Delacroix was their favourite painter).

For the young man who was later to lead a reform of impressionism, it is instructive that these are the aphorisms he earmarked among the hundreds Sutter gave: 'A clear and precise formula had to be found to express the rules governing the harmony of lines, of light and of

Georges Seurat *The Artist's Aunt, Anaïs Haumonté-Faivre, on her Deathbed* 1887

colours, and the scientific explanation of these rules had to be given. We insist on the essential point: all rules being drawn from the laws of nature itself, nothing is easier to know in its principles, and nothing is more indispensable. In the arts, everything must be consciously willed.'

Armed with such cuirasses and bucklers as these, fortified by a constant search for the latest scientific rules to place alongside them, borne along by a prodigious talent, Seurat was instinctively dedicated to the overthrow of impressionism even before he came to know it well. His training and his scientific readings acted as a shield, permitting only those aspects of contemporary art to pass through which suited the structure of his armour.

With the full flowering of his style in *La Grande Jatte,* after exposure to the whole range of impressionism, Seurat made his astonishing synthesis. To the impressionists' outdoor subjects, to their devotion to contemporary life, to their celebration of colour and light, he brought the harmonic laws of his own early training. Blanc's and Sutter's rules of order, their doctrine of essential form, their anti-naturalism and their insistence upon the permanence of form, became the geometric structure of Seurat's art. 'The Pan-Athenaic Frieze of

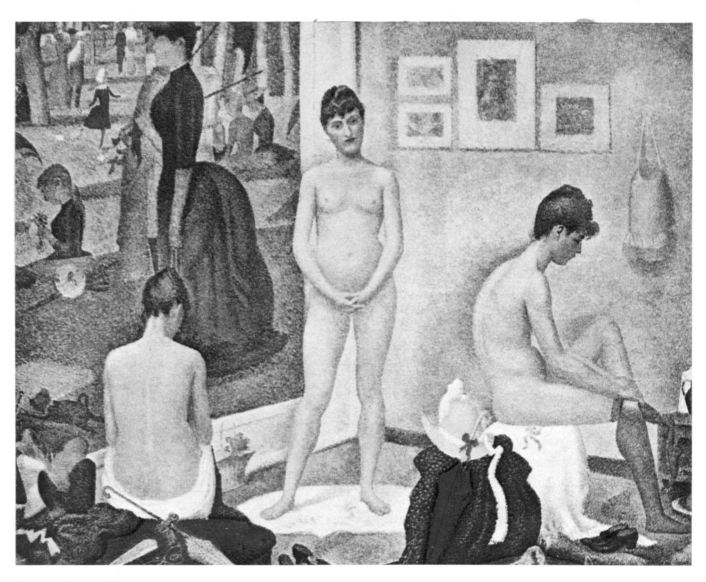

Georges Seurat *The Models* 1888

Phidias', Seurat told Kahn, 'was a procession. I want to make the moderns file past like the figures on that frieze, in their true essence.'[22]

The symbolists, helped by Seurat's conversations with them, gave instant recognition to his ambition to take impressionist subjects and colour-light and render them permanent. They openly espoused what can only be called 'anti-impressionism', and the pejorative is readily found in their choice of words: '[In impressionism,]

Nature is in permanent convulsion. Pissarro, Seurat, Signac, etc., gave nature a calmer aspect through a new process (juxtaposed dots), enabling them to conform more faithfully to the tenuity of light and of its effects. They chose calm landscapes, less troubled waters, and tried to convey a more permanent image of a landscape rather than its momentary appearance. With human figures, they suppressed indifferent rhythms and aimed at synthetic creation. As any contortions or movements

of joy or suffering were temporary, they were suppressed. Modern passers-by were lent some of the hierarchy and the eternal quality of the statues of Antiquity.'[23]

These ideas, so nearly identical with Blanc's, are absolutely central to the symbolists' view of art. They insist that painters seek 'essences', 'synthesis', qualities that are 'permanent'. Against the manner of the impressionists, 'summary and approximate', the symbolists held up the example of Seurat, 'precise and conscious'. Against the impressionists' cult of exterior, sensory enjoyment, they held up Seurat's interior, subjective vision.

Of course these ideas would not have been accepted by Blanc as the symbolists chose to apply them, nor would he have been capable of praising Seurat. His concepts are substantially the same, but in a matrix of general laws of aesthetics largely based upon classical art of the past, and seldom of his own invention. It is as though Seurat and the symbolists took the bones of his eclectic theories, and grew new flesh upon them. One of the best examples of this transposition is what we should call Blanc's 'primitivism'.

Blanc gave marked notice to Egyptian art, throughout the *Grammaire*. It is true that he regarded Greek art as more elevated, on the grounds that it made a better balance of the ideal with the natural; but his many pages on Egyptian art show a pronounced enthusiasm for its stately, ceremonial and abstract forms. We have seen already that Egyptian art probably contributed to the composition of *Circus Parade*, and no doubt Blanc had encouraged Seurat in this direction. His descriptions of Egyptian art could be used, with little alteration, to describe Seurat's late paintings. In the following passages, one can find what seems like a symbolist discussion of *Chahut*:

'The figures are represented in a concise, summary manner, not without finesse, but without details. The lines are straight and long, the posture stiff, imposing and fixed, the legs are usually parallel and held together, the feet touch or point in the same direction and are exactly parallel.... in this solemn and cabalistic pantomime, the figure conveys signs rather than gestures and is static rather than in action, since its predictable and somehow immobile movement will remain unchanged. ... Two characteristics are evident and consciously planned: the sacrifice of small areas in favour of large ones, and the non-imitation of reality.... The variety which is present in all human beings and is the essence of nature has been replaced by religious symmetry, adorned with majesty.'[24]

On the same page as these observations is a line engrav-

ing after an Egyptian relief whose repeated geometric rhythms are remarkably like *Chahut*, as though Seurat had unconsciously recalled the rhythms from his youthful reading.

The symbolists were quick to call Seurat's style 'Egyptian' and 'primitive'. For them, it was the highest praise to cite parallels with the hieratic art of Egypt, Greece, the Middle Ages and the early Renaissance. In *La Grande Jatte*, wrote Paul Adam, 'Here are people in their holiday best, stiff and solemn on a warm summer day, with gestures and poses reminiscent of those figures

who walk in pious procession on Egyptian stelae and sarcophagi.'[25]

Because classical art had been discredited, its values were transferred elsewhere, and the so-called primitive arts took over the role of providing historical legitimation of the new stylistic impulses: flat, decorative form; large, simple and geometric shapes; strong, pure colour; feelings of monumentality, permanence and at times, of ceremonial incantation. These, however, are qualities which had been ascribed to classical art, the least primi-

tive of western traditions, and which were part of Seurat's training.

An essentially conservative doctrine was thus given a new costume, and walked among the post-impressionist painters with all the exoticism of a new mode. It was not just Seurat and the symbolists who were stimulated by primitivism and Egyptianism. One has only to think of Gauguin and the Nabis. Furthermore, Gauguin knew Blanc, or, at least, he copied the colour wheel from the *Grammaire*, and he shared Seurat's interest in theories of harmonic proportion and expressive colour. Seurat must be given pride of place, nonetheless, for the simple reason that his art came to maturity and to public attention first, and through its force, a whole generation was freed to think and act in new ways.

Studying Seurat as we have, primarily through his readings and his theories, has led us full circle. Innovation reclothes tradition, tradition sustains innovation; youthful study which might seem a barrier to contact with the present, instead acts as an instrument of renovation, shaping the present into higher forms; these forms transcend their present and join ours, echoing all the while the rich past of which they were the heirs.

Where Charles Blanc wrote of the Greeks, we would gladly insert Seurat's name: 'It was the unique achievement of the Greeks, as we shall see, to marry these two elements, nature and the ideal; which is to say that they performed the unheard-of and eternally astonishing feat of creating abstractions that were alive.'[26]

Robert L. Herbert

[1] 'Un vaillant', *Paris*, 1 April 1891, pp. 5–8. For a comprehensive bibliography, see the invaluable *Post-Impressionism from Van Gogh to Gauguin* by John Rewald (New York, 1956 et seq.); in *Seurat and the Science of Painting* (Cambridge, Mass., 1964), William I. Homer has discussed Seurat's scientific readings; Seurat has been placed in the perspective of his fellow neo-impressionists in the exhibition which I organized for the Guggenheim Museum, New York, in February-April 1968, *Neo-Impressionism*.

[2] Henry in *Introduction à une Esthétique scientifique* (Paris, 1885), p. 4; Blanc in *Grammaire des arts du dessin* (Paris, 1867), 'Principes', section VII and also 'Sculpture', section X.

[3] Sources summarized by Françoise Cachin in Paul Signac, *D'Eugène Delacroix au néo-impressionnisme* (Paris, Miroirs de l'art, 1964), p. 96.

[4] See Appendix A; the citation is from the article Seurat mentions in his letter, 'Eugène Delacroix', *Gazette des Beaux-Arts*, xvi, 1864, pp. 23f.

[5] Copy in the Signac archives, from E. Piron, *Eugène Delacroix, sa vie et ses œuvres* (Paris, 1865), p. 415.

[6] *Modern Chromatics* (New York and London 1879), p. 317 (French edn, 1881, p. 273).

[7] Copy in estate of the late C. de Hauke; Seurat copied sections on pp. 197–201 of *De la loi du contraste simultané...* (Paris, 1839).

[8] See note 4.

[9] Dated February and November, 1881, now in the Signac archives.

[10] See note 5.

[11] In the Signac archives, also from Piron, *op. cit.*, pp. 416 ff.

[12] See especially 'New Light on Seurat', *Art News*, April 1958,

pp. 22 ff. Seurat's brother-in-law Léon Appert published in 1896 *Notes sur les verres des vitraux anciens*, full of the lore of chemistry and physics that seems suitable to the family connection; it was reedited in 1924.

[13] Camille Pissarro, *Lettres à son fils Lucien*, edited by John Rewald (Paris, 1953), letters of 7 and 9 January 1887, pp. 123f.

[14] For Fénéon's texts in a brilliant critical edition, see Françoise Cachin, *Félix Fénéon, Au-delà de l'impressionnisme* (Paris, Miroirs de l'art, 1966).

[15] See J. Carson Webster, 'The Technique of Impressionism: A Reappraisal', *College Art Journal*, iv, November 1944, pp. 3–22.

[16] Rood, *op. cit.*, p. 279 (French edn, p. 279).

[17] *Ibid*, p. 278 (French edn, p. 240).

[18] *Gazette des Beaux-Arts, op. cit.*, p. 106.

[19] 'Exposition des Artistes Indépendants à Paris', *L'Art Moderne*, ix, 27 October 1889, p. 339.

[20] Teodor de Wyzewa, 'L'Art wagnérien: la peinture', *La Revue Wagnérienne*, May 1886, reprinted in *Nos Maîtres*, (Paris, 1895), pp. 11–26.

[21] 'Les phénomènes de la vision', *L'Art*, vi, 1880, pp. 74–76, 124–125, 147–149, 195–197, 216–220, 268–269.

[22] Gustave Kahn, 'Exposition Puvis de Chavannes', *La Revue Indépendante*, vi, 1888, pp. 142–146.

[23] Gustave Kahn, 'La Vie Artistique', *La Vie Moderne*, vii, 9 April 1887, pp. 229–231.

[24] *Grammaire*, 'Sculpture', section xv.

[25] 'Les Impressionnistes à l'exposition des Indépendants', *La Vie Moderne*, x, 15 April 1888, pp. 223–229.

[26] *Grammaire*, 'Sculpture', section iii.

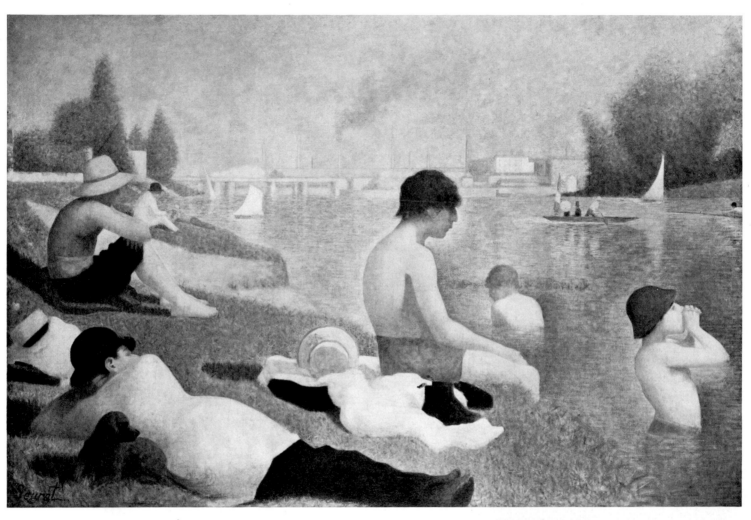

Georges Seurat *Bathing at Asnières* 1883–84

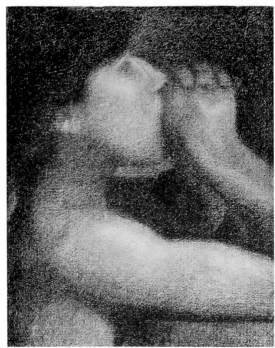

Georges Seurat *The Echo, study for 'Bathing at Asnières'* 1883

Georges Seurat *House with Red Roof* c. 1882

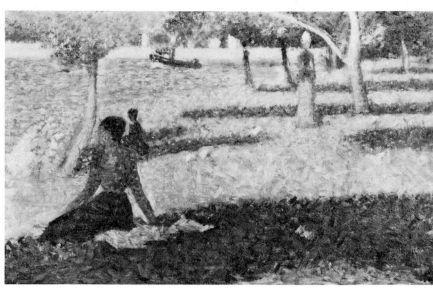

Georges Seurat *Oil sketch for 'La Grande Jatte'* c. 1885

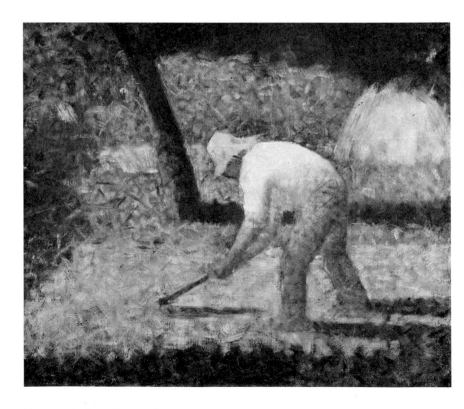

Georges Seurat *Peasant hoeing* c. 1882

Georges Seurat *Woman with Monkey,
study for 'La Grande Jatte'* 1884–85

Georges Seurat *A Sunday Afternoon at the Island of La Grande Jatte*
Detail

Georges Seurat *Beach at Le Bas-Butin* 1886

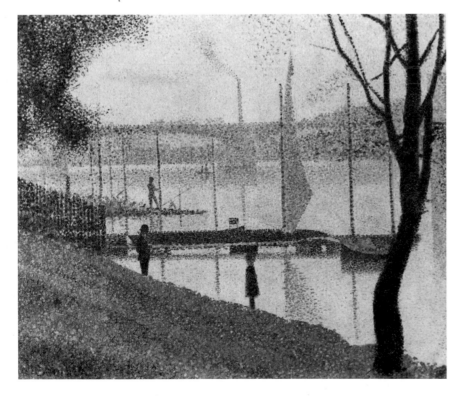

Georges Seurat *Bridge at Courbevoie* 1886

Georges Seurat *Harbour and Quays at Port-en-Bessin* 1888

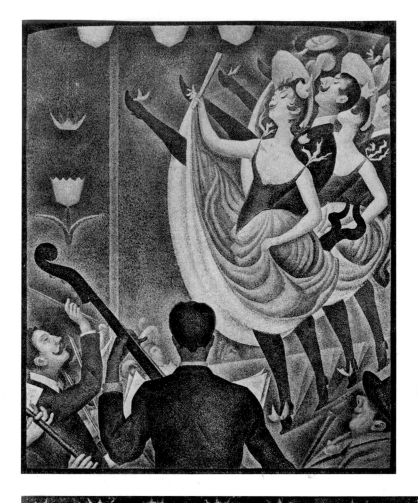

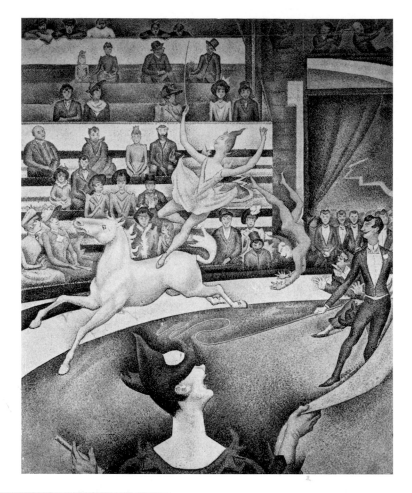

Georges Seurat *Chahut* 1888–90

Georges Seurat *The Circus* 1890–91

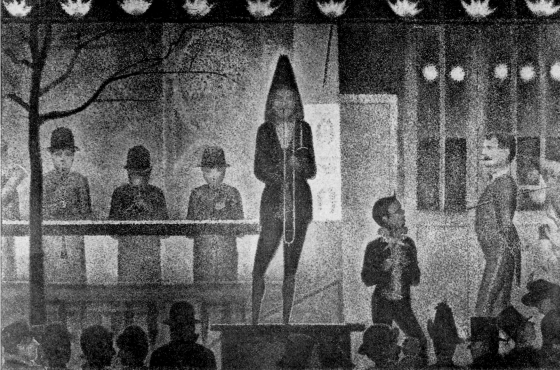

Georges Seurat *Circus Parade* 1887–88

Paul Signac 1863–1955

Paul Signac was born on 11 November 1863 at 33 rue Vivienne, near the Bourse, the Stock Exchange in Paris. He was the only son of Jules Signac and of Heloïse Doudon. His father was a high-class saddler, and, according to the fashion, there stood in his shop a stuffed horse for trying on saddles and bridles. The Signacs ran a prosperous business.

Signac went to school at the Collège Rollin. From a tender age, he was interested in drawing and painting. His father was art-lover, and drew in his spare time. His bourgeois and conventional taste often made him jeer at naturalistic literature and impressionist painting in front of his son who, inclined to be of a contradictory temperament, then defended the cause of the artists and writers his father attacked. He began to draw as a result of reading the lavishly illustrated periodical *La Vie Moderne* and looking at impressionist works.

In 1879, at an exhibition of modern paintings in rue des Pyramides, he was copying some paintings when Gauguin threw him out of the gallery, saying: 'No one copies here, monsieur!' In 1880, he went to look at the Monet exhibition organized by *La Vie Moderne* which fired him with enthusiasm. He then began to paint out of doors, mostly along the banks of the Seine.

Signac was sixteen when his father died, in Menton, at the age of forty-one, on 18 March 1880. Mme Signac left her business and went to live with her son at Asnières, at 42*bis*, rue de Paris. His mother wanted him to become an architect but he was already dedicated to painting. During 1883, he attended for a time the studio of Emile Bin, at one time winner of the Prix de Rome, and mayor of Montmartre. There Signac 'made the acquaintance of Père Tanguy who, on Mondays, closed his shop in order to sell paint to students' (George Besson). Among other painters working at the same studio as Signac were: Henri Rivière, Thévenot and Behrend, the German who was to become a great collector of modern paintings.

Signac did not paint in Bin's studio for long. He possessed a very independent nature and a strong personality. He began to paint alone and was to become, of all well-known painters, the perfect example of an autodidact.

One of his earliest works dates back to his stay in July and August 1882 in Port-en-Bessin. He was to make the acquaintance of Monet a short while later, and his paintings then became influenced by the impressionist trend. He returned to Port-en-Bessin in 1883 and 1884, and painted in a manner reminiscent of Monet and Sisley; during the following three years (1881–83), he painted views of the Seine and of the area round Asnières in the same style. Unhindered by material worries, this young man of twenty-two was remarkably active, painted relentlessly, visited his contemporaries and exhibitions. He made the acquaintance of another young man of means, Gustave Caillebotte, an experienced yachtsman who taught Signac sailing. The painter loved water and spent long hours sailing on the lake at Argenteuil. Signac became a keen sailor and a consistent winner at regattas, and was to own thirty-two boats during the course of his life.

Apart from painting, he had leanings towards literature. He became an habitué at the Chat-Noir, where, at uproarious meetings, he composed and recited poetry, and even had his name printed on the cabaret programme.

One day at the Chat-Noir, he and the eccentric Emile Goudeau staged the famous mock funeral of Rodolphe Salis, the director of the Chat-Noir, whose business was not flourishing. He was installed in a coffin in the front room and Emile Goudeau stood there, thanking mourners for their expressions of sympathy while Signac, disguised as a nun, stood by, reading out prayers. This scene was then followed by the resurrection of the body.

Progressive in politics as in art, Signac took an active part in the rebellious movement following the refusals at the 1884 exhibition. On 15 May, he sent a *Rue Caulaincourt* to the exhibition organized by the Groupe des Artistes Indépendants. With the aim of reshaping and strengthening the policy of the Groupe, he supported

the rebellion and attended all the meetings which were to result in the founding of the Société des Artistes Indépendants.

At the meeting on 3 or 9 June, he had a fateful encounter: 'There I met my neighbour: his name was Seurat.' The two men took to each other at once; they became friends and began to exchange their views on painting. As mentioned earlier, both painters worked under the aegis of Dubois-Pillet, who organized another exhibition, this time for the Société des Artistes Indépendants, in December 1884 and January 1885. Seurat had already begun *La Grande Jatte* in May 1884. During the summer of 1885, Seurat was at Grandcamp while Signac was at Saint-Briac. In the latter's paintings, the influence of Monet was still felt at this time, but there was already a hint of his leaning towards optical painting in the separation of hues.

Paul Signac *Antibes* Brush drawing

The year 1885 was to be for Signac a period of transition and enthusiasm. He had met Camille Pissarro – to whom he introduced Seurat in October – and decided with him to reshape impressionism using some of Seurat's ideas.

The painting *The Seine at Asnières* is representative of the artist's evolution, although it reminds one nowadays of Guillaumin, whom Signac had met in 1884. It is known that, on his return from Grandcamp, Seurat radically modified *La Grande Jatte*. Signac's first work in divided hues was *Dressmaker's Finisher, rue du Caire* (also entitled *The Dressmakers*), which he retouched several times.

During 1886, Signac completed his mutation and permanently adopted neo-impressionism and its new technique. In March-April, he painted *Passage du Puits-Bertin, Clichy* and *The Gasometers*. In May, Degas organized the eighth exhibition, deleting the word 'impressionism' from its title. Seurat's *La Grande Jatte* and Signac's *The Dressmakers*, as well as *The Gasometers*, were among the works exhibited.

The exhibition was a financial failure, due to lack of public interest, and Signac did not even wait for it to close before going on 14 June to Les Andelys, where he painted a remarkable series of very individual works.

He returned to Paris in August, at the time when Seurat returned from Honfleur, to attend the exhibition of Indépendants held from 21 August in building B, rue des Tuileries.

In 1887, he painted *Breakfast*, which is his most important work. This large canvas (89 × 115 cm, 36 × 46 in.) evokes precisely what Signac was to write much later (1935) about *La Grande Jatte* in his analysis of Seurat's work in the *Encyclopédie Française*: 'clear and gay composition, in well-balanced verticals and horizontals, with warm colours and clear hues and, in the centre, the most luminous white'.

Signac was now a true neo-impressionist. At this time, he met Vincent van Gogh, who had moved to Paris from Antwerp in 1886. He stayed in Collioures in 1887 and he produced works much admired by those critics who were already impressed by his paintings, and who were to remain his firm admirers. In 1888, from June to September, he stayed with Jean Ajalbert at Portrieux, where they both took part in regattas. Signac started work on a new large painting, *Parisian Sunday*, which was not completed until 1890.

He accompanied Seurat to the Salon des Vingt in Brussels in 1887, and in 1888 was himself invited to exhibit, together with other French painters including

Paul Signac *Saint-Briac* 1885

Jeanne Gonzalès, Charlotte Besnard, Jacques-Emile Blanche, Jules Chaplain, Cross, Anquetin, Caillebotte, Toulouse-Lautrec, Dubois-Pillet, Guillaumin and Helleu.

From April to June 1889 he stayed at Cassis, where he completed another important series of paintings. He spent September and October at Herblay with Maximilien Luce, staying at the village inn. It is evident that the two painters had a great influence on each other. Connoisseurs claim that it was then that Luce produced his best neo-impressionist works and that Signac painted some of the famous series *The River*. This had such luminous tones that some critics considered them to be too white. About the same date, Les Vingt elected a new member, Rodin, by fifteen votes. Signac had twelve votes, and Seurat ten.

In 1890, he painted at Herblay, Saint-Cast, and Saint-Briac (Ille-et-Vilaine). He was again invited by Les Vingt, together with others including Louis Hayet, Alexandre Charpentier, Cézanne, Dubois-Pillet, Lucien Pissarro,

49

Redon, Renoir, Sisley, Toulouse-Lautrec and Van Gogh.

That same year, while he was ceaselessly studying the basis of his art and the scientific aspects of his technique, Signac worked with the aesthetician Charles Henry for some time, and was very much influenced by him. Henry's *Harmonies de formes et couleurs* was published in 1894. Signac's *Portrait of Félix Fénéon* represents the rigid application of Henry's theories. Signac did not quite dare to produce a completely abstract painting, but he avoided it only by including a human figure on the canvas.

In 1891, after Seurat's death, Signac took on the responsibility for the development of the neo-impressionist school. Convinced as he was – like Charles Henry – of the relation between music and painting, Signac went to stay in Concarneau, Brittany, where he painted six canvases, numbering them as was his habit 'Opus 219', 'Opus 220', etc., and entitling them *Scherzo, Larghetto, Allegro Maestoso, Adagio, Presto*. Later, Signac was to abandon Charles Henry's ideas.

In 1892, on one of his sailing trips on the Mediterranean, he discovered in the department of Var the small port of Saint-Tropez, then unknown. He fell in love with the place and built himself a villa, La Hune, where he spent a great deal of his time. On 7 November he married Berthe Robles, a distant relative of Pissarro, and painted her in the fine portrait *Woman with Parasol* in 1893. The same year, he used encaustic for some of his works, including *Woman putting up her hair*.

Hayet had already been using the process for some years. In 1893, Signac painted scenes at Saint-Tropez. That year, Antoine de La Rochefoucauld, an ex-officer who had become Signac's pupil, lent the necessary capital to open the Galerie des Néo-Impressionnistes at 20 rue Laffitte where Signac and all the members of the school exhibited many works. Octave Maus in Brussels founded a new movement, to replace Les Vingt; this was La Libre Esthétique, of which Signac immediately became a member.

In December 1894, Luce held an important exhibition at the Galerie des Néo-Impressionnistes which included Signac's *Watercolour Notes from Saint-Tropez (1892-94)*. It was thus in 1892 that Signac painted his first series of watercolours.

From 1893 to 1895, he worked on a large composition, *In the Age of Harmony*. Living in close contact with anarchist militants and contributors to *La Révolte, Les Temps Nouveaux* and *La Sociale*, Signac had found in Malato's writings a short passage which he considered very representative: 'In the age of harmony. The golden age is not a thing of the past, but of the future.' It was this painting which was shown at the Indépendants in 1895 and at the retrospective exhibition in 1926, under the title of *Decoration for a House of the People*. In 1938, it was hung in a room at the Montreuil Town Hall at a ceremony organized by the Communist Party.

Later, Signac's works were far more 'thought out', and his art developed until he produced his most characteristic paintings, based on sound composition and free from any influence or decorative aim. *The Red Buoy*, a view of Saint-Tropez, is considered to be one of his major works. Thadée Natanson wrote in 1897: 'He achieves a luminous and vibrant intensity of colour, together with ingenuity of composition.... He exudes

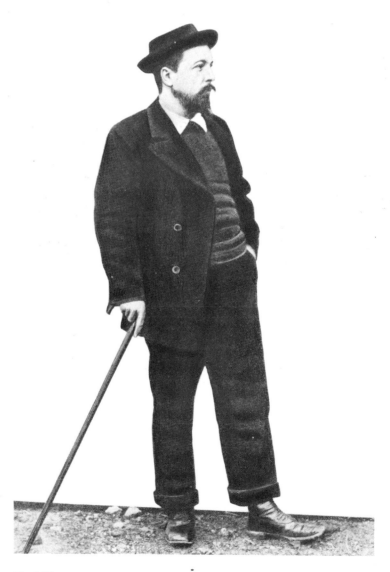

Paul Signac, 1900

Paul Signac *Roadstead at Portrieux* 1888

serenity, and his painting *The Red Buoy* possesses astounding quality.'

In 1896, he went to Holland with Van Rysselberghe, and there again completed an admirable series of paintings. Always an anarchist, he frequently contributed to *Temps Nouveaux*, the paper edited by his friend Jean Grave, sending in lithographs and drawings. By that time, he was beginning to paint far more freely and less systematically. 'From 1892 onwards', says Lucie Cousturier (1922), 'Signac no longer painted his works directly from the subject, but only made notes in watercolour or drawings or even simple handwritten notes.' His new method is clearly expressed in his diaries of 1894–95. This free composition is particularly noticeable in the Saint-Tropez series, in his most characteristic style, with the sea and boats visible through a screen of pines.

This liberation from the theoretical teachings of the neo-impressionist school became apparent in 1897 and 1898, the years during which he reflected deeply about himself and his work of the previous ten years. He wrote down the ideas which had inspired Seurat and his followers, and about which he had thought a great deal. This was to be the study *D'Eugène Delacroix au néo-impressionnisme*, which first appeared in issues of the *Revue Blanche* and later, in 1899, in the form of a book. The school now possessed a treatise. At the same time, he was actively working on five Mont-Saint-Michel paintings : *Mist, Mist and Sun, Sunset, Dull Weather* and *Morning Sun*. Meanwhile, he went to Marseilles, then to London in the spring of 1898 and again to Marseilles and exhibited in Berlin. In 1899, he exhibited at the Galerie Durand-Ruel in Paris. By then, the dots in his paintings had become much larger, and he was no longer so rigidly addicted to contrasts.

At the turn of the century, Signac was again working in Paris and at nearby Saint-Cloud and Samois. After 1900, as Mlle Lemoyne de Forges observed : 'His whole painting acquired an increasingly decorative appearance, and on the whole this appealed to the critics.' The typical and deservedly famous canvas of that date, *Harbour Mouth at Saint-Tropez* (1902), is a very beautiful painting and constitutes a summation of Signac's art and of his decorative aim. At that time, he entered some superb cartoons for a competition for the decoration of the Town Hall at Asnières, in the country of his childhood and youth ; the jury, disgracefully, turned them down. Apart from his active participation in the Indépendants and La Libre Esthétique, Signac held regular private exhibitions : in 1902, at Bing's and at Druet's, in 1903 in Germany and, in 1904, again at Druet's.

In 1904, he stayed in Venice, and this marked a new direction in his work, as Mlle Lemoyne de Forges wrote : 'For years, Paul Signac had been broadening his stroke until the small dots of the period 1886–90 had gradually become elements of square or rectangular shape, reminiscent of a fine mosaic.' It became his permanent style after 1905–06, when, apart from the usual subjects of Saint-Tropez and Marseilles, he also painted views of Holland, among others a series of fine paintings which were exhibited at Bernheim's in 1907.

In 1907, Signac went to Constantinople. Then, until the outbreak of war in 1914, he mostly worked at Antibes, except for several trips to Italy. This was also the time when he first tried his hand at still-lifes and flowers. In 1909, he was elected president of the Société des Artistes Indépendants. Watercolours fascinated him more and more, and after 1910 he painted his most important series of watercolours. They were exhibited at Bernheim-Jeune in 1910, 1911 and 1913. In 1911, he had visited La Rochelle for the first time, and went there again during the war. He was to return there in 1920, and rent a house where he sometimes stayed with Marquet and other friends.

In May 1913, he published the *Aide-mémoire Stendhal-Beyle*, a sort of tabulated biography of the writer and of his works, which Signac admired greatly. That year, the painter's only daughter, Ginette, was born.

During the 1914 war, he followed Romain Rolland, who considered himself to be 'above the mêlée' (unlike Luce who refused to sign Rolland's manifesto). The war affected him deeply, and his production of paintings was greatly diminished. He sought refuge in Stendhal, and wrote a second book, which remained unpublished, entitled 'Les Manies de M. Stendhal'. 'Under a number of headings he gathers together all the author's references to certain ideas, such as love, painting, religion or war' (Lucie Cousturier, 1922).

After the war, he took in hand the future of the Société des Artistes Indépendants and opened the first exhibition in 1920. Signac himself exhibited six times at Bernheim's, in 1920, 1923, 1924, 1925 (together with Cross and Matisse), 1927 and 1930. He was now mainly working in watercolour, and it seemed that, with age, he shrank from the effort needed for large oil compositions : 'Painting in oil is a hard struggle,' he wrote, 'whereas watercolours are a delightful pastime.' He had, in fact, mastered this medium and published in 1928 his famous study on Jongkind (his best book), in which he expounded a remarkable analysis of the art of watercolour painting.

Paul Signac
Félix Fénéon

Paul Signac *Félix Fénéon* 1890

He was still travelling a great deal as well as sailing. He worked at La Rochelle, Port-Louis (1920–22), Lézardrieux (1923–29), La Baule, Saint-Malo (1928), on the Channel and Atlantic coasts (1930), by the Mediterranean (1931), at Barfleur (1932, 1934, 1935) and, finally, in Corsica in 1935.

Well-known and appreciated abroad, he exhibited at Giroux's in Brussels, with Lucie Cousturier, in 1923, in London, at Wildenstein's in 1934 and in Amsterdam in 1935. In 1934, the City of Paris organized a large exhibition of all his works at the Petit-Palais. In December 1933 and January 1934 he held, at the Galerie des Beaux-Arts in Paris, an important retrospective exhibition entitled 'Seurat et ses amis – la suite de l'impressionnisme', which was a resounding success.

After resigning from the presidency of the Indépendants in November 1934, he set out, in the spring of 1935, at the age of seventy-two, on another cruise, to Corsica this time.

He felt unwell on his return, and, after a month's illness, died of uraemia on 15 August 1935.

Appearance and character

Signac was of medium height and heavy build, with a stout and healthy appearance. Here is how he was described by Thadée Natanson in *Peints à leur tour* (1948): 'Paul Signac had a round face which, with age, became even rounder. He moved gracefully like someone with well-exercised muscles. Age did not alter the harmony of the gestures, or slow down Signac's energy. He dressed with care and carried well his capes and homespun suits. He had a predilection, in clothes as well as at home, for gay and bright colours. His clothes were always original, without being gaudy.'

This was Signac the townsman; here is Signac the sailor, by his friend George Besson (1935): 'Standing about in the typical Concarneau red jacket, or in a loose light-coloured coat with a green or yellow or red splash of colour at his throat (a painter's uniform neckerchief rather than a cravat or necktie), or sitting on the jetty parapet, legs dangling in the air and his body leaning forward, he would be talking to an audience of coast-guards, off-duty fishermen or weatherbeaten old men too old to sail. His vocabulary was that of a seaman, and his attitude expressed friendly and well-bred familiarity. Strength and obstinacy emanated from his shaven head, grey and looking as if made of wood, from the broad surfaces of the jaws and cheeks, and from the greyish

goatee which gave him the appearance of a Norman sea-captain. Amiable and inquisitive rather than severe, his eyes tended to grow round during discussions, or protuberant and fixed when aroused by anger. His voice, normally amicably jocular, rose in protest or indignation, spluttering out words accompanied by hammering movements of his right arm. This was a danger signal, and the moment had come to escape from him, if there was still time before the storm really broke.'

Having lost his father at an early age, and possessing considerable means, Signac was, at the age of twenty, free from all restraint. He entered active life confidently, his only aims being success and fame. He soon adopted a mode of living to which he remained faithful: always active, combining hard work with an active social life, and blending serious reading with frequent long cruises. He liked entertaining, and dabbled in politics.

In 1894 the social psychologist Augustin Hamon, a pioneer of survey techniques who had previously published a study entitled *Psychologie du militaire professionnel*, brought out *Psychologie de l'anarchiste*, based on a questionnaire he had sent to leading anarchists such as Camille Mauclair, Bernard Lazare, Adolphe Retté and Signac. In a synthesis of his study on Signac and his anarchist friends, Hamon described the temperament of his subjects; and the generalized description fits Signac particularly well. 'An anarchist type could be described as follows: a man subject to the spirit of rebellion in any form (spirit of opposition, self-analysis, criticism or innovation), possessing a great longing for freedom, either an egotist or an individualist, with deep curiosity and thirst for knowledge. To these characteristics must be added a deep love for others, an acute sensibility, a vivid sense of justice, a logical mind with strong combative instincts.'

This exactly describes Signac, with his contradictions and unpredictable behaviour: abrupt yet diplomatic, cold yet hypersensitive, straightforward yet cunning, violent yet tender, capable of irrepressible hatred or boundless generosity towards others. He was kind and ready to help, thoughtful towards his friends, and took an active part in their lives, even to the point of looking after their children.

His social behaviour held the same contradictory characteristics: leading a rather opulent life and yet holding determined anarchistic views, orderly and yet libertarian.

Lucie Cousturier (1922) expressed well the contradictory sides of the man, contemptuous of the society

Paul Signac
Antibes, the Pine Tree
Watercolour

55

in which he was deeply rooted, detesting honours yet seeking them. 'Appreciations of Signac's artistic and literary achievements seem to use the obvious and easily compatible epithets "clear", "precise" and "original" to describe them; but his temperament tends to be qualified variously as generous, defiant, hard, violent, tender and cruel. This causes some surprise.'

It was in the management of the Société des Artistes Indépendants that Signac freely expressed his strong will, domineering temperament and talent for organization. Since Dubois-Pillet, the Société had suffered from difficulties due mainly to the often radically differing views and conceptions held by its thousand-odd members, most of which were strong personalities. It is a fact that Signac saved it from disaster when he took over in 1909; and, for twenty-six years, he was to rule it with a rod of iron, thus ensuring not only its survival but also its success. In this respect also, French art owes him a great deal.

His determined temperament and odd behaviour did not suit everyone. Vlaminck, in *Portraits avant décès*, described his first encounter with Signac when he and Derain had brought their paintings from Chatou to enter them for the 1905 Salon des Indépendants: 'A fat gentleman, seated at a table, with an air of self-importance, accepted our notices; this was Paul Signac.

He behaved towards us rather like a sergeant-major in a barrack-room enrolling conscripts. His bombastic, bureaucratic manner got on my nerves. Since then, I have met Signac many times, and, although our relationship is friendly, my first impression persists.'

This account explains the two camps within the Société, pro-Signac and anti-Signac. General meetings were tumultuous sessions at which strong words were exchanged. Violent diatribes were directed at the Chair by member artists such as Gustave Cariot, and Homeric scenes often developed in the course of debates. George Besson tells us how, in 1912, Delaunay protested so violently against the way his paintings had been hung that Signac expelled him by force.

Luce and André Léveillé were for a long time vice-presidents. The latter was devoted to Signac and helped him efficiently. He was a good administrator who was to prove his qualities later when he founded and directed the Palais de la Découverte from 1937 to 1960.

After 1933, dissensions grew within the Committee of the Société des Artistes Indépendants on the subject of exhibitions. In order to check the dwindling sales of works of art, due to the economic crisis of the 1930s, Signac had organized sales abroad and an exhibition train touring the provinces. The list of suitable exhibitors was decided by referendum amongst Société members.

Paul Signac *Dutch sketches*

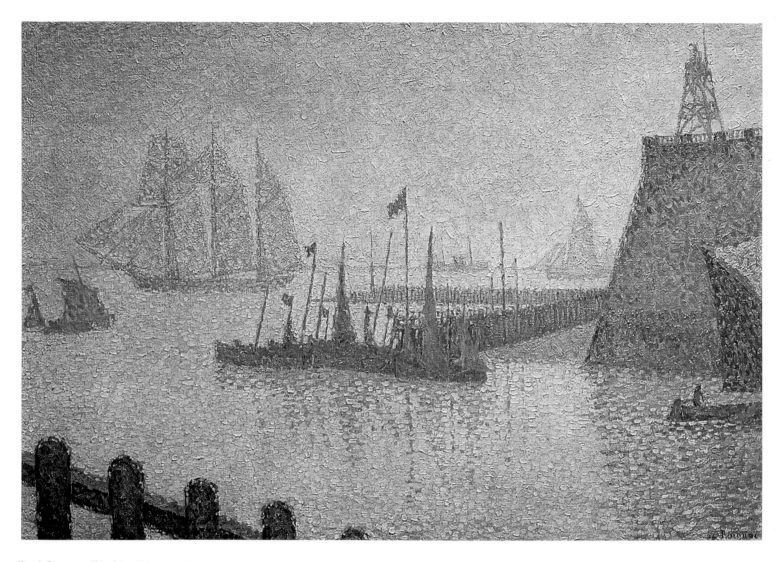

Paul Signac *Flushing Pier* 1896

Signac refused to allow members to exhibit in more than one of these shows, on the grounds that this would constitute an 'unfair privilege'. The Committee disagreed, and, finally, unanimously voted him down.

On 7 November 1934, Signac sent in a proud letter of resignation in which he stated his adherence to the high principles of 1884: 'This matter revolves around the very principles which constitute the basis of our Société and which have been respected for fifty years... faced with such divergence of opinion between yourselves and myself, I can go no further.'

Signac occupies a very important place in neo-impressionism, and Thadée Natanson was right when he called him the St Paul of the school. One wonders what would have happened to the movement if Signac had not from the beginning upheld its principles. This proselytism was in complete accordance with his temperament: his fluency of speech, his qualities of leadership and his spirit of enterprise contributed greatly to the diffusion of the neo-impressionist theories. From 1886 onwards, critics, painters and writers attended his Monday evening gatherings in the avenue de Clichy.

Paul Signac *Mont Saint-Michel* Brush drawing

His tireless activity covered all aspects of art, and he supervised the education of the second generation students of neo-impressionism. Among them were Lucie Cousturier, Jeanne Selmersheim-Desgranges, Antoine de La Rochefoucauld, Henri Person, E. Fer and Carlos Reymond.

He also encouraged the experiments conducted by fauve painters such as Matisse, for instance, who stayed with him in 1904 at Saint-Tropez. He also supported Van Rysselberghe, who was spreading throughout Europe the ideas which both painters shared. He controlled and managed exhibitions himself, and for fifty years organized everything at the Indépendants. A member of Les Vingt, and a close friend of Octave Maus, he was his adviser on matters concerning La Libre Esthétique. In Paris, through Félix Fénéon, his influence was felt for a long time at Bernheim's and even at Druet's. Furthermore, he directed his energies towards getting the paintings of the school into French and foreign museums. Signac was, in fact, the motive power behind neo-impressionism in its artistic, administrative, cultural and financial role.

Work

Among great modern painters, Signac occupies a special position : the criticism of his work was affected by the artist's overpowering 'presence', his worldly wisdom, his political connections, and even his valuable services as an organizer. It is sometimes just as difficult to forgive one's most generous benefactors as to forgive one's enemies. To a certain degree, Signac suffered from his enemies' silence and from his friends' ungratefulness. Here indeed is a perfect example of artistic talent visibly hindered by the artist's sheer strength of personality.

Thirty-five years have passed since Signac's death, but bitter feelings are still openly expressed at times about him. This has not prevented art lovers from honouring him as he deserves, and, judging from the commercial value of his works – certainly a sure indication – it is evident that, among neo-impressionists, Signac attained the height of success, immediately after Seurat, and that he stands in the first rank of the whole impressionist school.

Although so far no synthesis of Signac's work has been written, Mlle Lemoyne de Forges, in the catalogue for the centenary exhibition (Musée du Louvre, 1963), has compiled a complete bibliography of critics on Signac, well provided with quotations. For the reader's information, we quote below ten critics who have expressed accurately, over the years, the state of informed opinion concerning the artist.

Félix Fénéon (1890) : 'New techniques must represent a new general outlook if they are to justify their creation in the face of traditional techniques and masterpieces. Optical painting has lent a suitable form of expression to the obscure aims of impressionism – a form of art sufficiently specialized in its expression to assume a separate place in the series of art techniques. It is of no importance how it was received by the old impressionist masters. Around 1885, the new technique fascinated a few more philosophically-minded young painters who perceived that here was the means to promulgate their ideal colour harmonies. There was an intimate affinity between the new technique and the latent qualities it liberated and exalted. Paul Signac succeeded in creating the first specimen of an art possessing great decorative potentialities, in its ability to sacrifice the anecdote to the arabesque, the nomenclature to the synthesis, the ephemeral to the permanent, and lent to nature, instead of the customary precarious quality, a feeling of authentic reality even in its festive moods.'

Pierre-M. Olin (1891) : 'One found in Signac's work a display of vibrating light and scintillating, warm hues of incomparable beauty. Signac expressed in a new manner the slight movements of water, the long and slender wavelets of rivers, while, on the burning orange

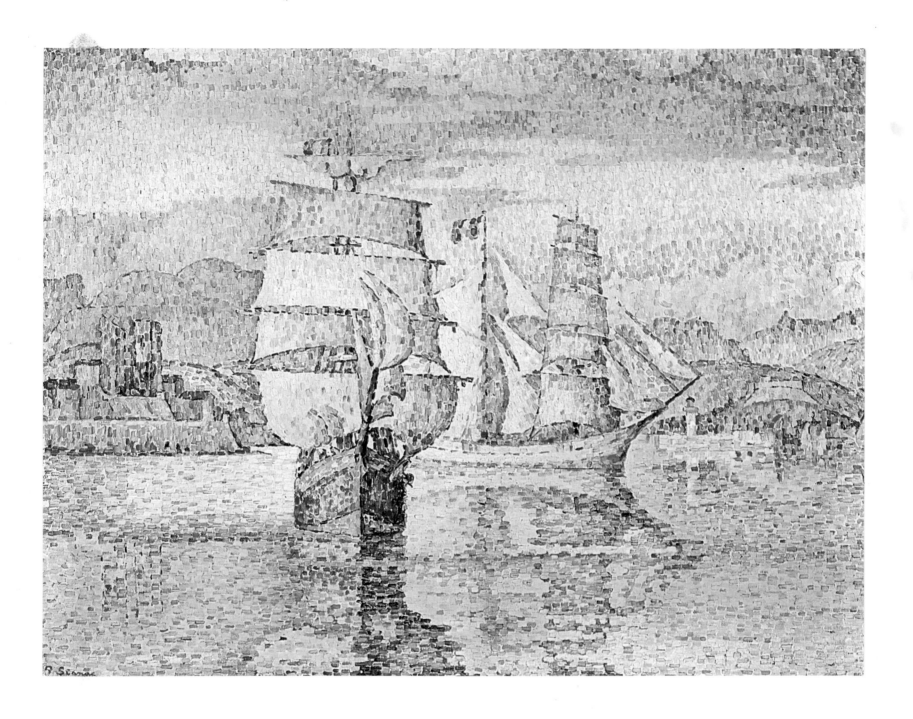

Paul Signac *Antibes Harbour* c. 1896

horizon, the sun goes down and down in ephemeral glory. The painting Opus 206 has made upon us the most lasting impression in this respect and all who love water will be filled with all the melancholy of recollection.'

Félix Fénéon (1904): 'This chromatic opulence in Paul Signac's paintings decorates deliberate, audacious and rhythmic compositions which inevitably bring to mind the names of great masters such as Poussin and Claude Lorrain.... Once day, while looking through [Claude's] *Liber Veritatis*, Goethe remarked: "These paintings exude a feeling of complete truth without reality. Claude Lorrain had a deep knowledge of the world of reality and he used it to express the fine feelings of his soul. This then is real idealism, when real means are used to lend the illusion of reality to the truth expressed in the painting."'

Paul Adam (1907): 'Excellent writers have written the history of this school and of its evolution, analysing neo-impressionism and the new means of expression (division of hues, optical mixing). These few words are aimed at stressing the importance of a form of art designed to provide the intense enjoyment of pure light and its effect on objects which thus acquire tones framed by lines and haloes, blending with the mood of the painting or standing out against the background.

'Such new vision requires great compositional skill. Planes of varying light must be massed together in architectural style, deep, fluid, vibrating and vaporous, scintillating with myriads of colours. A painting becomes a piece of linear jewellery, prodigiously decorated with precious stones, as can be admired in views of moist Holland, or of southern seas rocking their bejewelled waters in the sun, at Marseilles or in the gulf of Saint-Tropez or the Venetian lagoon.'

Lucie Cousturier (1922): 'Signac's art was inspired by water and matched his genius. The means and the subjects of his works were created to serve his poetic feelings. He observed water, he discovered the multiplicity of its aspect and coloration, he seized and fixed its secret by a subtle blend of hues which became the interpretation of all his visions.'

George Besson (1935): 'Whether they are studies or final works, Signac's simplest watercolours are most beautifully designed compositions in rich harmonies. Each one of these annotations reveals the elegance and the strength of a style which would have been perfectly suited for tapestries or palatial murals. The most ordinary wavelet, or the most accurately drawn boat, becomes under his brush a series of the noblest arabesques.'

Jacques Guenne (1935): 'Paul Signac's name has the magnificent resonance of a flag suddenly unfurling in a gust of wind, and is associated inseparably with that sun which he used to look at, straight without blinking. It belonged also to that sea which, to him, was only ever troubled by storms of light. Did he ever paint anything but water reflecting palaces, decorated boats, yachts with white sails swelling in the breeze? He expressed the perpetual festive spirit of nature, the many inventions of the sun, all the joys of light....

'Some may prefer, to Paul Signac's compositions, those watercolours expressing the first trembling sensation felt by a most sensitive lover of nature. But his carefully planned works bear witness to his overwhelming qualities of energy and calm.'

Gustave Kahn (1935): 'At the time of his first enthusiasm for pointillism, Signac attempted to draw in dots,

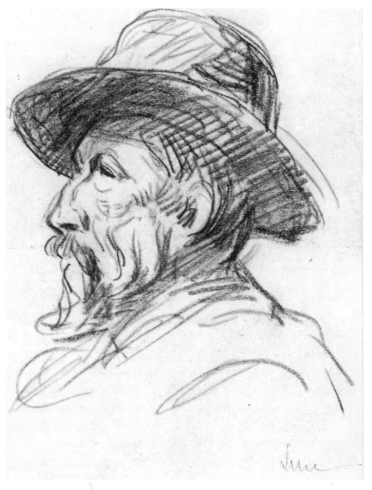

Maximilien Luce *Signac*

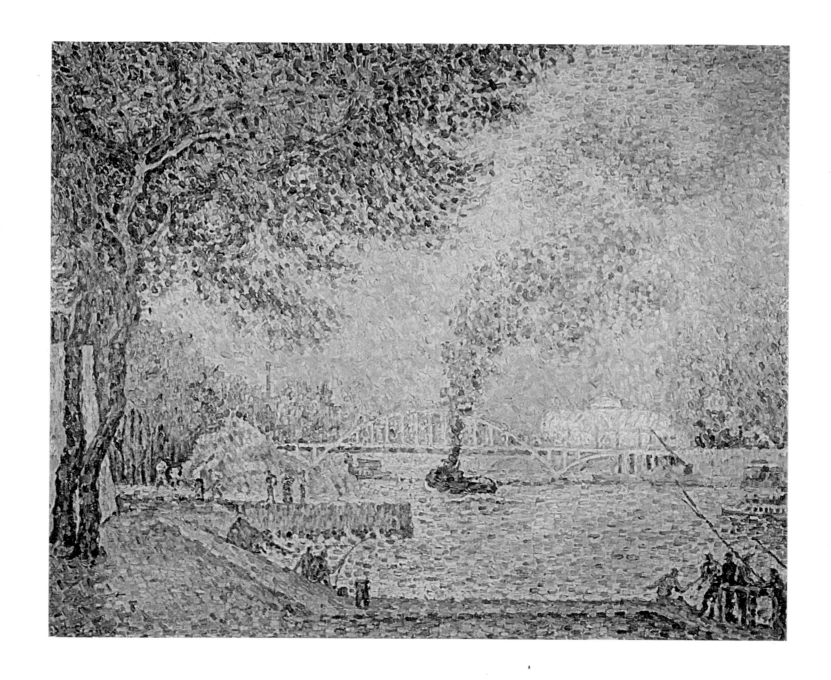

Paul Signac *Debilly Footbridge* c.1926

61

but he did not pursue this technique, nor did he apply it in the watercolours which served as an outlet for his absorbing pictorial technique. Here his improvisatory talent could be given free rein. Between two seasons of painting pointillist views, in a very restrained style but saturated with colour, he returned to the study of the figure. A large Arcadia, with hieratic figures, expresses his desire for brotherly love and human perfection. The

Paul Signac *The Tug* Brush drawing

general tone is a little faded, in accordance with Puvis de Chavannes' recommendations on the softness required in mural painting. The human figures are beautiful, the harmony pleasing and the setting accurate. He had most satisfactorily completed what he set out to do, but he did not venture any further in that direction, returning instead to the sea and the river, and putting into use his deep understanding of décor and of the enchantment of light, evoking a radiant poetry. The museums have his paintings of the Bosphorus, of the harbour in La Rochelle, of the Meuse estuary at Dordrecht, and astounding views of Marseilles under the silhouette of Notre-Dame de la Garde, of the Seine river, of Brittany, all so beautifully composed and bathed in magnificent light.'

Jean Cassou (1951): 'Light did, in fact, serve him well. It was for him not just a subject for study, but it inspired his magnanimous, friendly and human temperament with a matching abundance of gay and happy images. "Obsessive colourist", Huysmans was to call him, and, indeed, his study of truth and of its rules is founded on an ardent passion. Enamoured as he was of affirmation, acquiescence and positive certitude, Paul Signac looked at life in its most beautiful colours.'

Raymond Cogniat (1963): 'Paul Signac belongs to the history of modern painting, both through his work and through his initiatives. A friend and follower of Seurat, he was one of the first to accept his theories and to put into practice the principles of divisionism. His enthusiasm and energy led him to become not only the theoretician of the movement but also one of the most brilliant participants in the Salon des Indépendants from its very beginnings, so that he became and for many years remained its efficient and respected president. Time has passed, and new generations have rather forgotten most of those artists who prepared the ground for the discoveries of the present era. Signac's paintings, after being rediscovered and revealed at the Louvre, appear even more brilliantly coloured and detached from the contingencies of contemporary history. It is easy to determine both the support and the limitations which divisionism contributed to his work. Whereas impressionism perfectly suited his impulsive temperament, his love for clear colours and for sunny scenes, divisionism, on the other hand, imposed on him a more rigid and systematic frame which sometimes hardened his initial vision and set it more rigidly.

'His watercolours convey very clearly how his temperament retained its freshness and spontaneity. His paintings, however, reveal his submission to a premeditated discipline, aiming at a more stable art. These theories, which Seurat found it easy to apply, came far less easily to Signac, who was constantly caught in the contradiction between his ideas and his temperament.

'Perhaps this contradiction is the very mark of Signac's art, the source of its attraction and its particular brilliance. In fact, he might have become, a few years later, a fauve painter, had he not chosen to remain faithful to the memory of Seurat and to the deep impression the latter had made on him. It is not fanciful to conclude that some of Signac's paintings, dating from before the fauve works of Vlaminck or Derain, were their logical precursors.'

Jean Sutter

Henri Edmond Cross 1856–1910

Maximilien Luce *Cross*

Life

Henri Edmond Delacroix – for that was his real name – was born on 20 May 1856, in a house then occupied by his parents near the church of Saint-Pierre in Douai. His mother, *née* Fanny Woollett, came originally from the south of England, while his father, Alcide Delacroix, belonged to an old Douai family which had built up a large tin-smithing business in that town.

Shortly after the birth of their son (who was to remain an only child), the parents moved to Paris and there engaged in a commercial venture, the ill-success of which resulted in several difficult years. Thus, towards 1865, the young household moved north again, to Canteleu-les-Lille, in the textile area, where Alcide Delacroix was to manage a dye-works. This post had been offered him by a cousin, Dr Soins, who became a second father to Henri Edmond. In fact, not only did he make it possible, through his generosity, for the child to get a good education, but he also discovered and encouraged his vocation as an artist, and over a long period provided him with moral support and an equally precious financial backing. Thanks to him, from the age of ten, Henri Edmond had his first lessons in drawing, in Lille, from Carolus Duran, still a young painter without fame or fortune. This apprenticeship continued throughout his high-school days, and later, in 1878, at the Lille Ecole des Beaux-Arts, where Alphonse Colas taught at that time, the training being complemented by almost daily visits to the town's museum.

He then came to Paris and attended the studio of a painter of genre subjects, Emile Dupont-Zipcy, to whom it seems highly probable that he had been introduced by one of his relations or by one of his previous teachers. This artist had in fact originated in northern France and, like Carolus Duran and Colas, was an ex-pupil of François Souchon at the Ecole des Beaux-Arts in Lille. At this time, Henri Edmond must, additionally, have received advice from François Bonvin, a young friend of his family, of whom he always spoke in the warmest terms.

The young artist exhibited for the first time in the Salon of 1881. He figured there under his real name, Henri Edmond Delacroix. But, finding the memory of the master of *The Women of Algiers* a heavy burden, and embarrassed by a further similarity of name linking him with a certain academic painter, he soon adopted the

Henri Edmond Cross *Le Lavandou* 1909 Watercolour

abbreviated English translation of his name. For a time after this he signed 'Henri Cross', and then changed to 'Henri Edmond Cross', this time to avoid being confused with the painter, sculptor and ceramist Henry Cros, his contemporary.

The founding of the Indépendants, in 1884, was an important event for Cross, in which he was involved from the very first. He participated, in fact, in two exhibitions of that year: that of the Groupe des Artistes Indépendants from May to July, for which he was a member of the hanging committee, and that of the officially constituted Société des Artistes Indépendants in December. To this Salon, 'lively, proof against all rebuffs', Cross would remain faithful all his life, exhibiting his newest works there every year (except in 1889 and 1900).

There he met Seurat, Signac, Angrand and Dubois-Pillet, joined forces with them, and was present, so to speak, at the birth of neo-impressionism, though not taking part directly in the researches being pursued by the disciples of the movement. From 1884 to 1891, in fact, Cross, who was concerned to increase his mastery as a painter, was less influenced by his contemporaries than by certain of the masters of impressionism.

His first landscapes are a reflection of the surroundings in which his life was being lived at that time. Several works which portray the animation of the complex of streets meeting at the Observatoire, or the calm of the Luxembourg Gardens, peopled with nurses and children, are witness of his attachment to the Montparnasse district of Paris, where he lived until 1888. At the same time, he was finding new sensations and different themes in the South of France; having discovered the Alpes-Maritimes in 1883, on the occasion of a visit to his parents and to his uncle, who had settled there, he stayed there several times in the following years. Beyond this,

Henri Edmond Cross *Beach in South of France* 1891–92

he made a lengthy tour of Belgium and Holland in the autumn of 1886, and was impressed 'as much by the natural beauty as by the museums'.

In 1889, for the first time, Octave Maus invited him to exhibit with Les Vingt. Cross was all the more sensible of this mark of esteem in that his work, at this time, often overshadowed by that of more innovating painters, was attracting very little attention from the critics. But he was soon to receive his share of the praise and of the sarcasms bestowed upon the neo-impressionists, moving into their camp just at the time when it found itself weakened by the loss of Dubois-Pillet and Seurat.

In the Salon des Indépendants of 1891 (of which he was this time the vice-president), Cross exhibited a large portrait of his future wife in which, for the first time, he resolutely adopted the rules of divisionism, of which he was to be from that time on one of the most brilliant exponents.

65

The year 1891 was marked not only his adhesion to neo-impressionism but also by his decision to leave Paris for good and to settle on the Mediterranean coast where during the previous winters he had appreciated, as a rheumatic, the climate, and as an artist, the light. Attracted by the region of the Maures, in all its deserted grandeur, and particularly by the surroundings of Le Lavandou – which was then a small fishing village – he spent a year at Cabasson and then settled at Saint-Clair, an isolated hamlet between the sea and the lower slopes of the Alps. 'From this high pink mountain,... which discharges the landscape down to the sea, the pines, the cork oaks falling in groups or files and, among the vines and the orchards, the dark cypresses...' so did Lucie Cousturier describe this strong and colourful landscape in which Cross was to find an inexhaustible source of 'words for his poems'.

From this time onwards, Cross was never to leave Saint-Clair except on rare occasions : a stay in Paris every year at the time of the Indépendants to meet his friends, a few quick excursions along the Mediterranean coast in search of new themes, and two journeys to Italy. These journeys, and some pleasant visits – in particular from Signac and from Van Rysselberghe – alone broke the solitude in which he lived.

But, although Cross was now away from Paris for ten months of the year, he did not on that account cease to participate in the artistic life of his time. Helped by his Parisian friends such as Signac and Luce, who housed his paintings and kept them in circulation, he was able, from a distance, to share in the efforts of his comrades to make known their common aims, and to make himself felt. He not only exhibited regularly at the Indépendants ; he also took part in shows which, during the last few years of the century, were to be of decisive importance for neo-impressionism.

Thus, in 1892, he was represented at the second 'Exposition des Peintres impressionnistes et symbolistes', at the Galerie Le Barc de Boutteville, by six works, and by five at the 'Exposition des Peintres néo-impressionnistes' which, mounted at the Hôtel de Brébant in December of that year, enabled divisionism to affirm itself as a coherent movement. During 1894, works by Cross figured frequently at the gallery which the neo-impressionists had rented at 20 rue Laffitte. There, too, in December of the same year, he mounted his first private exhibition in conjunction with Petitjean, covering retrospectively the work of the years 1884–94. With the Nabis, and in company with other neo-impressionists, he also showed his paintings in January 1896, at the Salon de l'Art Nouveau

organized by the Galerie Bing. Similarly, in March 1899, he took part, at Durand-Ruel's, in the exhibition of young painters grouped around Redon, showing six canvases which, in the opinion of Signac, constituted the best ensemble in the show, and which won for him the favour of such critics as Thadée Natanson and Gustave Coquiot. Throughout these years, like the other neo-impressionists, he exibited in Belgium, in response to regular invitations from La Libre Esthétique, and in Germany where, in Harry Kessler, he had one of his first serious admirers.

However, while Cross found encouragement in these early successes, and a constant source of delight in the spectacle of the Mediterranean landscape which surrounded him, his state of health became more and more precarious. From now on, frequent painful attacks of rheumatism, from which he had suffered since his youth, were to lay him low. A particularly violent attack, in 1899, caused a deflection of the left foot accompanied by persistent pain, so that he could no longer walk without a limp. Two years later, eye trouble, which obliged him to cease work for a month, appeared for the first time. But during the periods when the illness allowed him a

respite, Cross worked with all the greater enthusiasm in the knowledge that his moments of peace were numbered.

In July and August of 1903, he made a stay in Venice of more than five weeks. At the Palazzo Ducale and at the Scuola di San Rocco, he was filled with enthusiasm for Veronese and Tintoretto, but the Venetian painters charmed him less than did the city itself. He explored it tirelessly, marvelling at the fiery glow of San Giorgio in the evening light, at the bright accent of a sail standing out against the lagoon, an effect of the light on the stones of a palace, at the bend of a narrow canal – the myriad aspects, constantly renewed, of a city in which, thanks to the water which embraces and penetrates it, all is movement, light, reflections and colour.

Back in Saint-Clair, Cross executed, from notes, drawings and watercolours brought back from this journey, a series of paintings inspired by Venice. Some of these were exhibited from 1904 onwards at the Indépendants and at La Libre Esthétique in Brussels, others only in 1905 on the occasion of a one-man show organized by the Galerie Druet. This exhibition, the catalogue of which was warmly prefaced by Emile Verhaeren, brought together thirty oils and thirty watercolours. For Cross it

Henri Edmond Cross *Parisian sketches*

Henri Edmond Cross *Landscape in the South of France seen through Trees* Watercolour

was a satisfying experience which confirmed to him the interest which critics and art-lovers were now taking in his work.

Shortly after this success, an iritis of rheumatic origin obliged him to spend three months with his eyes bandaged and prevented him from painting for a long time. The year 1906, on the contrary, was a favourable one, and during this period of better health numerous paintings were produced which would figure in the last one-man show to be held during his lifetime, that which Félix Fénéon organized at the Galerie Bernheim-Jeune in April-May 1907. At this Cross exhibited thirty-four recent canvases – landscapes of the Provençal coast and compositions glorifying the female nude – of which Maurice Denis, in the preface to the catalogue, provided a discerning analysis.

But once again Cross had barely time to rejoice in the happy result of this exhibition before a return of the iritis condemned him to five weeks of darkness, followed by a very trying winter.

Then, during the summer of 1908, he made a second journey to Italy, this time touring in Tuscany and Umbria. Pisa, Florence, Perugia, Assisi, Rome and Orvieto were his main points of call. He made quite protracted stays in each of these towns, particularly in Perugia, where he was particularly entranced by the rose-pink campaniles standing out against stormy skies and 'overhanging vast panoramas drawn by Rembrandt'. But this journey did more than provide him with new themes; it occasioned his discovery of the Trecento and Quattrocento painters. Overcome with admiration and enthusiasm, Cross realized that certain of his own preoccupations – the quest for an expressive synthesis, the importance given to colour – had also been theirs. He even noted in Perugino's frescoes a relatively systematic observation of tonal contrasts.

68

Henri Edmond Cross *The Clearing* 1906–07

On his return, fortified by the example of these masters, he applied himself vigorously to a few canvases inspired by the Umbrian landscape, which, with others depicting Saint-Clair and the surrounding countryside, were to be his last works.

From the spring of 1909 onwards, his illness had effectively taken possession of the artist, condemning him to suffering and enforced inactivity. After arriving in Paris to get treatment for his left leg, the condition of which had become worse, he soon felt the first pangs of the cancer which was to torture him for a whole year, and which he bore with wonderful courage. After a few months in a hotel and some time in a clinic, he returned to Saint-Clair where his wife and her family, the Van Rysselberghes and Signac surrounded him with care until he died, on 16 May 1910, at the age of fifty-four.

Appearance and character

A remarkably clear and vivid picture of Cross emerges from his friends' writings, from a few portraits, and from his own notes.

His physical appearance is quite familiar to us, since he often sat as a model for Van Rysselberghe and Luce, and there he is, beside Emile Verhaeren, in Van Rysselberghe's *Reading* (in Ghent). Luce painted him in a large portrait, now at the Musée National d'Art Moderne in Paris, which illustrates Maria Van Rysselberghe's description of the artist: 'Cross was of engaging appearance, with his clear Nordic complexion, weathered by the sun, his tawny beard, clear blue eyes, white hair, and the strict neatness of his clothes. He was always dressed in a dark blue suit with a white shirt and the artist's traditional spotted neckerchief. He was of medium height, of slim build and thin body. His hands, even in his old age, were still beautiful, free from any disfiguring rheumatism, and came to life when he spoke about painting; they then fluttered lightly, like birds, when suggesting delicate shades, or dipped in an arc to describe a curve whilst a forceful gesture of the thumb underlined a strong colour. His nicotine-stained fingers were supple and graceful when he rolled himself a cigarette, which he would smoke with an air of youthful casualness contrasting with his jerky and cautious gait' (*Galerie Privée*, Paris, Gallimard, 1947).

His exceptional qualities and rich personality made him a much-loved friend, who was remembered warmly by those who had known him.

He was a friend of Bonnard, Vuillard, Roussel, Valtat, Maurice Denis and, more particularly, of those painters who shared his own aesthetic preoccupations. Signac and Van Rysselberghe (who lived close to him at Saint-Tropez and Saint-Clair) were his loyal and devoted friends with whom he always remained in touch even when they went away on journeys. His friendship with Angrand – who, like him, lived away from Paris – and with Luce has already been recounted in the extracts from their extensive correspondence which I was privileged to incorporate in my own study of Cross, published in 1964. Emile Verhaeren's writings bear witness to the deep friendship which existed between Cross and himself and Lucie Cousturier. His kindness expressed itself with great tactfulness in the form of pleasures to be shared, moral comfort or financial help. A supporter of the social ideas held by the anarchist journalists, he often worked for Jean Graves, editor-in-chief of *Temps Nouveaux*, whose generous actions appealed to him.

Cross was a cultivated man, and kept in close touch with the work of contemporary writers and philosophers. Reading Nietzsche was for him 'like a personal adventure'. His mind was always willing to entertain new and adventurous ideas, which he would seek to express with accuracy and clarity. To converse with him was a rare pleasure. In discussions, his honesty prevented him from agreeing out of politeness, but he would listen with interest to others' ideas and make an effort to understand them.

Under his calm and gentle exterior, Cross hid a lyrical and ardent nature, coupled with exceptional energy. These contradictory aspects of his character were attributed by Maria Van Rysselberghe to his ancestry: 'Of English mother and French father, he had inherited from one race his violence, his sober attitude and his self-control, and from the other his wit and his expressive sensitivity.' He bore physical suffering with a courage which, in Verhaeren's words, was not 'merely a brief, quick trembling flame in the air, but a deep and hidden fire steadily burning down to the hearthstone.' The same strength of character was required to bring to completion and success the work which, burdened by his scrupulous conscience and honesty, brought him both the greatest joys and the deepest torments. His own words, 'to express the achievement of absolute freedom', reflected his constant aim. His masterpieces owe their triumphant strength to the self-conquest achieved through countless physical, moral and technical ordeals which, through a succession of torments and victories, strengthened his inner soul.

Works

Not much remains of the works which Cross completed during his youth, before 1884, except for a few portraits. Four paintings – now the property of the Musée de Douai – represent Dr Soins, Mme Delacroix, a madman, and Cross himself as a convalescent. They are painted head-and-shoulders against a dark background, dressed in dark clothes, all evoking a rather traditional style, although the features reveal a studied refinement of expression and character.

Another painting, of Dr Soins in his surgery, betrays a different aspect of the painter's work at that time, as he concentrates more on the interior than on the figure itself. The studied effects of light, and the meticulous rendering of objects, in a muted chromatic scheme, establish a link between Cross and Bonvin, whose love for still-lifes he shared, judging from the two paintings entitled *Old Things* and *Kitchen Corner* which he exhibited at the 1881 Salon.

The few works we have just referred to enable us to conclude that Cross, as a young artist, ranked among the painters who, after Courbet, perpetuated the tradition of a realist and sombre style of painting inherited from the Dutch and Spanish schools. However, a definite change soon became apparent both in his choice of subjects and in his manner of painting. He gradually came to favour landscapes rather than still-lifes and portraits, at the same time lightening his palette and perfecting his technique.

These new characteristics appeared in a huge decorative canvas entitled *Corner of Garden at Monaco* (Musée de Douai), which Cross exhibited in May 1884 at the founding of the Salon des Indépendants. This was one of his first works inspired by the South, and although it was still painted in muted colours, there was already a rejection of browns and blacks, a sign that Cross was becoming conscious of the impressionists.

Gradually, this influence became more marked as, in the paintings of the following years (landscapes, figures out of doors, portraits by a window), Cross, like the

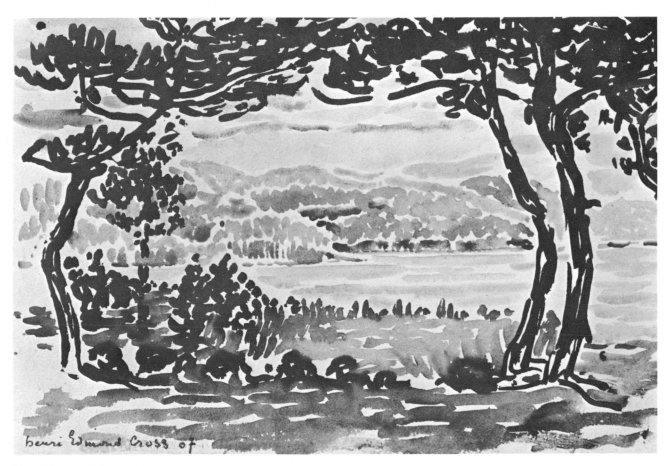

Henri Edmond Cross *The Beach* 1907 Watercolour

impressionists, exploited the play of light and sun, and sought to render the vibrant atmosphere surrounding the objects. Again, in the impressionist style, he abandoned greys and dull muted tones to favour light colours applied in divided touches.

Works such as *The Red Smock, August Afternoon in the Luxembourg Gardens*, and *Women tying up vines* mark the stages of his evolution between 1884 and 1891, when Cross – like many artists of his generation – progressively moved away from academic theories through impressionism. The three impressionist masters who appeared to influence him most deeply were Manet (an important posthumous exhibition of his paintings was held in 1884), Monet, for whom Cross – like Signac – felt deep admiration, and Camille Pissarro.

Cross was not satisfied with the progress he knew he had made during his impressionist period, but felt the need for a discipline which would help him to go beyond impressionism. He was convinced that the creation of a work of art was dependent upon 'organized sensations'. He himself wrote: 'Whereas impressionism responds to nature's visual colour vibrations in a subjective way, one must master these colour vibrations and use them in a composition ordained by the needs of one's cause.' He often stated that 'Creation embodies, apart from instinct, a great deal of "will".'

His previous discussions with neo-impressionist artists, and their achievements, enabled Cross to avoid the groping experimental stage. His first truly divisionist painting, the *Portrait of Madame Cross* (Musée National d'Art Moderne), painted in 1891, is a successful and skilful painting, with a composition based on a geometrical framework in which dark and light colours achieve balance; and the application of division and optical mixing results in a subtle harmony of yellows, blues and pinks.

Cross's favourite subject remained nature, and this portrait was followed in 1892 by a series of landscapes – *Plage de la Vignasse, Vintage* – inspired by the Mediterranean coast, where he had finally settled. The sea, the hills, the beaches under the shade of tall pines, the rocks jutting out into the sea, provided subjects of the required simplicity and bareness for the painter's aim to analyse patiently and painstakingly the various effects of light on shapes and colours, through which his subjects acquired life and character.

In these works which studied light and its effects, Cross – like the other neo-impressionists – used small round touches, of almost identical size and spaced at regular intervals, juxtaposed closely to cover the canvas, or, sometimes, leaving spaces revealing the coloured ground.

The tones were pure but soft, because of an admixture of white, or because of an interplay producing a muted brilliance. Cross, having observed that the sun absorbs colour, sought to render true light by means of discolouration. To violent effects, he preferred gradations, starting from a very simple scale of pink, faded blue, light green and sand yellow.

Apart from the analysis of colours, the interpretation of light, the attempt at over-all harmony, Cross also sought to give a decorative quality to his works.

Already present in his paintings dated 1892, this aim became obvious in 1893 in such paintings as *The Farm (Evening), The Farm (Morning)*, where the greatly simplified drawing of a tree introduces the fantasy of a wide arabesque and, again, in 1894 in *Evening Air*, representing female figures in a composition with pines, where the determined stylization and monumental style are reminiscent of Puvis de Chavannes' decorative works and of some Nabi works.

As from 1895, in his search for style, Cross began to apply the literal representation of nature more loosely and to relax the strict observance of neo-impressionist discipline. 'We are emerging from the arduous and necessary period of analysis, which results in a certain uniformity of painting, to enter a new phase, that of individual and varied creation', wrote Signac in his *Journal* in 1895, after looking at the latest paintings by Cross. It marked indeed the beginning of a new phase in Cross's artistic evolution, during which – to quote Signac again – 'sensations take precedence over technique'. Pure landscapes (*Pines on the Beach, Marseilles Harbour*), lively compositions with decorative figures (*Excursion, Nocturne*) or bathers (*The Joyous Bathing-Party, The Shaded Beach*), daily scenes (*Village Dance*), and a few portraits represented the painter's output between 1895 and 1903, the date of his first journey to Italy. His works of that period all shared one characteristic in that they all depicted outdoor scenes illuminated by sunlight, thus similar in the choice of subject to paintings executed in previous years, but, otherwise, very different in many aspects. Firstly, while Cross still applied the principles of 'division', he became convinced that light was impossible to render, and he therefore abandoned his attempts at accurately representing its multiple effects. Instead, he suggested its intensity by means of exalted tones and definite contrasts. From then onwards, according to Maurice Denis in his foreword for the Cross exhibition catalogue, in 1907, at the Galerie Bernheim-Jeune: 'The

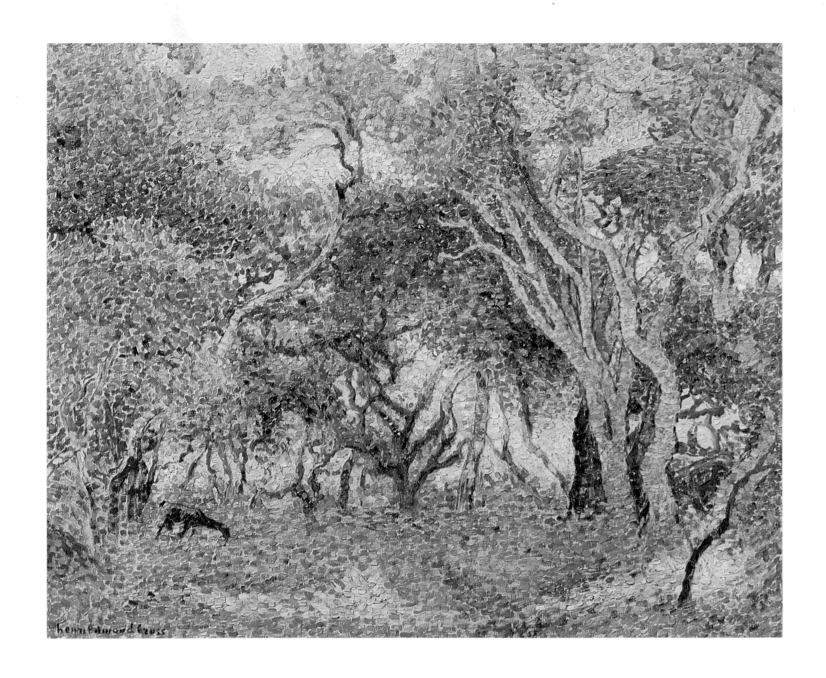

Henri Edmond Cross *Undergrowth* 1906–07

sun ceased to be, for Cross, a light phenomenon which bleaches every object but became the source of harmony which enhances nature's colours, suggesting more daring scales and offering inspiration for colour fantasy.' Sumptuous golds, oranges, violets, bright pinks, allied to greens and blues, invaded his canvases in vivid orchestrations of brilliant colours emphasized by their juxtaposition according to the law of complementary tones.

It is not only the colour in these later works dating after 1895 which differentiates them from his first neo-impressionist works, but also the technique of execution: in order to preserve the benefits of division and contrasts, Cross continued to apply colour in separate touches but increased their size, thus ensuring a more fluid and rapid execution. His earlier 'dots' were replaced by narrow brushstrokes, stretching in all directions, and then, after 1902, by even, square touches, accurately laid next to each other. He was to keep to this method without much modification.

Between 1895 and 1903, Cross daringly accentuated and transposed natural tones, adopting larger touches which, through their unsuitability for painting detail, forced the artist to simplify his forms. Relinquishing, progressively, his original scruples concerning realism, Cross moved towards the art of synthesis and imagination which reached its summit during the last years of his life.

In 1905, in the foreword to the catalogue for the Cross exhibition at Galerie Druet, Emile Verhaeren apostrophized the painter: 'Here you are at the crossroads where your questing mind, having observed objects for a long time, is now beginning to analyse itself. You now want to reorientate the deep reverence you have felt towards nature and the total honesty and sincerity with which you studied and loved its objects. As you have written to me, your dream is for your art to be not only the "glorification of nature" but the "glorifictation of an inner vision".'

Such was indeed the feeling guiding Cross at that time. The landscapes dated 1904 and 1905, inspired either by Venice (*San Giorgio Maggiore, Sails near Chioggia*) or by the Provence coast (*Cap Layet in April, Afternoon in a Garden*) expressed the aim to conquer the submission to analysis and realism which had previously affected the unity of his works: the natural elements, such as light effects, clouds, trees and leafy vegetation, which were used as subjects in those paintings, led to the kind of broader interpretation suggesting lyrical and inventive inspiration. More particularly in his choice of colours, Cross sought to create 'harmonies in affinity with feelings', tone compositions expressing an emotion. In fact, when studying a particular landscape as a subject, Cross would substitute a decorative representation influenced by his rational imagination. His desire to give free rein to his personal fantasy became evident in 1906, in the paintings exhibited at the Indépendants that year – such as *Faun, Nymphs* and *Flight of the Nymphs* (Musée des Arts décoratifs, Paris). The mythological allusion in the title was further proof of this new aim. The nude assumed new importance, the form was more simplified, and the colour, deliberately condensed, struck a vibrant note.

These paintings were succeeded during the period 1906 to 1908 by a remarkable series of works of the highest expressive and organized quality in which Cross indulged in sensual lyricism blended with rhythm, balance, simplicity and architectural quality.

The sea remained one of his favourite subjects, second to the love for hillsides and Mediterranean vegetation which inspired him to paint luxuriously decorative compositions through the density suggested by solid forms, and rich and varied chromatic harmonies. Pines and eucalyptus trees, almond trees and olive groves decorated many paintings such as *Landscape with Cap Nègre, Bay of Cavalière* (Musée de l'Annonciade, Saint-Tropez), *Le Lavandou, Landscape at Bormes, Afternoon at Pardigon* and *Cypresses at Cagnes* (the latter two paintings being now at the Musée National d'Art Moderne), as well as several views of Antibes. Cork-oaks frame female nudes in a

74 Henri Edmond Cross *Venetian sketch*

number of compositions. In these works – *Nude Woman, The Wood* (Musée de l'Annonciade, Saint-Tropez), *The Forest, The Clearing, Napées* – which reveal a pantheistic love of nature, the figures are integrated into the landscape; vegetable and human forms mingle in arabesques, lending rhythm to the paintings.

The unity, as well as the decorative and monumental strength, of these works is achieved through liberation from a literal representation of nature; certain elements are suppressed to emphasize others. The draughtsmanship is subjected to simplification and even distortion; the colours are treated with increased freedom and assume an individual beauty. Cross was now less interested in the analysis of local tones, passages and gradations than in the creation, through these elements, of expressive chromatic harmonies. This is the 'style of pure colour' referred to by Maurice Denis, which situates Cross among the pioneer painters who contributed most to fauvism. Matisse, in particular, owed much to the example set by Cross.

This evolution reached its peak after a journey by Cross to Tuscany and Umbria in the summer of 1908. His study of Italian primitives confirmed his idea that 'art is based on sacrifice' and he no longer hesitated to make full use of the synthesis of form and colour. The suppression of any unnecessary details, and the unification of colour achieved through the selection of the most characteristic note, lent splendour and serenity to the works of that period, such as *Santa Maria degli Angeli* (Hermitage, Leningrad), *Peasant Women of Umbria, The Oxen, Rosy Spring, Under the Cork-oaks* and *Little Girl in Garden*.

In his definition of the simplified unity in the painter's works, Maurice Denis wrote (*Catalogue de l'Exposition Cross*, Galerie Bernheim, 1910): 'With his growing desire for synthesis, his will to expression became more exacting and determined. What he had previously expressed through a variety of shades and dapplings, he now subtly indicated by the use of simplified forms and pure colour harmonies.'

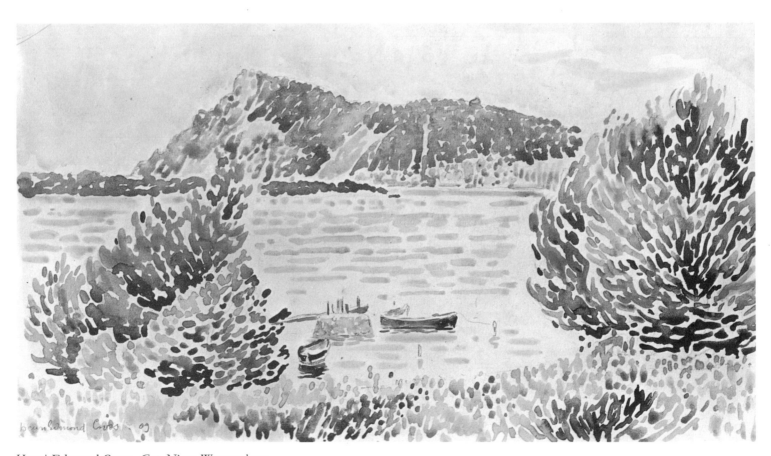

Henri Edmond Cross *Cap Nègre* Watercolour

Although death cut short his experiments, Cross had solved what had been to him 'a torturing dilemma': the problem of deciding to what extent a painter must be dominated by nature. His increasing awareness of the 'infinite beauty' of nature which, however, 'offers only beautiful details, without the unity of a whole', had brought him to the conclusion that, although the artist might find in the emotion aroused by nature's spectacle the primary inspiration for his works, he was nevertheless entitled to elaborate on his subject with complete freedom. The following extract from his diaries is very explicit: 'What has nature to offer? Disorder, hazard, gaps. Yet we fall into ecstasy at this chaos and exclaim:

"How beautiful". This is where the artist's work begins, and where he must "organize his sensations" by imposing order and completeness on this disorder. The fact that we feel a sensual emotion means that there is a subject for painting. But how are we to proceed in the concrete expression of our emotion? We must select fragments and details, and arrange them in an orderly manner with the artist's aim in mind, which is to transform, transpose and interpret.... Every time I feel tied down to the true fact, the documentation, the feeling "this is how it looked", I must ignore it and remember the final aim of rhythm, harmony, contrasts, etc. – I must paint in verse' (*Bulletin de la Vie artistique*, 1 June 1922).

Isabelle Compin

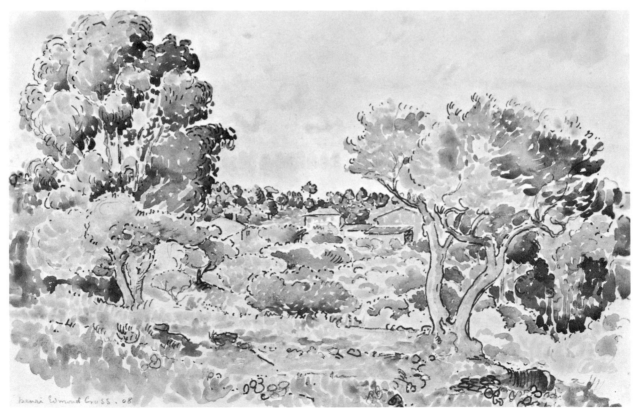

76 Henri Edmond Cross *Countryside near Bormes* 1908 Watercolour

Charles Angrand 1854–1926

Life

Charles Angrand was born on 19 April 1854 in Criquetot-sur-Ouville (Seine-Maritime), a village in Upper Normandy, equally distant from the cliffs above the sea and the elegant meandering curves of the Seine. The Angrand family had for generations lived in this corner of the Caux country. The father, Pierre-Charles, born in 1829 at Saint-Pierre-Bénouville, had married Marie-Elisa Grenier, born in Criquetot in 1833. Charles was the second child of the couple. He had an older sister, Marie, and a younger brother, Paul, both born in the same village. Their father, who had graduated as an elementary schoolteacher from the Ecole Normale of Rouen in 1848, had been made schoolmaster at Criquetot in 1849 and belonged to the first promotion of *instituteurs nationaux,* founded on the initiative of Hippolyte Carnot, a Minister in the Second Republic. He was to teach until his retirement in 1875, when he remained amongst his ex-pupils and acted as their adviser and arbitrator in numerous village matters. His fellow-villagers expressed their gratitude to him by electing him, under the Third Republic, mayor of their community in place of the local squire.

Angrand, after studying at a very good school in Rouen, was destined for the teaching profession, but chose instead to become a painter, to his father's disappointment. While he was working as an assistant at the Lycée Corneille in Rouen, he attended lessons at the Ecole des Beaux-Arts where Zacharie and 'Père' Morin taught. Angrand, however, took an active part in the rebellion against academic formulas, and his fellow students elected him as their 'leader' (according to Joseph Delattre). His *Gare Saint-Sever* (Rouen), in 1880, proof of his adherence to impressionism, was very badly received by the critics.

His first application for a job in Paris had been rejected in 1879 but he was finally accepted in 1882 and worked for a living as tutor at the Collège Chaptal, boulevard des Batignolles. In this neighbourhood also lived Manet, Mallarmé, Toulouse-Lautrec and a number of young artists who used to meet at the Café Guerbois and the Café d'Athènes. Angrand wrote to Monet, asking him to join the group of impressionists who were holding an exhibition in 1882. Monet replied that the group was in the process of breaking up and that its members would head in different directions to find exhibitions. The following year, Angrand joined the Société des Jeunes Artistes and exhibited the paintings which had been turned down by the jury of the official Salon des Artistes Français. In 1884, he exhibited successively at the exhibition of the Groupe des Artistes Indépendants, and at the exhibition of the Société founded in June by Dubois-Pillet. At this first exhibition of the Société des Artistes Indépendants, Angrand was represented by two works: *In the Garden* and *In the Farmyard* (now in Copenhagen). In 1886, he exhibited six paintings, including *Woman sewing, Paris: the Western Railway, The Seine in the Morning* and *Waste Land at Clichy.* Félix Fénéon reported on Angrand's manner of painting as follows: 'With calculated violence, his brush ingeniously mixes and kneads a thick and plastic impasto, moulding it into reliefs, scratching, scraping and chequering it.... His works are characterized by their richness, their rough melancholy and their tendency towards deep tones.'

As an impressionist painter seeking a new style, Angrand was on the brink of a radical change, which can be sensed in his painting *Woman sewing* (1885). He was to call his paintings of 1886 'transition work'. They were far removed from the smooth style he had adopted in Rouen. 'I am dreaming', he wrote in a local paper, 'of an art... in which colour and form... would represent the functional effect of the selected impression.' He felt that *The Harvest* marked 'the point of departure towards a new orientation'. From now on, Angrand was to produce neo-impressionist works which, in his opinion, were those best suited to express feelings 'harmonically' and 'subjective' impressions 'synthetically'.

'This technique', he went on, 'superficially termed

Charles Angrand *Sketchbook pages*

"pointillist" by numerous critics, consists of the division of hues, thus facilitating the application of the physical laws of vision : contrasts and reactions. This is a purely technical problem, but it is one of great importance, since intellectual evocation is directly dependent upon chromatic sensations.'

His *Farm Corner* and *Flood at La Grande Jatte* in 1887, and in 1888, *The Seine* and *The Haystacks* (Morris-Hadley Collection, New York), as well as many other paintings exhibited at the Salon des Indépendants, expressed this aim at 'synthetic and subjective' expression. *The Haystacks*, 'a large expanse of plains stretching in the brilliant sunshine towards a sharp horizon, lending languor and stillness to the landscape' (Gustave Kahn), was exhibited

at the Galerie Georges Petit at the end of 1888, with the Groupe des XXXIII.

In the previous year, Vincent van Gogh, who had just moved to rue Lepic, wanted to make Angrand's acquaintance and offered to exchange paintings. They met at the Café du Théâtre and discussed the suggestion, but nothing came of it ; Vincent was to leave very soon for his beloved South.

Angrand's friendship with Seurat was far more permanent and close. For the first time, one of Angrand's paintings (*Bouquet*) was sold ; the purchaser turned out to be Seurat. In February 1889, they were both invited by Les Vingt in Brussels. On 24 March 1891 the two friends discussed Seurat's *The Circus*, hanging at the

fifth Salon des Indépendants; Puvis de Chavannes went past the painting without even stopping to look at it. On 26 March the same year, Angrand went to visit his relatives at Criquetot, and there was told the news of his friend's death. The letter he wrote immediately to Signac expressed his profound grief.

Between 1891 and 1895, Angrand exhibited every spring, mostly drawings in Conté crayon, one of his latest experiments. He tended towards expressive stylization of form and the use of subtle gradated hues between black and white in order to lend depth to the compositions. Amongst these rather discreet and austere works were *Donkey, Sheepdog, Snow* and *Evening* (1892). Gustave Geoffroy was impressed by their 'delicate and precious' quality. So far as *La Revue Indépendante* was concerned, these luminous and hazy drawings suffered from 'the great disadvantage of being reminiscent of Millet and Seurat'. These works, primarily designed to convey chiaroscuro effects and saturated with poetic mystery, were seen again at Le Barc de Boutteville (at the end of 1892), at an Antwerp exhibition (in May 1893) and at the rue Laffitte neo-impressionist exhibitions (December 1893–March 1894). They included works such as *Lamplight* (Signac collection), *The Pilgrims at Emmaüs, The Good Samaritan* and *The Annunciation to the Shepherds. L'Echo de Paris* commented on Angrand's 'highly personal enigmas': 'Millet's name comes to mind when one sees the softly luminous drawings of the poet Angrand.' This isolated praise (1892) did not reflect the lack of interest shown by the public for Angrand's as well as for Seurat's drawings.

Angrand himself now faded from the scene. After the death of his father in 1896, he went to live quietly in a small village, Saint-Laurent, near Caux in Normandy. After fifteen years of living in Paris surrounded by friends, the painter deliberately chose this remote retreat and was gradually forgotten. His correspondence with Cross, Signac, Luce (who visited him several times), Van Rysselberghe and Antoine de La Rochefoucauld attested the permanence of the neo-impressionist group. In 1899, he reappeared to exhibit at Durant-Ruel a series of drawings on the theme of mother and child. These 'motherhood' drawings, smooth and graceful, veiled in an atmosphere of renunciation, failed to attract public attention. Signac alone noted in his *Journal* on 15 March 1899:

'Angrand: his drawings are masterpieces. It would be impossible to imagine a better use of white and black, or more sumptuous arabesques. These are most beautiful drawings, poems of light, of fine composition and

Charles Angrand *Sketchbook page*

execution. And yet everybody passes by without realizing their incomparable quality; although some visitors may notice their clean execution and the beauty of the gradated tones, no one feels the deep inner qualities of Angrand, this great artist.'

Angrand, meanwhile, was pursuing his experiments with charcoal, crayon and pastels, and even lithography. Very meticulous and determined, he worked slowly, reshaping his themes to achieve clear interpretations or shading variants with extreme stylization. Signac exhorted him to be less rigorously disciplined. The first years of the new century seemed to be a period of dissatisfaction and conflict for Angrand: he destroyed a lot of his work and exhibited little and irregularly. Pastoral scenes with

Charles Angrand *Study for 'Motteville Station'*

harvesters, woodcutters, cattle in their fields, copses and leafy landscapes were the compositions which expressed best his deep sensitivity and his love for orderly thoughts and for expressive simplicity. Good examples of that period were: *Peasant cutting his Hedge* (1903) and *End of the Harvest* (1905), together with the works dated 1907, a fertile and promising year, *Horses, Carriage, Goats* and *Valley*.

Angrand had not abandoned the use of colour harmonies as can be seen in *Path between the Apple Trees* and *Planted Yard*, and, more particularly, in *On the Threshold* and *The Norman Paddock*, in which the juxtaposed hues are painted in definite, large, square touches. The exhibition of such compositions in 1908 could not but stimulate

the still uncertain experiments of a new generation of painters and promote a technique of complete disjunction of colours, the application of paint in flat layers which was to become, in the following years, a characteristic of cubism. Angrand's skill at arabesque forms and his use of chromatic contrast and gradation made him a master among masters. It did not suit him to 'use technical means towards plastic aims'. (This attitude was equally valid for cubist and neo-impressionist painters.) He was perfectly aware of the risk involved in aiming solely at decorative effects, and of the disadvantages of the 'tapestry look', however effective the result might appear. Such process would, if successful, lessen the expressive finality, the feeling of depth and, therefore,

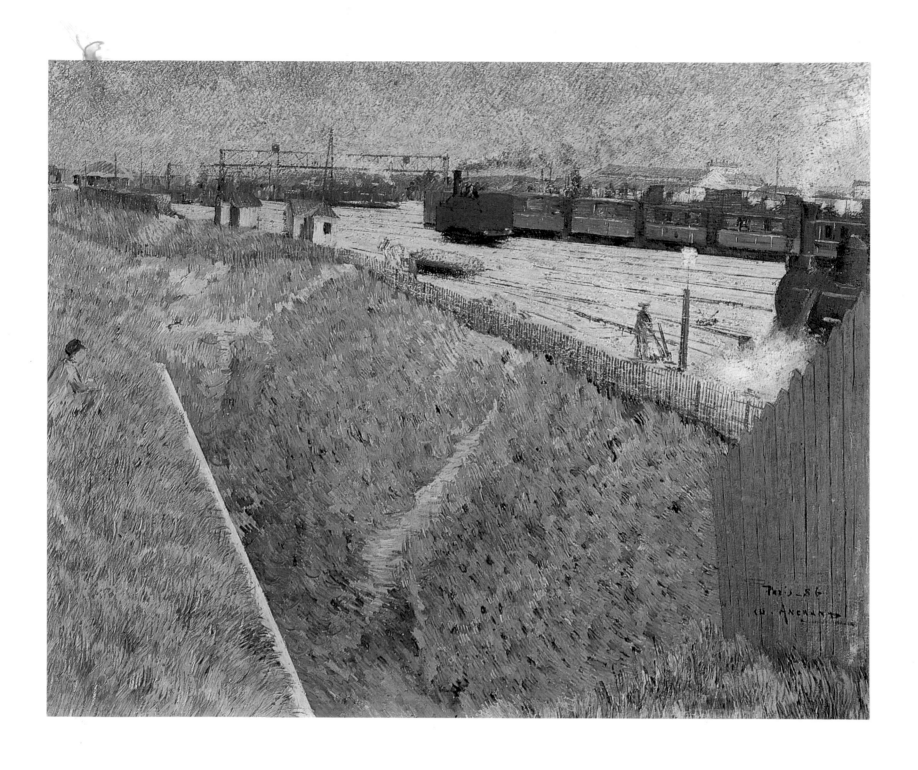

Charles Angrand *Paris : the Western Railway* 1886

the whole subjective aim in art. Angrand was one of those painters who 'allow themselves to disregard all rules' (notebook 7), one of those harmonists who 'feel aversion for certain sonorities of a loud nature' (notebook 10). Angrand refused to sacrifice the privilege of discretion, the charm of suggestion, or the pursuit of style, in favour of easy solutions. However, his experiments in the division of systematic, broad touches were not wasted but conferred on him instead a new freedom. Taking 'his own method as an absolute rule' (notebook 9), he pursued his work 'aiming not at finish, but at order and expression' (notebook 1), and relinquished the austere symbolism of black and white with its abstract tendencies. He moved towards powder pastels, a new means of expression which was best suited to blend shading with strength and tenuity with density. Angrand was fascinated by the speckled delicate effect of pastels which, without detracting from the most intense strength, thicken or thin at will, emphasize or attenuate, shout or whisper. These qualities fulfilled Angrand's stylistic requirements well. His drawing talent became closely involved with the use of this medium.

At this time, the painter should have reached a period of serenity and creative happiness but, with his capacity for deep friendship, he was painfully moved by Cross's fatal illness (1910). Within his own family, he also experienced sad losses: his mother's death in 1905, then, in 1912, that of his younger brother and of the mother of his two nephews. He moved away from Saint-Laurent, went to live for one year with his brother in Dieppe (1913), and then decided to go and live with his elder sister near Rouen. Just before war broke out, he went back to the town of his youth. The pacifist and humanitarian views which he shared with Cross, Luce, Signac, Jean Grave and his friends of *Les Temps nouveaux* were deeply affected by the coming of war in August 1914.

Until his death in 1926, he lived in a studio apartment on the fifth floor of a house on the quai de Paris in Rouen, overlooking a stone bridge and the bends of the Seine. His studio was large and brightly-lit, the only drawback being the yellow or grey mists rising from the river at times. He organized his time judiciously with regular work at his easel, at times crushing the powder under his thumb, or brushing it off with the light stroke of a pigeon feather. Sometimes, he would even use bellows to blow away some of the pastel, or to force the powder thickly into the Ingres paper. Behind the easel, he had hung works by some of his friends, including Seurat, Cross, Signac, and Luce. There were also folders of sketches and studies as well as glass transfers. Drawers were full of notebooks and a whole assortment of pastel sticks. When the light was bad or when darkness fell, Angrand abandoned the easel and spent the evenings either reading at the public library or quietly at home. He filled over one hundred notebooks with notes, references and rough sketches executed in an energetic hand. He collected biographies of great artists, books on the history of painters of the various schools, and publications on art. His notes reveal his constant preoccupation with aesthetics and his respect for the masters. Jean Le Fustec described him (*Journal des Artistes,* 8 May 1887) in these words : 'Motivated by high artistic ideals, he spends his life pursuing them in all his works. Every painting serves him as a document. A description by Zola, or a page by Joris Karl Huysmans, enchants him as much as any painting by a master, and this Norman's strong views cover not only the history of his own art, but also literature.'

However quiet and uneventful his life was, it was dominated by his constant aim at a deeper knowledge of his art. Not content with 'working during his leisure hours' to strengthen his vision, Angrand drew inspiration from direct consultations with nature. He would make short trips to his beloved Caux country, the cliffs at Dieppe or the Doudeville or Valmont countryside. He went to Honfleur to visit Boudin or to Amiens to pay his respects to Puvis de Chavannes. Sometimes, at Luce's invitation, he went down the river towards Caudebec or Jumièges, or up to Rolleboise, but he mostly walked with his notebook through the valleys and wooded hills around Rouen, receptive to the clear light of the countryside, the autumn colours and the progress of spring. The box of pastels soon opened and the subject was noted down in a free hand, often to be used immediately on his return home for the completion of a work.

One day in 1915, Angrand pulled out his sketchbook and began a crayon drawing in the vicinity of a British military camp of no actual interest to him (Rouen was at that time the most important British base in France). He was arrested as a spy and taken to the headquarters of the British forces, where he was closely interrogated, his sketches were confiscated and his identity carefully checked. He was finally reluctantly released thanks to the direct intervention of a local French official who knew him. The same misadventure occurred on the Dieppe cliffs, but that time he managed to explain himself, and he was not detained.

The war brought him discomfort and pain. He spent a whole winter without any heating, having kept his

Charles Angrand *Sketchbook page*

small ration of fuel for his sister. In November 1916, the poet Emile Verhaeren came to Rouen to give a lecture, and Angrand and Luce took him on a tour of the town. A few minutes after they left him in the evening, Verhaeren was accidentally pushed by a waiting crowd under the train he was to take back to Saint-Cloud. The next day, the two painters had to go and identify his body at the hospital, and they bitterly reproached themselves for not having stayed with Verhaeren at the station until his safe departure. Angrand suffered more anguish over his nephew Henri, who was fighting in the front line; he was twice wounded, and was killed in May 1917 during the second offensive led by General Nivelle on the notorious Chemin des Dames.

Then, after the war, he suffered more losses: in 1921, he looked after his elder sister during her last illness, and in 1924 his younger brother died. Angrand did not survive him for long. He had undergone a serious operation in 1922 which had immobilized him a whole summer at the clinic of the Château des Bruyères near Rouen. He became gradually weaker during the autumn and winter of 1925–26, when he had to give up painting. In the course of what he knew to be a fatal illness, he carefully tidied up his personal papers. He destroyed his private correspondence but kept family letters, as well as those he had exchanged with Cross, Luce and Signac over a period of thirty years (1896–1926). These were to be invaluable documents in the history of neo-impressionism. Having calmly prepared himself, he died on 1 April 1926. His one surviving nephew, together with Luce and Léveillé who were representing the Société des Artistes Indépendants, accompanied him to the Rouen cemetery on the chalky hillside where he was buried. His death was as unobtrusive as his life had been. The words which have been applied to Chardin could well be used of Angrand: 'He died just before reaching the summit he deserved through his clear and judicious intelligence and his great honesty.'

The last years of Angrand's life had been both more fertile and more significant than the earlier ones, in accordance with the maxim that poet painters often produce their best work in their old age. This does not necessarily mean that they are also recognized or appreciated in their old age. In the lax and disorderly period following the end of the war, a fashion emerged for strange and disparate forms of art. It was a time for forgetting the cruel war years, for living wildly and gaily. Angrand's art did not satisfy the cravings of the period.

To begin with, the Salons des Indépendants had been

interrupted during the war years, on Signac's decision. Then, in the following years, the intimism, harmony and balance of Angrand's works appeared old-fashioned. In 1920, he exhibited six large drawings at the thirty-first Salon des Indépendants. They were *Women picking up Apples, Woman in Grief, The Well, The Sawyers, Evening* and *The White House*. Then, in 1922, *The Harvesters, The Sea* and *The Tree*; in 1923, *The Meal* (Frédéric Luce collection), *The Triumph of the Harvesters* and *In the Garden*; in 1924, *The Harbour* (Ginette Signac collection) and *Autumn*; in 1925, *Motherhood Scene* and *Horses in the Rain*. Apart from other exhibitions at the Société des Artistes in Rouen, he exhibited in 1925 twenty-five

pastels at the Galerie Dru for which Signac wrote the catalogue's foreword; then, in 1926, at the Indépendants, he exhibited two works, *The Old Trees* and *The Flowers live on*. The retrospective exhibition 'Trente Années d'Art Indépendant' (February-March 1926) included several paintings by him, dated between 1884 and 1886, such as *In the Garden, Paris: the Western Railway*, and *The Seamstress*. By that time, Angrand was too weak to go and look at the works of his youth.

In 1929, his friends organized an exhibition of his drawings at the Galerie Rodrigues, with a catalogue introduced by Gustave Kahn. In 1933, the exhibition of neo-impressionists at Georges Wildenstein in Paris

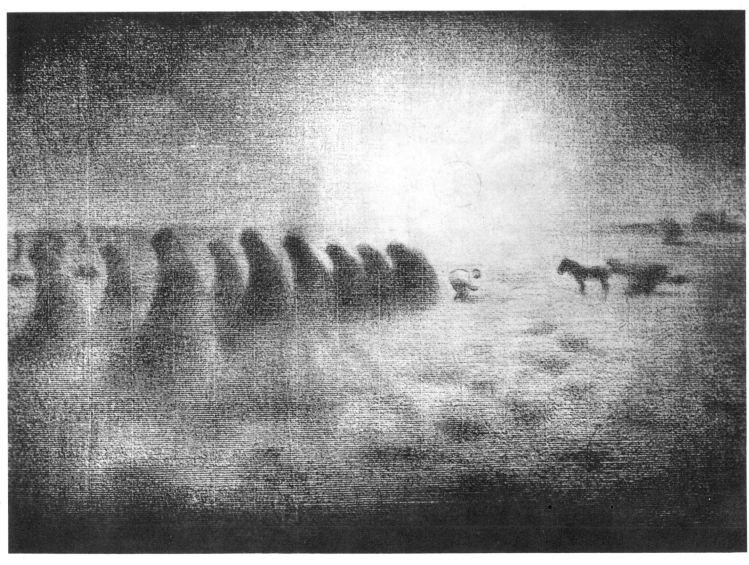

84 Charles Angrand *End of Harvest* Conté crayon

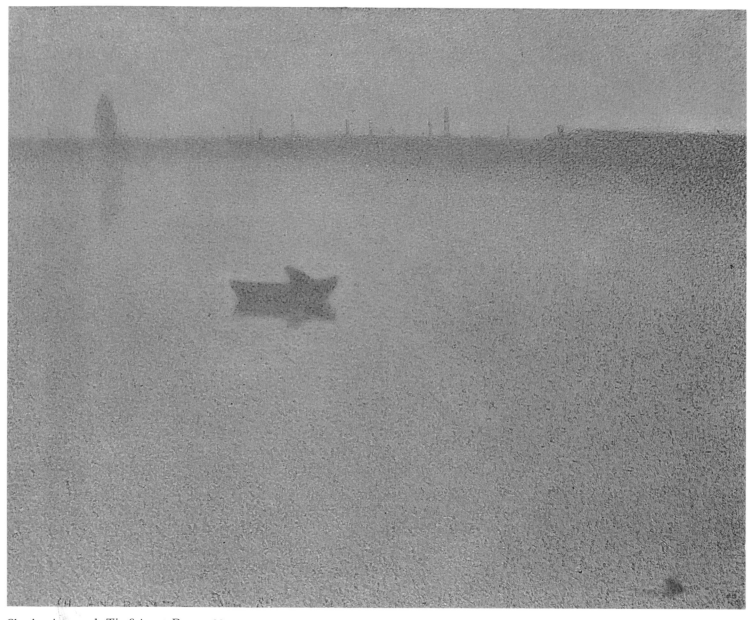

Charles Angrand *The Seine at Dawn* 1889

included seven works by Angrand. Only a few friends remained faithful to his memory; and among them were Signac, Luce, Jacques Rodrigues, Félix Fénéon and the young critic George Besson.

In the 1950s, art historians became interested in Angrand's writings, rather than in his paintings and drawings. His regular correspondence provided impor-

tant documentation concerning the history of independent art. Only occasionally were his works included among those of his contemporaries of the 1880s as was done at the Georges Wildenstein gallery in New York in 1953 ('Seurat and his friends'), at the 'Hommage à Paul Signac' in Paris in 1955, at the 'Exposition Luce' at Saint-Denis in 1958.

This then was the extent of his posthumous fame, but fame to Angrand was unimportant compared with a far more precious and permanent aim, the search for truth.

Appearance and character

If, in a manner contrary to Angrand's principles that 'only the essential character of things should be recorded in the most concise form', and 'a universal meaning should be sought for every subject', we indulge our curiosity and attempt to reconstruct the artist's character, we can start by recognizing his features in two drawings dating from the period he spent in Paris: the first of these, *Self-portrait in Top Hat*, is in New York (Robert Lehman Collection) while the other one, *Self-portrait with Cigarette*, is in Paris. He is also represented in two paintings which Luce produced at Saint-Laurent in 1910. In one of them, Angrand is reading at a table on which stands a small sculpture, a *Cat* by Barye; in the other, he is seen wearing a beige hat and blue suit, his hands leaning on a walking-stick, his face in three-quarter view. Seurat had also represented him in the first row of spectators in *The Circus*.

Jean Le Fustec, who knew him well in the early days of the Indépendants, described him as follows: 'A man of conviction and ideals, dedicated to art, such was this small dark-haired Norman with the face of a farmer. He was quiet and good-natured, and his face easily broke into a gentle smile. At relaxed moments, he could burst into loud laughter. He belonged to the Millet and Corot era; and, had he worn the traditional smock for his outdoor work, he could have been taken for a member of that family' (*Journal des Artistes*, 8 May 1887). Later on in life, a halo of white hair around his head, he was still the same, affable, discreet, a good listener.

'Is it necessary to speak of the man who wanted to disappear behind his work?' wrote René Trintzius. 'He loved silence above all, and welcomed solitude.... He listened to others and spoke little, preferring to pursue his meditation' (*La Normandie illustrée*, June 1926). Pierre Wolf wrote about him in 1921: 'As he walked, stooping a little, through the streets of Rouen, wearing a wide-brimmed hat and a grey cape, he could have been mistaken for an old Norman shepherd. At ceremonies or previews of exhibitions, when the grey cape was replaced by a blue waisted overcoat reaching down to white gaiters, one was pleasantly reminded of the picturesque costume of a half-pay officer. Under the soft hat, the face appeared etched in wrinkles, crowned by white hair, with a thick moustache and small beard, his clear and inquisitive eyes lending his features an expression of intelligence and of gentleness.'

Gentleness, benevolence and indulgence were some of his qualities, although the latter was reserved for those who deserved it, either through circumstances or nature. First of all, there were children. Angrand believed in giving them complete freedom, within the bounds of safety, and loved to watch them at play; as he wrote himself, he liked 'to witness closely their acts and movements without attempting to interpret them'. His observation of them led to results which he described when relating his attempt at using his very young nephew Henri as a model: 'Engrossed in his game, he looked enchanting, and I diffidently began to draw him in crayons although I was convinced that I could not translate the soft outlines and the adorable attitudes which blended into a poem of round curves. In my drawing he looked like a simian old man. I had completely failed to express the character of his nudity and its harmonious mobility. A few days later, I considered my sad failure and, with a crayon, changed the head, a foot and a leg, then again the head and the right arm, and repeated these progressive corrections many times until, finally, a child and his gestures began to appear on the paper. Since then, I have kept my hands in my pockets while observing my model, in recalcitrant or affectionate mood, with his mother at bath time. I would then try to combine the proportions and harmony of the two figures – or merely interpret the attitudes of the child alone, achieving only a vague likeness – but then art is not a facsimile or a literal reproduction.' One year later, Angrand wrote: 'Now.... he has already grown too much, his shape has become elongated and almost eccentric. He has lost that enchanting little pink behind which, in a bending position, had the round shape still of the original egg. Nowadays, I notice more his face, with his lively eyes and smile, framed by blond hair. Probably I will one day look at him less benignly and more professionally. Will this devotion still be detectable in a drawing one day? I am inclined to think that all our aesthetic actions are primarily caused by love, and, in turn, produce love.'

The feeling of human sympathy permeates his works, and extends naturally to tramps and beggars, to workers setting off at dawn and returning exhausted by evening, to simple labourers, to women at their daily chores or gossiping (although with some irony here). This fraternal feeling, which one should 'absorb in silence', is expressed in subtle pastels.

His judgment was always alert, but the instant opinions he would form might remain unvoiced or be expressed, laconically and decisively, some time later. The effect was to discourage small talk and inquisitive conversations. But, among his friends or in the company of trusted companions, Angrand would become lively and enjoy settling a discussion by firmly voicing his convictions. He liked reminiscing and never tired of conversing with Luce, whose memory was accurate and picturesque.

In his predilection for poetry rather than prose fiction – in this he was the opposite of Signac – he enjoyed the close friendship of Moréas, of Paul Fort and Emile Verhaeren, the 'trinity of demigods' described by Clovis Hughes, all of whom dedicated works to him. Among the arts, music appealed to him most, as representing art in its most intellectual form. He rejected, in all the arts, mere virtuosity and facile rhetoric. He loathed the bourgeois baroque style in the architecture of his day.

It would be difficult to list his favourite painters. His notebooks contain abundant references to well-known names, but it is perhaps significant that his first visit, when he came to Paris in 1875, was to the retrospective Corot exhibition at the Beaux-Arts, and that his greatest regret at leaving Paris twenty years later was that he would be far removed from the Louvre. When he left Saint-Laurent in the summer of 1902, it was to travel to Bruges and see an exhibition of approximately 413 paintings by Flemish Primitives from Van Eyck to Bruegel. It is also obvious that he admired Daumier and Millet, of whose work he possessed many reproductions. On Signac's visits to Rouen, Angrand would meet him at the museum in front of *The Justice of Trajan*. He constantly sought out great works and studied the problems involved in their creation.

As he himself said of H. E. Cross (*Temps Nouveaux*, 23 July 1910), he was interested only in the conquest of

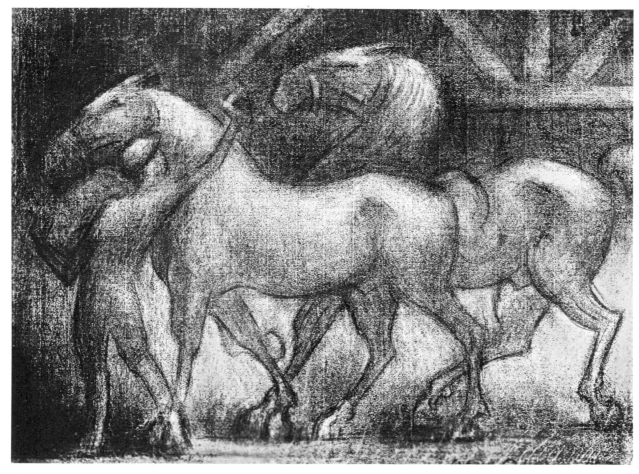

Charles Angrand *Horses* Conté crayon

'subtle and rare things'. This explains also his frugal, simple and full existence, spent 'in his fifth-floor apartment, sheltered from riches'.

Works

His works as a whole remain to be analysed. At the beginning of his career in Rouen, he used very light hues and strongly defined outlines, rather in the manner of Manet, Bazille or Caillebotte than in the impressionist style. Few examples of that period (1879–82) are still in existence: *The Museum at Rouen* (1880) and *The Parasol* (1881), as well as several family scenes. After his arrival in Paris, Angrand filled his paintings with darker or more brilliant colours, in thick impasted textures, with, already, some fine commas of juxtaposed hues, as in *The Seamstress* (size 30 canvas, dated 1885) and *The Western Railway*. Félix Fénéon recorded this period in the publication *Les Impressionnistes en 1886*.

Angrand's delicate yet vigorous style 'lent itself to the divisionist transposition then in fashion' – in the artist's own words about Cross – and, after many discussions with Seurat, he adopted pointillism which he applied, according to his particular requirements, either rigorously, with strong contrasts as, for instance, in *Scene on a Norman Sharecropper's Farm* (1890, Sutter collection) or in a more harmonious and gradated manner, as in *The Haystacks* and *The Seine at Dawn* (1889). In the latter painting, the strokes become like very fine criss-cross sequins, in such harmonious hues that they lend astounding depth to the painting.

Black-and-white drawings represent his main output in the 1890s. They feature the simplification and abbreviation of form within a systematic order of masses. The interplay of values is the ruling principle. These drawings tend towards a 'symbolism' saturated with poetry; their originality is indisputable, in spite of their alleged affinity with Seurat's drawings. The latter are marked by discipline, depth and strength, whereas Angrand's are mysterious, penetrating and graceful. Seurat's appear to achieve their effect by controlled agitation and balanced enthusiasm, while Angrand's lean towards melancholy or tenderness. Seurat's drawings give a powdery effect, while Angrand's seem evanescent, and, although there may be a likeness in apearance and effect, their technique differs greatly.

At the turn of the century, Angrand passed through a phase of crippling inhibition; but, after various experiments with charcoal and crayon, and even engraving, he strengthened his style and produced some finely composed rural scenes which create a remarkable general effect. The principles of the 'symbolist' period had begun to relax and transform the personalized concrete manner. These steps led (1906–08) to the revival of neo-impressionist technique, but in a less rigid form. The early pointillist and sequin-like touch gave way to a square or rectangular brushstroke, in pure colour; the 'symbolist' arabesques and basic lines, encircling the masses and clarifying their composition, were retained (*The Path under the Apple Trees, In the Garden, The Norman Paddock*).

Associating the style of black-and-white gradations with the splendour of juxtaposed colours in an original synthesis of drawing and texture, Angrand began his great series of pastels. This eternal seeker, who would never 'be guided in his career or in his art by anyone but himself', had found his definitive form of expression. Angrand adopted two kinds of pastel drawing in the last fifteen years of his life (1910–26): the pastels composed in his studio (equivalent to canvas size 15), and the pastels drawn from direct observation and then re-worked until final completion (equivalent to canvas size 8). These pastels are based on numerous lively sketches out of notebooks or ordinary sheets of paper which were treated with a carpenter's chisel-point pencil, producing a criss-cross effect of fine and thick lines to serve as a guide for future compositions.

From this period date *Road into the Village, Fox on the Prowl, Goats, Women picking up Apples, The Flock of Sheep returning* and several other fine pastels.

From this brief survey it is clear that no group classification can possibly be applied to Angrand, since he invented his own method. Some of his friends in Paris had nicknamed him *Le Chat*, 'the cat', because of his abbreviated signature (Ch. A.) but more particularly because of his calm, discreet and silent habits. Angrand added that he was 'the cat who walks by himself'.

He made every effort to be an inventive and honest worker. He was a sensitive, independent, lucid artist, with a capacity for proceeding from the particular to the general. With his cultivated mind and straightforward judgment, he lived like a philosopher, although he would have refused the title. Charles Angrand set out only to live like a man.

Pierre Angrand

Albert Dubois-Pillet 1846–1890

Louis-Auguste-Albert Dubois, later called Dubois-Pillet, was born on 28 October 1846 in Paris, 4 rue des Fossés-Montmartre (now rue d'Aboukir), in the Sentier shopping quarter. His father and mother, then aged thirty-one and twenty-six respectively, belonged to that class of bourgeois tradesmen so prosperous under the reign of Louis-Philippe. Jules-Sylvain Dubois, a southerner from the Haute-Garonne, had come to Paris to enter commerce and married Sophie-Hortense Pillet, who belonged to an old Parisian family, and whose brother was the famous auctioneer. They had two daughters and one son.

The young Albert Dubois, who was to be 'a revolutionary in art as in politics', was educated according to the conservative tradition of the time and studied at the Lycée in Toulouse where his parents lived after their retirement. He graduated from high school in literature on 15 February 1864 and in science on 8 March 1865. He then chose a military career, and, after passing the entrance examination at the Ecole Impériale Spéciale Militaire at Saint-Cyr, he signed his enlistment papers on 13 October 1865.

Dubois came out of Saint-Cyr as a subaltern on 1 October 1867, and was posted to the 72nd Infantry Regiment in Périgueux, then to Toulouse. He did well and attracted notice; he was transferred in November 1869 to the 1st Light Infantry Regiment of the Imperial Guard in Paris. He was not to wear the prestigious uniform of the Guard for long; in July 1870, war broke out between France and Prussia. His regiment immediately left for the eastern front, and Second Lieutenant Dubois, 'present at the battles of Borny on 14 August, Gravelotte on 16 August, Saint-Privat on 18 August, Servigny on 31 August and 1 September, and Ladonchamps on 7 October', fought courageously and desperately like the rest of the Guard, until 28 October, when Bazaine capitulated at Metz. The officers of the 1st Regiment were

taken as prisoners to Paderborn in Westphalia. One can well imagine the bitterness of these men who had believed in their Emperor; some of them, as a result of the defeat, were to transfer their loyalties to a Republican left-wing party. Among them was the former Bonapartist Albert Dubois.

There was more fighting to be done. In March 1871, Paris fell into the hands of the Commune. Bismarck and Thiers, anxious to strengthen the regular army in order to defeat the insurrection, concluded an agreement concerning the release of the officer prisoners of war. Dubois was liberated on 28 April, to be incorporated in the Versailles army which took part from 21 to 28 May in that 'bloody week' ending in the recapture of Paris.

His brilliant record in active service resulted in rapid advancement. Promoted to full lieutenant in 1872, he joined the 90th Regiment of the Line, on garrison duty at Givet (Ardennes). In May 1876, he was made a captain, and transferred to the 125th Regiment at Poitiers. He was at the time thirty years old.

It was during this period following the war that the latent talent of the painter began to emerge in the officer. From the provinces, he sent to the Salons in 1877 and 1879 two paintings, without much substance, but expressing the desire to escape, through art, from the military routine. His evolution towards wider horizons was orientated in a political direction at this time, and, although registered in the army as of 'Catholic religion', he joined the Freemasons, the powerful anticlerical force which 'made' the Third Republic. Important Masonic personalities immediately supported Captain Dubois in various ways, of which his posting to the Republican Guard in Paris in November 1880 was one.

The artistic climate of the capital city soon persuaded this novice to relinquish traditional ideas, and he escaped from academic principles so successfully that, between 1880 and 1884, the Salon rejected all the paintings he sent in. At this stage, Dubois broke away from his past attitude of diffidence and timidity by exhibiting on

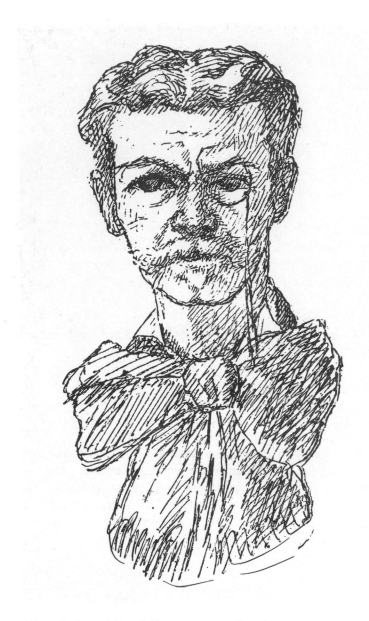

Albert Dubois-Pillet *Self-portrait* 1890 Pen drawing

At the exhibition, he had met Seurat as well as Redon, Lançon, Guillaumin, Angrand, Cross and Signac, the future champions of the neo-impressionist cause. They were all under twenty-five ; Dubois was already thirty-eight. With them he discovered a new world. Drawn closer together by circumstances, they spontaneously dissociated themselves from the strange crowd at the Groupe des Indépendants in order to found the Société des Artistes Indépendants.

As we have seen, this born organizer, active and energetic, ceaselessly battled on all fronts in order to strengthen the precarious foundations of the Société. Simultaneously, Dubois-Pillet began, with his customary enthusiasm, to orientate his own experiments towards optical art. In fact, this forty-year-old artist appeared to be making up for lost time. Already in February 1886, he made himself conspicuous in the artistic and literary circles by acting as a second at the tragic duel between the unfortunate journalist Robert Caze and the writer Charles Vignié. The fight attracted a great deal of publicity and, with it, comments on the reluctant hero.

There were, however, setbacks as when the former Groupe des Indépendants, who had on many occasions tried to cause trouble, sent Dubois-Pillet's commanding officer a letter accusing him of misappropriating rights as well as funds belonging to the Société des Artistes Indépendants. Captain Dubois' superiors were concerned, particularly as his actions gave him the appearance of acting in open defiance of order and morals. An investigation followed. The unfortunate Dubois-Pillet showed his first divisionist paintings at the Indépendants in the autumn ; a week later, the General commanding the Paris district issued an order which read as follows : 'It is found necessary to forbid Captain Dubois of the Légion de la Garde Républicaine to take any further part in exhibitions of paintings, and to belong to the Société des Indépendants.' A few influential interventions quickly settled the matter, and, as Arsène Alexandre wrote, 'the colonel was advised to turn a blind eye.'

Dubois-Pillet resigned from his functions at the Indépendants, at least officially. It is, however, clear from the evidence we have that he remained president in fact, if not on paper. Gustave Kahn, for instance, wrote about Dubois-Pillet's many activities, which included negotiations with the City Council, the invention of a formula to divide membership fees, exhibitions to the accompaniment of military music, and the organization of a great number of dinners at the Indépendants.

A man of action, Dubois-Pillet was equally energetic at his easel and, at the end of 1886, sent a *Landing-Stage*

15 May 1884 at the tumultuous exhibition of the Groupe des Indépendants his *Dead Child*, which scandalized the public, and made a deep impression on Emile Zola. The writer found direct inspiration in the painting ; he introduced into *L'Oeuvre* (1886) the character of the painter Claude Lantier, who exhibits at the Palais de l'Industrie the portrait of his dead son.

In the sinister atmosphere of black farce on this 15 May, however, a decisive landmark had been reached in the life of the painter, who, in view of his military position, was to sign himself Dubois-Pillet in future.

Albert Dubois-Pillet *Towers of the church of Saint-Sulpice*

to the exhibition of the Beaux-Arts in Nantes. In 1887, he executed pointillist pen drawings for the publication *La Vie Moderne* and, in March, gave the Indépendants nine paintings including a *Self-portrait with silk hat and monocle*, as well as a series of studies of Rouen harbour, where he had gone to paint with Pissarro. Seurat wrote to Signac on 2 July: 'I am the only impressionist-luminist Parisian left in Paris, with Dubois-Pillet who spends his time reviewing parades instead of working.'

Ironically, three days later, Captain Dubois was prematurely retired, following an order concerning the cutting down of the strength of the Republican Guard 'in view of an increase in expenditure for the Municipal Treasury' (*Le Journal Officiel*, 6 July 1887). Without delay, the Masons went into action. Letters of recommendation poured in at the War Ministry from important personalities such as Adrien Hébrard, editor of *Le Temps*, and Frédéric Passy, *Conseiller général* for Seine-et-Oise. To all

91

who shared the same cause – the cause of the Indépendants – it was essential to maintain Captain Dubois in Paris. Reinstated at the end of the year, he found himself put forward for the Légion d'Honneur.

The year 1888 passed peacefully. Living now at 4 rue des Grands-Degrés, below the place Maubert, Dubois-Pillet worked ceaselessly and without any disturbances. Invited in February to take part in the Salon des Vingt in Brussels, he sent thirteen paintings of the most varied inspirations: portraits, flowers, Seine banks, industrial landscapes, etc. He exhibited in March at the Indépendants, and in September, *La Revue Indépendante* organized his first one-man exhibition.

The year 1889 was also eventful but in a different manner. The underground movement of the former Groupe des Indépendants was still active; in the spring two anonymous letters reached the War Ministry, denouncing Captain Dubois as an active supporter of the would-be dictator General Boulanger. Ordered to answer the accusation in writing, Dubois emerged free from all suspicion.

A deceptive calm followed the storm, and enabled the painter to prepare for the October Salon des Indépendants. The following month, events took a dramatic turn when Dubois-Pillet was promoted to the rank of major and put at the head of the Gendarmerie of the department of Haute-Loire, with its headquarters at Le Puy-en-Velay. He left Paris, and it remains a mystery whether his sudden departure was engineered by his superiors because of his extra-military activities, or whether he himself applied for a transfer in order to seek inspiration in different surroundings.

Whatever the reasons were, the officer-painter, in the depths of the provinces, still took an active part in the artistic life both in France and abroad. Invited for the second time by Les Vingt in February 1890, he exhibited nine paintings which included his latest views of Paris, a *Railway Line* and various aspects of the quays and of the Seine, which he loved and painted so much at any time of the year or any hour of the day. At the Indépendants in March, he exhibited, amongst others, the first of the works executed at Le Puy, *Saint-Michel d'Aiguilhe in the Snow*.

Dubois-Pillet had only five months to live. He was seen seeking inspiration in the picturesque countryside of the Velay. 'He recorded the red earth, the villages poised near the summits, the streets of lacemakers...' (*Le Mercure de France*, 1 April 1924).

In the meantime, his biography by Jules Christophe appeared in *Les Hommes d'Aujourd'hui* with, on the cover,

a self-portrait in pen and wash. Jules Christophe's conclusion was optimistic: 'And this sincere artist is now on exodus at Le Puy-en-Velay, very far from the café, La Nouvelle Athènes, on Place Pigalle, where he used to enjoy discussions about art with his contemporaries. But he will return.'

He never did return. He fell prey to a smallpox epidemic and died in hospital at Le Puy on 18 August 1890, at the height of his active life, aged forty-three. A crowded religious funeral at Le Puy, a memorial service in Paris where he was buried at the Montmartre cemetery, a substantial obituary notice and the mourning of all who had known him surrounded the death of this man of strong character whose name, although unjustly neglected will forever remain bound to the history of the Société des Artistes Indépendants and of neo-impressionism.

Appearance and character

The physical appearance of Dubois-Pillet, aged nineteen, was registered at Saint-Cyr in these words: light brown hair, round forehead, grey-green eyes, strong nose, dimpled chin, oval face, light complexion, height 1 m 64 (5 ft 5 in.).

A directory of artists and writers, the *Petit Bottin des Lettres et des Arts* (1886), gave the following description of the artist: 'Dubois-Pillet, Captain and impressionist. Monocle, thick short-cropped hair and hard moustache. Flowers, landscapes, portraits and figures. He is proud of his ability to convey winter sunrays reflecting through ice crystals suspended in the atmosphere.'

Here is his portrait by Jules Christophe in *Les Hommes d'Aujourd'hui* in 1890 as caption for the self-portrait of Dubois-Pillet on the cover of the publication: 'The features above the elegant, emphatic cravat on the cover of the publication give a true picture of the man: round head, wide forehead, pale blue eyes, squat nose, greying dark brown hair and moustache, round chin divided into two segments, his gaze direct, searching, and alert behind the monocle.'

The character of this 'cultivated, witty and friendly' man (Félix Fénéon) was borne out by the respect, trust and friendship which his painter friends at the Société des Artistes Indépendants felt for him, even though some of them such as Pissarro, Luce, Signac and Petitjean were known as anarchists and anti-militarists. The fact that the tough Commune supporter Luce should have been devoted to Dubois-Pillet was one more proof of the

Albert Dubois-Pillet *River Bank in Winter* c. 1889

fine qualities of the officer's character. His honesty, unselfishness and kindness were acknowledged by all who met him. Camille Pissarro, whose caustic wit spared few, was disarmed by Dubois' generosity and wrote: 'Dubois-Pillet, knowing my financial difficulties, asked me whether he could lend me fifty francs. It is very kind of him, as he is himself not rich' (Letter to Lucien, Paris, 3 December 1886).

Michel Zevaco, the popular socialist writer, went to interview Dubois-Pillet in his studio at the beginning of September 1889 and wrote in *L'Egalité*: 'M. Dubois-Pillet, whose talent as a painter is well-known and unanimously recognized, is above all a charming man.' The painter Majola wrote: 'How often did I not see him settling the long overdue membership fees owed by some impecunious artist, with such delicacy that no one ever knew about it, not even the artist in question who probably believed there had been some miracle! (*La Haute-Loire*, 27 August 1890).

Colonel de Christen, Major Dubois' commanding officer, accurately expressed the general feelings at the painter's funeral: 'Loyal and honest, an excellent friend always helping others, he conducted his relationships with the greatest courtesy. It can be said of him that he leaves only friends. An impressionist painter of real talent, he held original views and spoke with great humour, a natural trait further increased by the long time spent among intelligent minds.'

Works

Dubois-Pillet's work cannot be situated in the history of neo-impressionism without taking into account the circumstances of his career as a painter. Unlike the other neo-impressionists, he had received no artistic education except for the very elementary instruction at the Lycée where, according to his biographer Jules Christophe, he had been 'the eagle in the drawing class'.

As a peacetime soldier, Dubois-Pillet sought a diversion from daily routine in the pleasures of Sunday painting. However, his duties in the provinces until the age of thirty-four limited his outlook and kept him in ignorance of the ideas and new theories in vogue in Paris. Later, when he had already reached the age of forty, he found his vocation in Paris, only to be prevented by death from reaching his full evolution as an artist. For this reason, it would be unjust to compare his work unfavourably with others since fate reduced his productive life to a mere five years. It should also be remembered that Dubois-Pillet had to divide his time between his painting and his military duties.

It is interesting to follow the progress of this amateur talent towards pure art. The very first beginnings were marked by the two still-lifes *Corner of a Table* and *Chrysanthemums*, which he exhibited at the Salon in 1877 and 1879. The paintings passed completely unnoticed. 'They deserved it', wrote Maurice Beaubourg, because they appeared to be 'licked clean, brushed smooth, decorated, pampered' (*La Revue Indépendante*, September 1890). This scrupulous fidelity to likeness alone explained the fame of the scandal caused by *The Dead Child* at the Groupe des Indépendants in May 1884. It could be called a cruel painting, except that it fulfilled the naïve wish to express the macabre subject itself 'painted immediately after death, for the mother'; it was only this feeling that compelled the artist to paint this aggressively naturalistic portrait, of otherwise mediocre quality.

His encounters with Redon, Pissarro, Seurat, Cross, Angrand, Signac and Guillaumin were to him the revelation which transformed his vision and, as a result, his pictorial conceptions. Although still concerned with the faithful representation of nature, he now followed the example of his new friends and aimed at the spontaneity of the impressionist style. Light colours on his palette and broad separate touches characterized this preliminary stage of his evolution. This period, from 1884 to 1886, could be called Dubois-Pillet's 'bronze period', during which he appeared to have suddenly become conscious of the sun, and saturated – sometimes excessively perhaps – his landscapes and portraits with light.

On 10 December 1884, at the inauguration of the first Salon des Artistes Indépendants, the painter was able to present this new style which attracted admiration as well as criticism. Jean Le Fustec, among others, admired the qualities evident in the paintings and wrote (*Le Journal des Artistes*): 'M. Dubois-Pillet exhibits, among other landscapes, *October in the Bois de Meudon*, in warm colours. The yellow leaves are aglow with sun on a fine autumn's day amongst the last greens of the season and the already bare branches. The delicate sky ends the perspective in violet hues which, instead of limiting the landscape, extend it beyond what the eye can see. The portrait of Mlle H. is also very successful. The head stands out vividly against the vibrating background through the freshness of the colours and the strength of the drawing.'

This painting, however, also attracted a distinctly unflattering comment from Albert Pinard in *Le Radical*, who criticized Dubois-Pillet's 'crude' vision: 'This portrait of a woman, carefully covered by glass, appears at

Albert Dubois-Pillet *The Steam Crane* Drawing

first sight to be stained with palette scrapings. Then, from a distance, one can blend it into a whole image, although the head of the young woman remains crudely coloured and blotchy.'

In 1886, Dubois-Pillet took up divisionism, but, in view of Degas' opposition, he did not take part in the eighth exhibition in May, above La Maison-Dorée. In August, at the Indépendants, he asserted his conversion to scientific impressionism, and Félix Fénéon marked the occasion of Dubois-Pillet's first steps in avant-garde art with a complimentary review published in *Les Impressionnistes*: 'M. Dubois-Pillet shows ten paintings and we know a few more. His slightly blond vision lends to his oils an astounding pastel delicacy. A diffused, amber, lucid light imbues the landscapes with convincing sky colour and receding distances.'

Dubois-Pillet thus applied divisionism; but the critics were in disagreement over his new method. J. K. Huysmans, in *La Revue Indépendante* of April 1887 wrote: 'M. Dubois-Pillet, in his turn, pins out his hues.... His

96 Albert Dubois-Pillet *The Pont des Arts and the Quays* India ink on tinted paper

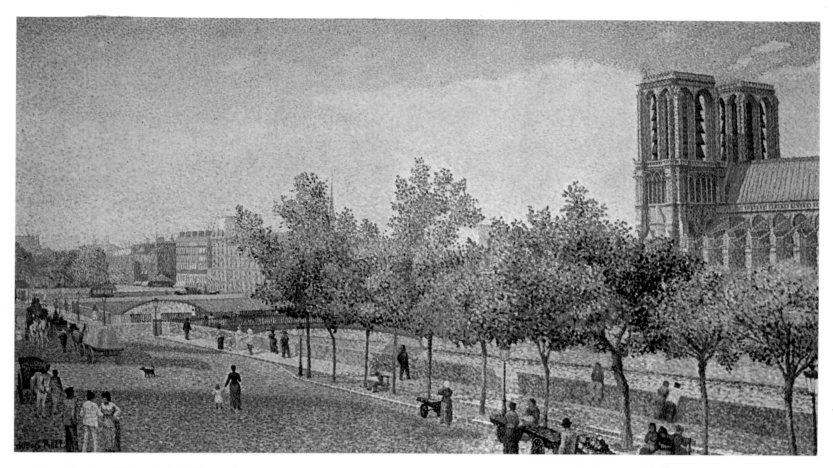

Albert Dubois-Pillet *Quai de Montebello* 1889–90

portraits, which convey such sincerity, have become angular and hard. On patchy backgrounds, the faces are spotted and weak, and yet I feel drawn towards them by the expression of truth they evoke. Two landscapes, in fact, illustrate the accuracy of his impressions : a *bateau-lavoir* in Saint-Maurice and a steamer at Rouen. As with M. Signac, I confess that I preferred his earlier works which were more supple and frank, and less entangled in the ties of a rigid system.'

Despite what Huysmans wrote, however, Dubois-Pillet had succeeded, particularly in *The Wash-boat at the Pont de Charenton*, in overcoming the theories on optical art as applied by Seurat. To the four separate touches used by the latter (colour of the object – light – reflections – complementary colours), Dubois-Pillet added a fifth category of strokes which he called 'passages'. The painter explained this to Jules Christophe who reported it in *Les Hommes d'Aujourd'hui* as 'using as justification Thomas Young's theory according to which the retina was able to relay three different categories of sensations'. This theory was very much disputed by the painter's friends, but he held obstinate views concerning improvements in the 'chromo-luminarist' system and was relentlessly searching for new means of expression.

In 1888, he was the first to produce oval paintings, and at the spring exhibition of the Indépendants he and Seurat both exhibited works in which the frames had been executed in pointillist style to match the paintings. The critics reacted violently to this daring innovation, and even the forbearing Félix Fénéon protested this time: 'Dubois-Pillet's canvas is surrounded by a crownlike frame decorated in violet variations. The frame has lost its neutrality and now assumes an importance of its own. Was it painted to enhance the painting or viceversa?' In conclusion, an indirect verdict appeared in *L'Art Moderne* (15 April 1888): 'The frame, although still white, acquires absurd reality, as is the case in M. Dubois-Pillet's method.'

Félix Fénéon still kept an open mind; on the occasion of the private exhibition of the artist's works in September at *La Revue Indépendante*, with thirteen canvases and four drawings, he wrote: 'On the other hand, Dubois-Pillet's *Steam Crane* possesses the neatness of a working drawing. Four portraits reveal living beings behind masks: a young girl, a lady, M. Dubois-Pillet himself and Captain Pool. In the background, foliated scrolls, rosettes, carpet and wallpaper mosaics. Brightly coloured apples and mounds of tangerines give a cheerful, illuminated effect' (*La Revue Indépendante*, October 1888).

Maurice Beaubourg's opinion read as follows: 'Within all that, instead of the anticipated truculence, one finds controlled innovations, the sober calm mentioned earlier; the achievement of a man who possesses a quasimathematical system and uses it accurately' (*La Revue Indépendante*, September 1890). During 1888, Dubois-Pillet painted in thin, tight strokes, punctuating the work mostly in delicate harmonies of greys and blues. This could have been called his 'silver period', whereas a year later, at the Indépendants of 1889, the painter distinguished himself by the 'daring tonalities' of his daisies.

His skilful use of colours enabled Dubois-Pillet to translate, at Le Puy-en-Velay in January 1890, an effect of snow on Mont Saint-Michel d'Aguilhe, with violet hues gradated in mauves and blues, and contrasting with yellows and oranges. Probably at the torchlight parade at Le Puy on 14 July, he painted an evening celebration which ranks amongst the finest neo-impressionist drawings: a dark field, studded with pale patches, interprets the mystery of this summer evening, with its moving shadows and flickering flames. There is no statement, merely a suggestion, and this work approaches fantasy not easily reconcilable with the image of Dubois-Pillet working 'with, under his arm, the translation of O. N. Rood's theories'.

It has been argued against the pointillists that they sacrificed individuality and spontaneity in favour of collective aims. Dubois-Pillet's early death halted a creative impetus which might possibly have reached further. His will to contribute personally to the 'Century of Impressionism' was expressed in this statement: 'I owe everything to Seurat, who drew me after him. His feeling for order and discipline made a deep impression on me. To follow him closely would have been dangerous and this is why I tried to paint other subjects than the ones he chose. By doing this I may have lost my way, but I have no regrets' (quoted by Gustave Coquiot in *Seurat*, 1924).

Lily Bazalgette

Lucien Pissarro 1863–1944

Lucien Pissarro was born in Paris on 20 February 1863, the eldest child of the painter Camille Pissarro. The Salon des Refusés, held in the year of Lucien's birth, marked the beginning of his father's public life as an artist, and marked the coming together of the group of painters who were later to have so great an effect on Lucien's own career. Lucien's sister and four brothers were all to become painters, too, and all mastered the art with greater or less success; but of all the children of the renowned impressionist Lucien attained the greatest international reputation, and carried abroad the lessons of French independent painting.

Camille Pissarro must have been a tower of strength to his colleagues, and it is impressive testimony to his enthusiasm and dedication that his children all became involved with drawing and painting at an early age. Lucien's seriousness and evident talent, as well as his position as the eldest son in the family, combined to make him Camille Pissarro's favourite child. In 1866, the family (there were then two children) moved to Pontoise, and it settled a few years later in Louveciennes. Then came the Franco-Prussian War. Late in 1870 the family was forced to flee, and – after stopping in Brittany for a while – crossed to London to stay with Pissarro's half-sister.

When they returned, in June 1871, to find their belongings (and Camille's paintings) destroyed, they moved to Osny, near Pontoise, where Camille once again settled down to work. Monet was a frequent caller, and many of the other painters who joined in the impressionist exhibition of 1874 were familiar to young Lucien as they came to seek advice from Camille.

For the next few years, Lucien remained with his family studying and painting, but around 1880 he had to find work. Camille Pissarro, like those other impressionists who were without private incomes, led a life of privation and bitterness in these early years, and matters were not improved by the dissatisfaction of his wife, who nagged him continually to become a better provider for his growing family. To help out, Lucien secured employment at the Paris offices of an English textile firm.

His heart was not in his work, and his employers soon made their displeasure known. But for Lucien, Paris had other delights. He continued with his drawing in the time left after work, sketched scenes of the city, and went to *cafés-concerts* with his closest friend, Louis Hayet, with whom he also visited the galleries and museums.

After a time, Camille Pissarro and his wife decided to have Lucien spend a year abroad in order to learn English and to broaden his horizons. It was arranged that he would stay with an uncle in London. Undoubtedly, Mme Pissarro hoped that the earlier diagnosis of Lucien's lack of aptitude for business was in error, for she was unwilling to see her son waste himself as an artist and starve as his father was doing. Camille Pissarro's motives may have been different; he may well have wished to see Lucien mature away from paternal influence (as Rewald has suggested), but he did not discourage Lucien's artistic inclinations. In January 1883, with a small allowance from home, Lucien departed for England.

At this time began the remarkable series of letters between father and son which reveals much about the correspondents and about the milieu in which they worked. No employment could be found that both gave Lucien the time he wanted for drawing and allowed him to hear English well spoken; therefore, he accepted a job without salary at the music printing establishment of Stanley, Lucas, Weber & Co.

Notwithstanding Mme Pissarro's wishes, both Lucien and his father were determined not to sacrifice art for commerce. Hardly a letter came from the elder Pissarro without an admonition to draw and study. 'Have you been to the National Gallery... and seen the Turners?... Don't let your drawing go, draw a great deal, always from life, and whenever you can look at the Primitives.'

Unfortunately, Lucien felt isolated from proper instruction and from sympathetic painters. All too evident

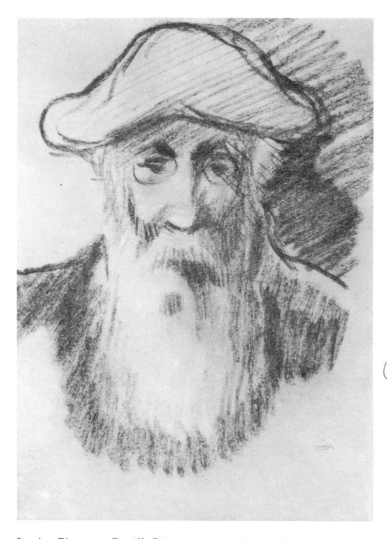

Lucien Pissarro *Camille Pissarro* c. 1892 Red chalk

had led him into error. He questioned whether he was correct in renouncing the niceties of preconceived proportion and fine execution which were so much a part of the academic canon. What had seemed previously to be a desirable naturalism and spontaneity now appeared to be 'rude and rugged execution'. Perhaps this was a consequence of the lack of success he was having in the sale of his paintings, but whatever the cause Camille Pissarro began to search in earnest for a new direction in his art around 1883.

At the same time, he showed an interest (which he soon communicated to Lucien) in becoming involved in the decorative arts, partly on the grounds that this would appeal more directly to a larger public. Another component of the Pissarros' thought at this time was anarchism, not of the active, bomb-hurling variety, but born of a despair with the aristocratic, superficial, stratified society of their time – which also comprised the primary source of art patronage. Both father and son drew for anarchist periodicals, attended political meetings, and felt a great sympathy for the proletarian masses to which they belonged only in economic terms.

After a year in England, Lucien returned to France, this time to live in Paris and work in the plate-making department of the art publishing firm of Manzi. Here was a possibility of learning something that might be of help in earning a living without abandoning art, and though Lucien again failed to make an impact in the commercial world he gained valuable experience in the craft of printing – to which he would return in a few years.

The Pissarros had by now moved to Eragny, midway between Paris and Dieppe, but Lucien had a small flat in Paris at which his father was a frequent visitor. Lucien soon came to know his father's friends in Paris; at the home of one of them, Armand Guillaumin, Camille and Lucien were introduced to Paul Signac in 1885, and through Signac to Georges Seurat. Signac was the interpreter-to-the-world of Seurat's and his own theories of colour and form, and his enthusiasm was infectious. Among Lucien's particular friends at this time, in addition to Hayet, were Félix Fénéon and Théo Van Rysselberghe, and the young men became fascinated with the new techniques and theories to which they were introduced.

Up to this point, it has been impossible to tell the story of Lucien's development without constant reference to his father, so closely dependent was the younger man on the older. Now for the first time a potent outside influence affected Lucien's art, and it seems likely that the

were the Royal Academicians with their 'Greek eyeglasses', and all too difficult to find were studios such as those in Paris where models were available with a minimum of guidance and instruction. Alphonse Legros was then teaching at the Slade School, and was considered and rejected as a possible teacher for Lucien. Finally, Lucien gave up his job, and, following his father's suggestion, used his time for painting out of doors and developing his taste in the museums of London.

While Lucien was searching to find his way in art, his father was becoming troubled about the direction of his own work. He had often spoken of the inspiring search for the ultimate in which he felt himself involved; now he began to wonder whether his whole concept of style

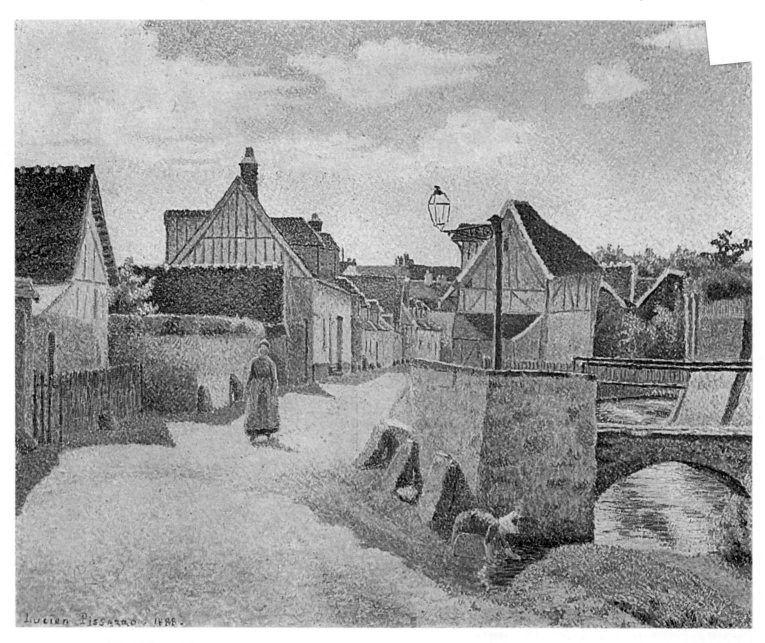

Lucien Pissarro *The Village of Gouvernes* 1888

younger generation served to sustain Camille Pissarro's interest in neo-impressionism once they had been captivated by it. And, of course, Camille responded to these ideas as a possible solution to his own artistic dilemma.

It is not hard to understand why Seurat's and Signac's theories would appeal to Lucien. He had been struggling to evolve a technique of his own; but, beset by uncertainties and inexperience, he found it difficult to harmonize his drawing and his handling of paint. Now the composition could be more carefully constructed in advance; the tricky matter of capturing the 'moment' was given a more scientific basis, and dangerous freedom yielded to more comforting control and predetermination.

Lucien Pissarro *Two Illustrations for 'The Queen of the Fishes'* 1894

Even the drawings of Camille and Lucien Pissarro reflected this new affiliation. Curiously, the technique which was evolved in terms of the translation of the natural sensations of light and colour into paint also provided the artist with a new formal and textural language in black and white. Lucien found he could control variations in value more precisely than he previously had been able to do, and his drawings in the pointillist style

are his first self-assured works. Lucien remained interested in the possibilities of neo-impressionism throughout his life; Camille Pissarro soon abandoned it.

The eighth (and last) impressionist exhibition in 1886 marked Lucien's debut as a painter. The composition of the group had now changed radically, and Seurat's admission was the cause for the defection of several of the original exhibitors; Camille Pissarro's sympathies were with Seurat, and with such younger painters as Lucien and his friends. In addition, Lucien published his first wood-engravings in 1886, and through his artistic activities became friendly with Vincent van Gogh and many of the younger artists in the neo-impressionist group.

As early as 1884, Lucien had decided to try and combine his interest in the arts with a craft which might provide a decent living, and went to Auguste Lepère to learn the rudiments of wood-engraving. Within a year, he had mastered the technique sufficiently to consider the publication of engravings based on his father's drawings, and to submit his work to a literary magazine for use as illustrations. Although Lucien kept up his painting, it became obvious to such people as the critic Fénéon that the prints showed greater originality and command. From then on, Lucien exhibited prints as well as watercolours and paintings at the exhibitions of the Société des Artistes Indépendants (with whom he was a regular exhibitor from August 1886 onwards) and with such societies as Les Vingt in Brussels, Blanc et Noir in Amsterdam, and Les Peintres-Graveurs in Paris.

In November 1890, having meanwhile revisited London, Lucien decided to move to England and try to build a career there. He would teach painting, make some prints, and continue with his own work away from the direct influence of his father. To French eyes, London was a more sympathetic centre for the avant-garde artist than Paris (although the English artists did not always share this view), and the example set by William Morris seemed to indicate that the crafts would find a more satisfactory reception in England than in France.

Lucien arrived with several letters of introduction, one of which put him in touch soon after his arrival with the group around Charles Ricketts and Charles Shannon in Chelsea, which included the artists and writers of the Aesthetic Movement. Here, printmaking was held in high esteem, and the group was much involved with typography and the production of fine books. To them Lucien carried the discoveries of the neo-impressionists about colour and draftsmanship, and from them he learned the principles of book production, and gained a

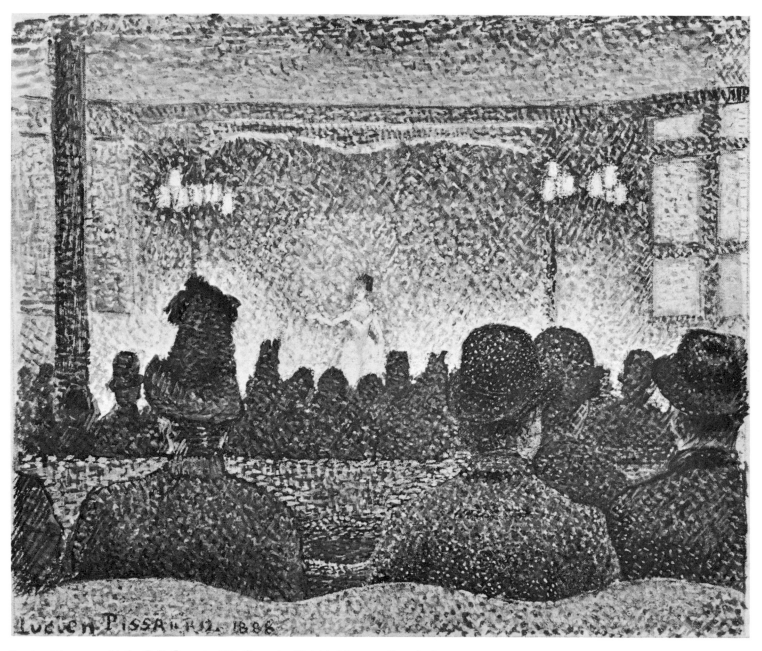

Lucien Pissarro *At the Café-Concert* 1888 Gouache (British Museum, London)

broader historical perspective than was common in his circle in France.

In 1892 he married Esther Bensusan, and she became his collaborator in the execution of the prints and books which now occupied most of his time and attention.

Their first book, *The Queen of the Fishes*, shows how well Lucien could incorporate the divisionist treatment of colour into his wood engravings. The colours are luminous and subtle, and are created by elaborate over-printings of transparent hues; the wood blocks for each colour do not carry solid printing areas but are scored and cross-hatched so that the underlying colours can vibrate through. Lucien's handling of colour, and his ability as an original engraver on wood, gave him a unique position among the private press artists in England. Following the lead of Maurice Denis and the symbolists, he felt that his illustrations should add to the book a 'visible poetry' rather than be literal depictions of the

Lucien Pissarro *Two Illustrations for 'The Queen of the Fishes'* 1894
Four-colour wood engravings

text. His handling of colour always owed much to the neo-impressionists, although for a time after his arrival in England his draughtsmanship lost the direct earthiness he learned from his father and came to resemble the work of the Pre-Raphaelites.

Lucien closed the Eragny Press (as his establishment was called, after his family home) during the First World War, largely as a result of the difficulties which then arose in obtaining materials and labour. Moreover, Lucien found his interest in painting reawakened, and the choice had to be made whether to resume his printing when the war ended or return to his first love in the arts. Lucien chose the latter course.

As early as 1891, shortly after he came to live in England, Lucien had become associated with a group of artists who called themselves the New English Art Club. They were sympathetic to impressionism, and asked Lucien to speak to them about the French artists with whom he was so closely allied. As a result, Lucien became the quasi-official interpreter of the new French art to his English colleagues, and such artists as Sickert and Steer acknowledged his contribution to their art as it developed around the turn of the century.

Camille Pissarro died in 1903. Lucien now began to share his artistic life increasingly with his British friends, and began to exhibit his paintings in London. He showed with the Camden Town and Monarro groups, and in 1913 had his first one-man exhibition at the Carfax Gallery. Lucien painted actively until 1937, when his productivity began to slow. He died in Dorset on 12 July 1944, having become a British citizen in 1916; he had retained his close ties with family and friends in France through frequent visits, until these became impossible with the onset of the Second World War and Lucien's advancing age.

Today his work is surprisingly little known. It was never exciting, and seems tame indeed to anyone familiar with later generations of French artists, but surely his pictures deserve more recognition. His sensitivity for colour harmonies, his considerable gifts as a draughtsman, and the vigorous combination of French and English advanced styles, make Lucien's work particularly interesting – especially his printmaking. His landscape paintings tend to have a dry chalkiness which was the result of the admixture of white (perhaps in response to the quality of diffused light in the English atmosphere), but they are fresh and directly seen; they are given substance by the application of the neo-impressionist principles to which Lucien adhered throughout his career.

Lucien Pissarro *Illustration for 'Deux Contes' by Perrault* 1899 Wood engraving

Lucien Pissarro *Illustration for 'Ballades' by Villon* 1900 Wood engraving

Lucien Pissarro *Goose Girl* Wood engraving

In his prints and his books, Lucien Pissarro was a master of the folk song and the fairy tale. This gentleness reflects much of his character as a person. He was unassuming, even shy, and yet he cared deeply enough about the theoretical basis of his art to argue persuasively for his ideas with his English friends. Although he mastered the English language, he never lost his French accent. He was not a large man, and was somewhat frail in health, but a massive beard gave him a patriarchal appearance later in life, reminiscent of his father. He had many loyal friends in England (although his relationship with Charles Ricketts cooled, after Lucien's marriage, when he could no longer agree with Ricketts's doctrinaire pronouncements on art), and occupied the same house and studio in Hammersmith from 1902 until his death (except for a period of evacuation during the London Blitz). He was an unusually devoted father and husband, and treated both his wife and his daughter Orovida as artist-collaborators. He was, by all accounts, an extraordinarily gentle man.

Lucien Pissarro *Engraving for Christmas card* 1927 Wood engraving

Lucien Pissarro *Illustration for 'La Charrue d'érable'*, Paris 1912 Three-colour wood engraving

Despite this, his beliefs were firmly rooted. He cared very much for the niceties of style, but, unlike the artists of aestheticism, he never strayed from his personal mode of expression (which was deeply rooted in French independent painting) for intellectual or fashionable reasons. He believed deeply in the integration of art and society (joining Fénéon and his father in their anarchist activities), but he never surrendered himself to the visionary medievalism of William Morris. By keeping to

Esther and Lucien Pissarro *Camille Pissarro* 1927 Wood engraving

Apart from his treatment in such standard works as John Rewald's *History of Impressionism* and *Post-Impressionism*, and newspaper notices of his exhibitions, Lucien's work was discussed during his lifetime in articles in such periodicals as the *Zeitschrift für Bildende Kunst* (November 1906), *The Imprint* (London, April 1913), *The Studio* (London, 15 November 1916), *Gazette des Beaux-Arts* (November-December 1919) and *Art et Critique* (March 1892). The correspondence between Lucien and his father has been published by John Rewald in *Camille Pissarro, Lettres à son fils Lucien* (Paris, Albin Michel, 1950), and this remains a major source for the study of the Pissarros' life and ideas.

Alan Fern

Lucien Pissarro *Harvest*, after a drawing by Camille Pissarro Three-colour wood engraving

his own style and working within the confines he set for himself, Lucien Pissarro was able to serve as the advocate of neo-impressionism in England and of the Arts and Crafts movement in France.

His studio catalogue lists more than 340 paintings, almost 390 prints (primarily wood engravings used in the 32 books printed at the Eragny Press) and scores of watercolours and drawings. His widow and daughter have presented a large collection of Lucien's work to the Ashmolean Museum in Oxford, where it joins the work of Camille Pissarro and other members of the family in an impressive collection.

106

Lucien Pissarro *Camille Pissarro* 1906–27 Three-colour wood engraving

Louis Hayet 1864–1940

Life

He was born in Pontoise on 29 August 1864, the fourth child of Calixte Hayet (1831–90) and of Léontine Dufour (1837–1925). His parents, who were first cousins once removed, had married in Pontoise on 1 June 1858. The Hayets were a very old family from Meulan (Seine-et-Oise) ; in the sixteenth century, one of its members was bridgemaster in that town. Calixte Hayet often drew and painted, and those who ha ve seen his works have admired them. He was of an unstable character and a dreamer. He had inherited from his father a firm of 'Painters, Glaziers and Decorators', which employed between ten and sixteen workmen. The business soon deteriorated and, in 1869, he gave it up, to lead from then on a nomadic existence, in ceaseless search of profitable employment. The painter's mother was perpetually pregnant ; in fact, she had sixteen pregnancies, twelve of which reached their term. Eight of her children died in infancy.

In 1870, the Hayets tried, too late, to escape from the Germans to Normandy, and were brought back to Pontoise where they were forced to give billets and food to German soldiers. In the same year their seventh child was born.

In 1877, they were living at Parc-Saint-Maur. The father was earning a living at various obscure jobs, while the mother took in laundry work. Louis Hayet was removed from school at the age of twelve so that he might earn money, and he regretted all his life the education he had missed. He helped his father in various jobs such as taking vegetables to market in a handcart.

In 1878, the year of the Exposition Universelle, the Hayets were at La Queue-en-Brie, then at Joinville-le-Pont. Louis went as an apprentice to a housepainter in Adamville. He had been drawing since he was a small child, and now his father discovered his talent. Calixte Hayet, who had only given him one lesson in drawing, was delighted, and encouraged him by buying him models, busts and watercolours.

That same year, an eleventh child was born, Adrien. For a time, Louis took lessons at the Ecole des Arts Décoratifs, and it was probably there that he learned perspective, at which he was to become so skilful. In 1880, he worked as a signwriter, and followed his parents to Caen, then to Le Havre, where a twelfth child, Paul, was born.

In 1881, among his father's papers, he found some notes about Eugène Chevreul's theories on colour (Calixte Hayet had read Chevreul's treatise), and Louis decided that he wanted to study optical painting. His father refused, as the family was in dire poverty. The years 1881–82 brought the Hayets to the brink of disaster. They had only 2 francs a day to feed five people : father, mother, and three of the surviving four children. 'My teeth chattered with hunger', Louis wrote in his autobiography. In 1882, he travelled to Rouen and looked at the blue Corots in the museum for a long time.

At Pontoise, he roamed around the countryside searching for subjects, drawing or painting in watercolours, and often saw from the distance two painters : one old, with a long white beard, and the other very young. They were Camille Pissarro and his son Lucien. Through mutual friends, the Daurignacs, Hayet was introduced to the Pissarros, and they sometimes painted together.

In 1883, he spent a short time in Le Havre, drawing and painting seascapes. In 1884, Hayet painted many watercolours in Pontoise, then in Paris. His parents decided to return to Argenteuil to work and, in October, Louis was sent to work with Rubé & Chaperon, a firm of decorators. In 1885, Hayet ran into Camille Pissarro in Paris, and a closer friendship soon developed between them. Pissarro introduced him to Cézanne, and in the same year he met Signac.

In 1886, Calixte Hayet was working as a framer, and later made and sold funeral wreaths at Pontoise and in Paris. Louis met Seurat in the shop of Clozet, the art dealer in rue de Châteaudun and, a few days before the eighth exhibition, went with Camille and Lucien Pissarro

Louis Hayet *Paris Boulevard, Evening* 1884 Pen drawing

to 19 rue de Chabrol to look at *La Grande Jatte*, which Seurat had just completed. Hayet gave a strange account of his visit. Camille Pissarro had begged him to exhibit at rue Laffitte, but Hayet obstinately refused. He was, at this time, having arguments with Seurat.

From September 1886 to September 1887, he did his military service in Versailles as a driver in the 1st Regiment of Engineers. On duty in the stables, he very nearly got killed by a mule. This was the period of his close friendship with Lucien Pissarro. Hayet got hold of a little money and rented a studio in Paris.

In 1888, he showed great artistic activity and made several neo-impressionist experiments as well as others. But in 1889, impecunious as ever, he went back to work for Rubé & Chaperon. He was frequenting musical circles, knew Francis Casadesus and painted the portrait

Louis Hayet *Place de la Concorde* 1888

of the well-known cellist Abbiatte. For the first time, he exhibited his works at the Salon des Indépendants, including his *Place de la Concorde*, which many consider to be one of the masterpieces of neo-impressionism, as well as some interesting landscapes. The same year, he completed most of his *Circus* series.

In 1890, he received the great honour of being invited to Les Vingt in Brussels. He then went to Aix-les-Bains with his family and painted mountain landscapes. His father, worn out by poverty, went out of his mind and died on 21 December. Hayet was deeply affected, and finding himself poor as usual, worked for Amable & Gardy, for whom he painted stage sets. He was to come back to them for work on many occasions. In January 1892, he drew in crayons a portrait of Verlaine as illustration for *Liturgies intimes*, published as a de luxe edition by the periodical *Le Saint Graal*. He also worked for Jumau, sign writer and lithographer. He thought a great deal about painting but produced little. In 1893, he painted in Pontoise.

In 1894, he met Paul Fort and Lugné-Poë, creator of the Théâtre de l'Œuvre. In March of the same year, he exhibited two canvases at Le Barc de Boutteville during the sixth exhibition of impressionist and symbolist painters. Later, he was to exhibit another seven times with the group, until December 1897.

At this time, he made a short stay in Algiers and met Charlotte Meister, born in 1873, who became his wife.

In 1895-96, he earned a living by working for Amable & Gardy and for Jumau. His renewed friendship with Lucien Pissarro enabled him to go to London in 1895. In 1897 and 1898, he was painting again, at Mantes. This was an important period in his work, during which he used encaustic in an impressionist manner, solid and structural with traces of optical painting, and many of his works showed signs of 'divisionism'. On 15 January 1899, his only son, Georges, was born. Hayet was working for d'Alesi, a printer-lithographer, and at the same time painting views of Montmartre and of the eighth Arrondissement.

In 1900 and 1901, he travelled around for fifteen months and worked actively in the Alps at Grenoble, in Provence at Avignon and Marseilles, on the Mediterranean Coast at Monaco, Cannes and La Bocca, in Auvergne and the Massif Central, and in the Cantal. Back in Paris, he suddenly lost his inhibitions about exhibiting, and, in 1902, held two exhibitions: one from 3 to 14 April and the other from 19 to 30 November. He did not make use of galleries but sub-rented vacant premises where he hung drawings, watercolours, gouaches, oils and encaustic paintings. His first exhibition was at 42 *bis*, boulevard de Bonne-Nouvelle, in a basement previously occupied by a restaurant which had gone bankrupt. The critic Charles Saunier tells us: 'The floorboards were worm-eaten, and Hayet had nailed some planks from old cases over the more perilous cracks.' In 1903 he held another exhibition, from 19 to 30 November at 19 rue Lamartine, this time in a dairy shop which was to let. He exhibited again in November 1904.

His efforts at commercial success came to nothing; Hayet sold so little that in 1905 he went back to painting stage sets for the appreciative Lugné-Poë at the Théâtre de l'Œuvre. He also had spells as an actor in mime parts.

He now sought refuge in La Frette (Seine-et-Oise) where, on rented space, he erected a prefabricated wooden house with one single room. There he often went to live during the following twenty-five years. Not much is known of these years; he seems to have painted without much success, and his time was mostly spent trying to earn a living. In 1908, 1909 and 1910, he painted rural scenes in the surroundings of La Frette. In 1910, he was at the same time painting stage sets. In 1911 he went to Brittany and executed seascapes at Saint-Malo and Saint-Servan.

During the First World War, he painted mostly views of Paris, as he was to do all his life. After the end of the war, he painted in Rheims in 1922, and in 1924 he wrote his autobiography. His mother died in 1925. From 1925 to 1928, he seems to have painted mostly still-lifes. He was forced to leave his retreat at La Frette in 1929. There still exist several of the rough sketches of Paris streets which he made in 1929, 1930 and 1931 representing Montmartre, the boulevard de Clichy and the Parc Monceau. He liked to paint café terraces, vegetable barrow girls, fairs, etc.

At this time his wife had a house built at Cormeille-en-Parisis. The painter's health was deteriorating, and in 1932 he suffered from very painful asthma. He painted little but wrote a philosophical story, *Kun l'ahuri*, a sort of autobiography, mixed with his views on economics and containing some very original ideas on the evolution of modern society. In 1935, he wrote a very interesting essay on the art of colour combinations, in fact the history of his own experiments in colour orchestration. The same year, his health became much worse; he was now over seventy. He did not paint any longer, but wrote another small treatise, *Des notaires*.

Louis Hayet *Café* 1888 Encaustic on prepared cotton

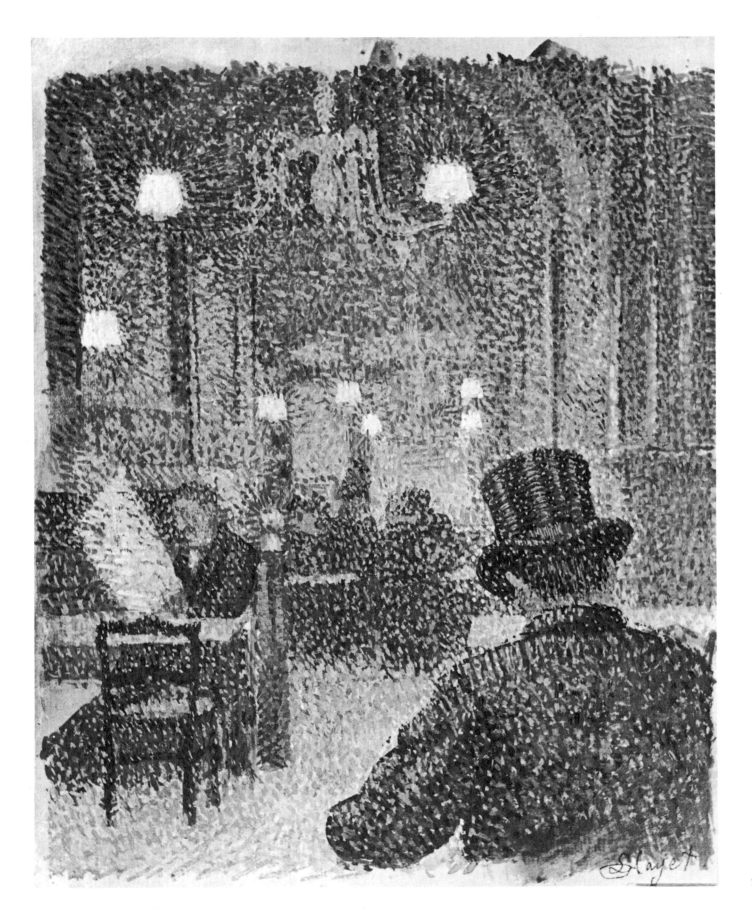

The Second World War affected him deeply. Ill with urinary trouble, he suffered through the first part of the terrible winter of 1940–41, keeping a daily account of events in a home-made diary. He died on 27 December 1940 at Cormeille-en-Parisis, where he was buried in the new cemetery.

Character

The outline given above of Hayet's life reflects its hardships. The Hayet family suffered from the nineteenth-century proletarization which brought the downfall of countless prosperous craftsmen who could not adapt themselves to the changing society and were unable to find a new social status.

This was the background of Hayet's tragedy. His need to create, draw and paint clashed with the necessity to earn a living. He was continuously torn between conflicting activities, and his family suffered from the resulting poverty. Fruitless ventures often took precedence over the well-being of his wife and child.

Physically, he was a tall man, with handsome features. He was reserved, gentle and friendly. This is how Charles Saunier described him : 'Hayet was a tall man of phlegmatic appearance, with a long beard. He managed to earn the barest of livings by working almost regularly for a scene painter. I met him at the composer Gabriel Fabre's sixth-floor apartment in rue Lepic, where all eccentrics used to be welcome. As soon as he entered the room, Hayet would lie down on the carpet, where he would listen to the musician at the piano or discreetly take part in the conversation.'

Like most painters of that period, he was a follower of the anarchist and socialist movements of the 1890s. A great admirer of Louise Michel, he took a very active part in the 'Pain Gratuit' movement, which advocated the distribution of free bread by the state. Social matters occupied him throughout his youth ; he later blamed this preoccupation for his own failure, but it expresses only one of the many peculiarities of his character.

It is, in fact, difficult to explain Hayet's personality without acknowledging in him a certain degree of persecution mania. This manifested itself in a touchy temperament which, at times, made him abandon his friends and withdraw from human society. This feeling became very strong in 1889, when he was only twenty-five ; he quarrelled with Luce over trivial matters which he explained in his autobiography. That same year, he also quarrelled with the Pissarros although Lucien had been his best friend for three years. In 1890, he broke off relations with the Pissarros completely. Lucien had expected Calixte Hayet – who had earned some money – to buy one of his paintings but the deal did not materialize, and his father's refusal gave Hayet a motive for breaking off relations with Pissarro.

This need for solitude is also apparent in the letter which Hayet wrote to Signac at the beginning of the same year in which he announced his wish to break away from the neo-impressionists : 'When I found myself involved in the impressionist movement, I thought they were a group of intelligent people helping each other in their experiments, with pure art as their sole ambition, and this I believed for five years. Then, frictions began to occur frequently and made me reflect. I then realized that what I had erroneously taken for an élite of seekers was, in fact, divided into two camps : one seeking, the other bickering and sowing discord (perhaps unintentionally), with only one aim in mind : the race to success. I have lost all confidence in them and, unable to bear my doubts, I have decided to isolate myself.'

After working for more than thirty years with Lugné-Poë, he also broke with him ; as a result, Hayet's name was not even mentioned in Lugné-Poë's memoirs.

This state of mind greatly affected his attitude towards exhibitions. In spite of Camille Pissarro's pressing exhortations, Hayet refused to exhibit at the eighth exhibition, in May 1886, which was to play such an important role in the history of art. He condescended only to exhibit three paintings at the Indépendants in 1889, and, on invitation, seven works at Les Vingt in Brussels in 1890.

Yet, after the 1889 Indépendants, he exhibited in the basement of a café in rue Gay-Lussac, and eight times, between 1894–97, at Le Barc de Boutteville with the 'surimpressionists' and symbolists.

He had the greatest mistrust for exhibitions. In 1902, when he was for once in the middle of a feverish rush of exhibitions, he was invited by the famous critic Julius Meier-Graefe to show works in Vienna with all the great impressionists and neo-impressionists of the time. At first he accepted, but, regretting his action, he wrote to Gustave Kahn who acted as intermediary and asked him for information concerning the patronage of this exhibition, explaining : 'because life has given me an aim from which I must not deviate by coming into contact with crowds, as this would reduce my individual and *autonomous* efforts to a single unit in a collective mass.' He ended up by withdrawing his paintings. 'I do not very much wish to exhibit my work', he wrote to Kahn, ignoring the contradiction in his behaviour ; he rented

shop premises to show his works, and yet refused a major opportunity to become known by exhibiting in a gallery.

As a result of this isolation, Hayet was, of course, completely forgotten, particularly after the 1914–18 war. He was never included in either the Bénézit dictionary of painters or in Edouard Joseph's. When, in December 1933, the Galerie des Beaux-Arts organized an important exhibition on the theme 'Seurat et ses amis', Raymond Cogniat wrote the following note in the catalogue: 'Little is known about the painter Hayet. He did not lack talent nor sensitivity but he was a strange, secretive person and lived apart from the group, taking part in some exhibitions without, however, being actively involved. Paul Signac, who is well informed on all the artists belonging to the group, has no knowledge of Hayet's present whereabouts.'

Charles Saunier, on a similar occasion, included a biographical note on Hayet, although merely in the catalogue supplement. He also wrote in *Beaux-Arts* of 12 January 1934 an article entitled 'Hayet, peintre inconnu'.

After sinking thus into oblivion, Hayet never attempted to leave his isolation.

Works

Hayet was a precocious painter and a born draughtsman. His first drawings still in existence date from his twelfth year. At fifteen, he drew, in a rather conventional manner, but with talent. Some of his drawings executed in his nineteenth year which have been preserved are very beautiful and individual, such as *Paris Boulevard, Evening* (1884), reproduced here.

The earliest extant watercolours are dated 1883 and possess a very 'Barbizon' feeling: as, for instance, in the one representing the Pissarros painting on the banks of the Oise. These are followed by a long series of watercolours dating from 1884 until the period when Hayet became aware of Seurat's optical painting. Hayet then considered himself essentially a watercolour painter. His works appear at that time impressionist in style, and were without doubt inspired by a technique derived ultimately from Eugène Chevreul by way of Calixte Hayet's notes, which his son read as early as 1881.

In 1902, Hayet himself intimated that during the years 1881–89 he had used harmonies of at first three hues, then five and finally seven. He was, therefore, ideally suited to understand Seurat's experiments. In fact, he explained the meaning of those experiments to the Pissarros and provided them with a great deal of information to be used by journalists after the sensation caused by *La Grande Jatte*.

There is no doubt that Hayet's neo-impressionist period was the best of his career. He produced few large canvases, apart from his famous *Place de la Concorde* (the fate of which is unknown) and a landscape which was very much admired by Camille Pissarro and Félix Fénéon at the Salon des Indépendants in 1889. His neo-impressionist works in encaustic possess extraordinary luminosity and freshness. He painted views of Paris, orchestras, bands, circuses, café scenes, portraits and landscapes. His best series is definitely the circus paintings. In the years 1889–90, he made many colour discs and painted on cotton duck (prepared calico) as well as on tarlatan, searching for the 'coloured orchestration' which was always his aim. His neo-impressionist period also includes watercolours and gouaches.

After 1890, when he had assimilated optical painting, Hayet adopted a more classical mixture of darker colours reminiscent of his watercolours of 1885–86. The subjects were still mostly street scenes in Paris. Between 1895–96, he used a different technique, with thick and greasy paint, rather in the manner of Adolphe Monticelli. Street scenes became heavily impasted, with a textual richness comparable with that found in the paintings of the Marseilles artist.

These interesting and successful experiments did not prevent Hayet from reflecting on optical painting. In 1895, the result of these meditations on 'coloured orchestration' was recorded in four rough sketches under the heading of 'technical essays' or 'geometry of variations in tone and harmony of colours applied in pointillist style'. These experimental sketches are unfortunately lost.

The Monticelli period was followed by the Mantes period (1897–98), much more bare in style. He used either divided hues or a structural impressionist manner in tonalities both muted and brilliant. His very active period of fifteen months in 1900 and 1901 followed the same pattern. Grenoble, Isère, Cannes, La Bocca, Marseilles and Auvergne are depicted in this more neutral style. The Ile-de-France period, on which Gustave Kahn wrote favourable reviews, is in the same style with mostly landscapes and forests.

Later, Hayet adopted an impressionist style which he was never appreciably to alter. His rural views dating from 1908–10, his seascapes of 1911, his views of Paris in 1914–18, are either in light 'divided' hues or in darker

113

Louis Hayet *La Pointe Saint-Eustache, Paris* 1888
Watercolour on prepared cotton

In 1935, he explained the thoughts behind these discs and his intellectual aims. He was searching for a 'coloured orchestration', and the terms he uses to explain the various structures of his discs belong to musicography.

His catalogue of associated hues contains on each page a series of coloured paper strips in pure tones on which are painted dots or strokes of varying sizes in the complementary colour. There are nearly one thousand such combinations. Studying this catalogue, one is reminded of Teodor de Wyzewa's words about Seurat: 'He wanted to know why certain tone combinations produced an impression of sadness, whilst others evoked gaiety, and he had made for himself a kind of catalogue in which each tone was associated with the emotion it expressed.' Hayet's catalogue may have been designed for the same purpose, or it may have served to cover the four points expressed by Signac in his description of the mechanism of neo-impressionist creation: (1) the optical mixing of pure pigments (all the shades of the prism and all tones); (2) the separation of various elements (colour deriving from surroundings or from light, their reactions, etc.); (3) the balance between the colours, and their proportions (according to the laws of contrast, gradation and irradiation); (4) the choice of a touch proportionate to the dimensions of a painting.

This constitutes, however, only a hypothetical assumption.

From the age of four, Hayet had been fascinated by a type of fire screen which represented one landscape in daylight and a different one when lit from behind by the fire. These popular nineteenth-century objects were designed on the pattern of Carmontelle's transparencies and Daguerre's Dioramas. The transparencies invented by Carmontelle well before the Revolution were sometimes fifty feet long, and were painted in gouache on transparent strips of paper 30 cm to 50 cm high (12 to 20 in.). Carmontelle used to paint on a sheet of paper held against a window in order to reproduce, by transparency, the exact tones of a landscape. Daguerre's Dioramas, some of which were as large as 22 × 14 m (70 × 45 ft), were cotton canvases painted on both sides. On one side, the paint had to be very thin in order to keep the transparency of the canvas when lighting it on the other side. The drawing of both sides had to combine and thus preserve the harmony of the landscapes when they were lit alternately from different angles. The landscapes painted on the reverse sides of nineteenth-century dioramas were often painted in pure, prismatic colours.

The memory of these screens probably incited Hayet to paint on semi-transparent cotton, or, even better, on

colourings reminiscent of his watercolours in 1885. After 1930, at the age of seventy, he continued to paint his lively Paris scenes as well as some still-lifes.

During his whole artistic career, Hayet carried out coloured graphic experiments which can be divided into three categories: firstly, colour discs; secondly, a catalogue of associated hues; and, thirdly, painting on prepared cotton.

His first chromatic disc dates from 1887; he made it in ten copies to give to friends, including Camille and Lucien Pissarro, Seurat, Signac and Zandomeneghi. He also gave one copy to Gausson in 1888. One of these discs has been preserved in the John Rewald collection. He made others at various periods, but they too are mostly lost.

tarlatan. Perhaps he painted thus, in watercolour and on a translucent white material, mainly in order to study the effect of the separate hues on grounds of various colours. A few neo-impressionist painters painted on coloured grounds; Luce, for instance, painted several panels on a red background. Obviously, on tarlatan, the optical effect changes completely when the painting is placed against a succession of backgrounds in different pure colours: red, yellow, blue and green.

Whether these were his intentions or not, Hayet did, from as early as 1889, paint in pure tones separated on a white ground. It would be impossible in this summary essay to pass judgment on this aspect of Hayet's work or, without a thorough study of its meaning, to compare it with Seurat's works or Charles Henry's theories. In order to understand Hayet's experiments, it would be necessary to carry out an analysis as detailed and thorough as that which W. I. Homer (1964) has made of Seurat's work. This, therefore, is merely a documentary report on Hayet's activities.

Mention should also be made of his precocious cubist or abstract experiments. He left a series of clouds and skies which would deserve a place in any modern gallery specializing in abstract art. Another series, depicting treetops, was lost in 1943.

Hayet's work presents a very definite 'chemical' aspect, and he mostly used encaustic as a painting medium. A book by Henry Cros and Charles Henry published in 1884 and entitled *L'Encaustique et les autres procédés de peinture chez les anciens*, gave him the idea. In 1889, Théodore Graf exhibited in Paris approximately one hundred works by Greek painters living at the time of the last Egyptian Ptolemies; many of those were painted in encaustic and had retained remarkable freshness.

Hayet always kept at his disposal a laboratory where he dissolved coloured pigments in oils, encaustic, waxes and essences. The various materials which he used could alone constitute a rewarding subject for study. Some of his experiments were unsuccessful, as when, in the years 1905–08, he tried out new substances which, after application, caused the canvases to blacken within a short time. Also, some of his works peeled off and had to be glued back on to the canvases. This was a proof of Hayet's permanent dissatisfaction: in spite of having found a perfect medium in his neo-impressionist works, he went on experimenting with other and inferior substances. His refusal to accept anything without argument is also apparent in the canvas sizes used for his paintings and his studies. Apart from his *Three Landscapes*, which he particularly liked, he rarely used the

Louis Hayet *Elegant Lady*

standard sizes. His works were almost all executed on cardboard, probably in order to achieve the matt effect sought by all painters using pure hues. (By the way, it is criminal to apply varnish to neo-impressionist paintings.)

Quite a few paintings are either on canvas re-mounted on cardboard, or on *feuillart* card as used under the Second Empire. The larger size works were almost all executed on cardboard re-mounted on canvas.

His output followed his moods, either producing prolifically or spending a few years without creating much. His productive periods were 1884–86, 1888–90, 1897–99, 1900–1903, 1909–10, 1924 and 1929–31. There were, therefore, gaps in his work with periods of discouragement succeeding the enthusiasm of creative activity. At an estimate, he produced between 100 and

150 drawings and pastels, only approximately 200 water-colours and gouaches, and between 250 and 300 sketches and small size canvases not exceeding No. 3. Of the sizes 4, 5 and 6, there were not more than 150 to 200 paintings. It is thought that half his works are lost, mostly of the larger sizes.

Perhaps with the growing interest in this painter's life and works, a larger number may be traced eventually.

Hayet's talent was quite well-known in his own life-time, and he was much admired by such important people as Camille Pissarro, Félix Fénéon, Gustave Kahn, Charles Saunier, and Maurice Robin. Fénéon wrote, concerning the fine landscape exhibited at the Indépendants in 1889: 'M. Hayet's third painting is one of the most beautiful yet produced by an impressionist painter and represents the afternoon in a valley divided into cultivated patches, with a tall, leafy tree reaching to a sky of clouds and sun, with a superb foreground. From this first painting, exhibited by M. Hayet, it would be reasonable to expect a series of fine works by him in the future.'

On the other hand, Camille Pissarro in a letter to his son Lucien in 1892 wrote: 'As I left Portier, I was thinking how rare it is to find real painters who really can harmonize two tones. And I thought of Hayet and his complicated ways, of Gauguin with such a good eye for colour, of Signac who also had something, but all of them more or less paralysed by theories...'.

Jean Sutter

Louis Hayet *Peasants in the Fields* Watercolour on prepared cotton

Hippolyte Petitjean 1854–1929

Life

Hippolyte Petitjean was born on 11 September 1854 in Mâcon (Saône-et-Loire), at 48 faubourg de la Barre, to Achille Petitjean and Claudine Renaud. This only child from a third marriage lost count of his half-brothers, all of whom, in accordance with the wishes of their artistic and despotic father, became military bandsmen. Achille Petitjean cut a picturesque figure : poor, working at all hours, he never stopped learning or trying to improve himself. At a very early age, he worked as a two-sou barber and taught himself to read and write. Then he became a postmaster, made string instruments with makeshift tools and played the fiddle at country weddings. He also tried his hand at painting.

Strict with himself and his family, Petitjean felt more benevolent towards his youngest son, Hippolyte, whom he, a widower by then, 'took in hand' when the boy was aged seven. Anti-clerical, anarchist, lone wolf, home tyrant and unrecognized talent, Hippolyte Petitjean was to inherit the best and worst in the character of his intractable father. The image of father and son reading, side by side, with their feet in the oven to fight the severe winter, illustrates well the close relationship between father and youngest son as well as the poverty of the working classes under the Second Empire.

Hippolyte had a hard childhood, and left school at thirteen. He immediately decided to become a painter, and, with encouragement from his father, took evening lessons at the municipal school of drawing after spending the day working hard as an apprentice to a housepainter. His indomitable determination to succeed supported him through a laborious and poverty-stricken adolescence. He did succeed ; in 1872, the city of Mâcon gave him a modest student grant for the Académie des Beaux-Arts in Paris, where he went to Cabanel's studio.

Secretive and shy to the extent that he would go and hide when the master came near him, this eighteen-year-old student already suffered from the 'hunger syndrome' which was to remain with him all his life. He lived in a tiny attic in rue Visconti where, as he was to recall later, his head 'stuck out of the ventilator', and he suffered bitterly from the cold, as he did not possess an overcoat. However, he overcame obstacles and worked relentlessly, both at the Arts Décoratifs and at the Beaux-Arts. There he admired from afar Puvis de Chavannes who was to have a decisive influence on Petitjean's painting.

In 1879, Petitjean, a tall gawky young man of twenty-five, met a very young but determined Parisian girl, Louise-Claire Chardon, aged fifteen. He followed her to her mother, who worked for a chain manufacturer. The painter had found the girl with whom he wanted to share his life. It does not seem to have occurred to them to marry ; they set up house together in small lodgings at 51 boulevard Saint-Jacques. Louise herself had an artistic temperament ; she modelled for the allegorical figures which played an important part in Petitjean's career. The painter also did hourly-paid work for Motte, a well-known architect-decorator. The work did not pay well, as was obvious from many sketchbooks in which the painter used to enter his accounts. Big sums of money and meagre amounts alternate in these notes and reveal the fear of the future.

Pressed by necessity, Petitjean, who was of unsociable temperament, entered the world of art in 1880, exhibiting at the Salon and visiting galleries. In 1884, he met Seurat at Brébant's, rue Laffitte and, in 1886, joined the neo-impressionist movement. In this small circle of supporters of the Indépendants, Petitjean was an exception, and remained faithful to the Salon for many years.

In 1887, he sent to a Stockholm exhibition a large composition, *Agar*, which had already been shown at the 1886 Salon. He later gave it to the Hospice Paris. In 1890, Petitjean's *Compassion* was rejected by the Salon. The artist destroyed the painting on the spot and, turning his back on official hanging committees, joined the Indépendants in 1891 instead. The works he sent for exhibition at last attracted the attention of avant-garde

critics and were awarded two lines in *La Plume*. It seems very little, but it brought this hitherto unknown painter to the attention of art dealers. Already in 1892, he was invited by Le Barc de Boutteville to take part in their first impressionist and symbolist exhibitions in January, August and December. They sold two of his paintings and Petitjean received 121 francs. This was the beginning of Petitjean's career as a professional artist. Apart from those three exhibitions, Petitjean took part in April in the Indépendants as well as in the neo-impressionist exhibition at the Hôtel Brébant, 32 boulevard Poissonnière. His *Bathers* and *Portrait of Jules Antoine*, among others, received very interesting reviews in *La Plume*.

The financial situation improved and the couple rented in the summer a small room at Bièvres (Seine-et-Oise), where Petitjean painted from 1890 to 1894 a series of landscapes, woods, gardens and fountains. Daily food was not such a problem there, thanks to a providential cherry-tree, and Louise provided a staple diet of cherry tarts, which the baker on the ground floor baked for her since the room did not possess the necessary cooking facilities.

In 1893, the painter widened his horizon by exhibiting at the very selective Salon des Vingt in Brussels, then in Mulhouse. But, at the spring exhibition of the Indépendants, he made the common mistake of repeating himself; this time, his *Bathers* attracted bad reviews. Petitjean, during this period, was going through a crisis. He was then forty, and, as an experienced painter, was contemplating the possibilities of escaping from scientific impressionism. He quarrelled with Signac at the opening, on 15 December, of the neo-impressionist gallery in the rue Laffitte, the 'Boutique 94', where he was exhibiting portraits, nudes and landscapes. The quarrel became more serious one day when Petitjean, looking admiringly at a painting by Monet, exclaimed: 'It flattens you!'

Hippolyte Petitjean *Nude Studies*

Hippolyte Petitjean *Women in a Landscape*

Signac took this as a remark directed at himself, and became so angry that the two painters parted company for ever. This left Petitjean in even greater isolation.

The convivial neo-impressionists never came to visit him, because he would never drink with them. He rarely went to Indépendants' dinners, and he was painfully aware of his chronic poverty and their relative affluence. Seurat and Signac came from comfortable backgrounds, and Cross and Angrand too had some income of their own. Petitjean naturally felt more drawn towards the equally poor Pissarro, the proletarian Luce and the kind and tactful Dubois-Pillet; but even so he only met them at exhibitions. His only bond with the neo-impressionist movement lay in the shared affinity for revolutionary ethics affecting both life and art.

His unsociable nature hindered him in his relationships. Unlike Luce, for instance, he never adhered to the extremist party, nor did he ever produce illustrations for *Le Père*

Peinard, the anarchist publication, although he was on good terms with its editor, Emile Pouget. His secretive nature made him an outsider, even at the Indépendants, to whom he gave 'twice the same portrait of the same woman, exquisitely...' (*La Plume*, 1 June 1894).

To celebrate the number of years they had lived together, the Petitjeans went to be photographed: he, with a black beard and wearing a cravat, was about a head taller than his companion, although she stood on a stool. On 10 April 1894, they had a daughter, Marcelle, whose birth upset further a budget which was precariously dependent upon the sales of paintings at the Boutique 94. In a notebook carefully kept up to date from 1886 until his death, Petitjean recorded the history of his works, of which 236 were accounted for meticulously with such remarks as: 'sold' or 'given in lieu of payment', 'given away as present in return for help', or 'exchanged' against something indispensable. In 1895, he made a profit of 50 francs; in 1896, it increased to 300 francs.

In 1897, there was no sale; this might have been caused by intrigue. The painter had left the Indépendants for the Salon, where he was to exhibit until 1901.

From 1898 onwards, however, his luck changed and the City of Paris made him a teacher of drawing at the Ecole Complémentaire in rue de Patay, as well as at evening classes in rue du Moulin-des-Prés in the 13th Arrondissement. This was an eventful year, when the painter and his family left Faubourg Saint-Jacques to live near the Parc Montsouris in a little house they rented from the writer Charles Albert, also known as Daudet. The same year, Petitjean was invited to La Libre Esthétique in Brussels, to the Berlin exhibition, and then to the Salon and Groupe Indépendant des XIX in Paris. There he exhibited his first views of Verchizeuil (Mâcon) where, until 1901, he and his family went in the summer to stay with a childhood friend.

In March 1899, an important exhibition of neo-impressionists took place at Durand-Ruel, with works from all the painters of Boutique 94, now closed. The event was reported in the *Revue Blanche* under the title 'A landmark in the history of French painting'. The article had some effect, and Petitjean, who had only been given mild praise in it, nevertheless made 2700 francs from the sale of his paintings.

In 1900 he exhibited at the Exposition Décennale, and in 1901 he returned to the Indépendants with a *View from the Studio Window* and a *Parc Montsouris-Observatoire*. He then took his family for the summer to Banyuls, where the sculptor Maillol's sister had a house. There he painted a series of landscapes which were successively exhibited at the Indépendants in 1902 and at the Douai exhibition, in which Petitjean was to take part every year until 1905.

The year 1903 was favourable as far as his artistic activities were concerned, and he exhibited in Mâcon and in Weimar. But his private life was not so satisfactory. Petitjean, on one of his walks in the park, had conceived the idea of having a house built in the surrounding waste ground, and he said to an old friend from the Beaux-Arts, the architect Duret: 'Build me a hut.' The latter, however, protested that 'it should be something nice', and had his way. Petitjean found himself having to borrow money, and was assailed by the fear that he might die leaving debts to Louise and Marcelle. The future worried him so much that he made life a misery for his wife and daughter, cutting all domestic expenses to a minimum, cancelling holidays and sharing one apple between three. He decided to marry Louise, so that she might benefit from a new law protecting civil

Hippolyte Petitjean *Woman Sewing*

Hippolyte Petitjean *The Seine at Mantes*

Hippolyte Petitjean *Girl reading* Watercolour

– sold to X for 380 francs interest', and one *View of Notre-Dame* 'to X, in lieu of payment on account'. Other works were simply given away, or were entered in the book as, for instance, 'payment for Louise's and Marcelle's bicycle : one framed sketch'. In spite of these privations, the artist was nevertheless working actively and painting scenes remarkable for their richness of execution and their underlying pride. They were the portraits of his wife and daughter in 1903, his self-portrait in 1904, *Summer* in 1906–07 and *Spring* and *Autumn* in 1907–08. The first three of these huge compositions, destined for the dining-room walls, were exhibited at the Indépendants and then re-mounted. *Winter* was painted directly on the wall.

The 1909 Indépendants brought relative affluence to Petitjean. His *Nude Figure* was bought by the state, and a copy was later made for a collector in Moscow. In 1910, *Parc Montsouris* was sold to the Mâcon museum. Now that conditions were better, the Petitjeans, went on holiday to an inn at Donzy-le-Perthuis, about five miles from Cluny, and a series of landscapes was done there between 1911 and 1918.

The Petitjean family was now sometimes seen in the cheapest seats at the Odéon or at the Théâtre Antoine, at the Concerts Colonne and the Concert Rouge. Petitjean had an eclectic taste in music, with a preference for Handel, Bach and Beethoven. Both polyphonic discipline and romantic sentiment appealed to his tormented desire for the absolute.

In 1912, the brutal realities of life once more struck Petitjean. He had left most of his recent paintings with a certain Pétavy, the dishonest head of a gallery in rue Bonaparte, in exchange for a meaningless contract which left him with only two landscapes for the Mâcon exhibition. He had not only sacrificed the Indépendants' exhibition but had lost fifteen months' work, apart from 3,000 francs in gold.

Aged sixty, Petitjean now started afresh and, the following year, 1913, stayed for two months in Holland with his wife and daughter. He was represented again at the Indépendants with, among other paintings, a self-portrait. In 1914, he had reached retirement age as a teacher, and was recalled to the colours on the outbreak of war. This enabled Petitjean to settle his debt at last with his demobilization gratuity, without, however, erasing his obsession with the accursed bricks and mortar which represented his capitulation to the conventional way of life. He was, after all, a champion of free love, a proletarian and a bohemian. The anarchist who had become a bourgeois came to doubt his own beliefs, and

servants' widows and children. He was then fifty and Louise forty; Marcelle was nine. This bohemian wedding took place in 1904 at the town hall of the 14th Arrondissement. As the Petitjeans were so short of money, the celebrations were not held in their own new house at 26 rue Nansouty, but at the house of one of the witnesses, Daniel de Monfreid, together with their friend Luce, the second witness. The latter apparently drank excessively on this occasion, to the great disgust of the abstemious bridegroom.

Petitjean became more and even more obsessed and depressed, and the new house seemed to bring bad luck. Certainly the sales between 1903 and 1909 decreased abruptly and only two paintings were sold, and these went to a creditor. The account book recorded : 'No. 110

Hippolyte Petitjean
Nude Watercolour

123

the artist began to suspect the validity of his creative work. From 1917 onwards, his production slowed down considerably. This was the period when he reflected deeply on the idea he had had twenty years earlier: 'The conception of a synthesis combining divisionism and impressionism'. In 1919, at the age of sixty-five, Petitjean finally decided to abandon the plastic values which had ruled him since 1886 and adopted, under impressionist outward appearances, a means of expression free from empty of substance. He could never compare with Pissarro, but the merit of his work as a whole was sufficient to be recognized both in France and abroad during the painter's lifetime. His works were exhibited at Wiesbaden in 1921, at the retrospective exhibition of

the Indépendants in 1926, at the retrospective neo-impressionist show in Lyons in 1927 and at the Franco-Belgian exhibition in 1928. That year, one lot of paintings by Petitjean, dating 1919–26, was sold by Moline, the intermediary agent for the neo-impressionists, for 10,000 francs.

1929 was Petitjean's last year, and was successful. He was by then seventy-five. From 4 to 18 May he exhibited 28 works at the Galerie Eugène Blot, and a *Portrait of Louise (full length)* dated 1893–94 was bought officially by the Musée du Luxembourg in Paris. This was the consecration of a long career and marked the advent of a relative prosperity which Petitjean did not live long to enjoy. In June, after attending to the hanging of his *Morning* at Saint-Ouen, the old man was admitted into the Necker hospital suffering from a prostate infection. In order to forget his illness, he made sketches in small books. His death in the morning of 18 September prevented him from bringing up to date his 'logbook' and, under a discoloured inscription of an *Idyll* dated 1911, an entry in fresh ink of the day before his death read: 'Re-done in dots in 1929: No. 237'. This catalogue thus ended after listing the details of 236 paintings. After many experiments, this artist had painted his last work 'in dots', having never really relinquished neo-impressionist theories.

Lily Bazalgette

Works

Apart from the paintings listed in his 'logbook', Petitjean painted innumerable study panels as well as approximately 200 watercolours mostly in pointillist style, and probably over 1,500 drawings and sketches. On the façade of his newly-built house in Parc Montsouris, Petitjean had inscribed the names of his favourite painters: Ingres, Puvis de Chavannes and Millet. It was doubtless Puvis de Chavannes who had the deepest influence on Petitjean's works.

It is worth noting that the influence of the master of Lyons extended to most painters in the second half of the nineteenth century, from Beaux-Arts students to neo-impressionists. To quote a few among them, Seurat and his friends Aman-Jean, Osbert, Laurent, Séon and even Signac were influenced by Puvis de Chavannes, as well as a great number of symbolists and *roses-croix*. Some of them soon developed their own individual style; others permanently adopted his.

Petitjean was so impressed by Puvis de Chavannes'

124 Hippolyte Petitjean *Head of Woman*

Signac

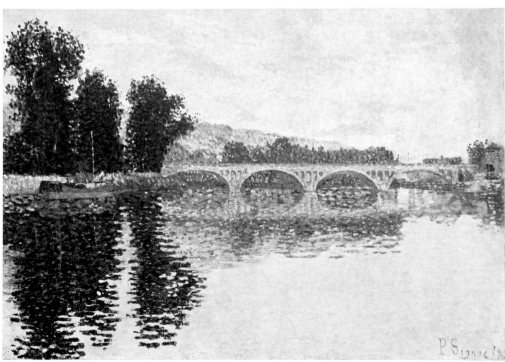

Paul Signac *Portrieux Harbour* 1888

Paul Signac *The Bridge* 1886

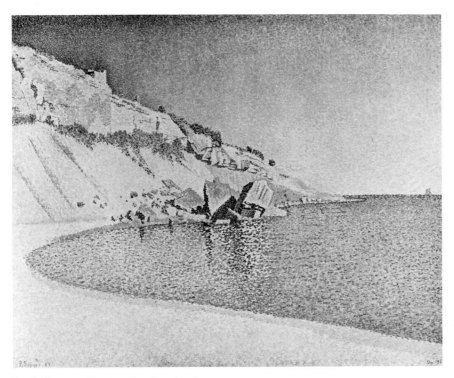

Paul Signac *Cassis: Cap Lombard* 1889

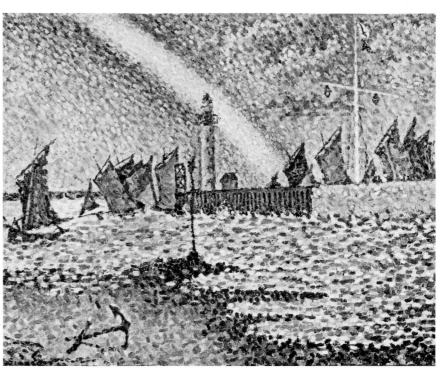

Paul Signac *Rainbow, Breton Harbour* 1893

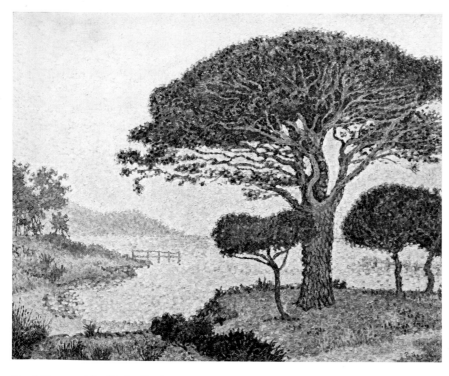

Paul Signac *The Umbrella Pine* 1897

Paul Signac *The Yellow Sail, Venice* 1904

Paul Signac *Les Andelys*

Paul Signac *Brig at Marseilles*

Paul Signac *The Papal Palace at Avignon* 1909

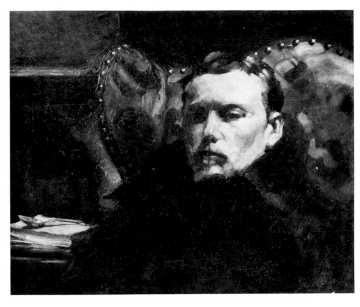

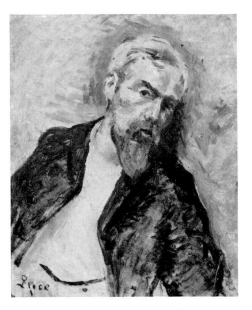

Henri Edmond Cross *Convalescent : Self-portrait c.* 1882–85

Maximilien Luce *Cross c.* 1905

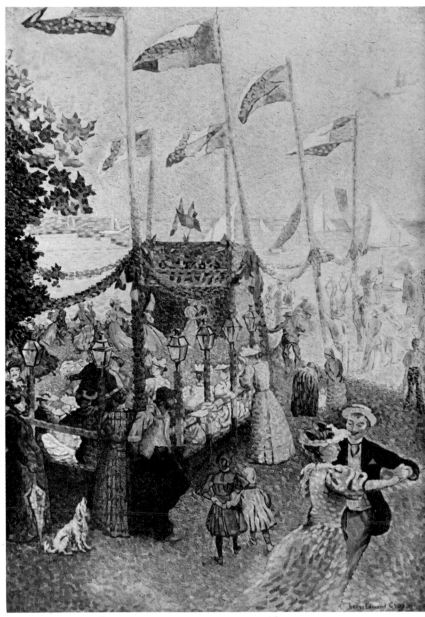

Henri Edmond Cross *Portrait of Mme Cross* 1891

Henri Edmond Cross *Village Dance in the Var* 1896

Henri Edmond Cross *Calanque des Antibois* 1892

129

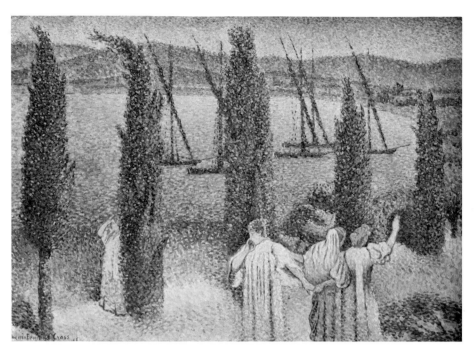

Henri Edmond Cross *Nocturne* 1896

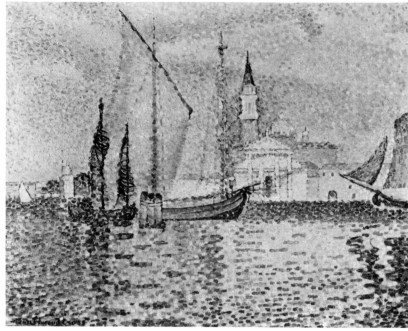

Henri Edmond Cross *San Giorgio Maggiore, Venice* 1904

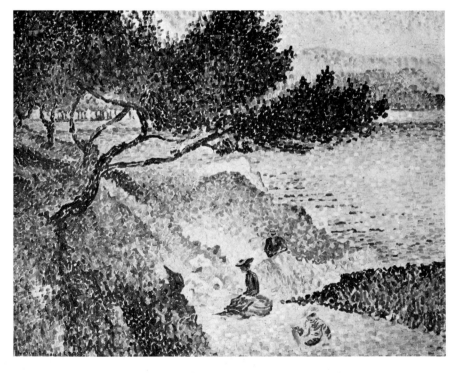

Henri Edmond Cross *The Bay of Cavalière* 1906

Henri Edmond Cross *The Forest* 1906

Henri Edmond Cross *Landscape at Bormes* 1907

Henri Edmond Cross *Santa Maria degli Angeli* 1909

Henri Edmond Cross *The Beach of La Vignasse* 1891–92

Henri Edmond Cross *Afternoon at Pardigon* 1907

Angrand

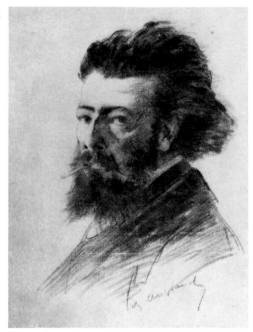

Charles Angrand *Self-portrait* c.1885

Charles Angrand, c.1925

132 Charles Angrand *The Parasol* 1881

Charles Angrand *Couple in the Street* 1887

Charles Angrand *The Ile des Ravageurs* 1886

Charles Angrand *The Little Farm* c. 1890

Charles Angrand *Study in the Bois de Boulogne* 1888

Charles Angrand *Scene on a Norman Sharecropper's Farm* 1890

Charles Angrand *The Bowl of Milk* 1908

Dubois-Pillet

Albert Dubois-Pillet
The Seine, Paris c. 1889

Albert Dubois-Pillet
Cliffs at Yport 1888

Albert Dubois-Pillet *The Wash-boat at the Pont de Charenton* 1886–87

Albert Dubois-Pillet *The Dead Child* 1881

Albert Dubois-Pillet *Paris: the Seine at the Quai Saint-Bernard* 1885

Albert Dubois-Pillet *Rouen: the Seine and the Canteleu Hills* 1888

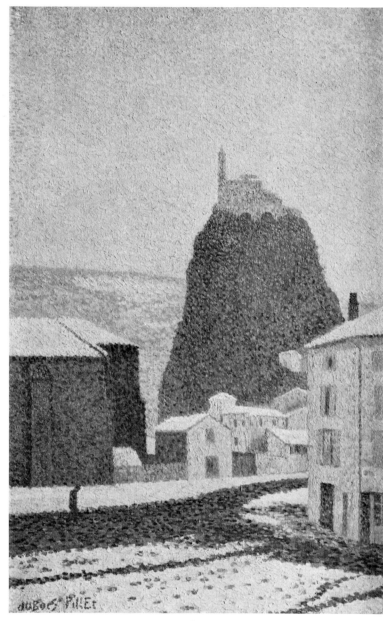

Albert Dubois-Pillet *Portrait of Mlle M.D.* 1886 Albert Dubois-Pillet *Le Puy: Saint-Michel-d'Aiguilhe* 1890

Lucien Pissarro

Lucien Pissarro *Eragny Church* 1887

Lucien Pissarro *The Garden* c. 1889

138

Lucien Pissarro *The Crowning of Esther* c. 1896

Lucien Pissarro *Eragny Church* 1886

Lucien Pissarro *Woman sewing* 1886

L. Pissarro *Rue Saint-Vincent, Winter Sunlight* 1889–90

Hayet

Louis Hayet *Self-portrait c.*1910–14

Louis Hayet, *c.*1930

Louis Hayet *The Building of the Eiffel Tower* 1887

Louis Hayet *Camille and Lucien Pissarro painting by the River Oise* 1883

Louis Hayet *The Doors* 1889

L. Hayet *The Market* 1889

Louis Hayet *Paris Street Scene* 1889

Louis Hayet *The Tumbrils* 1889

Louis Hayet *The Little Girls, London* 1895 ('Monticelli period')

Louis Hayet *Paris, Coster Women* 1924

Petitjean

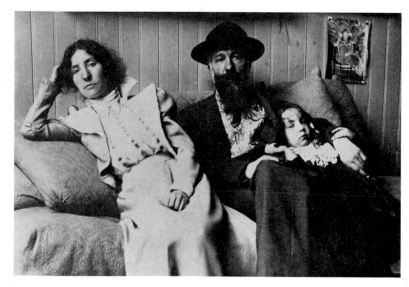

Hippolyte Petitjean, wife Louise and daughter Marcelle, *c.* 1900
Photograph

Hippolyte Petitjean *Nude* 1907

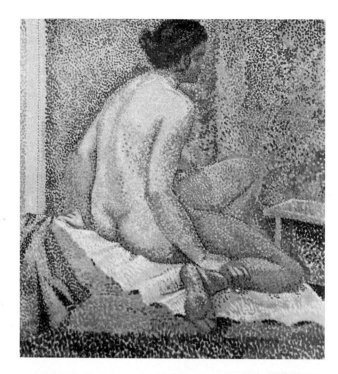

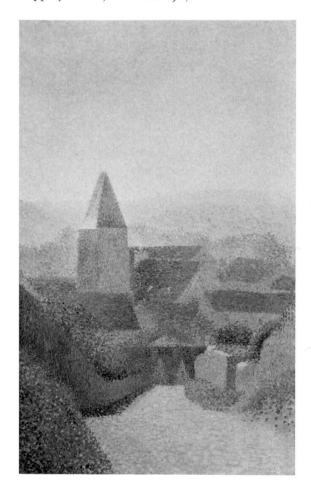

Hippolyte Petitjean *The Village* 1893

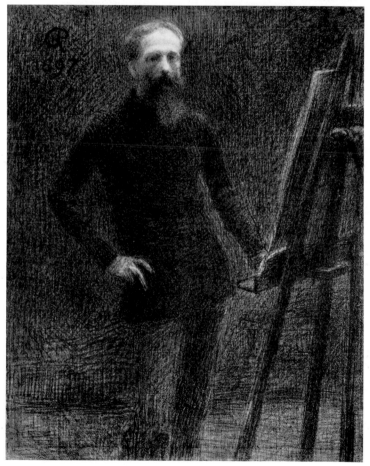

Hippolyte Petitjean *The Artist at his Easel* 1897

143

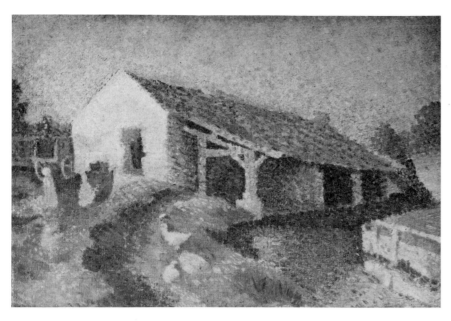

Hippolyte Petitjean *Wash-house by the River Bièvre* 1891–92

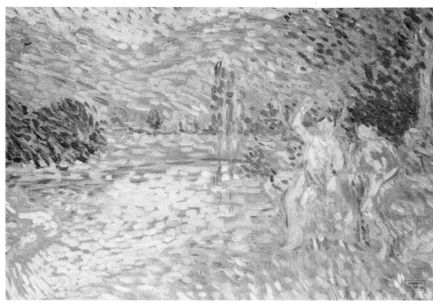

Hippolyte Petitjean *The Bathers*

Hippolyte Petitjean *Mâcon : View of the Main Bridge* 1870

Hippolyte Petitjean *Flower-gathering* 1913

Hippolyte Petitjean *Landscape* Watercolour

drawing and his sense of composition that he even copies the latter's choice of subjects, such as Daphnis and Chloë, Hesiod and his Muses, pastoral scenes, eclogues, bathers, harvests and seasons.

He was very aware of this influence but, although he wanted to break away, he found it very difficult to evolve his own individual style. The same applied to neo-impressionist technique.

Alternately ruled by Puvis and by optical painting, alternately rebellious and contemptuous of his masters, Petitjean illustrates clearly the problem created by the art of painting when subjected to literary tendencies.

He seems to have slightly drawn away from Puvis in his neo-impressionist watercolours which did not come to light until 1955. All executed in pointillist style, they reveal a very individual side of his talent which fully justifies the collectors' interest in them.

Petitjean's main claim to fame, however, lies in his drawings, which have unfortunately never been exhibited on their own. He was among the best draughtsmen of his generation, and in fact spent more time drawing than painting. Again, Puvis's influence can be felt in some of the drawings but the critic Maurice Robin aptly described the others in the phrase: 'Petitjean has a delicacy of

145

touch which relates him to Prud'hon and Fantin-Latour.'

In the works where the literary leaning is absent, Petitjean reveals great talent as a watercolourist, draughtsman and painter, irrespective of whether his works are in divisionist style. His *Notre-Dame de Paris*, and *Village in Burgundy* offer proof of this statement and certainly rank among the finest works of the neo-impressionist school.

Critics who were most consistent in their praise of Petitjean included such well-known names as Charles Saunier, Jules Antoine, Adolphe Dervaux, Henri Eon, Thadée Natanson, Yvanhoé Rambosson and Gustave Coquiot. The last-named aptly expressed the general opinion in the notice he wrote about the painter in his book *Les Indépendants* (1920), when he said : 'In the phalanx of neo-impressionists, M. Petitjean ranks very high. He is best known for his bathers, of pure classical style, and for his vividly coloured landscapes. His bathers were often set against the background of Parc Montsouris where he would seek solitude and work painstakingly to express his rare talent.'

Jean Sutter

Hippolyte Petitjean *Landscape* Watercolour

THE LAGNY-SUR-MARNE GROUP

At the time of the Second Empire, Antonio Cortés (1826–1908), a Spanish painter born in Seville, came to France for an international exhibition. He married and lived in Paris where his son André was born in 1866, but his wife died in 1870. He married again and settled at Lagny-sur-Marne (Seine-et-Marne), about thirty kilometres (twenty miles) east of Paris. Two children were born of his second marriage: Jeanne (1874–1954) and Edouard, born in 1882, All the members of the Cortés family were painters. Antonio painted rural subjects such as harvest and haymaking, horses drinking and farm animals. André, who died aged 33, painted horses; Jeanne painted farmyard scenes. Edouard Cortés is well known for his scenes of Paris in 1900, with its flower markets, its carriages, and its grey dusks illuminated by yellow gaslight.

The famous engraver Eugène Froment, who was born in 1844 in Sens and died in 1916, had lived in Lagny before the 1870 war. He started an engraving business in rue Saint-Jacques in Paris, and engraved on wood, illustrating catalogues, fashion magazines and various publications. Of the Froment family, the daughter died of diphtheria in 1870 and three of the sons died in infancy. Of the remaining children, Albert became a tradesman, Maurice a lithographer and Emile a successful engraver (1866–1928). The family lived at Le Bois-de-Chigny, close to Lagny but within the commune of Montévrain.

The Froment and Cortés families were friends and Léo Gausson, the young son of an old Lagny family, knew them and often visited Eugène Froment at his Paris workshop; there, in 1876, he made the acquaintance of two other wood-engravers, Cavallo-Péduzzi and Luce.

Cavallo-Péduzzi settled in Lagny in 1880 after his marriage and became a friend of the Froment, Cortés and Gausson group. Until 1901, Luce frequently visited Lagny to stay with Mme Gausson who always welcomed him (Léo's father had died in 1874).

In the course of the years, the small town in Seine-et-Marne became a centre of artistic activity. Charles Jacque and his sons, Edmond Aman-Jean, Henri Lebasque, Henri-George Ibels, Edmond-Marie Honer, Camille and Lucien Pissarro and Louis Hayet, among others, were all working in the vicinity of Lagny. Writers and critics, such as Adolphe Retté, also came to visit the group. Léon Bloy, although living in Lagny, kept himself apart from the others.

From 1883 onwards, the new process of photographic reproduction, process engraving, began to put wood-engravers out of work. Eugène Froment, after being very prosperous, faced bankruptcy and was forced to close down in 1886.

Although records are missing, it was certainly Cavallo-Péduzzi who kept Gausson and Luce aware of Seurat's experiments in painting. Cavallo-Péduzzi's painting *Les Trois Malins du Pays* (*The Three Local Characters*) dates from the summer of 1885. Cavallo-Péduzzi was a student at the Beaux-Arts at the same time as Seurat, and, although they worked in different studios, it is obvious from drawings of that period that they sometimes used the same models.

In 1885 and 1886, Luce stayed for long periods at Lagny and painted panels in divided, if not complementary, tones on a minium ground. These were most probably painted in Carolus Duran's studio where Luce is known to have worked until the end of 1885. There are also experimental paintings by Gausson dating from the same period.

In 1886, the three friends perfected their individual techniques after the style of Seurat and worked prolifically, experimenting with very interesting results. Gausson painted on white backgrounds, on calico. Cavallo-Péduzzi produced canvases and watercolours in pure tones, already precursors of the Fauve feeling. Luce created a sensation when he exhibited a number of his works at the Indépendants in 1887.

Mme Seurat presented Cavallo-Péduzzi with a sketch of *La Grande Jatte*, in memory of her dead son. The

painter thanked her in a letter which proves that he knew the Seurat family.

These pioneers of neo-impressionism could not pass without mention in this book.

148 Cavallo-Péduzzi *Knacker's Yard at Carnetin: Dead Horse* Charcoal

Cavallo-Péduzzi 1851–1917

Emile-Gustave Péduzzi, who later gave himself the name of Cavallo-Péduzzi, was born in Paris on 15 July 1851, 1851, at 103 rue Saint-Lazare. He was an illegitimate child, and it was not until 1859 that his mother, Anne Péduzzi, an actress born in Metz in 1832, recognized him as her son. Later on in life, Cavallo-Péduzzi was to maintain – without any proof – that he was descended from an old Italian family of Counts. Although Anne Péduzzi's tumultuous life was hardly conducive to the establishment of a settled home, a daughter Léonie was also born. Nothing is known about Emile-Gustave's early years, which were probably spent first in a foster family and then at boarding-school. He inherited from his mother an exuberant and impulsive temperament. At the age of about fifteen, he was sent as apprentice to a hatmaker in London, but the future painter disliked both the work and the country, the latter more particularly as he could not bear the meals consisting of potatoes and beer. His knowledge of the English language was the only useful result of his stay abroad.

His return to France coincided with the outbreak of the Franco-Prussian War in 1870, and he became a corporal in the fire brigade of the 2nd Arrondissement, where he carried out his duty during the siege of Paris. Between 18 March and 4 June 1871, he was in charge of two pumps and used one of them to extinguish the fires lit by the Commune rebels.

In 1873, Péduzzi, suffering from a haemorrhage, was hospitalized at La Maison-Dubois, and from this time dates his love of drawing, to which he had already felt attracted in England. During the following years he led the life of an artist, with financial support from his mother. Between 1875 and 1880, while living at 11 rue Girardon, he studied at the Beaux-Arts and frequented the studio of Léon Gérôme (1824–1904). Three times he tried, unsuccessfully, to obtain the Prix de Rome.

At the beginning of 1880, Anne Péduzzi died in the South. Her property in Croissy-sur-Seine and her apartment in rue Gluck contained furniture, objets d'art, silver and diamonds which were sold in May 1880 at the Hôtel Drouot. The inheritance enabled Cavallo-Péduzzi to marry, on 19 July, at the registry office of the 17th Arrondissement, Marie-Louise Baloffe, dressmaker, born in Clichy on 28 October 1856. She was to be a loving and devoted companion to the artist, and supported him loyally during difficult times.

After a few months in Auvers-sur-Oise, the couple moved to Lagny-sur-Marne in November 1880. Four children were born: René Emile (1881), who died aged a few months, Rita Charlotte (1882–84), René Emile Cavallo (1886–1951) and Rita Emilie Charlotte (1889–1968).

According to the marriage contract, Cavallo-Péduzzi brought to his wife 100,000 francs from his mother's estate. This legacy was to shrink gradually in the course of the years until it disappeared completely in the Panama shares and the Franco-Russian loan. The generous hospitality which the couple extended to any friend also helped them on their way towards eventual penury.

Cavallo-Péduzzi, who had probably become acquainted with Eugène Froment in Lagny, worked in Froment's workshop as an engraver, at the same time pursuing his own vocation. A drawing dated 1873 and a self-portrait in oils of a slightly later date are his earliest known works. He joined the Groupe des Artistes Indépendants when it was founded, and in 1884 exhibited works at the first exhibition of the Groupe, and at the first Salon of the Société. Over the years 1886–89, 1891–93, 1895 and 1903, he was to send in sixty-two works. In 1891, he took part in the first symbolist Salon at Le Barc de Boutteville. Then, in 1896, at the *Petite Revue Documentaire*, in passage des Princes, he exhibited sixty-seven paintings, watercolours, pastels, drawings and etchings.

He now became more closely interested in Lagny, where he centred his activites. In 1899, the Union Artistique et Littéraire du Canton de Lagny was created under the direction of Honer, ex-president of the Société des

Artistes Indépendants. Cavallo-Péduzzi became a member, together with many artists living in the district. That same year, the first exhibition of paintings took place at Lagny, to be followed by shows in 1900, 1901, 1902 and 1904. These were organized by the indefatigable Cavallo-Péduzzi, who also sent in about fifty of his own works. Not only local painters took part in these shows ; other exhibitors included Aman-Jean, Colin, Forain, Eugène and Emile Froment, Gausson, Honer, Ibels, Lebasque, Lhermitte and Luce.

Unfortunately, this prosperity was short-lived, and in 1907 the Union Artistique ceased to exist. Cavallo-Péduzzi's name was amongst the signatures on the Society's final report.

At the turn of the century, Cavallo-Péduzzi wrote a detailed history of his adopted home, inspired by the ancient monuments of Lagny which he defended with passionate energy against vandalism. He wrote many articles in the local press, based on a deep archaeological knowledge which earned him public respect and esteem.

Cavallo-Péduzzi's financial difficulties forced him, after 1900, to find employment. He became a representative in Lagny for a body known as the Ligue Commerciale et Industrielle pour l'amélioration des transports en chemin de fer. The director of the Ecole d'Alembert in Montévrain, who was a cousin of Hayet, engaged him as a teacher of decorative drawing, and there he taught six hours a week until 1911. Other sources of income were provided by private drawing lessons, either in his own studio or at his pupils' homes, and by the publication of etchings, postcards and writing-paper reproducing his works. At the Concours Lépine in 1910, he was awarded a gold medal for his invention of a 'universal articulated tripod with its own triptych table'.

In September 1914, he was official interpreter for the British Forces stationed in Lagny. He also selflessly worked in the Groupement des Consommateurs which had to deal with difficult problems in connection with food supplies.

When nearly sixty, an attack of asthma forced Cavallo-Péduzzi to retire to his bed, and he died on 29 April 1917 at his house on the Tournan road. The funeral on 1 May was attended by large crowds who followed his coffin to the Lagny cemetery. His widow survived him until 1939.

Appearance and character

An old photograph shows us Cavallo-Péduzzi, with his dog, looking young and bohemian, but dressed with care. However, in 1900, while he was living in Lagny, his appearance was different. He cut a very colourful figure, clad in a thick-ribbed corduroy suit under a huge cape, a loose cravat round his neck, heavy wooden clogs on his feet and wearing a felt or straw wide-brimmed hat with a rather pointed crown. The painter was never without his walking-stick, curiously carved out of a hawthorn branch surmounted by a crow's skull polished smooth through use.

Cavallo-Péduzzi was a small, slight man, with intelligent and mischievous eyes glinting in his thin long face, a bristling goatee, curly hair and a rather large nose.

His feelings were usually uninhibited and his gestures unrestrained. His voice carried far and he knew how to make use of it for best effect, never too shy to expound his ideas in public whether in the street, in a café or even on a train. When travelling by rail with his wife, although she used to forbid him any conversation, the whole carriage would soon be filled with his loud voice. In Lagny, he had spectacular arguments with the Municipal Council and reported these himself in the local press. His views on the matter of the town's monuments and coats of arms were fierce, inflexible and, at times, unreasonable. This probably explained why his proposals to counsellors were often ignored. 'They are like the dogs in the Bible,' he would say, 'for ever returning to their own vomit.'

Like his colleague Gausson, Cavallo-Péduzzi was a tireless walker, for ever searching the outskirts of Lagny for subjects to paint or draw. In his youth, he often made trips to Auvers-sur-Oise, Concarneau, Le Havre, Nice and elsewhere, but towards the end of his life he hardly left Lagny and his comfortable simple home life, with his wife and children whom he adored and of whom he painted many portraits. On his trips to Paris, he always sent postcards to his daughter Rita, and he designed her costumes for fancy-dress parties.

His library was not extensive but he had a fine collection of stamps. He loved nature, particularly trees and animals. He had two dogs, Faro and Bismarck, and his donkey Bazaine carried his painting equipment on his trips around the countryside. The names of his pets were illustrative of a sense of humour which could be very caustic at times. At the municipal elections in 1904, he published a mock announcement reporting the death of an old fountain (which had been demolished the previous year) and signed himself 'Cavalli-Péduzzo, almost first cousin'.

His studio was a very popular meeting place for his friends with whom he enjoyed endless discussions,

Cavallo-Péduzzi *Clogmaker's workshop at Gouvernes* Etching

mostly about his main preoccupation, the destiny of man. He felt anguish at the useless, narrow part science played on the moral plane and at the rigid stagnation of Catholic dogma. His own rather mystical philosophy leaned towards the religious doctrines of the Far East. He considered that the mind was the only living reality that the earth, a superior conscience keeping the memory of man's thoughts, possessed a soul, and that matter was dominated by the mind which, in spite of regressions and mishaps, led towards higher ideals of justice and love. At this point, Cavallo-Péduzzi would dwell at length on the necessity of providing a new post-war religion for humanity. According to the tradition of his family, he was a Freemason, and his dealings with the clergy of Lagny, although very satisfactory in artistic matters, became very stormy over questions of doctrine. In 1894, he agreed to engrave *The Miracle of Joan of Arc in 1430*, but no trace was ever found in his works of any represen-

tation of the elegant Gothic architecture of the church in Lagny.

Works

As a Beaux-Arts student and at the studio of Gérôme, his first works were classical in style and very skilful, if lacking in originality, as witnessed by his self-portrait dating before 1880. A large canvas, dated 1883, *The Return of the Flock*, revealed Barbizon influence; without passing through the transitional stage of impressionism, he progressed directly towards neo-impressionism. This happened also in the case of Gausson, who claimed to be Cavallo-Péduzzi's pupil.

The most striking proof of his abrupt evolution can be found in *Les Trois Malins du Pays* (*The Three Local Characters*), dated 1885 and representing three domino players. This painting's background is purely 'Barbizon' in style, but the foreground and figures are neo-impressionist.

On friendly terms with Seurat since his days at the Beaux-Arts, or at any rate since the founding of the Société des Artistes Indépendants, he was certainly among the few painters to visit him while *La Grande Jatte* was nearing completion, after March 1885. The painting *Les Trois Malins du Pays*, which has always remained in the same Lagny family, was painted at the same time as – if not earlier than – Signac's *Dressmakers*. It is one of the earliest neo-impressionist paintings.

Unfortunately, very few paintings by Cavallo-Péduzzi have so far been traced. Many may have been lost or attributed to other painters of the school whose names held more commercial value. At the retrospective Cavallo-Péduzzi exhibition at the Musée de Lagny in June 1967, there was a *Marne Valley near Annet*, on cardboard, dating probably from before 1890 and painted according to the theories of optical painting with exquisite sensitivity. From this work, it is obvious that the painter skilfully handled complementaries, suggesting that he had carried out many experiments in that direction. It is also worth mentioning his watercolours dated before 1890 and executed in pure tones, such as, for instance, *The Wash-boats and the Iron Bridge at Lagny*, which is historically a most interesting neo-impressionist work.

It is probable that Cavallo-Péduzzi largely abandoned the neo-impressionist technique very early on in the 1890s. He continued to apply it, curiously enough, in certain parts of his paintings, as in *Clogmaker's Workshop at Gouvernes*, which he modified several times. He occupied a very prominent place in the initial phase of the neo-impressionist school, as the few paintings of that period bear witness. As Seurat's companion, he soon understood perfectly all the possibilities of the technique and, had he persevered, he would certainly have produced neo-impressionist works of great importance.

Apart from his talent as a painter, he was an accomplished draughtsman and engraver. Professor Robert L. Herbert, who recently studied the works of Cavallo-Péduzzi at the Musée de Lagny, has expressed his surprise at the skill shown in the engravings and the perfection of some drawings. Cavallo-Péduzzi seems to have been gifted in many different directions, but to have lacked the perseverance needed to make a good artist. Those who knew him depict him as indulging his talents frivolously, scattering his enthusiasms among several interests without creative discipline or determined energy. He worked only intermittently; much of his time was consumed in talking, and, after 1900, in making a living.

Among the writers and journalists who took an interest in his works, Jacques Copeau, art critic, aptly expressed the general opinion (*Mercure de France*) on the occasion of the 1901 Salon in Lagny: 'One stops wonderingly in front of M. Cavallo-Péduzzi's works. It is generally known that M. Péduzzi indulges daily in what is termed by some originality. One dare not smile; after all, it may be that this painter is a genius. What else could it be but genius? M. Péduzzi should write a detailed manifesto in order to elucidate for us the aesthetic value of that composition called *Marriage*, or of that pastel where a pregnant woman lies, smiling, under a bundle of corn. However, the portrait of Mme P. shows style. Two or three engravings, as well as a supple and clear drawing, prove the artist's talent when he forgets about genius.'

Pierre Eberhart

Maximilien Luce 1858–1941

Life

Maximilien Jules Luce, second child of Charles-Désiré Luce and of Joséphine Dunas, was born on 13 March 1858 at 13 rue Mayet in Paris, 6th Arrondissement. A daughter, Almézia, was born in 1856 but was to die in 1880. Two generations of the father's family had lived in Paris ; the mother's family came from Beauce. Luce's father, bookkeeper at the Compagnie du P.L.M., became a clerk at the Paris Town Hall. Luce was six years old when his parents went to live in rue d'Odessa, in the still sparsely-populated quarter of Montparnasse. He was sent to school in the avenue des Maines where he was finishing his elementary schooling at the age of thirteen, at the time of the Commune uprising in Paris. In the course of the Repression in May 1871, Luce witnessed atrocities which left an indelible mark on him. As a child, he was always drawing, and his father complied with his wish to study at the Beaux-Arts on condition that this be to learn a manual trade. Maximilien became a wood-engraver, an honoured trade in those days when the first illustrated papers had begun to appear. He entered into apprenticeship with the engraver Hildibrand. At first, he attended evening classes in drawing at a primary school, but he soon became acquainted with the painter D. Maillart, who taught drawing, in the evenings, to the weavers employed by Gobelins. Whilst other students were only admitted after taking an examination, Luce was accepted straight away. He drew and engraved all day, and also started to paint ; his first known painting is a *Garden at Le Grand Montrouge* (1876). Thereafter, he pursued his studies as a painter at the Académie Suisse, in quai des Orfèvres, where he met the student-treasurer of Carolus Duran's studio, who took him along to the famous studio itself.

Luce finished his apprenticeship as a wood-engraver in November 1876. A qualified craftsman, he entered the workshop of Eugène Froment, rue du Faubourg-Saint-Jacques where the plates were engraved for a great number of French and foreign publications such as *Le Magasin Pittoresque, Le Journal des Voyages, L'Illustration* and *The Graphic*. For ten years, Luce was to work more or less regularly with Froment. He met there two artists who were to become his friends, Cavallo-Péduzzi and Léo Gausson. Gausson, who lived at Lagny-sur-Marne, was to take Cavallo-Péduzzi and Luce there with him.

In 1877, Eugène Froment took Luce with him to work in London for two months. In 1878, he was called up by the army. The conscription system at that time was hard on working-class men ; the nominal period of service was five years, of which four were actually served. On 7 November 1879, Luce was incorporated into the 48th Infantry Regiment stationed in Brittany, at Guingamp (Côtes-du-Nord). Here is his description from his military record : hair and eyebrows, light brown ; eyes, brown ; forehead, wide ; nose, medium ; mouth, medium ; chin, rounded ; face, oval ; height, 1 m 68 (5 ft 7 in.) ; religion, Catholic.

When his talent became recognized, he was asked to decorate the walls of the Officers' Mess, as well as other rooms in the barracks. He painted some Breton landscapes with the help of another soldier-artist, Antoine Bail. Promoted to the rank of corporal on 1 October 1880, he was demoted to private 2nd class at his own request on 8 January 1881. Towards July of the same year, Carolus Duran successfully interceded at the Ministry of War on his behalf, and Luce was sent back to Paris on subsistence pay for the rest of his term of service. He had been at Guingamp for eighteen months. While stationed there, he had established ties of friendship with a 'volunteer' (a middle-class conscript on a one-year engagement), Alexandre Millerand, future President of the Republic.

As his biographer Tabarant was to say, he was 'artist and trooper at the same time'. He divided his life at that time between three studios : that of Carolus Duran, where he was pursuing his education as a painter, and those of Froment and of Lançon, where he earned a living

153

Henri Edmond Cross *Luce c.* 1890

working man, was not in touch with the progressive circles of contemporary artists, but Pissarro, charmed by this gifted newcomer, asked to be introduced to him. Through Pissarro, Luce was immediately accepted within the neo-impressionist group, then in the process of becoming a school. Seurat and Signac received him warmly. Signac, in a gesture of friendship, bought from Luce, for 50 francs, his *Man dressing* (*L'Homme à sa toilette*). Through his new friends, Luce became acquainted with Guillaumin, Dubois-Pillet, Angrand (with whom he was to develop a deep friendship) and well-disposed critics, such as Félix Fénéon and Jules Christophe. He also knew Lucien Pissarro and Hayet. Optical painting was at that time in the full swing of its early days. The small Lagny group merged with the Paris group, into which Cross and Petitjean were also taken.

In 1887, the anarchist journalist Jean Grave founded a weekly publication, *La Révolte*. Luce soon became a regular reader, and a friendship developed between him and Jean Grave.

For Luce, success was not far off. In July 1888, Félix Fénéon, who had immediately perceived his talent, invited him to exhibit at *La Revue Indépendante*. This was his first one-man exhibition, with ten canvases. On 28 July, in Georges Lecomte's *La Cravache*, Jules Christophe devoted to Luce an exclusive article, the first one. That same year, Luce went to live in Montmartre, in rue Cortot.

In February 1889, Luce was invited to Les Vingt in Brussels, along with Besnard, Bracquemond, Cross, Desboutin, Frémiet, Gauguin, Pissarro, Monet and Seurat. He was now at the very centre of the movement. That year, he went to Eragny-Bazincourt to stay with the Pissarros, whom he was to visit often. He worked at Herblay with Signac for several weeks. He published his first album of lithographs. That same year, Emile Pouget started a social-anarchist popular weekly, *Le Père Peinard*. Luce, in answer to Pouget's appeal, was to supply him up to the First World War with over two hundred drawings and lithographs for the paper.

During the course of 1890 and 1891, Luce pursued his work actively. He painted views of Paris, landscapes of the western suburbs, at La Frette, and at Herblay. It was without doubt there that he applied the neo-impressionist technique to best effect, and his masterpieces were executed in that style. The series from Herblay was remarkable, as is witnessed by the very beautiful landscape now at the Musée d'Art Moderne in Paris. After this period, he was to lean more towards a divisionist style. He was very much admired by the avant-garde

by engraving. Auguste Lançon, a fine animal painter and engraver, had also depicted numerous military scenes. During that period, Luce painted, amongst others, suburban landscapes and a panoramic view of the Pantheon. He spent time observing, visiting the Louvre, studying the impressionists. He was demobilized on 27 September 1883; he lived at that time in Montrouge.

In 1885, he left Carolus Duran. It was at that period that, along with his friends Cavallo-Péduzzi and Gausson, he discovered the experiments of Seurat. Following the summer of 1885, the three friends, at Lagny, painted certain parts of their pictures in pure complementary tones. Luce, in addition to his innumerable engravings, began to produce a great number of paintings.

Cavallo-Péduzzi, at the birth of the Société des Artistes Indépendants, was among the very first exhibitors, followed by Luce and Gausson who exhibited at the Salon des Indépendants of 1887. The paintings by Luce, done according to the theory of division of tones, attracted much interest. Luce, who had remained very much a

critics. Jules Christophe dedicated to him, in July 1890, a whole issue of *Hommes d'Aujourd'hui*, following those on Pissarro, Seurat, Dubois-Pillet and Signac.

Luce, who had proposed to publish a series of lithograph albums called *Corners of Paris*, had printed 150 copies of *Small Betting*, in which the Saint-Ouen racecourse was vividly brought to life.

En 1891, he continued to contribute to socialist and anarchist publications. The writer Georges Darien wrote a very pertinent criticism of Luce's work in *La Plume*. That same year, Seurat died on Easter day, from malignant diphtheria. Luce, together with Fénéon and Signac, was entrusted by Seurat's family with the sorting out of his friend's works.

In 1892, another invitation to Les Vingt, with, this time, Besnard, Mary Cassatt, Maurice Denis, Gausson, Lucien Pissarro and Seurat. At the commemorative Seurat exhibition organized by Les Vingt, Luce exhibited his beautiful portrait of the painter, which had been reproduced in the April 1890 issue of *Hommes d'Aujourd'hui*. That same year, Luce went to London with Pissarro. During his stay, he executed a remarkable series of canvases and drawings. Back from London that summer, he went to join Signac at Saint-Tropez. The fruits of his activity were seen at the Indépendants of that year, where he exhibited two views of London, two of Saint-Tropez and one of Montmartre, *Rue Ravignan at night*.

Maximilien Luce *Corners of Paris: Small Betting* Lithograph

Shortly thereafter, Luce exhibited in one of the rooms of the Restaurant Brébant, along with Angrand, Signac, Gausson, Petitjean, Van Rysselberghe and the sculptor Alexandre Charpentier, all of them assembled around the canvases and drawings of Seurat. From that year until 1896, he was to exhibit five times at Le Barc de Boutteville with the group of impressionist and symbolist painters.

In 1893, he went to Camaret in Brittany where he worked in a great surge of creative activity. The year 1894 was for Luce a very unsettled one. 'From 1892 to 1894, a real epidemic of terrorism broke out and grew in France', wrote the historian J. Maitron. The anarchists had separated from the socialists ten years previously. At Clichy, in 1891, militant anarchists exchanged shots with the police. On 28 August, the same year, they were given harsh sentences. This affray, in which the police had played a rather suspicious role, triggered off the most serious crimes yet known under the Third Republic. They increased in number during the whole of 1892, which was also the year of Ravachol, and his execution did not check their progress until, in 1893, they assumed terrifying proportions. On 13 November, a shoemaker called Léauthier inflicted knife wounds – a purely gratuitous act – on the first bourgeois passer-by, who happened to be a diplomat. Then, on 9 December, Vaillant threw a bomb in the middle of a deputies' meeting at the Chambre, and on 12 February 1894, to avenge the guillotined Vaillant, Henry threw a bomb into the crowded Café Terminus. On 15 March, a device exploded in the Eglise de la Madeleine, killing the doorkeeper. On 4 April, it was the turn of the famous Restaurant Foyot to blow up. Lastly, the climactic blow : the President of the Republic, Sadi Carnot, was knifed by Caserio on 24 June 1894.

The Government then took draconian measures. A great number of anarchist militants and supporters were arrested. Luce was among these, and he spent forty-five days at the Mazas prison without being convicted. The defendants at the famous trial of 'Les Trente,' in August 1894, included Félix Fénéon, Jean Grave and Sébastien Faure, the theoretician of anarchy. Luce's friends were acquitted. Emile Pouget, convicted, had managed to reach London, where he went on publishing *Le Père Peinard*. Luce made up for the hardships of his imprisonment by publishing 250 copies of an album of ten lithographs under the title *Mazas*, in which he evoked scenes of prison life with a text by Jules Vallès.

In December 1894, he exhibited with Signac in the Galerie du Néo-Impressionnisme, in rue Laffitte. It was in the course of this troubled year that, on 5 June, Luce's first son – who was to die at the age of fourteen months – was born. In 1895 he was again invited to Brussels, this time by La Libre Esthétique, which had taken over from Les Vingt, the latter having been dissolved after their tenth anniversary. The same year, *Les Temps nouveaux* were published, which, until 1914, was to replace the suppressed *La Révolte*. Luce was often to contribute to this publication. That same year again, Emile Verhaeren invited Luce and his wife to Brussels. Luce went also to Charleroi, where he first came into contact with the *Pays Noir*, the Black Country.

In 1896, he published an album of ten drawings, *Les Gueules noires (The Black Faces)*, inspired by the works of Constantin Meunier. He returned to work in the Black Country, in the towns of the Sambre valley such as Charleroi, Couillet and Chatelet, the most important iron and steel centres in Europe. Luce was impressed by these landscapes, where noise, heat, dust and smoke prevailed. He spent three months observing this inferno, and painting it with a genuine feeling for the men who lived there. He went back to Paris, his head full of plans. That same year, his son Frédéric was born.

In 1897, he was again invited to La Libre Esthétique. He exhibited his first paintings of Belgium at the Indépendants. In 1899, he returned a last time to the Black Country. In November, Durand-Ruel organized an exhibition of the works of Luce which the critics unanimously praised. In 1900, he left Montmartre for the 16th Arrondissement and went to live in rue Le Marois. At the same time, he rented premises as studio at 102 rue Boileau. He painted certain aspects of the Exposition Universelle, and – still tormented by memories of the Commune – a painting of the execution of Genton, a well-known *communard*. At La Libre Esthétique where he was again invited, he exhibited some paintings done in Charleroi. The same year saw the appearance of a new publication, *La Voix du Peuple*, edited by Emile Pouget. It was the journal of the Confédération Générale du Travail (C.G.T.), the main trade union organization. Luce was to contribute several drawings.

During the first years of the new century, he painted – as he was to do his whole life long – a great number of views of Paris; his portraits included those of Emile Verhaeren, Lucie Cousturier, Félix Fénéon and Charles Angrand. He painted also at Méréville and Chalou-Moulineux, often visiting those little valleys which cut across the Beauce in the vicinity of Etampes. He also began to paint flowers.

In 1904, La Libre Esthétique mounted an important

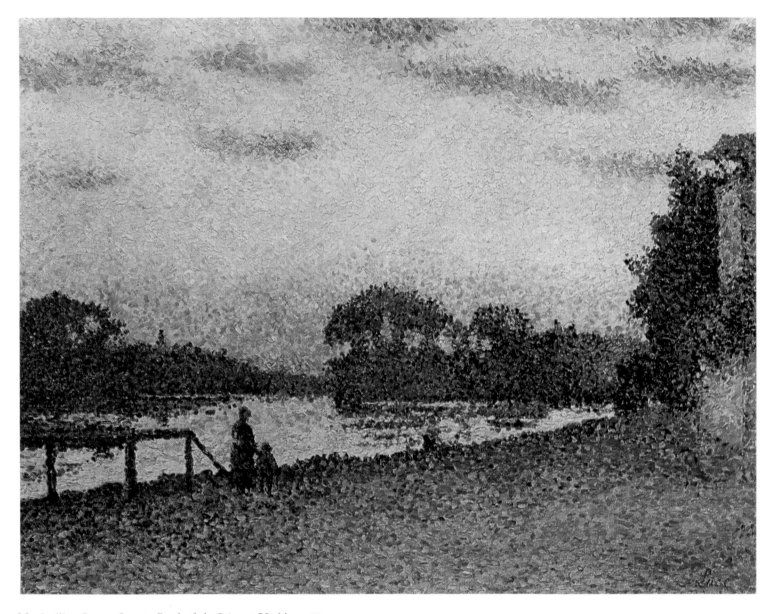

Maximilien Luce *Sunset, Bank of the Seine at Herblay* 1889

exhibition on the theme 'L'Art impressionniste'. Luce was represented, with twenty-five other painters, from Manet to the latest schools. This was success indeed. The best French painters of the century were present, including impressionists, neo-impressionists, the Pont-Aven school, Nabis and such post-impressionists as Albert-André and Charles Guérin. That same year, he exhibited two hundred drawings at the Galerie Druet.

Still haunted by what he had seen in the days of the Commune, he began work on a large canvas, after executing many studies for it. The subject was a street in Paris in 1871, in which four bodies – one of them a

157

Maximilien Luce *Breton sketch*

woman – lie, shot dead, in a heap on the ground. This powerful evocation of his childhood memories was to be exhibited at the Indépendants in 1905.

Also in 1905, Buffalo Bill's circus came to Paris, and Luce painted an interesting series inspired by that colourful and active troupe. It was in 1906, 1907 and 1908 that he went to the province of Yonne. He stayed there, in the valley of the Cure, at Bessy, Arcy and Vermanton. There he began a series of works of an extreme luminosity, this period which became known by the name of 'the Cure period', was one of the most successful in his whole artistic career.

Maximilien Luce *Camaret, Breton sketch*

From 1907 onwards, Félix Fénéon, who had become adviser and head salesman at Bernheim-Jeune was to do everything in his power to support Luce. In 1907, the first large exhibition took place. Luce, introduced by Gustave Geffroy, sent in paintings of flowers, the Paris street of 1871 and a series of la Cure. Gustave Hervé, then an anarchist, brought out *La Guerre Sociale*, to which Luce contributed.

The impressionist painters, ranging from Monet to Signac, had all loved Holland. In 1907, Luce went there, and his friend Van Dongen, who had gone back to Amsterdam for a time, showed him around. Luce completed a series of works in Holland, including paintings, drawings and engravings which, upon being exhibited at Bernheim in April 1909 and presented by Emile Verhaeren, were very well received. At the beginning of that year, he had some works exhibited in Brussels at La Libre Esthétique, which was celebrating the twenty-fifth anniversary of the founding of Les Vingt.

In November 1910, an important exhibition took place at Bernheim, in which Luce showed mostly views of the banks of the Seine, from the Pont-Royal to Meudon. In 1911, Luce exhibited a large canvas of great beauty, *The Scaffolding*, which he was to donate to the C.G.T. In January 1912, another exhibition was held at Bernheim, with scenes of Parisian life, showing streets, markets, errand boys and bathers. In February 1914, Luce exhibited, at the Galerie Choiseul, a collection of his works depicting workers and their labours. Pierre Hamp, the socialist writer of *La Peine des Hommes*, was to write the foreword for the catalogue. As well as factories, yards, and workers, there was a sketch of the execution of Varlin, a journalist hero of the Commune. Angrand had now permanently settled in Rouen, and Luce often went to visit his great friend and to work in that beautiful city.

The year 1914 found Luce in Brittany, at Lézardrieux, where he had been the guest of the painter Thorndike. The war imposed on him contradictory opinions which deeply upset him. He refused to sign the manifesto in favour of Romain Rolland who had put himself 'above the *mêlée*'. In 1916, he also refused to associate himself with a declaration by Jean Grave, Kropotkine and other European anarchists who had sided with the cause of national defence, while another group (the Zimmerwald Conference) had declared itself against this. All this contributed to Luce's disturbed state of mind. He did, in fact, justify his attitude with very valid arguments.

Luce sympathized in his own manner with the hardships of a soldier's life. In 1915 and 1916, he painted

some unforgettable scenes of railway stations in Paris, overflowing with men on leave, wounded soldiers, and refugees.

In 1916, he exhibited at Bernheim this series of new masterpieces. The following year, the painter Veillet took Luce to Rolleboise, a village on the banks of the Seine past Mantes. There he spent long periods, dividing his time between this village and 16 rue de Seine, where he went to live in 1920.

When peace returned, Luce was sixty years old, still strong and healthy. He continued to paint views of Paris, scenes of work and landscapes of Rolleboise. He still exhibited regularly: in May 1920, at the Galerie Marseille, in April 1921 at the Galerie Dru, and in May 1922 at the Galerie Durand-Ruel. In March of 1926, he exhibited eighty pictures at the Gallerie Druet.

Luce then became vice-president of the Société des Artistes Indépendants, where he had faithfully continued to exhibit since 1887. After the retrospective exhibition in 1924 celebrating the fortieth anniversary of its founding, Luce showed an interesting selection from all his works. In 1926–27, he painted the seasons, including some snow landscapes which have been much admired.

In 1928, A. Tabarant brought out an important biography of Luce, then aged seventy. His health was still excellent and he continued relentlessly to work, depicting, more often than not, views of Paris and of Rolleboise. In February 1929, there was a Luce exhibition at Bernheim, entitled 'Cinquante ans de peinture'. The show was well chosen, and met with great success. In December 1933 and January 1934, he took part in the important exhibition at the Galerie des Beaux-Arts 'Seurat et ses amis, la suite de l'impressionnisme'.

In 1934, Signac resigned and Luce was elected president of the Société des Artistes Indépendants. This was the only honour he was ever to accept. The Second World War found him without illusions: he was eighty years old, and the sudden death of his wife in June 1940 during a stay in Rolleboise left him alone and helpless. He gradually became weaker, and died in the rue de Seine at the age of eighty-three on 7 February 1941. On the previous day, he had still been working on a painting. He was buried in the cemetery of Rolleboise by the Seine, his beloved river which he painted so often and so well.

Appearance and character

It is an easy task to draw a physical and mental portrait of Luce; his colourful and independent personality

Maximilien Luce *The Tumbril*

which remained consistent throughout his life. Jules Christophe described him at the age of thirty, in 1890, in *Hommes d'Aujourd'hui*, as follows: 'This man in the shapeless hat who sits in a modest café attentively reading *La Révolte*, an anarchist publication, is of medium height, with a bulging forehead, Socratic nose, round skull, chestnut hair and red beard, warm, melancholic gold-flecked eyes and thick twisted lips. There is something of Vallès and of Zola in his expression, with much of the rancour of a plebeian revolutionary.'

Many writers were to give similar descriptions thereafter. Here is the one by Texcier, painter and friend of

Maximilien Luce *The Tugs*

Maximilien Luce *Camille Pissarro* 1895

human of men, and that the gruff exterior conceals a delicate and sensitive temperament.

'The general appearance is that of an old workman from the Faubourg Saint-Antoine, and indeed both Luce's origins and his beliefs draw him towards the working class. He flees the Salons, where the conversation and affectations bore him. He prefers to eat salt beef in a modest restaurant, sitting next to the bricklayer in his white blouse, or the corduroy-clad navvy or the mechanic in his blue overalls.'

The same Texcier, in his eulogy of Luce six years after his death (1947), gave a character description of his old friend. 'Here was a true man, a free man. I never knew anyone of a more noble or sensitive character, or more inclined to compassion. He possessed great dignity, and never made any concession to fashion or to interest. This attitude, so natural to him, was to cost him a great deal all through his life. He went straight along his own path, however difficult it was at times. He was too proud to complain of the poverty which affected him all his life, and was never heard to voice his worries.'

Luce's life was characterized by this delicacy of temperament and dignity of behaviour. He was as strict with himself as he was towards others. His deep friendship with Angrand lasted without a cloud until the latter's death in 1926. The story has it that Millerand, who had become a minister, wanted to honour by his presence at the Galerie Bernheim the exhibition of the works by his old companion of Army days, but Luce, who considered Millerand to be a traitor to the socialist cause, refused to meet him. He also broke with Van Dongen when the latter became fashionable. At the trial of Douanier Rousseau in January 1909, Luce without hesitation testified in his friend's favour, and, ignoring the sarcasms, praised Rousseau's works in the courtroom.

Luce's personality could have come out of Agricol Perdiguier's *Mémoires d'un Compagnon,* the autobiography of an Avignon carpenter. Had he been born fifty years earlier, he would have been a *Compagnon du tour de France,* one of those journeymen described by Perdiguier: those craftsmen who, throughout French history, have been the strength of their country.

Works

Throughout his life, Luce greatly admired Corot, and his rather dark, dense paintings dating from before 1886, such as his large painting *Aunt Octavie,* are somewhat reminiscent of the Italian Corots. The resemblance ended,

Luce, who forty years after Jules Christophe's study, depicted Luce at the age of seventy : 'A grey, almost white beard, one of those coarse beards, alive and expressive, which follow the moulding stroke of the hand and the movements of the features. Thick black eyebrows lend a terrifying appearance to the face. An abundance of grey, unruly hair over a round face and bulging forehead. Eyes like Turkish coffee, warm and sweet, sheltering behind iron-rimmed spectacles, such as only old peasant women wear. A pouting mouth beneath a reddish moustache, generally imprisoning a cigarette. A felt hat ; even at home, Luce rarely goes without a hat. A loose suit of which the trousers, held up by a belt, hang loosely over a pair of heavy shoes; his neck too uncovered in a soft shirt collar. His speech is coarse, and he speaks little, wasting no words. Strangers call him surly, but his friends know that he is the kindest and most

Maximilien Luce *Notre-Dame* 1900–01

however, when he began to paint in a divisionist style. As mentioned earlier, he was one of the first adepts of the neo-impressionist technique, which he applied consistently until 1891–92. Thereafter he broadened his touches and combined this divisionist style with a loosely-applied impressionist manner which became and remained the hallmark of his works. For the next ten years, until 1901–02, he was to use both styles alternately; at the same time, a strong feeling for optical painting permeated all his works.

So far, no one has analysed the influence of Seurat's theories on Luce's works. Only a specialist in neo-impressionist theory could describe his technique, with its highly individual character. As in the case of Hayet, a great deal of research – such as W. I. Homer has carried out in respect of Seurat – would be necessary. It would be erroneous to believe that Luce, whose technical skill has yet to be acknowledged, was a mere imitator. His experiments evade immediate analysis, but this is possibly because his style is so eminently descriptive that one tends to forget to study its theory.

Luce may well have been unique in his use of red grounds, on which the green complementary tones were laid. From an early date, in his sketches, he was to separate widely the hues on a white ground. Amongst 'optical' painters, he certainly stands out for the great diversity of his touches in divided hues, ranging from tight dots to broad mosaics. Although it is impossible to estimate the extent of Pissarro's or Dubois-Pillet's influence in his use of 'passages', he applied this method at a very early stage in his career.

Maximilien Luce *Fishing Boats*

With his awareness of contemporary experiments and theories, Luce was, with Dubois-Pillet, the only neo-impressionist who painted oval pictures. He was certainly the first to paint divisionist portraits, as early as the beginning of 1887.

In the biographical part of our study of Luce, the characteristics of the various 'periods' in his life have been described at length. The main subject in his works was certainly Paris, and Luce faithfully recorded sixty years of Parisian life, with the various events which occurred between 1870 and 1940. Luce was the first artist to discover picturesque Montmartre, with its narrow streets and still unspoilt alleyways. His series of views of rue Mouffetard is famous. He also painted the boulevards and the avenues, the outskirts and suburbs, with the perpetual motion of people and traffic, the churches such as Notre-Dame, Saint-Gervais, Saint-Médard, and the Sacré-Cœur in the course of construction. He captured the strangeness of Paris at the time of the International Exhibitions in 1889 and 1900 and, in 1915–16, during the war, with the railway stations overflowing with soldiers.

He loved the Seine, and paid tribute to it at all times of the day and night, through the changing of the seasons, in the snow or in the rain, or stirring in the wind, or under the pearly sun of spring. He depicted the stages of transformations in the town with the demolition of whole quarters, as in his series of the rue Réaumur, and the massive reconstruction of bridges, factories and tall buildings with scaffoldings.

In his intense vision of the city, the human element was for ever present, and his paintings are animated by the workers handling the tools of their trade: heavy carts drawn by powerful horses, cranes, jacks, drays, dredgers and drills. Or, on fine days, his men and women relax by the Seine. The representative aspect of Luce's huge creation make him a valuable witness in the history of Paris.

He was equally skilful in rendering the atmosphere of London, of harbours in Holland, in Brittany or on the Mediterranean. He was masterly in his depictions of industrial landscapes, but, at the same time as he painted these oppressive views so faithfully, he expressed, in other works, the serenity of woods, fields and rivers. One wonders at the variety and accuracy of his vision.

With the exception of Seurat and Signac, Luce must be the most discussed neo-impressionist painter; I have selected from the enormous body of criticism the foreword by Gustave Geffroy for the catalogue of the Luce exhibition of February 1907 at Bernheim's. His very

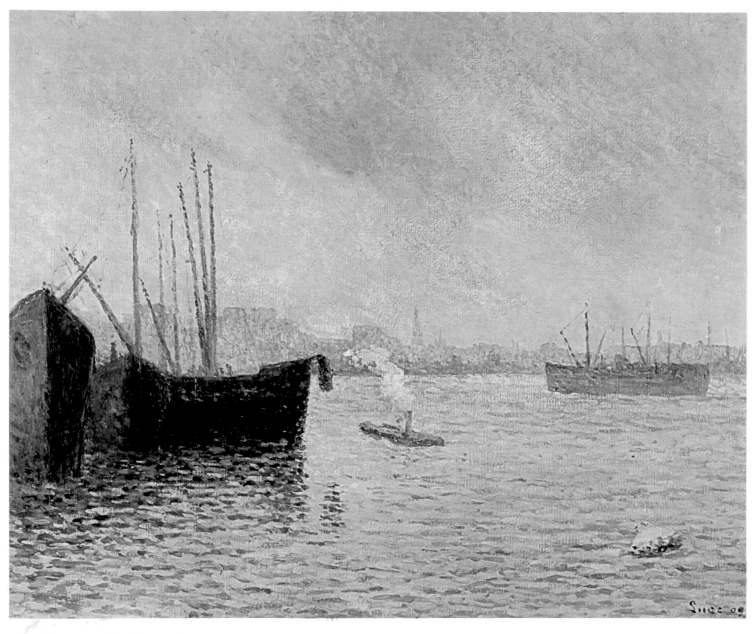

Maximilien Luce *The Meuse at Feynor* 1909

accurate appreciation, dating from the middle of the painter's career, expresses perfectly the essence of Luce's works as a whole: 'It could be said that Luce did not persevere in the method of colour separation to achieve gradation of light on form. In my opinion, this lack of consistency does not represent a valid argument, since the method in itself was more of an experimental than a creative nature. It was far more important for Luce to retain his passionate love for light and truth, and to follow his artistic impulses.

'His art held no artifice, and conformed to no convention. He went his own way, for ever looking, perceiving

163

and expressing. He learned his ability to see from the impressionist masters who had been themselves influenced by other schools. Luce was, in this sense, a traditional artist, although one must remember that there are various aspects of tradition, and there is a difference between continuation and imitation. Luce was no imitator, but he worshipped at the altar of the masters who had perceived the poetry of reality.

'He escaped, however, from the discipline of schools and quite naturally chose the aspects of nature, the time of day, the setting of objects and the features most representative of his own region, of the domestic scenes he loved and the humanity he observed.

'His was a talent able to express, with great power, the tragedies of suffering, of poor and cold interiors, of industrial landscapes where man-powered factories fill the sky with their fire and smoke. The tumult of London and the power of the sea came to life under his brush. In other moods, he was also in love with the light-heartedness of life which he expressed with charm....

'Luce loved the spring and the summer, the softness of the first fine days, the sumptuous weight of foliage in July, the peace of warm dusks, the light clouds scurrying through blossom-laden branches, the sapphire of skies and the last light of day and season. He loved the trees reflecting in the clear river water, the emerald pastures, the stone bridges with arches like windows into the landscape, the willows with knotted trunks and frail foliage, the villages calmly resting amongst the trees, the gently waving poplars, the immense plains, the interminable roads and the moving arabesques of birds in the sky.

'Flowers were included in his love and, like landscapes, were painted with a masterly touch. The red, yellow, orange and white chrysanthemums on blue, green and pink grounds, his poppies, snowdrops, anemones, all revealed the artist's passion for opulent forms and rich colours. The magnificence of nature was represented in these flowers, mysterious goddesses of fields and gardens for ever offering to us the enigma of colour and scent.'

Of all the painters of the twentieth century, Luce must have been the most prolific. Only an approximate estimate of the extent of his works can be given here : over 4,200 canvases, nearly 3,000 drawings, and approximately one hundred lithographs, engravings on wood and etchings. As well as some pastels, a few gouaches and a very small number of watercolours, there are many political drawings, posters, designs for earthenware and the innumerable engravings of his youth.

If price be the measure of success, Luce long remained an unsuccessful painter. No doubt this may have been due to the lack of scope for myth-making in the artist's personality as in his works : both are straightforward, healthy, without affectation in expressing the painter's love of life, truth and humanity. This lack of artifice severely limited Luce's snob appeal; unlike Gauguin and Van Gogh, for instance, whose instant fame was largely due to the emotive myths attached to their life and works, he was neither mad nor eccentric. There was in him an affinity with Daumier, Millet and Courbet, disciples of truth and life, free from sentimental or romantic motivation.

Among the adepts of optical painting, Luce is probably the painter who managed best to escape from symbolism. This is not unusual if one recalls that he was the least intellectual artist of his time, and his works are best located in the sphere of naturalism. They are the counterpart, in painting, of Zola's naturalism in literature. Luce occupies a place in that powerful creative current which flows directly from the French people, without the adulterating effect of the bourgeoisie, and which is associated with the names of Pierre Proud'hon, Emile Zola, Jules Vallès and Charles Péguy.

Jean Sutter

Léo Gausson 1860–1944

Louis-Léon Gausson, later called Léo, was born on 14 February 1860 in Lagny-sur-Marne (Seine-et-Marne), at 3 place de la Fontaine, to Louis Victor Gausson, a crockery merchant, and Adèle Laurence Montesiste, of Italian descent.

He was the fifth and last child in the family. Three had died in infancy. Georges, two years older than Léo, became a chemist. The Gausson family was comfortably off and had lived in Lagny for a long time. One of their ancestors had come back alive from Napoleon's Russian campaign, and, from his garrison in Strasbourg, had come on foot the whole way to Lagny to reassure his family about his fate.

Up to the age of sixteen, Léo Gausson studied at the Pensionnat Fleury in Lagny, a fashionable private boarding-school. A friend of the Froment family, he visited Eugène's studio whenever he went to Paris. It was there that he was to meet Luce, who was working as a wood-engraver. The invention of process engraving marked the end of the profession as early as 1883, and Gausson, with his friends, became an artist.

In 1886, the Salon accepted his *Profile of Small Girl*, a plaster medallion. As in the case of Luce, Gausson's first Salon des Indépendants was in 1887, when he exhibited eight canvases. Cavallo-Péduzzi had already been exhibiting since 1884.

With Luce, he was soon accepted in artistic circles and became the friend of most painters. For twelve years, between 1888 and 1900, Gausson was a sort of commercial traveller in avant-garde painting. He was always on the move, carrying ideas and news. Among the painters whom he frequented before 1890 were Seurat, Pissarro, Guillaumin, Gauguin, Van Gogh, Signac, Hayet, Luce, Emile Bernard and the Douanier Rousseau. He was one of the first to realize the importance of Seurat, Gauguin and Van Gogh.

After 1890, he became fascinated by the Nabis, the symbolists and the *rose-croix*, frequenting the artists of all the new schools and taking an active part in all the movements. During the twelve years of his painting career, he participated in many exhibitions, including private ones. His name can be found in all the catalogues of that time.

At the Indépendants in 1888, he exhibited eight paintings, then in 1889, two and, again, two in 1890. His works were, in fact, regularly seen at the Salon until 1900. In 1891, he exhibited at Le Barc de Boutteville, at the first symbolist Salon, together with Pierre Bonnard, Maurice Denis, Henri-Gabriel Ibels, Cavallo-Péduzzi, Alphonse Osbert, Paul Ranson, Paul Sérusier, Jan Verkade and Edouard Vuillard. Later, he also took part in the other symbolist exhibitions.

In 1892, he was invited to exhibit with Les Vingt in Brussels; this was probably the summit of his career. In 1896, he exhibited studies and sketches at the Galerie Laffitte. His mother died a short while later.

In 1899, at the Salon in Lagny, he exhibited a diversity of works: drawings, paintings, three bronzes, a work in pewter, plaster medallions and a showcase of jewels. In 1900, at the same Salon, there were his paintings, pastels and a plaster medallion.

These exhibitions, however, only included a small part of his output; he drew unceasingly, and engraved the works of his favourite artists, among whom Millet ranked foremost. *The Angelus* and *The First Steps* were received with great admiration. From reliable sources, it appears that Gausson carried out some engraving work for Camille Pissarro during his frequent stays at Eragny. He was very talented as a poster artist. His poster for a washing product, Lessive Figaro, was well known, and he designed some interesting ones for his own exhibitions.

Gausson also frequented literary circles and became a friend of Adolphe Retté, author of hallucinatory poems, for whom he illustrated some books. From time to time, Gausson himself wrote prose and in 1896 he had published – under his mother's name, Laurent Montesiste – an anthology of poems entitled *Histoires vertigineuses*.

In 1899, he exhibited at the Théâtre Antoine without

Maximilien Luce *Gausson* 1890

much success. In the spring of 1900, Charles Colinet, 'Sylvain' of the Fontainebleau forest, was publicly acclaimed for the paths and walks which he had created in the forest, and a public collection was made in order to erect a stone in his honour. Gausson engraved the plaque. In May 1900, Gausson was awarded an official decoration for this work.

In spite of this limited success, he could not ignore his many failures and the fact that, for twelve years, he had sold practically nothing. Filled with distaste for life in Europe and weary of being unable to earn a living by his many talents, he relinquished all artistic aspirations and, like his friend Gauguin ten years earlier, emigrated.

He went to live in Africa, where he found a post in the local administration in French Guinea, and, on arrival in Conakry on 18 August 1901, he was made district officer in a village eighteen days distant from the capital. He stayed there for twenty-four months, but soon fell victim to malaria, and the frequent attacks of fever developed into anaemia. Gausson had to leave Africa and arrived back in Bordeaux on 22 May 1903. In Guinea, he had become very interested in the linguistic problem and had begun a grammar of the Fulani language which he had not been able to complete because of his many duties.

At the end of his leave, he applied through a Minister for a special posting which might enable him to finish his book, but was unsuccessful. After six months in France, he returned to Guinea at the end of 1903 with promotion but, then months later, another attack of malaria forced him to take six months' leave.

On 15 May 1905, he left again for Conakry. A year later, his declining health once more forced him to return to France. Finally, for unknown reasons, he resigned from his post.

However, he had not abandoned his work on the grammar and went back to Guinea on 25 December 1906 on his own account. The private secretary to the Governor of Guinea reported: 'He intends to visit Guinea in order to pursue, privately, his linguistic and artistic studies.'

There followed two quiet years, the last of his life in Africa. In 1907, he made the acquaintance in Guinea of a certain Landré, a big game hunter, who had married an African eight years earlier. Gausson and Landré made plans to cross Africa on foot at its widest point, living from what Landré would shoot, while Gausson would send his travel notes to the Geographical Society in return for their financial support of the expedition. Although few details are known about their trip, it seems to have been successful. What is known is that a young and intelligent Guinean girl, with whom Gausson was living, went with them and was their main informant during the journey. Following mysterious circumstances, Gausson ended up in a hospital in Cairo in 1908, almost dying from poisoning. It was believed that he had attempted suicide following the death of his female com-

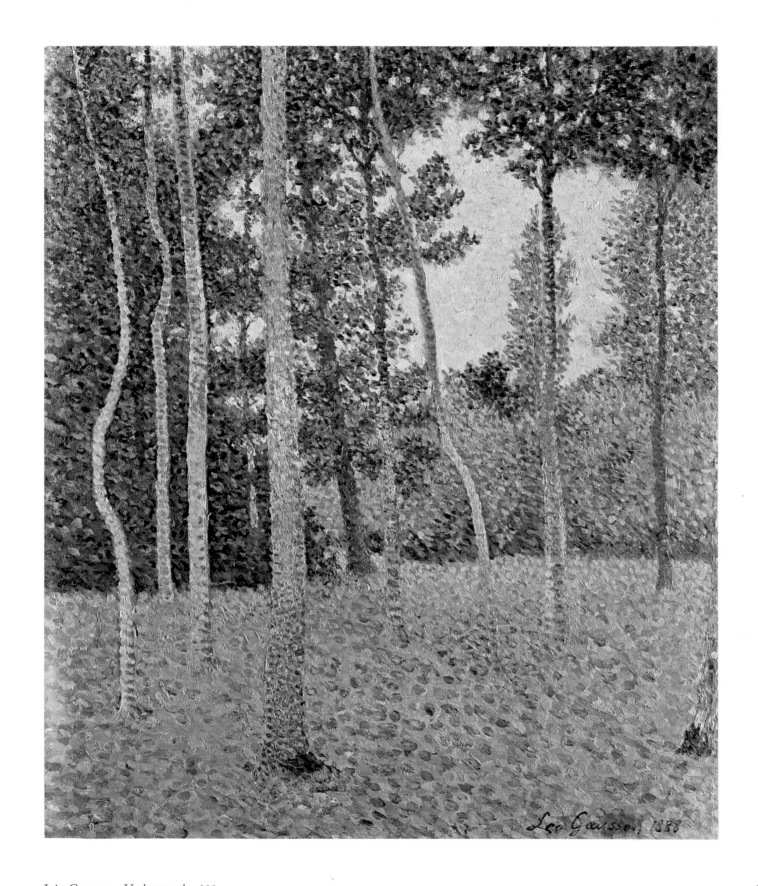

Léo Gausson *Undergrowth* 1888

panion. From the Sudan, Gausson had reached Egypt with native caravans.

Thus ended his adventures in Africa. Back in France, he lived quietly on the banks of the Marne and, cured of malaria, resumed his long walks, visited friends and took an interest in all around him, having abandoned painting almost completely. Always alert and impulsive, paying gallant compliments to his friends' wives, he lived on the family income.

During all this time, he had no fixed occupation. For a couple of years, he helped a urinary specialist who had invented a lamp for the examination of the bladder and the urethra. Gausson had drawn the designs for the apparatus as well as a chart of the possible tumours, infections and contractions.

He was a talented musician, playing the oboe and the fashionable mandoline well, and taught music to several children in Lagny. His favourite composer was Schumann.

During the First World War, he was forced to take up regular employment again. From 1916 to 1920, his sixtieth year, he worked as a clerk at the Préfecture de Police. Later, he was to spend his free time in working on his interminable grammar, on which, incidentally, he was still engaged at the time of his death.

Around 1923, on a recommendation from Edmond Sée, he became an employee at the Ministry of Education in the film censorship department, at the Palais-Royal and later in rue de Lubeck. Until the age of nearly eighty, Gausson filled the modest post of temporary auxiliary. In his fine calligraphy, he kept the records of film titles in large registers, the accounts, and the files. He was a conscientious and punctual employee. Although he never mentioned his past to anyone, he gave his employer a copy of his *Histoires vertigineuses* and told him about his grammar.

At the beginning of 1940, a few months before the débâcle, he disappeared; according to rumours, he was first believed to be ill and then dead, but in fact he had retired to spend his remaining years first at Noisy-le-Sec, living with one of his nieces, then at Lagny, where his other niece took care of him until his death on 27 October 1944 at the age of nearly 85 years. He was buried in the town's cemetery.

Appearance and character

Gausson was a small man, 1 m 55 (5 ft 2 in.) tall, with narrow shoulders and slight limbs, but very strong. His regular features, with a thin beaked nose, bore an alert expression due to his steely blue-grey eyes. His hair was usually long and his beard was shaped into a point. Those who knew him described his appearance as 'ageless'. As a young man, he appeared old, but at the age of eighty he had the looks of a man of sixty. Always correct, courteous, polite, neatly dressed and well spoken, he was quite unlike his friend Cavallo-Péduzzi.

He was a keen sportsman by the standards of his time and a tireless walker; he often walked over 50 km (30 miles) in a day in the forest of Fontainebleau. He was experienced at handling a canoe, and his swimming feats included the saving of two lives. He could also dive from a great height through a lifebuoy and walk on the Marne bed carrying a 10 kg. (22 lb.) weight.

Léo Gausson *Exhibition Poster* 1896

His frail appearance belied his physical fitness. His healthy constitution helped him to cure himself completely of the chronic malaria he had contracted in Africa. At the age of eighty-two, during the troubled days of the Occupation, he would walk 20 km (12 miles) from Lagny to Noisy-le-Sec to catch his train to Paris.

Gausson was of an unusually nervous and sensitive temperament. An idealist, he was fascinated by social and scientific progress, and he would discuss for argue for hours over subjects such as socialism or aviation, banging the table with his fist. His lyrical nature took him at night into the forest where he would talk to the trees, particularly to the huge poplars of Pomponne, outside Lagny, which he often painted in moonlight. Some thought him slightly mad; he was not, although he did at one time receive medical attention for nervous trouble.

His excitable temperament explained his friendship with Adolphe Retté, the poet 'who claimed to have written his *Thulé des Brumes* (1891) while possessed' (Henri Clouard). In 1914, while the battle of the Marne was raging not far from Lagny, he searched for a gun in order to join in the fight. He went to the battlefield, and returned sick from the sight of death and destruction. At the time of the 1944 landings, he again wanted to join in the battle and help the American soldiers to victory.

His private life was stormy; he fell in love with countless women. In 1883, he proposed marriage to Antonio Cortés' daughter, Jeanne, fourteen years younger than himself. But she married instead the less eccentric Emile Froment. His liaison with the girl in Guinea was not the only one to lead him close to suicide; in 1909, shortly after his return from Africa, a sentimental disappointment made him threaten to throw himself into the sea from some cliffs at Le Havre. He took the train to Le Havre, but once there he soon abandoned his plan and returned home. He ended up a bachelor.

This stormy side of his character did not alter the fact that he was a model employee. His services were highly praised both by his superiors in Guinea and by the censorship department. Even after he had settled in France, he still loved travel and adventure. Living modestly, he saved up carefully for the holidays which he spent in Belgium, Germany, Italy or Switzerland. In July 1934, at the age of seventy-four, he decided that he wanted to fly over Mont-Blanc, and a Swiss pilot took him up, afterwards sending him a photograph inscribed: 'To Monsieur Gausson, my courageous passenger over Mont-Blanc, who withstood perfectly the altitude of 8800 metres.' At the 1937 Exhibition in Paris, he leapt from the parachute tower, and the subsequent certificate read: 'Jumped bravely with parachute from the top of the tower in Esplanade des Invalides (60 metres)'.

He was an atheist most of his life, but loved to argue religion. At the end of his life he was converted, and would address fervent prayers to the Virgin Mary; however, his faith was never very orthodox.

Works

As a painter, Gausson professed to be a pupil of Antonio Cortés and of Cavallo-Péduzzi. He was a great admirer of Millet and Théodore Rousseau, whose portraits he sculpted side by side (after Chapu), but Seurat was his favourite painter.

Gausson was a minor painter, but his works have some importance in the context of the history of neo-impressionism. Although his first paintings (1882) are very dark, he applied divisionism at a very early stage, in 1885. The most significant proof of Gausson's pioneer experiment lies in a painting on a white ground in sharply divided hues, dated 1886, two years before white grounds became used by painters of the neo-impressionist school (such as Hayet). Like the latter, Gausson painted on prepared cotton, and the majority of his neo-impressionist works were painted in quiet tones in the manner of Seurat. Gausson's landscapes are very characteristic, with their systematic pointillist outlining of roofs. Only a few of his paintings are still in existence, scattered in various collections and his engravings are scarce. Apart from what can be seen at the Musée de Lagny most of his sculptures have been lost, and little is known about his drawings. It would be impossible to gain any overall impression of his works without the help provided by the talented painter Edouard Cortés, who was a close friend and probably the only qualified observer to have seen all Gausson's works. His opinion is reported below.

Gausson was a very versatile artist, always willing to experiment. His style varied greatly, belonging in turn to impressionism, neo-impressionism, 'Pont-Aven', Nabi, synthetism, symbolism and *rose-croix*. His works remind one in turn of Millet, Théodore Rousseau, Whistler, Seurat, Gauguin, Sérusier and Vuillard. They are skilful, if lacking in individuality. The few paintings dated after 1910 are equally varied in style.

His versatility as an artist matched his unstable temperament and unsettled habits, his continuous moves, his endless arguments with colleagues. His acute sensitivity made him subject to constant and diverse outside

influences. He was incapable of sustaining his efforts in one direction for long, and soon lost interest in one subject to experiment with another. Even at the peak of his creative career, he painted intermittently and switched from oils to drawing, watercolours, engraving or sculpture. Most of his works depict the town of Lagny or the surrounding countryside. He also painted at Eragny, where he often stayed with the Pissarros, in Pontoise, and in Brittany. Some works were painted in Africa, mainly portraits of Africans. His works are very uneven in quality. Some possess charm, but others, such as those paintings of rocks looking like heaps of pebbles, are not worth looking at. His real talent lay in colouring, and in his ability to combine tones harmoniously. Contemporary critics, such as Gustave Kahn, Félix Fénéon, Jules Christophe and René Barjean were agreed in recognizing him as a talented colourist.

It is impossible to gauge the number of his works exactly, but it is estimated that there are 350 paintings and a number of watercolours and pastels. Drawings, including sketches, number probably several hundreds, and it cannot be estimated how many of his sculptures and engravings remain. The latter seem to find favour with connoisseurs. In the opinion of Edouard Cortés, Léo Gausson was more gifted as an engraver and draughtsman than as a painter.

Jean Sutter and Pierre Eberhart

Henri Delavallée 1862–1943

Henri Delavallée *Street in Sunlight* 1907

Life

Henri Delavallée was born in Rheims in 1862, from a middle-class family. His father was a prosperous industrialist. Henri was a brilliant student at the Lycée in Rheims, and was awarded the first prize in philosophy at the general examinations. At the age of nineteen, he was a student both at the Faculty of Letters at the Sorbonne and at the Ecole des Beaux-Arts, where his teachers were Henri Lehmann, Luc-Olivier Merson and Ernest Hébert. He also went regularly to the studio of Carolus Duran. At the Sorbonne, he gained an excellent degree in the shortest possible time.

It was at the Beaux-Arts that he met Gabrielle Moreau, herself a very gifted artist, whom he was to marry. He was particularly impressed by the works of Millet, as well as of Corot and Courbet. He was drawn to the open air and inspired by men at work, both labourers and peasants. In 1881, one of his studio friends, Hersart du Buron, took him on holiday with him in Brittany and showed him Ouessant, Le Faouët and Châteauneuf-du-Faou. He was one of the first to discover Pont-Aven. He found great inspiration in the landscapes and in the local inhabitants. From then on he was to come back every year for several months to Pont-Aven, where he acquired a house and, later, a sailing boat on the Aven. In the village, he came across the artists staying at the Pension Julia and the Pension Gloanec, and heard their heated discussions about art. This was how he became a friend of Gauguin, Sérusier and Emile Bernard. He was also one of the first artists to become initiated to the secrets of the Pont-Aven school.

His intelligent and clear mind prevented him, however, from adopting one technique to the exclusion of any other. In 1886, he painted in the manner of Gauguin, then in 1887, of Seurat. He did meet the latter at the time but his initiation to neo-impressionism came through Camille Pissarro, with whom he worked at Marlotte, near Fontainebleau. From 1887 to 1890, Delavallée painted a series of remarkable canvases in the optical technique with exceptional skill.

Still obsessed by Millet, Delavallée stayed in 1889 at Londemer, near the Cap de la Hague, in Millet's native countryside. He began there a new series, of etchings this time, in a style different from neo-impressionism. At Londemer he met two engravers, Pierre Vidal and Louis Monzies, who, impressed by their new friend's engravings, encouraged him to exhibit them in Paris. Delavallée followed their advice, and in the following year he exhibited at Durand-Ruel. This was the first success of his career.

After 1891, he not only left Pont-Aven but, like Gauguin, left France. He went to Turkey, in order to seek inspiration in another atmosphere and in a different light. He lived for nearly ten years in Constantinople, where his works were greatly admired. He painted and engraved landscapes and seascapes as well as what was still a favourite subject: the poor at work. Then the Vizier, who had admired his work, commissioned Delavallée to paint his portrait as well as those of his daughters, the princesses. Delavallée took an active part in local life; he was a friend of the Lumière brothers, and he brought cinematography into Turkey. He became so popular that, on his departure, the Union Française de Constantinople, which represented the resident French colony, awarded him an honorary diploma and the Turkish authorities covered him in medals and ribbons.

172 Henri Delavallée *Breton Woman, Pont-Aven*

Henri Delavallée *Farmyard* 1887

Back in France – he was about forty years old by that time – he shared his time between his estate at Apremont (Oise) and his house in Pont-Aven. There, he would get up early and catch the subtle effects of sun and light upon the sea and the fields. His work progressed steadily during the quiet, calm course of his life. After 1900, he turned back towards neo-impressionism, which had left a permanent mark on him, and went on tirelessly engraving. Later, his style became more classical, although still influenced by impressionism.

Emile Bernard was his most devoted friend; they were made to understand each other, and shared the same

173

reverence for art. Durand-Ruel and Vollard actively supported his work, which provided him with a comfortable income. During the Second World War, he became a citizen of Pont-Aven. A retrospective exhibition of his works took place at the Galerie Saluden in Quimper between October and November 1941. He died a short time later, in 1943, in Pont-Aven, at the age of eighty-one. He was buried in the Brittany he had loved.

<div align="right">Jean Sutter</div>

Gustave Perrot d. 1891

Very little is known about Gustave Perrot, who died young in 1891 or at the beginning of 1892. An ardent neo-impressionist and a close friend of Luce, he painted, like Luce, at Arcueil and Gentilly and at Villejuif where his family lived.

All the contemporary critics, from Félix Fénéon to Paul Alexis, praised his talent. The latter included a few paintings by Perrot in his famous collection. In the course of thirty years of research work into neo-impres-sionist painters, I have never come across a single work by him. He did, however, exhibit regularly, between 1886 and 1892, at the Indépendants, where a small retrospective exhibition of some fifteen of his works took place.

The only memory of this gifted painter can be found in an interesting painting by Luce, entitled *Interior : My Friend Perrot getting up.*

<div align="right">Jean Sutter</div>

Henri Delavallée *Breton Houses* Etching Théo van Rysselberghe *Auguste Descamps* 1894 ▶

Anna Boch 1848–1936

Anna Boch was born in La Louvière in 1848 and died in Brussels in 1936. She was the sister of the painter Eugène Boch, whose portrait was painted by Van Gogh. As a pupil of Isidore Verheyden, she later worked with Van Rysselberghe, fifteen years younger than herself. Landscapes, flowers and seascapes were her subjects. Her own work was uneven, but she showed a deep understanding for the problems of modern art. She bought from Van Gogh the only painting he was to sell during his lifetime. She also bought, and later donated or bequeathed to the Musées Royaux des Beaux-Arts in Brussels, a Gauguin, a Seurat and Ensor's *Russian Music*. Her private collection which was sold in 1936, after her death, included works by Jan Toorop, Van Rysselberghe, Alfred William Finch, Pantazis and Verheyden.

She became a member of Les Vingt in 1886 and exhibited every year at their Salon. In 1887, Emile Verhaeren wrote in *La Vie Moderne* that Anna Boch was making great progress.

In 1888, *Le Cri du Peuple* considered her to be of the standard of Vogels, and of Toorop 'whose retarded art stands nevertheless at the same level as that of the best exhibitors at the Salons'.

In 1889, the founder of Les Vingt, Octave Maus, in *La Cravache*, gave her the same ranking as Toorop, de Regoyos and Van de Velde, adding that her colours 'have become much purer'. In 1890, she exhibited in Paris, at the Société des Artistes Indépendants, at the same time as several members and guests of Les Vingt.

In 1893, Anna Boch tried her hand at decorative art, and exhibited at Les Vingt a four-panelled screen which unfortunately seems to have been lost.

Francine-Claire Legrand[1]

Frantz Charlet 1862–1928

Frantz Charlet was born in Brussels in 1862. He studied painting with Portaels in Brussels and spent two years in Paris working in the studios of Jules Lefèvre, Carolus Duran and Gérôme.

In 1883, after a first visit to Morocco, he took part in a successful exhibition at L'Essor, a Brussels art club, together with his friends Van Rysselberghe and Dario de Regoyos. He was to go back to Morocco several times, and to draw inspiration from Belgium and Holland, before settling down to chronicle the life of Paris, where he lived for most of his life.

He was a founder member of Les Vingt, and exhibited there in 1884, 1885, 1886, 1887 and 1889; he exhibited at La Libre Esthétique in 1897 and 1908.

On the occasion of the first Salon des Vingt, in 1884, Madeleine Maus mentioned Charlet as one of the younger painters who were anxious to lighten their palette and to use light as a means of expression.

Signac, in an undated letter, probably written in 1887, writes: 'The Belgian artists who come closest to our ideas are MM. Van Rysselberghe, Finch, Schlobach, de Regoyos and Charlet.' Seurat, too, mentioned Charlet as one of his followers, in 1889. At this period Charlet's links with the avant-garde artists were very close; Signac and Seurat expected his development to resemble that of Van Rysselberghe.

From 1903 onwards, Charlet took part in the exhibitions mounted by the Société Nationale des Beaux-Arts, in Paris, and in others at the Galerie Petit, including a one-man show in 1908. He was also a founder member of the Société Nationale de la peinture à l'eau. In 1925, at the Galerie Georges Giroux in Brussels, Charlet had a retrospective exhibition which revealed him as a minor impressionist master, alive to the fugitive and joyous aspects of life, and with a skilful and sensitive handling of the brush. He was always hostile to rigid theories.

Alfred William Finch 1854–1930

Finch, called 'Willi' or 'Willy' by his friends, was born in Belgium of British parents in 1854, and should be regarded essentially as a Belgian artist. He visited England periodically, and his wife and children bore English names, but little is yet known of his ties with his parents' homeland. He studied at the Brussels Academy from 1878 to 1880, at the same time as his friend James Ensor. They were both among the founders of Les Vingt in 1884. Finch also knew Whistler, perhaps through visits to England, and had him invited to the first exhibition of Les Vingt (Whistler, in turn, invited Finch to successive exhibitions of The Royal British Artists in London, in the winters of 1887 and 1888). Finch's work in the neo-impressionist manner began in the winter of 1887–88, following the exhibition of Seurat's and Camille Pissarro's paintings at Les Vingt in February 1887, and the constantly growing contacts with Paris. In January 1888, he wrote to tell Octave Maus (secretary of Les Vingt) of his fear that his work would too closely resemble that of 'our friends in Paris', and he volunteered a dotted drawing for the catalogue of the February exhibition. Paintings exhibited that year included several of Suffolk, England, but these antedated his adoption of the new style. The height of his neo-impressionist activity was reached in the period 1890–92, after which his paintings drop sharply off.

By 1890 he was attached to the Boch pottery works at La Louvière, and he remained there until 1892, increasingly concerned with ceramics. He experimented with neo-impressionist colour theory in pottery glazes, and wrote to Maus that he had designed some plates using Charles Henry's theories of harmonic proportions. With Georges Lemmen, who seems to have been his most intimate friend, he visited England in 1892. Then he settled in Brussels for several years. Few paintings are dated after 1892 until his later removal to Finland, and it is known that he had his own kiln for his ceramics. It can now be proved, furthermore, that he worked with Henry van de Velde at Uccle, and that his pottery was chosen to represent the Uccle establishment in 1897.

Count Louis Sparre, a Swedish painter, met Finch in 1897 and lured him to the Iris pottery works at Borgå, Finland. Although he intended to stay but a year, Finch spent the rest of his life in Finland, with occasional visits to Paris, Germany, Italy and England. By May 1899, the Borgå arts and crafts centre began to founder – according to Finch – owing to Count Sparre's frivolity and to the fact that every commercial order had to pass through the hands of the historian Julius Meier-Graefe, appointed sole agent for the Continent. Finch was named teacher of ceramics at the Central School of Industrial Arts in Helsinki in 1902, and he entered prominently into the art life of the capital. In November, 1903, he wrote to tell Van de Velde of the 'Exhibition of French and Belgian Painters' that he was organizing for the coming year, to include Seurat, Signac, Cross, Van Rysselberghe and Lemmen, as well as Monet, Degas, Pissarro, Renoir, Denis, Vuillard, Bonnard and others. It was the first exhibition in Finland of impressionist works, and had an immediate effect. Rallying around Finch and the critic and architect Sigurd Frosterus, young artists began to develop the modern Finnish school. In 1908 Finch helped form the Septem Group, which began exhibiting in 1912 and continued until 1928. Of the original group (Enckell, Ollila, Oinonen, Rissanen, Thesleff, Thomé), only Werner Thomé seems to have painted in the neo-impressionist fashion. In the opening exhibition of 1912, his and Finch's divisionist works were noted, and Finch's early paintings were preferred by the critics to his current, softened style. Although he sometimes used large, free dabs of paint, his paintings after 1900 are usually in a quasi-impressionist style rather like Luce's. His role in this century was found more in his ceramics, furniture and other industrial arts, and his collaboration with Saarinen and others to establish modern art in Finland. As a neo-impressionist, he was most significant from 1889 to 1892, and his paintings of those years are of truly superior quality.

Robert L. Herbert[2]

Georges Lemmen 1865–1916

Life

Born on 25 November 1865 in Schaerbeek, on the outskirts of Brussels, Georges Lemmen was the son of an architect who painted in his leisure time. His artistic talent and temperament, coupled with his family background, helped him to break away at an early age from academic influences.

Madeleine Maus described him as 'a cold and disconcerting man, secretive about himself and about his art'.

Elslander, in his *Figures et Souvenirs d'une Belle Epoque*, wrote of him: 'He was a cultured man, too proud to speak of his disappointments; no one could have guessed his sadness. Always elegantly witty, with sometimes a trace of irony in his eyes, he would enthuse about the works he loved with youthful excitement and infectious fervour.' His intense reserve, together with his ardent love for art, explain the contrasts to be found in both his life and works.

Accepted at the age of twenty-four by Les Vingt, he

22 *juillet* .91.

Georges Lemmen *Sketch for 'Seaside Promenade'*

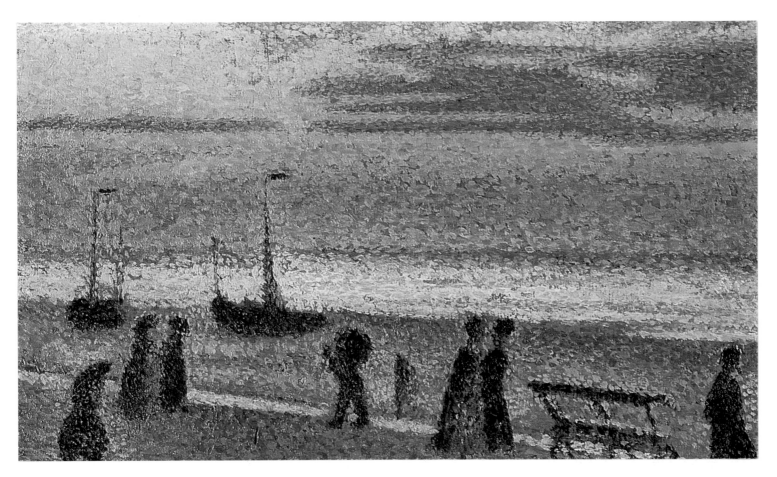

Georges Lemmen *Seaside Promenade* 1891

joined the battle for progressive art and realistic painting. He became one of the most active members of La Libre Esthétique as early as 1894, date of its founding, and of the Association pour l'Art in Antwerp, as well as of Vie et Lumière founded by the Belgian luminist painters. In *L'Art Moderne*, he published aggressive articles directed at official juries and backward museum directors, attracting a great deal of resentment. He formed deep and lasting ties of friendship with, among others, the symbolist poets Emile Verhaeren, Gustave Kahn and Grégoire Le Roy.

From 1890 to 1893, he sent some paintings to the Salon des Indépendants every year, and even thought so highly of the Parisian public as to send, in 1906, eighty works to Galerie Druet. This brought him so much success that, two years later, he again took part in an exhibition there, this time with sixty paintings. It was not until 1913, after many hesitations and under pressure from his friends, that he ventured to hold a large exhibition, in Brussels, at the Galerie Georges Giroux. To his surprise, it was a tremendous success, and at last brought him fame and some material comfort.

Recognition came too late; he died on 15 July 1916, at the age of fifty, in the pretty house he had just built at Uccle.

Works

It would be illogical to analyse Lemmen's paintings before drawing attention to his important contribution to decorative art, to which he devoted a great deal of his

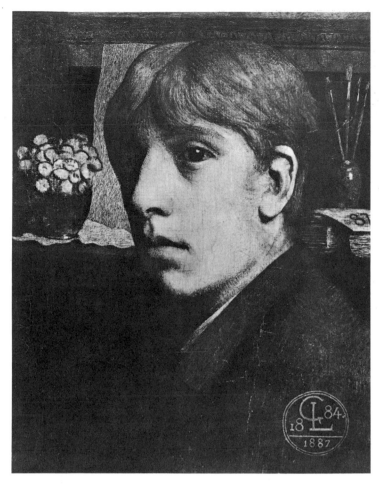

Georges Lemmen *Self-portrait* 1884–87

progressed alongside several. Any new technique interested him, and he conscientiously experimented with each one, thus showing perhaps more individuality than other artists who remained faithful all their lives to one particular technique not of their own invention. His neo-impressionist phase covered the longest period of his career. Although lasting only for five years (1890–95), during this period he nevertheless explored all the possibilities of optical mixing, from the use of the small, sharp dot to the broad juxtaposed touches, by means of drawing, gouache or oils, for portraits as well as for scenes of domestic life and landscapes. However suited the process appeared to be to his intellectual aims, it may be that it did not fully satisfy his sensitivity as a means of expression, although all his divisionist paintings manifest it clearly.

Lemmen's subjects were diverse, but intimate scenes seem to have suited him best. He has been compared to Vuillard and Bonnard, but it seems evident, in spite of some affinities, that Lemmen did not draw inspiration from either of these painters.

Scenes of domestic life, to his hypersensitive nature, represented a shelter from the irritating and disappointing world outside. The unity of his art was fully expressed in this intimism, which is the key to the sensitivity shown in his landscapes, flowers and nudes, as well as in his portraits, which possess a startling physical and psychological conviction.

Paintings by Lemmen are in many museums and private collections, both in Europe and in America. Since his death, there has only been one important retrospective exhibition, at the Galerie Maurice in 1959, as well as a smaller exhibition at the Galerie de l'Institut in 1966. However, the Guggenheim Museum in New York, in its 1968 exhibition 'Neo-Impressionism', allotted an important position to him.

A great number of Lemmen's drawings have been preserved, including crayons, red chalk, charcoal, pen and ink, often finished in watercolours. They stand out as a diary of the artist's life from which one can follow the direction of his experiments and the aims of his paintings. Of particular interest are the pastels and gouaches, often executed in diverse styles.

Lemmen reflected his era at the same time as his own personality. He is still a little-known painter, but knowledgeable collectors already recognize his value, and it may not be very long before the general public follows suit.

work. It must be said that decoration, around 1900, played an important and generally underestimated role, and that Lemmen, together with Van de Velde, promoted in Belgium this form of art which influenced his own work, in the sense that his paintings acquired a 'contemporary' style without, however, looking merely 'fashionable' as that of some of the minor painters did at the time. Furthermore, Lemmen's social attitudes – close to those of Emile Verhaeren and Constantin Meunier – incited him to promote the appreciation of applied arts such as wallpaper, posters, tapestry, typography, bookbinding and ceramics, of which he himself left many original examples, often reproduced in foreign publications.

Lemmen's work is, first and foremost, characterized by a great diversity of form combined with unity of inspiration. This is due to the fact that Lemmen did not – for a long time at least – adopt any particular school but

Henri Thévenin

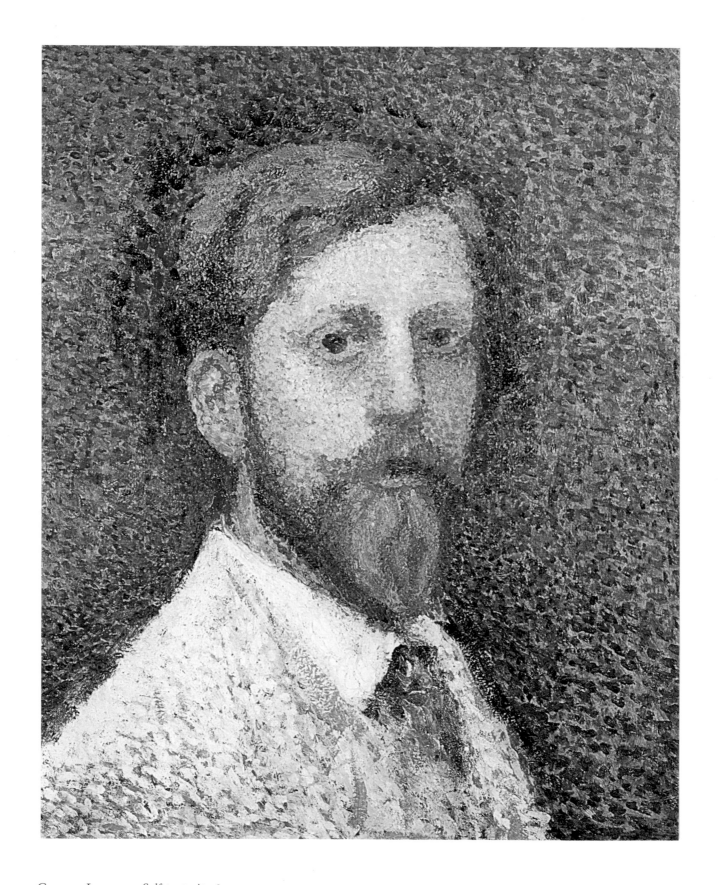

Georges Lemmen *Self-portrait* 1890

Dario de Regoyos 1857–1913

Born at Rivadesella in Spain, Dario de Regoyos died in Barcelona in 1913. From 1880 onwards he stayed frequently in Belgium. His portrait, painted by Van Rysselberghe in 1882, confirms the written description of him, given in 1883, in *L'Art Moderne*: 'This Spanish Moor, with his wild, swarthy, smiling, hirsute face and his guitar, is a familiar and popular figure.'

He was one of the founding members of Les Vingt in 1883, and exhibited every year except 1891. In 1884, he wrote to Maus: 'and now to something else, by Jove, it is good to come to Belgium, see one's friends, the exhibition at Les Vingt'. Every year, he went off to paint in Spain and returned to exhibit his works at Les Vingt.

In 1884, he adopted impressionism, although, in 1888, he admitted, in his own words, to 'experimenting with unmixed prismatic painting in thick brushstrokes', adding, however, 'I think that I will go back to my method of mixing with a knife'. Neo-impressionism was not a suitable style for his fiery temperament.

His works express the harsh and gloomy atmosphere of the provincial Spain which he called 'España Negra', and to which he introduced Emile Verhaeren in the course of their travels together.

In 1892, *Le Journal de Bruxelles* wrote: 'He is a talented and sensitive, even tragic, painter but, as in previous shows, what he is exhibiting consists of mere annotations, studies, strange experiments and picturesque sketches; he has not assembled them in a definitive work.'

Marie-Jeanne Chartrain-Hebbelinck[3]

Jan Toorop 1858–1928

Johannes Theodorus Toorop was born in Java on 20 December 1858, and died in The Hague on 3 March 1928. He has long been regarded as a major figure in Dutch art from 1890 to 1910, but primarily as a symbolist and Art Nouveau artist. His neo-impressionist work, although less important, extends over a period of twenty years. Brought to the Netherlands at the age of fourteen, Toorop studied at the Academy in Amsterdam from 1880 to 1882, and then moved to Brussels. During his three years there he studied first at the Brussels Academy, but his principal master was James Ensor, who befriended him in 1883. He went to Paris with Ensor, and confirmed there an admiration for Manet and French painting, in harmony with Ensor's early style. Toorop was made a member of Les Vingt in the winter of 1884–85, and exhibited with them regularly thereafter. His cosmopolitan formation continued with a stay in England in 1885, where he met Whistler and apparently developed an admiration for William Morris. Whistler's art became one of the principal influences on his work, and this continued strongly for several years.

In 1886 Toorop went to The Hague, but he was back in Brussels from 1887 to 1889, and absorbed the new enthusiasm for French neo-impressionism. Peasant subjects done in a modified neo-impressionist style are dated as early as 1886. At Les Vingt in 1889, he exhibited *On the Nes, Mother and Daughter* (Gemeentemuseum, The Hague), a street scene with a crepuscular tonality distantly derived from Whistler, but in a rather regular brushwork and divided colour that marked the acceptance of neo-impressionism. In 1889 also, Toorop moved to The Hague, where, with periods on the coast at Katwijk and Domburg, he remained until 1903. As a leading member of the Kunstkring in The Hague, he helped organize exhibitions of French and Belgian art, and it was undoubtedly his example that led Bremmer, Aarts and Vijlbrief into neo-impressionism in the years 1893–95. Aside from two seascapes exhibited at the Indépendants

Jan Toorop *Katwijk Harbour* 1892

in 1892, Toorop had little first-hand contact with Paris, but he kept abreast of developments thanks to his friendships with Van de Velde and Finch, and to the exhibitions in the Low Countries. Although he turned to Art Nouveau and the arts and crafts in the early 1890s, he continued to paint landscapes and occasional figures out-of-doors in the neo-impressionist technique. His brushstroke became progressively larger towards the turn of the century, and in the period 1903–09, when he was living in Amsterdam, his work might have had significance for Mondrian.

Robert L. Herbert[4]

Théo van Rysselberghe 1862–1926

Van Rysselberghe, long regarded as the principal Belgian neo-impressionist, was born in 1862, the last of five sons of a well-to-do building contractor in Ghent. He studied at the Academy there, then for a short time at the Brussels Academy. When only nineteen, in 1881, he won a travelling fellowship on the strength of two pictures he showed in the Brussels Salon. He went to Spain with the Hispano-Belgian painter Dario de Regoyos (later a neo-impressionist for a short period), and in 1883 to Morocco. These were the first of many trips which took him all over eastern and western Europe, as well as North Africa and the Near East, by the end of the century. As a founding member of Les Vingt in 1884, and already an intimate friend of Octave Maus, its secretary, and the poet Emile Verhaeren, Van Rysselberghe began to play a major part in the introduction to Belgium of avant-garde French and English art. For all the significance of Ensor and others of the group, Van Rysselberghe was second only to Maus in forming the taste of the exhibition society and its successor (from 1894), La Libre Esthétique. In 1887, for example, he visited Toulouse-Lautrec in Paris and urged him upon Les Vingt, long before the French artist was known; in 1889, in a single letter to Maus from Paris, he records efforts to enlist Gausson, Hayet, Van Gogh, Lautrec, Dubois-Pillet, Degas, Gauguin and Filliger, either visiting them in person or attending their exhibitions.

Van Rysselberghe's early style shows an admiration for Manet, Degas, Hals, the Spanish masters, Whistler (whom he met in 1885), and the Ensor of the early 1880s, not as eclectic a combination as it might seem, for they had in common a loose but strong brushwork and a love of contrasting light effects that was the mark of much progressive painting of the period in Belgium. The fact that they were all portraitists is equally significant, because Van Rysselberghe remained one all his life. His earliest important neo-impressionist paintings were in 1888, two years after his first contact with Seurat and Signac, and only in 1889 did he turn over completely to the new style. By then he was thoroughly immersed in the art circles of Paris, as well as Brussels, and along with Signac and Verhaeren he was among the chief emissaries linking the two cities. For a time in the middle 1890s, he designed furniture and the applied arts (some in collabo-

ration with Henry van de Velde), and he was a major illustrator of books by Verhaeren and other writers. He also designed posters, catalogues and the actual installations for Les Vingt and La Libre Esthétique, but in essence he was a painter. His work of the early 1890s is largely portraits and landscapes. From 1895 to 1898 he had a crisis of self-doubt and did much less painting. In the latter year he moved to Paris, and began to confirm changes that were already noticeable: he turned increasingly to the female nude, to large decorative paintings of the human figure out-of-doors, and to a loosened and modified neo-impressionist brushwork. This essentially conservative streak steadily broadened, until by about 1908 he had left neo-impressionism behind. His close friendship with Signac had waned by the turn of the century, but he remained intimate with Cross until his death in 1910, and he joined both of them in contributing to the development of fauvism. It was apparently he who got the Fauves to exhibit regularly in Brussels with La Libre Esthétique from 1906 on. Most of his later life was spent in Paris and on the Mediterranean coast, where he died in 1926.

Paul Fierens, Van Rysselberghe's admirer and biographer, said simply that 'he lacked imagination'. Van Rysselberghe's strength and his weakness lay in the same qualities: he never forsook a rather traditional concept of chiaroscuro (he did grisaille drawings right through his neo-impressionist period), and he did not, as did Cross and Signac, give first place to the construction of colour harmonies in the dialogue between picture and nature. Instead, he gave it to the subject *qua* subject, without always making a proper balance with creativity. One should be content, however, with such a large number of paintings in which directness of vision and a love of light formed what Maurice Denis called 'an art of probity and reflection, with neither hesitations nor maladroitness, a realistic art, but with all the seductions of reality'.

Exhibitions of neo-impressionism have always included Van Rysselberghe, and from the late 1890s to the First World War he was usually included in major international exhibitions of contemporary art. As a leader of Les Vingt and La Libre Esthétique he was in most of their annuals, and in 1898 and 1904 was given virtual one-man shows by the latter group. In Paris, he contributed to the

Théo van Rysselberghe *Big Clouds* 1893

Indépendants from 1890 to 1895, and from 1901 to 1906. His first one-man exhibition was at Laffitte in Paris, in 1895, and thereafter, at the Maison des Artistes in 1902, Druet in 1905, Bernheim-Jeune in 1908, Giroux (Brussels) in 1922 and 1927, Braun in 1932 and the Musée des Beaux-Arts, Ghent, in 1962.

<div align="right">Robert L. Herbert[5] 185</div>

Henry van de Velde 1863–1957

One of the most gifted and influential artists in Europe at the turn of the century, Van de Velde is thought of chiefly for his role in the decorative arts and architecture. Until 1894, however, he was a painter, and he figured importantly in the development of neo-impressionism in the Low Countries and Germany. He was born in 1863 of a highly cultivated Antwerp family, and had his early studies in the Antwerp Academy with Charles Verlat.

After spending the autumn and winter of 1884–85 in Paris, when he studied with Carolus Duran (Sargent was there at the same time), Van de Velde began to associate with the native Belgian school of Emile Claus, A. J. Heymans, Rosseels and Crabeels. From 1886 to 1890 he spent part of each year in Antwerp, but longer periods in semi-isolation at Wechel-der-zande, the Barbizon of Belgium, where Heymans and the others painted. His preoccupations were those of the native school: peasant subject matter, a related social consciousness, rural landscape, and light-struck painting; Millet was his chosen hero (and he saw Millet's retrospective in Paris in 1887). These were the concerns of Camille Pissarro and Seurat in the early 1880s, and it was logical that Van de Velde was gradually won over to their neo-impressionism. He first

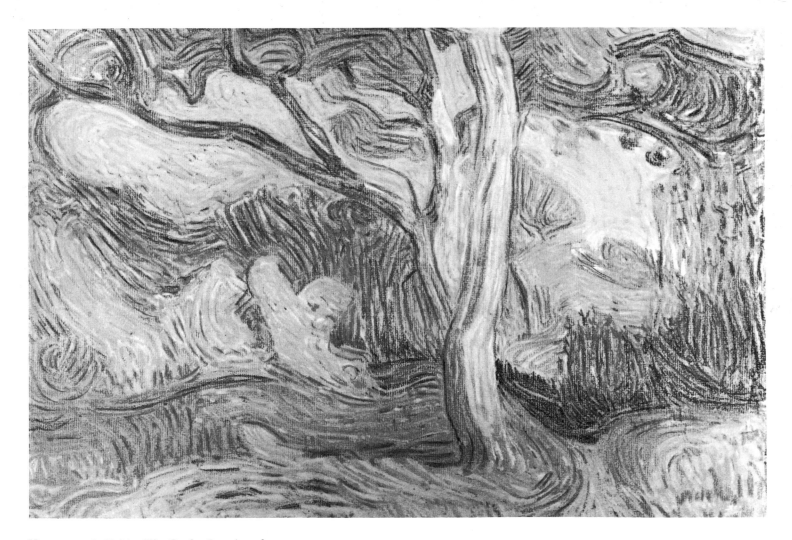

186 Henry van de Velde *The Garden* Pastel study

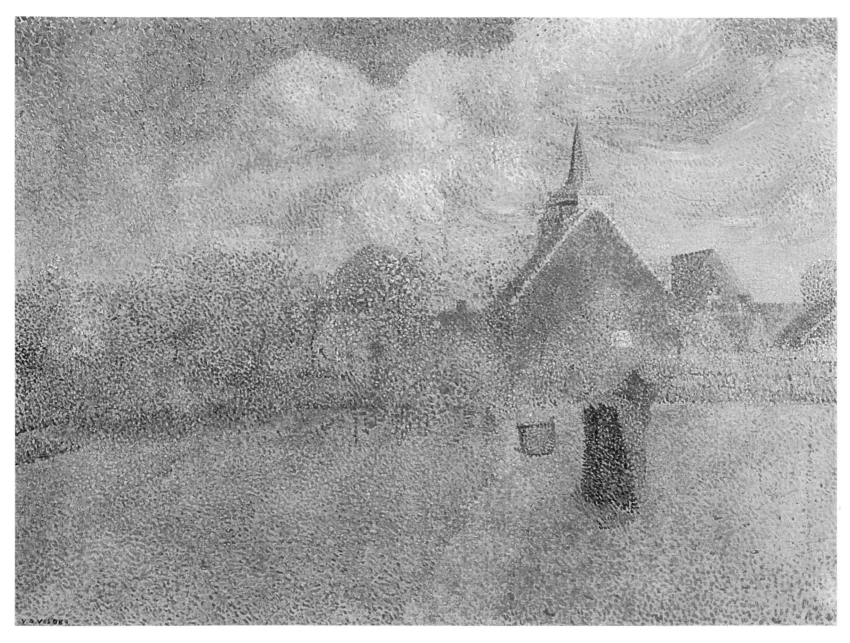

Henry van de Velde *Woman in an Orchard* 1888

saw Seurat's *La Grande Jatte* at Les Vingt in Brussels early in 1887. Two years later, when he himself exhibited as a member of Les Vingt, he was painting in a divisionist technique.

In 1890, Van de Velde left his partial retirement at Wechel-der-zande and began his long and productive life as a many-sided artist, with painting itself gradually giving way to other activities. He regularly published essays on art in *La Wallonie* and *L'Art Moderne*, and shared in the organization of important art societies and exhibitions in Antwerp. His prior devotion to social thought, including a great admiration for Ruskin and Morris, led him progressively towards the decorative arts, and inevitably, towards the style of Art Nouveau. There was a fascinating interim period, in 1891–93, when he painted and drew in a *Strichmanier*, long strokes of

pure colour in serpentine movements, combining neo-impressionist colour with the new enthusiasm for Van Gogh, yet in a highly personal manner.

By 1894 he had largely given up painting, and his history thereafter belongs to the world of architecture and the applied arts, in which he is a towering figure, both for the significance of his art and for the quality of his thinking. He collaborated with Finch, Lemmen and Van Rysselberghe in a number of applied arts projects. He contributed essays and designs to a number of the principal reviews in France, the Low Countries and Germany which favoured the neo-impressionists. As a friend of Julius Meier-Graefe and Count Kessler, he helped introduce Seurat, Signac, Cross and the others to Germany by organizing exhibitions and encouraging German patrons. In 1900 he designed the Folkwang Museum in Essen, so important for neo-impressionism, and among his later activities one might mention his plans for the Rijksmuseum Kröller-Müller in Otterlo, which houses the greatest public collection of neo-impressionism.

Of the many exhibitions devoted to Van de Velde, the most important for his paintings are those in 1958 at the Kunstgewerbemuseum in Zurich, in 1959 at the Karl-Ernst-Osthaus-Museum in Hagen, and in 1963 at the Palais des Beaux-Arts, Brussels. His neo-impressionist paintings include *Woman going to Church*, 1889 (Mr and Mrs Herman E. Cooper, New York), *Woman at Twilight,* 1889 (Rijksmuseum Kröller-Müller, Otterlo), and *Père Biart reading in the Garden,* 1889 (Edgar Biart, Lausanne). The *Strichmanier* paintings in which neo-impressionism is still felt strongly include *Garden at Kalmthout, c.* 1892 (Bayerische Staatsgemäldesammlungen, Munich), and *Garden in Summer, c.* 1892 (Karl-Ernst-Osthaus-Museum, Hagen).

Robert L. Herbert[6]

Guillaume Vogels 1836–1896

Born in Brussels in 1836, Vogels was a self-taught painter of landscapes, seascapes and flowers. He started as a housepainter, with his own firm. A few years ago there were still a few houses in Ixelles, near Brussels, painted by him. His earliest easel paintings or, at least, the earliest paintings still in existence, are dated 1878–80 and still bear traces of a realism and an attention to detail which were to disappear in later works. The Greek painter Pantazis had arrived in Brussels a short time earlier to work for Vogels. The two artists probably influenced and helped each other. Vogels exhibited in 1878 at La Chrysalide in Brussels, then in 1881 at the Salon de Paris.

He became the most impressionistic of Belgian painters. The unevenness of his style, with its impulsive spontaneity, did not match the style applied in France at the time, but belonged to a form of pure painting, already beyond impressionism, where the subject lost importance in favour of muted colours occasionally scarred by a vivid streak of loud hue.

He was a founding member of Les Vingt in 1883, with Ensor and Pantazis. He was much admired at the beginning, and remained loyal to the movement until it dissolved in 1893. Emile Verhaeren wrote in *La Jeune Belgique* (1883–84): 'Vogels is a master who is steadily progressing in a style of real importance. He has talent and individuality.' *L'Art Moderne* described him even more accurately: 'So far, there are not many painters who have so successfully managed to surround their subjects with the air and light enveloping them. Manet attempted to solve this problem, and his school of followers carried it further than he did. Now Vogels and Ensor are trying to solve it once and for all. To a certain extent, they are succeeding.'

Francine-Claire Legrand[7]

1 3 7 *Le Groupe des Vingt et son temps,* Brussels, 1962 2 4 5 6 *Neo-impressionism,* New York, 1968

Cavallo-Péduzzi

Cavallo-Péduzzi *The Three Local Characters* 1885

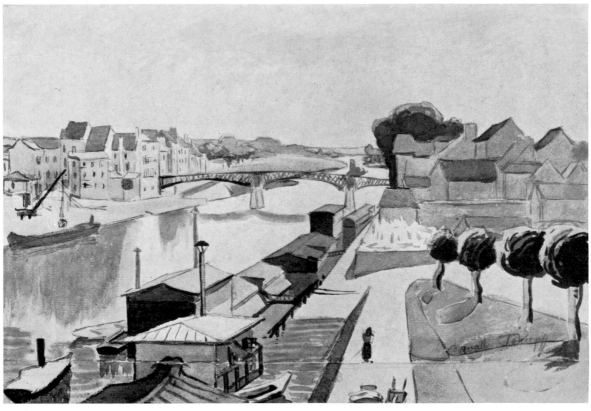

Cavallo-Péduzzi *The Wash-boats and the Iron Bridge at Lagny* c. 1890

Cavallo-Péduzzi, *c*. 1910

Cavallo-Péduzzi *Portrait of a Young Woman c.* 1890

Léo Gausson *Cavallo-Péduzzi* 1892

Luce

Maximilien Luce, 1885

Maximilien Luce *Charles Angrand*

Maximilien Luce, 1938

M. Luce *Aunt Octavie at Home* 1880

Maximilien Luce *The Banks of the Bièvre* 1888

Maximilien Luce *The Ragpicker* 1887

Maximilien Luce *The Bièvre at Arcueil* 1887

Maximilien Luce *A Kitchen* 1888

Maximilien Luce *Rue Mouffetard*
1889-90

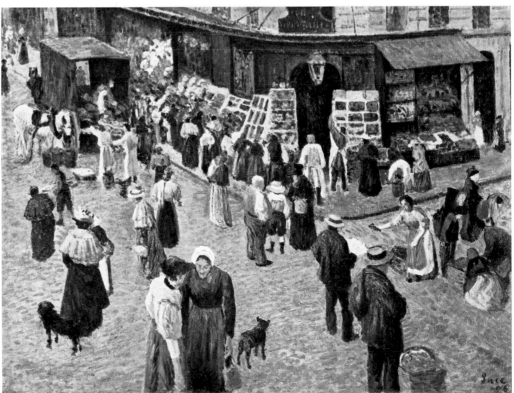

Maximilien Luce *Rue des Abbesses,
Grocer's Shop* 1896

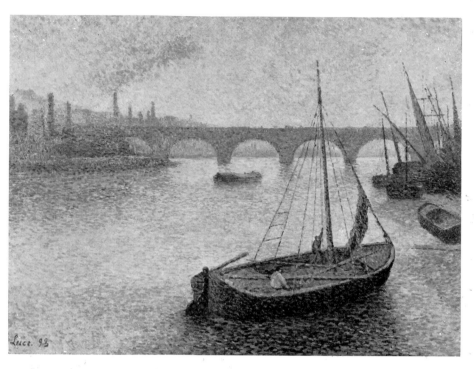

Maximilien Luce *The Pool of London* 1893

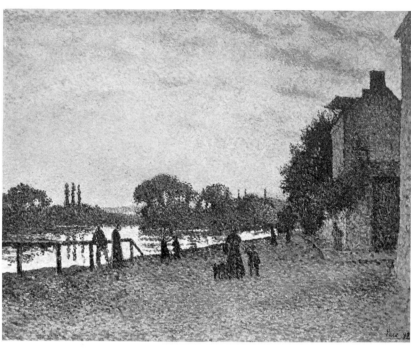

Maximilien Luce *The Banks of the Seine at Herblay* 1892

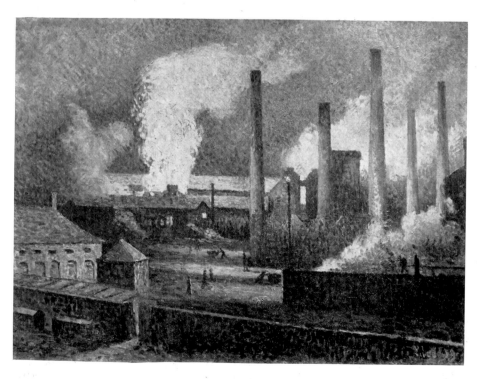

Maximilien Luce *Factory near Charleroi* 1899

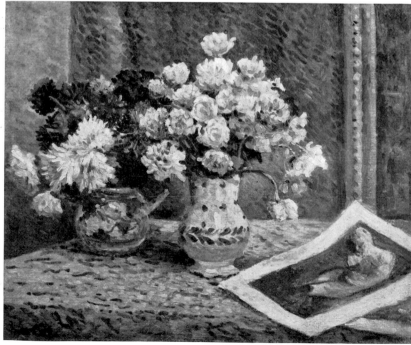

Maximilien Luce *Flowers* 1906

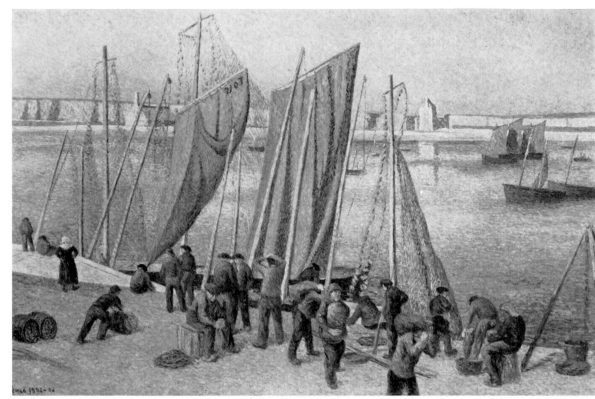

Maximilien Luce
Camaret Harbour 1894–1906

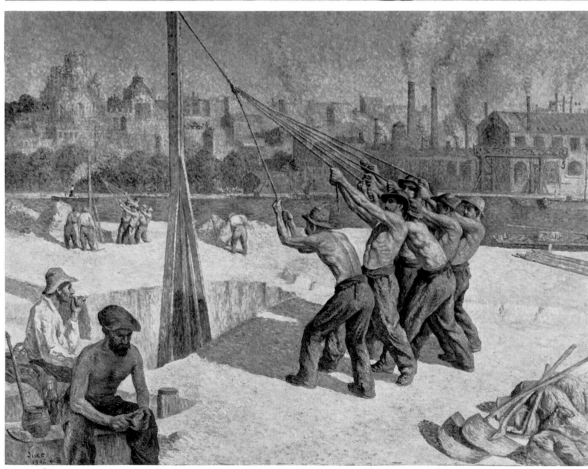

Maximilien Luce *Pile-drivers* 1902

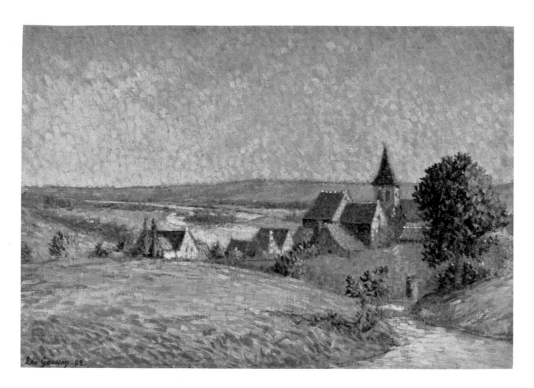

Léo Gausson *The Village* 1888

Léo Gausson as colonial official, Guinea, *c.* 1905

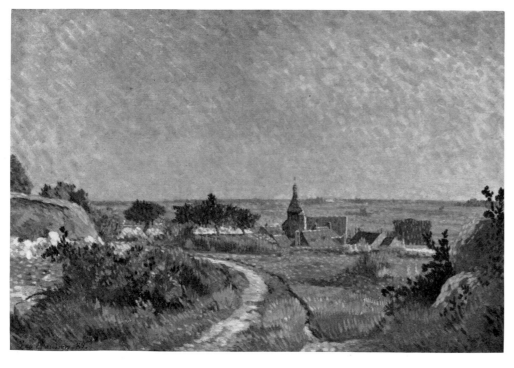

196 Léo Gausson *The Village* 1889

Léo Gausson *French Village* 1887–88

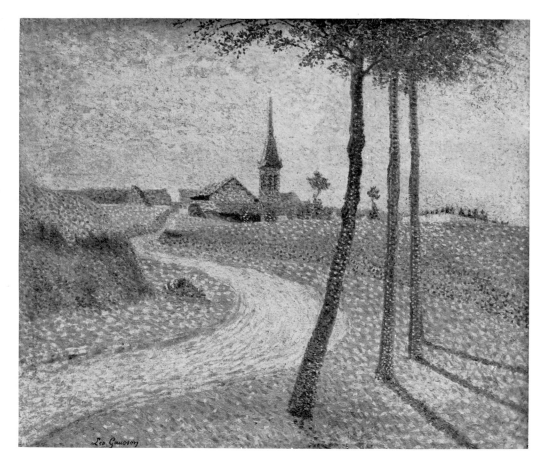

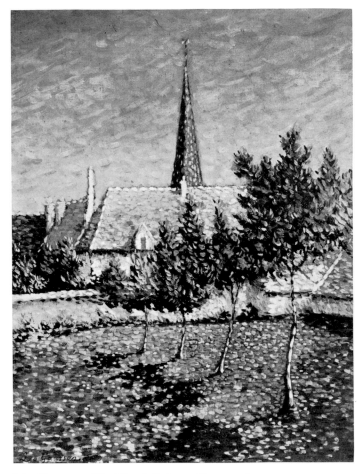

Léo Gausson *The Church Spire at Eragny* 1890

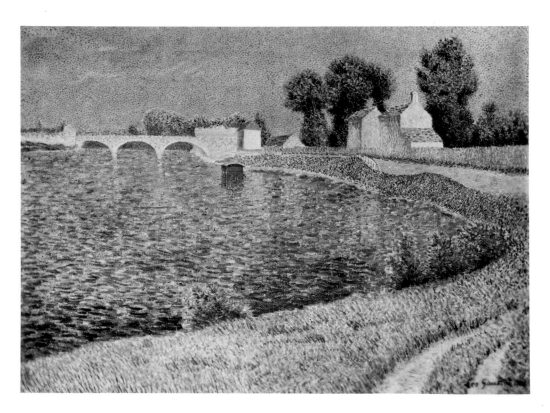

Léo Gausson *The Pré-Long Basin on the Marne at Lagny* 1886

Léo Gausson *Farmyard at Gouvernes* 1890

Léo Gausson *Farmyard* 1891

Léo Gausson *Barges on the Marne* 1890

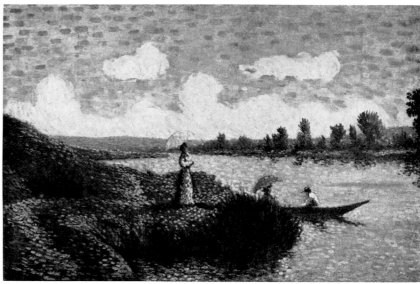

Léo Gausson *Boating c.* 1891

Delavallée

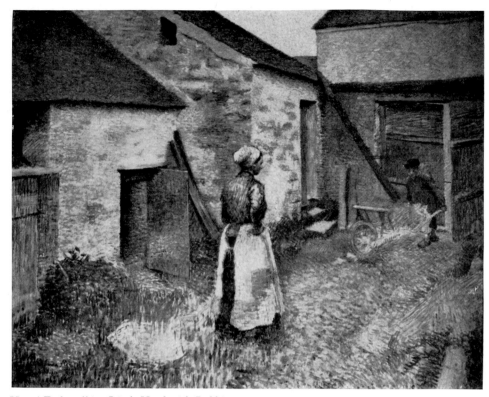

Henri Delavallée *Little Yard with Rabbits* 1887

Henri Delavallée at 25, 1887

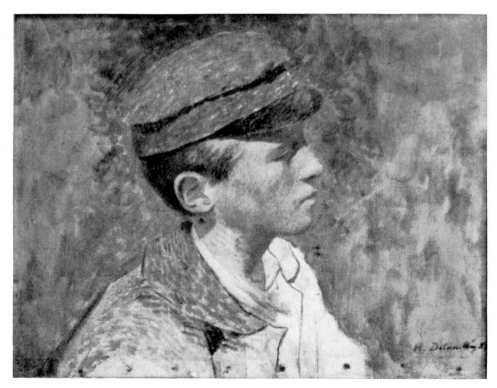

Henri Delavallée *Boy in Cap* 1887

Henri Delavallée *Cabin by the Sea* c.1888

Henri Delavallée *The Groom* 1888

Maximilien Luce *Interior :*
My Friend Perrot getting up 1890

Boch

Anna Boch *Landscape*

Théo van Rysselberghe *Anna Boch* 1893

Charlet

Frantz Charlet *The Terrace of the Tuileries* 1924

Finch

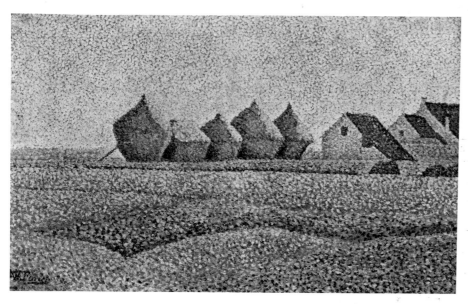

Alfred William Finch *The Haystacks* 1889

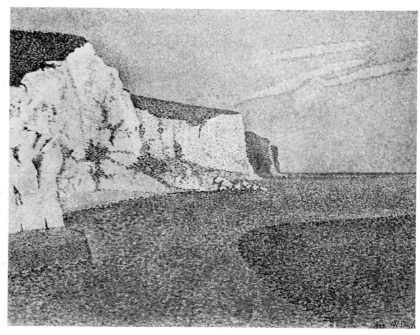

Alfred William Finch *Cliffs at the South Foreland* 1891–92

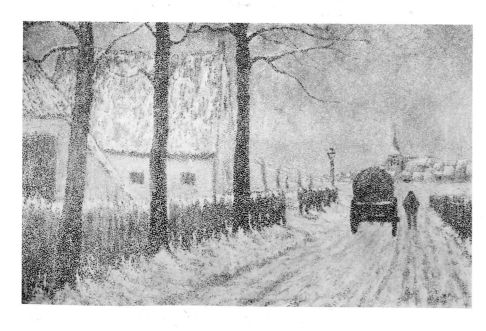

Alfred William Finch *Suburb in the Snow* 1888–89

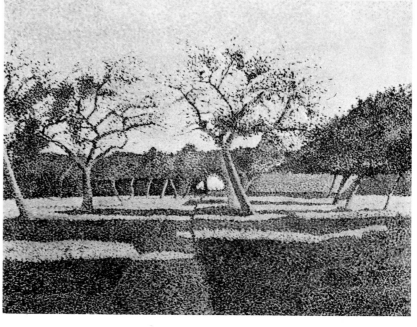

Alfred William Finch *Orchard at La Louvière* c. 1891

Lemmen

Georges Lemmen *The Thames* 1892

Georges Lemmen and his wife, *c.* 1895

Georges Lemmen *Factory on the Thames c.* 1892

Georges Lemmen *The Serruys Sisters* 1894

Georges Lemmen *Woman sewing* c. 1896

Georges Lemmen *Washing*

De Regoyos

Théo van Rysselberghe *De Regoyos* 1882

Dario de Regoyos *San Pedro de Torello*

Toorop

Jan Toorop *Shell-fish Gatherer on the Beach* 1891

Jan Toorop *The Sea* 1898

Jan Toorop *Guillaume Vogels*

Jan Toorop *The Middelburg Canal* 1907

Van Rysselberghe

Théo van Rysselberghe *The Scheldt upstream from Antwerp* 1892

Théo van Rysselberghe, 1900

Théo van Rysselberghe *Landscape with Mill* c. 1892

Théo van Rysselberghe *Young Woman by the Sea* 1901 Théo van Rysselberghe *Woman before a Mirror* 1908

Théo van Rysselberghe
Harbour Entrance, Volendam 1896

Théo van Rysselberghe *Bathers at Cavalaire* 1905

Van de Velde

Henry van de Velde *Blankenberghe* 1888

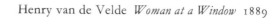
Henry van de Velde *Woman at a Window* 1889

Henry van de Velde, *c.* 1896–1900

Henry van de Velde *The Beach, Blankenberghe* 1889

Henry van de Velde *Childish Landscape* c. 1890

Henry van de Velde *Père Biart reading in the Garden* 1891

Henry van de Velde *Winter Sunlight* 1892

Henry van de Velde *Wechelderzande Church* c. 1900

Vogels

Guillaume Vogels *Twilight over the Pond*

The Société des Artistes Indépendants

The history of the neo-impressionist school is closely interwoven with that of the Société des Artistes Indépendants (S.A.I.), or, in other words, with the de-institutionalization of art and of artists. In France, until 1648, the future of the arts was intimately bound up with the guild system. Then Charles Le Brun founded the Académie Royale de Peinture, in opposition to the Académie de Saint-Luc which represented the guilds. The Académie Royale took over the Salon du Louvre in 1737, and the jury was created in 1747. In 1791, the Constituent Assembly freed all artists. In 1793, the Commune générale des Arts replaced the Académie Royale, under the same management, however. A republican and popular Société des Arts was then founded in opposition. The hold of the Academy on the Salon lasted from the reign of Napoleon I to the Third Republic. In 1863 came the Salon des Refusés, the safety valve instituted for irate artists by Napoleon III. The Third Republic attempted in vain to grant them their freedom and this gave rise to the founding of several private societies. From one of them salvation finally came, when a representative society of artists was created, without juries or awards.

As we have mentioned in the study of Seurat's life, a group from the Société des Jeunes Artistes – who, since 1882, had succeeded in organizing two efficient exhibitions – took over the lead of the rebellion against the 1884 Salon by the rejected artists, and founded the Groupe des Artistes Indépendants (G.A.I.). They also organized the exhibition of 15 May 1884. Inconsistent and disorganized, the new group fell apart during that exhibition, under the impulse of an older artist, Redon. It was the officer-painter Dubois-Pillet who finally carried out the necessary reorganization.

The Société des Artistes Indépendants was founded on 4 June 1884; its statutes were laid down by Dubois-Pillet and Jaudin and registered at a notary's office in Montmorency on 11 June 1884. Over one hundred artists rallied round Dubois-Pillet and were to trust him implicitly in future. A three years' fight ensued between the Groupe – which was stronger than anticipated – and the Société. The exhibition of 10 December 1884 to 20 January 1885, organized by Dubois-Pillet at the Pavillon des Champs-Elysées for 139 artists, was a complete financial failure. The Société had to face debts amounting to 2,300 francs which precluded for a long time any new venture on the part of Dubois-Pillet.

After a few weeks' truce, hostilities began afresh between the Groupe and the Société. The Groupe's leader, V. Sardey, was a tough and efficient organizer who relentlessly fought the Société and its members. *Le Moniteur* announced that the next Groupe exhibition would open, as in 1884, in May.

Sardey was supported by a Committee which, apart from the Salon's rejected painters, included such artists as Henry Cros, Guérin des Longrais and Lutor. *Le Moniteur* was filled with announcements by the Groupe, as well as with fantastic promises to present and future adherents. As arranged, the Salon opened on 1 May 1885, in Building B of the Tuileries, where 511 works were exhibited. Large crowds came to the exhibition. Sardey re-instated awards such as medals in various metals, mentions etc. New adherents hastily added paintings to the exhibition. Sardey also agreed to the collection of money at the exhibition by the Comité des Femmes de France for the benefit of the wounded in the Indo-Chinese wars. The critic of *Le Moniteur*, de Rockencourt, wrote several notices about this exhibition which was so successful that it was extended until 21 June, and ended by saying: 'M. Sardey, the life and soul of the "Groupe" – not to be confused with the Société – has very intelligently conducted its organization.'

It was now up to Dubois-Pillet to react in the face of this obvious success. In order to strengthen his ranks of adherents and boost their morale, he organized a dinner, celebrating the anniversary of the founding of the S.A.I. at 8 o'clock precisely on 23 June at Catelain's Restaurant de Paris, 23 Galerie Montpensier, Palais-Royal. This

dinner was to take place in future every other month. The report in *Le Moniteur* of 3 July described Dubois-Pillet's strategy: apart from a great number of artists, 'some members of the Municipal Council were present', and, again, 'after a toast by the President to the future of the Société, the dinner was given the humorous name of "Le Rouge et le Bleu", ("The Red and The Blue"), the colours of the City of Paris. The Société was obviously aiming at political support.

Furthermore, the Committee of the S.A.I. presented the Municipal Council on 2 July 1885 with a report describing in detail the aims of the S.A.I. as opposed to the G.A.I., in justification of the founding of the Société.

The report was in the shape of a faithful record of the events of the spring of 1884. This time, the attack directed at Sardey was deliberate and open, as can be judged from the following text:

'Finally, we should like to inform you that M. Sardey, in October last, promised the artists an exhibition which would not require the payment of an entry fee. However, at his latest exhibition in the Carrousel buildings, he demanded payment of 10 francs from each exhibitor and, now that the exhibition is closing down, he demands another five francs before works can be taken away.'

'We hope that the Municipal Council will differentiate between a legally constituted Society, created for the benefit of artists and aiming at the development of their talent, and an industrialist of art, an exhibition contractor.'

Sardey, who believed he had won the battle since his successful Salon, retaliated by publishing, on 13 August, in *Le Journal des Arts,* a Groupe circular directing accusations at Dubois-Pillet personally. On 27 August, the Société replied by publishing in the same paper a letter signed by several artists including Seurat, Signac and Cross.

At the close of 1885, the Société revised its rules for the benefit of adherents residing outside the departments of Seine and of Seine-et-Oise. In future, after their first year of membership, they would be exempted from exhibition fees. Dubois-Pillet thus opened the doors of the Société to provincial artists, and thereby broadened his base.

During that year he had managed to help the Société over the most difficult period of its existence in spite of the difficulties involved in organizing exhibitions, the debts, the suspicions and the competition from the Groupe. He kept the Société on a tight rein and inspired its members with faith in the future.

In this long-drawn struggle, the year 1886 was decisive. 'Le Rouge et le Bleu' held a dinner on 12 January. On 26 March, Sardey gave the date of the G.A.I.'s next exhibition, 5 May to 20 June 1886, announcing the prizes: medals, mentions, lotteries, etc. The Committee was still the same, and he claimed that the Groupe numbered approximately one thousand members.

On 2 April, the Société des Artistes Indépendants retaliated at its 13th General Meeting with, on the agenda: 'To discuss the next exhibition'. A week later, it was announced that the next exhibition would open on 20 August in rue des Tuileries.

Dubois-Pillet now proceeded to outmanoeuvre Sardey. On 23 April he fixed the sending-in date of the works for the exhibition: 13 August. The 15th General Meeting dealt with the organization of the exhibition. On 4 May, Dubois-Pillet put an announcement in *Le Moniteur* pointing out that the Société was not to be confused with the Groupe, that each member would be allowed to send in five exhibits, and that the rules would be published later. Meanwhile, the Groupe was prevented from holding its own spring exhibition in Building B. Sardey was forced to announce, in *Le Moniteur* on 11 May, that the Town Council was holding examinations in Building B and that the opening date of the Groupe's Salon was postponed until 18 August; the closing date was to be 20 September.

It would be interesting to know what discussions took place in the Municipal Council, and what political intrigues led to the famous buildings being shared by the two rival bodies. This drastic move was bound to cause the downfall of one of the two groups.

Dubois-Pillet calmly went ahead with his plans, and on 9 July he announced his 17th General Meeting, with, on the agenda, the election of the hanging committee. The 18th Meeting was held on 30 July, and on 6 August he again published a notice in the press drawing attention to the Société as distinct from the Groupe. At last, on 20 August, the exhibition opened.

As soon as the twin exhibitions opened, the critics' preference became obvious and the editor-in-chief of *Le Moniteur des Arts* himself, Alfred Chérié, praised on 27 August the statutes, the integrity and the exhibited works of the Société.

The press began to attack Sardey. Jean Songère of *Le Gaulois* called him 'a speculator, representing nothing but his own interests'. Lengthy extracts from Songère's article appeared in the artistic press. *Le Moniteur des Arts,* for instance, wrote: 'The personal attack directed at the Groupe's president will surely lead him to wish to refute

the accusations levelled at him', adding: This calls for a reply which we will have pleasure in printing'.

But there was no reply, and Dubois-Pillet, aware of his impending victory, wrote on 10 September: 'Following an announcement in several newspapers to the effect that the exhibitions in rue des Tuileries are unable to cover their expenses, the Société des Artistes Indépendants wishes it to be known that its own expenses have been met in their totality several days ago, and that any subsequent income therefore represents a net profit for the Société.' This, again, was a wise move.

Victory was confirmed when, in 1889, the Société established itself firmly. The Salon des Indépendants – still very much in existence today – went on to a brilliant career, playing a prominent part not only in the development of French art but also in international modern art. Over the years, the Salon was to be intimately involved with every modern school or group: neo-impressionists, Nabis, Fauves, cubists, orphists, futurists, purists and abstractionists. They enabled a great number of outstanding artists, such as Douanier Rousseau, Van Gogh, Ensor, Rouault and Van Dongen, to become known through their exhibitions.

During the fifty-six years between 1884 and 1940, there was always a member of the neo-impressionist school actively engaged in the S.A.I. either as president, or on the committee, or dealing with administration or such matters as the hanging of works. We have already recounted Signac's role over a period of fifty years. After his resignation in 1934, Luce took over his duties until his death at the beginning of 1941. Dubois-Pillet's dedicated work was thus carried on, through his friend's devotion, and ensured the freedom of art and artists from institutional control, one of the most important steps towards democracy in France.

This liberalization became generally effective in 1912, when Marcel Sembat introduced a bill into parliament claiming independence from the State for art and artists. In practice, the Société had already achieved this for itself, with powerful political support, mostly behind the scenes. This point still remains to be finally settled. It must be emphasized, however, that the Municipal Council in Paris was instrumental in the S.A.I.'s achievement.

Jean Sutter

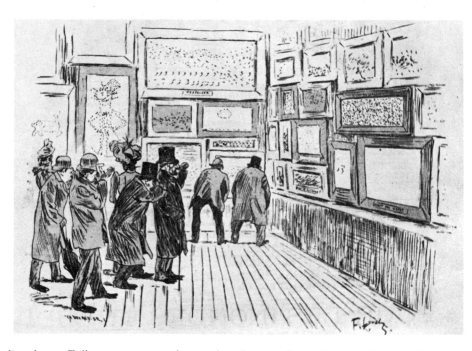

F. Lunel *The Salon des Indépendants: Full stops, commas and semi-colons* Cartoon from *Courrier Français*, March 1890

216 Albert Dubois-Pillet *The Town Hall Ball: the Prefectural Entrance* 1887

Appendices, Bibliography, Index, List of the Plates

Félix Fénéon, his wife Fanny and a niece, *c.* 1900

Félix Fénéon at Saint-Raphaël, 1937

Appendices

Letter from Seurat to Félix Fénéon

Paris, 20 June 1890

My dear Fénéon,

Please allow me to correct an error in your biography of Signac, or rather, to avoid doubt, please allow me to clarify. – It beguiled – 'It was about 1885' (p. 2 para. 4). Begun [*sic*] the evolution of Pissarro and Signac was slower. I protest, and I set out, to within 15 days either way, the following dates:

The purity of the spectral element being the keystone of my technique – which is enshrined by *you* first and foremost.

Having sought, ever since I have been able to hold a brush, an optical formula on this basis 1876–84.

Having read Charles Blanc at school and knowing Chevreul's laws and Delacroix's precepts for the same reason.

Having read the studies of the aforesaid Charles Blanc on the aforesaid painter (*Gazette des Beaux Arts*, vol. XVI, if my memory serves me aright).

Knowing Corot's ideas (copy of a personal letter 28 October 1875) on colour values, and the precepts of Couture on the delicacy of tints (at the period of his exhibition), being struck by the intuitions of Monet and Pissarro, sharing certain of Sutter's ideas on the ancient art of the Greeks, which I was pondering at Brest (*Journal de l'Art*) March and February 1880.

Rood having been brought to my notice by an article by Philippe Gille, *Figaro*, 1881.

I wish to establish the following dates, indicative of my prior claim to paternity.

1884 *Grande Jatte* study – exhibition of the Indépendants.
1884–5 *Grande Jatte* composition.
1885 Studies at La Grande Jatte and at Grandcamp, more work on *Grande Jatte* composition.
1886 October at Durand-Ruel's.
1886 January or February little canvas by

Pissarro at Clozet's the dealer's in the rue de Châteaudun – divided and pure.

Signac finally convinced; had just finished *The Dressmakers* at the same time as I finished the *Jatte*. On the same lines as my technique he painted:

(1) *Passage du Puits Bertin, Clichy*. March–April 1886.
(2) *The Gasometers*. Clichy, March–April 1886 (catalogue of the Indépendants).

For these reasons estrangement from Guillaumin who had introduced me to Pissarro, and whom I saw on the strength of Signac's old friendship.

You will admit that there is a slight difference, and that although I may have been unknown in 1885 I did exist, and so did my vision, which you have described in an impersonal form, in such a distinguished way. apart from one or two insignificant details.

M. Lecomte had already neglected me in favour of Charles Henry, whom we did not even know before the rue Laffitte (error cleared up).

It was at Robert Caze's that we were brought into contact with a number of writers of Lutèce and Le Carcan (*Petit Bottin des arts et des lettres*).

Pissarro came then with Guillaumin.

Then you brought me out of the shadows – together with Signac who benefited from my researches.

I rely on your integrity to pass on these notes to MM. Jules Christophe and Lecomte.

Yours most cordially and sincerely,

Seurat

Letter from Seurat to Maurice Beaubourg
28 August 1890

AESTHETICS

Art is harmony. Harmony is the analogy

Maximilien Luce *Félix Fénéon c.* 1905

between opposites, the analogy between like things, in value, colour and line, considered in terms of the dominant, and under the influence of a lighting in cheerful, calm or sad combinations.

The opposites are:

For *value*, that which is $\begin{cases} \text{more luminous} \\ \text{lighter} \end{cases}$

and that which is darker.

For *colour*, the complementaries, i.e., a certain red contrasted with its complementary, etc. (red-green, orange-blue, yellow-violet).

For *line*, those which make a right angle.

Cheerfulness, in terms of *value*, means a luminous dominant tone; in terms of *colour*, a warm dominant tone; in terms of *line*, lines above the horizontal, thus:

Calm, in terms of *value*, means equilibrium between dark and light; in terms of *colour,* equilibrium between warm and cold; in terms of *line*, the horizontal.

Sadness, in terms of *value*, means a dark dominant tone; in terms of *colour*, a cold dominant tone; in terms of *line*, downward movements, thus:

TECHNIQUE

Given the phenomena of the duration of the light impression on the retina.

Synthesis is an inescapable consequence. The means of expression is the optical mixing of values, and colours (both local colours and those of the light source : sun, paraffin lamp, gaslight, etc.), i.e. the optical mixing of lights and their reactions (shadows) in accordance with the laws of contrast in the gradation of illumination.

The frame is coloured in that harmony which contrasts with the values, colours and lines of the paintings:

Bibliography

GENERAL

1924 Gustave Kahn, 'Au temps du pointillisme', in *Mercure de France*, 1 April, p. 5–23.

1938 Jean Ajalbert, *Mémoires en vrac. Au temps du symbolisme 1880–1890*. Paris, Albin Michel, 1 vol., 416 p.

1948 Félix Fénéon, *Œuvres. Introduction de Jean Paulhan*. Paris, N.R.F., 1 vol., 480 p.

1948 Thadée Natanson, *Peints à leur tour*. Paris, Albin Michel, 1 vol., 390 p.

1949 K. J. A. Halbertsma, *History of the Theory of Color*. Amsterdam, Swets et Zeitlinger, 1 vol., 247 p.

1950 Camille Pissarro, *Lettres à son fils Lucien*. Paris, Albin Michel, 1 vol., 526 p.

1956 John Rewald, *Post-Impressionism from Van Gogh to Gauguin*. New York, Museum of Modern Art, 1 vol.

1959 John Rewald, *Histoire de l'Impressionnisme*. Paris, Club des Editeurs, 1 vol., 296 p.

1960 Robert L. Herbert and Eugenia W. Herbert. 'Artists and Anarchism. Unpublished Letters of Pissarro, Signac and Others', in *Burlington Magazine*, vol. 102, p. 473–482, 517–522.

1961 John Rewald, *Post-Impressionism from Van Gogh to Gauguin*. New York, 1 vol. (2nd edn).

1964 W. I. Homer, *Seurat and the Science of Painting*. Cambridge (Massachusetts), The M.I.T. Press, vol. XVIII, 328 p.

1964 Françoise Cachin (ed.) : Paul Signac, *D'Eugène Delacroix au Néo-Impressionnisme*. Paris, Hermann, 1 vol., 173 p.

1966 Françoise Cachin (ed.) : Félix Fénéon, *Au-delà de l'Impressionnisme*. Paris, Hermann, 1 vol., 189 p.

1968 Robert L. Herbert, *Neo-Impressionism*. New York, Guggenheim Museum, 1 vol., 264 p. Catalogue of exhibition.

GEORGES SEURAT

1890 Jules Christophe, 'Georges Seurat', in *Les Hommes d'Aujourd'hui*, No. 368.

1891 Jules Christophe, 'Georges Seurat,' in *La Plume*, September, p. 292.

[1891] *Georges Seurat*, [Brussels], 1 vol., 36 p.

1921 Lucie Cousturier, *Seurat*. 1 vol. 1st edn – 1926, 2nd edn (augmented), Paris, Crès, 1 vol. 174 p.; *Les Cahiers d'Aujourd'hui* series.

1922 André Lhote, *Georges Seurat*. Rome, Valori Plastici.

1924 Gustave Coquiot, *Georges Seurat*. Paris, Albin Michel, 1 vol., 256 p.

1926 Gustave Kahn, *Les dessins de Georges Seurat*. Paris, Bernheim-Jeune, 2 vol.

1931 Claude Roger-Marx, *Seurat*. Paris, Crès.

1935 Daniel Catton Rich, *Seurat and the Evolution of La Grande Jatte*. Chicago, The University of Chicago Press.

1943 John Rewald, *Georges Seurat*. New York, Wittenborn & Co.

1946 Douglas Cooper, *Georges Seurat, Une Baignade, Asnières*. London, Gallery Books, No. 9.

1947 Germain Seligman, *The Drawings of Georges Seurat*. New York, Curt Valentin.

1947 André Lhote, *Seurat*. Paris, Braun & Cie.

1948 John Rewald, *Georges Seurat*. Paris, Albin Michel, 1 vol., 171 p.

1952 Jacques de Laprade, *Georges Seurat*. Paris, Somogy, 1 vol.

1959 Henri Dorra and John Rewald, *Seurat*. Paris, Bibliothèque des Arts, 1 vol., 315 p.

1961 C. M. de Hauke, *Seurat et son œuvre*. Paris, Gründ, 2 vol., 308 et 336 p.

1962 Robert L. Herbert, *Seurat's Drawings*. New York, Shorewood, 1 vol., 194 p.

1964 Jean Sutter, *Recherches sur la vie de Georges Seurat. I : les chroniques familiales*, 39 p. (privately printed).

1965 John Russell, *Seurat*. London, Thames and Hudson, and New York, Abrams, 1 vol., 288 p.

1966 Henri Perruchot, *La vie de Seurat*. Paris, Hachette, 1 vol., 270 p.

1969 Pierre Courthion, *Seurat*. Paris, Cercle d'Art, 1 vol.

PAUL SIGNAC

1890 Félix Fénéon, 'Paul Signac', in *Les Hommes d'Aujourd'hui*.

1891 Félix Fénéon, 'Paul Signac,' in *La Plume*, 1 September, p. 292–299.

1922 Lucie Cousturier, *P. Signac*. Paris, Crès, 1 vol., 146 p.

1935 George Besson, *Signac*. Paris, Crès, 1 vol., 46 p.

1950 George Besson, *Signac*. Paris, Braun, 1 vol., 64 p.

1963–1964 Marie-Thérèse Lemoyne de Forges, *Catalogue de l'exposition du Centenaire de Paul Signac*. Paris, Musée du Louvre, 1 vol., 134 p. This remarkable work contains an exhaustive Signac bibliography, and is central to any understanding of Signac and of the school as a whole.

HENRI EDMOND CROSS

1905 Emile Verhaeren, *Lettre-préface*. Exposition H. E. Cross, Galerie Druet, Paris, 21 March–8 April.

1910 Charles Angrand, 'Henri Edmond Cross,' in *Les Temps Nouveaux*, 23 July.

1910 Emile Verhaeren, 'Henri Edmond Cross,' in *La Nouvelle Revue Française*; reprinted in *Sensations*. Paris, Crès, 1 vol., 1927, p. 204–208.

1911 Jules Leroux : 'Un artiste douaisien méconnu : Henri Edmond Cross' in *La Vie douaisienne*, 29 April, 20, 27 May, 3, 10 June.

1913 Maurice Denis, *Théories*. Paris, Bibliothèque de l'Occident, 1 vol., 280 p. Includes prefaces to 1907 and 1910 Cross exhibitions.

1922 H. E. Cross, extracts from notebooks. *Bulletin de la Vie artistique*, 15 May, 1 June, 1 July, 1 and 15 September, 1 and 15 October.

1932 Lucie Cousturier, *H. E. Cross*. Paris, Crès, 1 vol., 52 p.

1947 M. Saint-Clair [Maria van Rysselberghe], *Galerie Privée*. Paris, Gallimard,

1 vol., 192 p.

1964 Isabelle Compin, *H. E. Cross*. Paris, Quatre Chemins-Editart, 1 vol., 368 p.

CHARLES ANGRAND

1881 *Chronique de Rouen*, 11 August.
1882 *Nouvelliste de Rouen*, 29 September.
1884 *Journal des Artistes*, 12 December.
1886 *Le Petit Rouennais*, 26 October.
1886 *Journal des Artistes*, 29 August.
1886 *L'Art Moderne*, 19 September.
1887 *Journal des Artistes*, 8 May.
1888 *Nouvelliste de Rouen*, 16 April, 3 October.
1888 *La Revue Indépendante*, March.
1888 *Journal de Rouen*, 2 October.
1889 *La Cravache* (Catalogue des XXXII), 19 January.
1890 *Nouvelliste de Rouen*, 24 January.
1890 *La Vie Artistique*, 22 April.
1891 *La Vie Artistique*, 10 April.
1892 *La Vie Artistique*, 29 March.
1892 *L'Echo de Paris*, 26 November.
1892 *L'Art Français*, 3 December.
1899 *L'Eclair*, 25 March.
1904 *Gil Blas*, 13 January.
1912 *Comoedia*, 23 March.
1921 *Par Chez Nous, Revue normande de Littérature et d'Art*, February–March.
1926 *Journal de Rouen*, April.
1926 *Normandie Illustrée*, June.
1936 *La Vie*, October.

ALBERT DUBOIS-PILLET

1888 Félix Fénéon, 'Treize toiles et quatre dessins de M. Albert Dubois-Pillet', in *La Revue Indépendante*, October, p. 134–137.
1890 Jules Christophe, 'Dubois-Pillet', in *Les Hommes d'aujourdhui*, No. 370.
1890 Jules Christophe, 'Le commandant Dubois', in *Art et Critique*, 30 August, p. 555–556.
1890 Anonymous, 'Echo sur Dubois-Pillet', in *Art et Critique*, 20 September, p. 605.
1891 Jules Antoine, 'Dubois-Pillet', in *La Plume*, 1 September, p. 299.
1969 Robert Gounot, 'Le peintre Dubois-Pillet', in *Cahiers de la Haute-Loire*, p. 99–131.

LUCIEN PISSARRO

1892 'Lucien Pissarro', in *Art et Critique*, March.

1893 Anonymous, 'Lucien Pissarro', in *Gil Blas et L'Art Moderne*, 6 August, p. 255.
1906 *Zeitschrift für Bildende Kunst*, November.
1913 *The Imprint*, London, April.
1916 *The Studio*, London, 15 November.
1919 *Gazette des Beaux Arts*, November-December.
1962 W. S. Meadmore, *Lucien Pissarro*. London, Constable, 1 vol., 252 p.
1962 Alan Fern, *Lucien Pissarro*. Cambridge, University Press.

LOUIS HAYET

1889 Jules Antoine, *Art et Critique*, 14 December, p. 403–404.
1889 Félix Fénéon, *L'Art Moderne*, p. 339–341.
1890 [Paul Signac], *Art et Critique*, 1 February, p. 77.
1902 Gustave Kahn, 'Exposition de M. Louis Hayet', in *Art et Décoration*, May supplement, p. 5.
1902 Adolphe Dervaux, 'Notes rapides sur une peinture sympathique: M. Louis Hayet', in *La Plume*, 15 June, p. 743.
1902 Charles Saunier, 'Louis Hayet', in *La Revue Blanche*, p. 621.
1903 Maurice Robin, 'Louis Hayet', in *L'Œuvre, revue d'Art International*, p. 159–160.
1903 Gustave Kahn, 'L'exposition des œuvres de Louis Hayet', in *Petit Bleu*, 19 April.
1903 F. Fagus, 'Louis Hayet', in *La Revue Blanche*, p. 619.
1934 Charles Saunier, 'Hayet, peintre inconnu', in *Beaux-Arts*, January.
1937 Raymond Cogniat, 'Les maîtres et les méconnus du néo-impressionnisme', in *Beaux-Arts*, January.
1965 Robert L. Herbert, 'Louis Hayet', in *Neo-Impressionists and Nabis in the collection of Arthur G. Altschul*. Yale University Gallery, p. 38.

HIPPOLYTE PETITJEAN

1924 Maurice Robin, 'Hippolyte Petitjean', in *Les Hommes du Jour*, p. 8–9.
1929 Maurice Robin, 'Le souvenir d'Hippolyte Petitjean', in *Paris-Soir*, 25 December.
1930 Maurice Robin, 'Hippolyte Petitjean', in *Partisans*, January–February, p. 26.
1930 Tristan Klingsor, 'Hippolyte Petitjean', in *L'Art et les Artistes*, vol. 19,

p. 138–139.
1954 Jules Joets, 'Souvenirs recueillis par M. A. Bernard. Hippolyte Petitjean', in *Documents* (Geneva), November, p. 6–7.

CAVALLO-PÉDUZZI

1899–1901 *Lagny-Artiste*, three issues.
1901 [Jacques Copeau], *Journal de Seine-et-Marne*, 18 August.
1917 *Le Briard*, 5 May.
1917 *Le Publicateur*, 12 May.
1954 Jacques Copeau, 'Lettres de jeunesse', in *Mercure de France*, 1 December, p. 616–618.
1956 Pierre Eberhart, 'Cavallo-Péduzzi, 1851–1917', in *Lagny-56*, No. 25, July-August.
1967 Pierre Eberhart, 'Cavallo-Péduzzi', in *Préface au catalogue de la rétrospective*: June. Reprinted in *Bulletin Officiel Municipal de Lagny*, January 1968, p. 16.

MAXIMILIEN LUCE

1888 Jules Christophe, 'Maximilien Luce', in *La Cravache*, 28 July.
1890 Jules Christophe, 'Maximilien Luce', in *Les Hommes d'Aujourd'hui*, No. 376.
1891 Georges Darien, 'Maximilien Luce', in *La Plume*, 1 September, p. 299–300.
1904 Félix Fénéon, *Préface au catalogue de l'exposition chez Druet*.
1907 Gustave Geffroy, *Préface au catalogue de l'exposition chez Bernheim-Jeune*.
1909 Emile Verhaeren, *Préface au catalogue de l'exposition chez Bernheim-Jeune*.
1909 Victor Méric (Flax), 'Maximilien Luce', in *Les Hommes du Jour*.
1914 Pierre Hamp, *Préface au catalogue de l'exposition à la Galerie Choiseul*.
1917 Maurice Guillemot, 'Maximilien Luce', in *Carnet des Artistes*, 15 July, p. 3–5.
1921 Tristan Klingsor, 'Maximilien Luce', in *L'Art et les Artistes*, April, p. 287–290.
1927 Jean Texcier, 'Maximilien Luce', in *Triptyque*, No. 8, p. 25–32.
1928 A. Tabarant, *Maximilien Luce*. Paris, Crès, 1 vol. in-8, 155 p.
1930 Paul Moreau-Vauthier, 'Le peintre Maximilien Luce', in *L'Art et les Artistes*, November, p. 58–61.
1931 Georges Turpin, *Dix-huit peintres indépendants*. Paris, 1 vol.
1947 Jean Texcier, 'L'exemple de Maximilien Luce', in *Gavroche*, 15 February.

LÉO GAUSSON

1891 A. Retté, in *Ermitage*, May.
1892 Kalophile Lhermitte, in *Ermitage*, p. 243.
1896 Bouillet, 'Exposition Gausson', in *Ermitage*, p. 300.
1896 Félix Fénéon, 'Léo Gausson', in *La Revue Blanche*, 10 April, p. 336.

HENRI DELAVALLÉE

1941 G. S. Henri Delavallée, *Catalogue de l'exposition Henri Delavallée*, Galerie Saluden, Quimper, 29 October–11 November.
1967 P. Tuarze, 'Le peintre Henri Delavallée', in *Ouest-France*, 12 September.

LES VINGT DE BRUXELLES: GENERAL

1926 Madeleine Octave Maus, *Trente années de lutte pour l'Art. 1884–1914*. Bruxelles, L'Oiseau Bleu, 1 vol., 512 p.
1944 François Maret. *Les peintres luministes*. Bruxelles, Le Cercle d'Art, 1 vol., 110 p.
1962 A. M. Hammacher and F. C. Legrand (ed.), *Le groupe des XX et son temps. Catalogue de l'exposition – 17 février au 31 mai 62*. Bruxelles, Musée Royal des Beaux-Arts, Otterlo, Rijksmuseum Kröller-Müller, 1 vol., 196 p.

ALFRED WILLIAM FINCH

1966 Bertel Hintze, 'A. W. Finch, peintre néo-impressionniste', in *Ateneumin Taidemuseo Museojulkaisu*, Helsinki, vol. 11, 1–2, p. 8–15, 39–42.

GEORGES LEMMEN

1954 Marcel Nyns, *Georges Lemmen*, in *Monographies de l'art belge*. Antwerp, de Sikkel, 1 vol., 16 p.

JAN TOOROP

Robert Siebelhof, 'Jan Toorop'. Department of Fine Arts, University of Toronto. Unpublished thesis.

THÉO VAN RYSSELBERGHE

1937 Paul Fierens, *Théo van Rysselberghe*. Brussels, Editions de la Connaissance, 1 vol., 35 p.
1948 François Maret, *Théo van Rysselberghe*, in *Monographies de l'art belge*. Antwerp, de Sikkel, 1 vol., 42 p.
1962 Paul Eeckhout and G. Chabot, *Rétrospective Théo van Rysselberghe*. Ghent, Musée des Beaux-Arts, 1 vol., 150 p.

HENRY VAN DE VELDE

1967 A. M. Hammacher, *Le monde d'Henry van de Velde*. Antwerp, 2 vol.
Cahiers d'Henry van de Velde. Brussels, Association Henry van de Velde.

SOCIÉTÉ DES ARTISTES INDÉPENDANTS

1920 Gustave Coquiot, *Les Indépendants. 1884–1920*. Paris, Ollendorff, 1 vol., 240 p.
1926 *Trente ans d'Art Indépendant, 1884–1914*. Paris, Société des Artistes Indépendants. Catalogue, 1 vol.
1932 Gustave Kahn, 'Les origines de la Société des Indépendants', in *ABC*, March, p. 65–68.
1965 Pierre Angrand, *Naissance des Artistes Indépendants*. Paris, Debresse, 1 vol., 128 p.
1969 Marie Brédif, *Répertoire des artistes ayant exposé au Salon des Indépendants de 1884 à 1914*. Paris, 1 vol., 156 p. Duplicated thesis.

Index

List of the Plates

CHARLES ANGRAND

5
Self-portrait 1892
Charcoal 60 × 45 cm
Robert Lehman, New York

81
Paris: the Western Railway 1886
Oil on canvas 73 × 92 cm
Private collection, France

85
The Seine at Dawn 1889
Oil on canvas 65 × 81 cm
Petit-Palais, Geneva

132
Self-portrait c. 1885
Drawing 56.5 × 40 cm

Charles Angrand c. 1925
Photograph

The Parasol 1881
Oil on canvas 73 × 59 cm
Private collection

132
Couple in the Street 1887
Oil on canvas 38 × 33 cm
Musée National d'Art Moderne, Paris

133
The Little Farm c. 1890
Oil on panel 18 × 26 cm
Private collection, France

The Ile des Ravageurs 1886
Oil on canvas 46 × 55 cm
Private collection, New York

Study in the Bois de Boulogne 1888
Oil on canvas 33 × 41 cm
Private collection, Paris

134
Scene on a Norman Sharecropper's Farm 1890

Oil on canvas 54.2 × 73 cm
Private collection, Paris

The Bowl of Milk 1908
Oil on canvas 78 × 99 cm
Private collection

ANNA BOCH

201
Landscape
Oil on canvas 45.8 × 59.7 cm
Mr and Mrs W. J. Holliday, Indianapolis, Ind.

CAVALLO-PÉDUZZI

189
The Three Local Characters 1885
Oil on canvas 58 × 76 cm
Private collection

The Wash-boats and the Iron Bridge at Lagny
 c. 1890
Watercolour in pure tones
Musée de Lagny

190
Cavallo-Péduzzi, c. 1910
Photograph

Portrait of a Young Woman c. 1890
Oil on canvas
Private collection, France

FRANTZ CHARLET

201
The Terrace of the Tuileries 1924
Oil on canvas
Private collection

HENRI EDMOND CROSS

65
Beach in South of France 1891–92
Oil on cardboard 38 × 61 cm
Private collection, France

69
The Clearing 1906–07
Oil on canvas 162 × 130 cm
Private collection, France

73
Undergrowth 1906–07
Oil on canvas 58 × 70 cm
Private collection, France

128
Convalescent: Self-portrait c. 1882–85
Oil on canvas 50 × 61.5 cm
Musée de Douai

129
Portrait of Mme Cross 1891
Oil on canvas 207 × 150 cm
Musée National d'Art Moderne, Paris

Village Dance in the Var 1896
Oil on canvas 92.5 × 65.5 cm
Toledo Museum of Art, Toledo, Ohio

Calanque des Antibois 1892
Oil on canvas 65 × 94 cm
Mr and Mrs John Hay Whitney, New York

130
Nocturne 1896
Oil on canvas 65 × 92 cm
Petit-Palais, Geneva

San Giorgio Maggiore, Venice 1904
Oil on canvas 60 × 73 cm
Mr and Mrs Morris Leverton, New York

The Bay of Cavalière 1906
Oil on canvas 64 × 80 cm
Musée de l'Annonciade, Saint-Tropez

The Forest 1906
Oil on canvas 65 × 81 cm
Private collection, Lausanne

131
Landscape at Bormes 1907
Oil on canvas 73 × 92 cm
Bernheim-Jeune collection, Paris

Santa Maria degli Angeli 1909
Oil on canvas 73 × 92 cm
State Hermitage Museum, Leningrad

The Beach of La Vignasse 1891–92
Oil on canvas 65 × 92 cm
Private collection, France

Afternoon at Pardigon 1907
Oil on canvas 81 × 65 cm
Musée National d'Art Moderne, Paris

HENRI DELAVALLÉE

171
Street in Sunlight 1907
Oil on canvas 45.8 × 56 cm
Mr and Mrs W. J. Holliday, Indianapolis,
Ind.

173
Farmyard 1887
Oil on canvas 59 × 73 cm
M. and Mme Samuel Josefowitz, Lausanne

199
Henri Delavallée at 25, 1887
Photograph

Little Yard with Rabbits 1887
Oil on canvas
Private collection, France

Boy in Cap 1887
Oil on canvas
Private collection, France

200
Cabin by the Sea c.1888
Oil on canvas
Private collection, France

The Groom 1888
Oil on canvas
Private collection, France

ALBERT DUBOIS-PILLET

93
River Bank in Winter c.1889
Oil on canvas 37.7 × 49.8 cm
Mr and Mrs Arthur G. Altschul, New York

97
Quai de Montebello 1889–90
Oil on canvas 97 × 177 cm
Private collection, London

135
The Seine, Paris c.1889
Oil on canvas 79.9 × 99.5 cm
Mr and Mrs Arthur G. Altschul, New York

Cliffs at Yport 1888
Oil on canvas 26 × 41 cm
Private collection, France

136
The Wash-boat at the Pont de Charenton
1886–87
Oil on canvas 27 × 40 cm
Musée d'Art et d'Industrie, Saint-Etienne

The Dead Child 1881
Oil on canvas
Musée Crozatier, Le Puy

Paris: the Seine at the Quai Saint-Bernard 1885
Oil on canvas 33 × 45 cm
Private collection

Rouen: the Seine and the Canteleu Hills 1888
Oil on canvas 24 × 33 cm
Private collection

137
Portrait of Mlle M.D. 1885
Oil on canvas 86 × 75 cm
Musée d'Art et d'Industrie, Saint-Etienne

Le Puy: Saint-Michel-d'Aiguilhe 1890
Oil on canvas 60 × 37 cm
Musée Crozatier, Le Puy

ALFRED WILLIAM FINCH

202
The Haystacks 1889
Oil on canvas 32 × 50 cm
Musée d'Ixelles, Brussels

Cliffs at the South Foreland 1891–92
Oil on canvas 66.5 × 80.5 cm
The Art Museum of the Ateneum, Helsinki

Suburb in the Snow 1888–89
Oil on canvas 90 × 152 cm
Mr Hugo Perls, New York

Orchard at Louvière c.1891
Oil on canvas 54 × 67 cm
The Art Museum of the Ateneum, Helsinki

LÉO GAUSSON

167
Undergrowth 1888
Oil on panel 31.8 × 26 cm
Robert Rann, Michigan

190
Cavallo-Péduzzi 1892
Plaster medallion
Musée de Lagny

196
The Village 1888
Oil on canvas 23 × 31.2 cm
Hammer Galleries, New York

196
The Village 1889
Oil on canvas 27.5 × 40.5 cm
Private collection

Léo Gausson as colonial official, Guinea
c.1905
Photograph

197
French Village 1887–88
Oil on canvas
Gemeente Musea, Amsterdam
(This was exchanged with Van Gogh for one
of his works in January 1890)

The Church Spire at Eragny 1890
Oil on canvas 35 × 27 cm
Private collection

The Pré-Long Basin on the Marne at Lagny
1886
Oil on canvas 61 × 82 cm
Private collection

198
Farmyard at Gouvernes 1890
Oil on canvas 45.5 × 60.5 cm
Private collection

Farmyard 1891
Oil on canvas 61 × 75 cm
Private collection

Barges on the Marne 1890
Oil on canvas 21 × 35 cm
Mr and Mrs W. J. Holliday, Indianapolis,
Ind.

Boating, c. 1891
Oil on canvas
Private collection, USA

LOUIS HAYET

109
Place de la Concorde 1888
Oil on panel 18.5 × 27 cm
Private collection, New York

140
Self-portrait c. 1910–14
Oil on canvas 16.5 × 13 cm.

Louis Hayet, c. 1930
Photograph

The Building of the Eiffel Tower 1887
Watercolour on prepared cotton 17.5 × 23 cm
Private collection

141
*Camille and Lucien Pissarro painting by the River
Oise* 1883
Watercolour 35 × 27 cm

The Doors 1889
Watercolour on tarlatan 18 × 11 cm
Private collection

The Market 1889
Oil on canvas 18.5 × 26.5 cm
Mr and Mrs Arthur G. Altschul, New York

142
Paris Street Scene 1889
Encaustic 19 × 27 cm
Private collection

The Tumbrils 1889
Encaustic 19 × 27 cm
Private collection

The Little Girls, London 1895
'Monticelli period'
Oil on cardboard 19 × 27 cm
Private collection

Paris, Coster Women 1924
Oil on canvas 12 × 17 cm
Private collection

GEORGES LEMMEN

179
Seaside Promenade 1891
Oil on canvas 13 × 22 cm
M. et Mme Samuel Josefowitz, Lausanne

181
Self-portrait 1890
Oil on canvas 43 × 38 cm
M. and Mme Samuel Josefowitz, Lausanne

203
Georges Lemmen and his wife, c. 1895
Photograph

The Thames 1892
Oil on canvas 61 × 86.7 cm
Museum of Art, Rhode Island School of
Design, Providence, R.I.

Factory on the Thames c. 1892
Oil on canvas
Rijksmuseum Kröller-Müller, Otterlo

204
The Serruys Sisters 1894
Oil on canvas 60.5 × 70.5 cm
Mr and Mrs W. J. Holliday, Indianapolis,
Ind.

204
Woman sewing c. 1896
Oil on canvas
Private collection

Washing
Oil on canvas 54.6 × 49.5 cm
Private collection, USA

MAXIMILIEN LUCE

128
Cross c. 1905
Oil on cardboard 36.5 × 29.5 cm

157
Sunset, Bank of the Seine at Herblay 1889
Oil on canvas 50 × 65 cm
Private collection, France

161
Notre-Dame 1900–01
Oil on canvas 85 × 79.4 cm
Mr and Mrs Arthur G. Altschul, New York

163
The Meuse at Feynor 1909
Oil on canvas 60 × 73 cm
Petit-Palais, Geneva

191
Maximilien Luce, 1885
Photograph

Angrand
Oil on canvas 35 × 27 cm
Petit-Palais, Geneva

Maximilien Luce, 1938
Photograph taken in his studio at Rolleboise

Aunt Octavie at Home 1880
Oil on canvas 50 × 61 cm
Private collection

192
The Banks of the Bièvre 1888
Oil on canvas 55.3 × 40 cm
Hammer Galleries, New York

The Ragpicker 1887
Oil on canvas 46 × 38 cm
Private collection

The Bièvre at Arcueil 1887
Oil on canvas 50 × 61 cm
Private collection, France

193
A Kitchen 1888
Oil on canvas 65 × 54 cm
Private collection, Paris

Rue Mouffetard 1889–90
Oil on canvas 80 × 64.8 cm
Mr and Mrs W. J. Holliday, Indianapolis,
Ind.

Rue des Abbesses, Grocer's Shop 1896
Oil on canvas 54.5 × 73 cm
Petit-Palais, Geneva

194
The Pool of London 1893
Oil on canvas 61 × 81 cm
Private collection, Lausanne

The Banks of the Seine at Herblay 1892
Oil on canvas 65 × 81 cm
Private collection, France

Factory near Charleroi 1899
Oil on canvas
Private collection

Flowers 1906
Oil on canvas 50.4 × 61 cm
Hammer Galleries, New York

195
Camaret Harbour 1894–1906
Oil on canvas 95.4 × 145.5 cm
Hammer Galleries, New York

Pile-drivers 1902
Oil on canvas 153 × 195 cm
Musée National d'Art Moderne, Paris

200
Interior : My Friend Perrot getting up 1890
Oil on canvas 65 × 81 cm
Private collection

HIPPOLYTE PETITJEAN

121
The Seine at Mantes
Watercolour 41.2 × 62.2 cm
Mr and Mrs W. J. Holliday, Indianapolis, Ind.

143
Hippolyte Petitjean with his wife Louise
and his daughter Marcelle, *c.* 1900
Photograph

Nude 1907
Watercolour 29 × 26 cm
Petit-Palais, Geneva

The Village 1893
Oil on canvas 60.4 × 38 cm
Roland, Browse & Delbanco, London

The Artist at his Easel 1897
Drawing 62 × 48 cm
Petit-Palais, Geneva

144
Wash-house by the River Bièvre 1891–92
Oil on canvas 21.5 × 32 cm
Private collection

The Bathers
Oil on cardboard 21.6 × 32.5 cm
Maurice Sternberg, Chicago, Ill.

Mâcon : View of the Main Bridge 1870
Watercolour 10.5 × 12 cm
Private collection

Flower-gathering 1913
Oil on canvas 65 × 81 cm
Private collection, France

LUCIEN PISSARRO

101
The Village of Gouvernes 1888
Oil on canvas 58.5 × 71 cm
M. and Mme Samuel Josefowitz, Lausanne

138
Eragny Church 1887
Gouache 18 × 23 cm
Private collection, France

The Crowning of Esther *c.* 1896
Gouache
Ashmolean Museum, Oxford

The Garden *c.* 1889
Oil on canvas 44.5 × 37 cm
Mr and Mrs Morris Leverton, New York

139
Eragny Church 1886
Oil on canvas 51 × 70 cm
Ashmolean Museum, Oxford

Woman sewing 1886
Gouache 15.2 × 20.3 cm
Jacques O'Hana, London

Rue Saint-Vincent, Winter Sunlight 1889–90
Oil on canvas 65.4 × 81.3 cm
Mr and Mrs Cecil Lipkin, Eastern Pennsylvania

DARIO DE REGOYOS

205
San Pedro de Torello
Oil on canvas
Private collection

THÉO VAN RYSSELBERGHE

175
Auguste Decamps 1894
Oil on canvas 64 × 53 cm
Petit-Palais, Geneva

185
Big Clouds 1893
Oil on canvas 50.8 × 63 cm
Mr and Mrs W. J. Holliday, Indianapolis, Ind.

201
Anna Boch 1893

205
De Regoyos 1882
Oil on canvas 30 × 42.5 cm
Musées Royaux des Beaux-Arts de Belgique, Brussels

207
Théo van Rysselberghe, 1900 Photograph

The Scheldt upstream from Antwerp 1892
Oil on canvas 66.7 × 90.2 cm
Mr and Mrs Arthur G. Altschul, New York

Landscape with Mill *c.* 1892
Oil on canvas 50.8 × 76.8 cm
Hammer Galleries, New York

208
Young Woman by the Sea 1901
Oil on canvas 99.7 × 81.3 cm
Hirschl & Adler Gallery, New York

Woman before a Mirror 1908
Oil on canvas 73.8 × 54.6 cm
Mr and Mrs W. J. Holliday, Indianapolis, Ind.

Harbour Entrance, Volendam 1896
Oil on canvas 38 × 55 cm
Private collection

209
Bathers at Cavalaire 1905
Oil on canvas 81 × 100 cm
Private collection, France

GEORGES SEURAT

3
Woman Carrying a Basket
Conté crayon 32 × 24 cm
Private collection, Paris

4
Portrait of Paul Signac 1889–90
Conté crayon 34.5 × 28 cm
Private collection, Paris

6
The Painter at Work *c.* 1884
Conté crayon 30.7 × 22.9 cm
Philadelphia Museum of Art, A. E. Gallatin Collection

25
Houses and Garden 1882
Oil on canvas 27.6 × 46.3 cm
Private collection, USA

27
Stonebreaker at Montfermeil 1882
Oil on canvas 47 × 56.8 cm
Sir Isaac Wolfson, Great Britain

33
Study for 'La Grande Jatte' 1884–85
Oil on panel 15.5 × 24.4 cm
Mr and Mrs Paul Mellon, Upperville, Va.

36
The Seine from La Grande Jatte c. 1888
Oil on panel 16 × 25 cm
Private collection, Paris

37
*A Sunday Afternoon at the Island of La Grande
Jatte* 1884–86
Oil on canvas 206 × 306 cm
The Art Institute of Chicago
Helen Burch Bartlett Memorial Collection

40
The Models 1888
Oil on canvas 199 × 250 cm
Barnes Foundation, Merion, Pa.

43
Bathing at Asnières 1883–84
Oil on canvas 200 × 300 cm
Reproduced by courtesy of the Trustees
of the National Gallery, London

The Echo, study for 'Bathing at Asnières' 1883
Drawing
Yale University Art Gallery, New Haven,
Conn.

44
House with Red Roof c. 1882
Oil on panel 16.2 × 25 cm
Private collection, France

Oil sketch for 'La Grande Jatte', c. 1885
Oil on panel 16 × 24.8 cm
Albright-Knox Art Gallery, Buffalo, N.Y.,
Gift of A. Conger Goodyear

Peasant hoeing c. 1882
Oil on canvas 46 × 55.8 cm
The Solomon R. Guggenheim Museum,
New York

*Woman with Monkey, study for 'La Grande
Jatte'* 1884–85
Oil on panel 24.7 × 15.7 cm
Smith College Museum of Art, Northampton,
Mass.

45
*A Sunday Afternoon at the Island of La Grande
Jatte* (detail) 1884–86
The Art Institute of Chicago (see p. 37)

Beach at Le Bas-Butin 1886

Oil on canvas 67 × 78 cm
Musée des Beaux-Arts, Tournai

Bridge at Courbevoie 1886
Oil on canvas 45.7 × 54.7 cm
Courtauld Institute Galleries, University of
London

Harbour and Quays at Port-en-Bessin 1888
Oil on canvas 65 × 82.5 cm
The Minneapolis Institute of Arts

46
Chahut 1888–90
Oil on canvas 169 × 139 cm
Rijksmuseum Kröller-Müller, Otterlo

The Circus 1890–91
Oil on canvas 185 × 150 cm
Jeu de Paume, Musée du Louvre, Paris

Circus Parade 1887–88
Oil on canvas 100 × 150 cm
The Metropolitan Museum of Art, New York

PAUL SIGNAC

49
Saint-Briac 1885
Oil on canvas 49.5 × 79.5 cm
Private collection, New York

51
Roadstead at Portrieux 1888
Oil on canvas 65 × 81 cm
Private collection, USA

53
Félix Fénéon 1890
Oil on canvas 74 × 95 cm
Private collection, New York

57
Flushing Pier 1896
Oil on canvas 58 × 89 cm
Private collection, Lausanne

59
Antibes Harbour c. 1896
Oil on canvas 88 × 114 cm
Private collection, France

61
Debilly Footbridge c. 1926
Oil on canvas 65 × 81 cm
Private collection, Geneva

125
Portrieux Harbour 1888

Oil on canvas 61 × 92 cm
Staatsgalerie, Stuttgart

The Bridge 1886
Oil on canvas 33 × 46.5 cm
Mr and Mrs Sydney Barlow, Beverly Hills,
Calif.

126
Cassis: Cap Lombard 1889
Oil on canvas 66 × 81 cm
Gemeentemuseum, The Hague

Rainbow, Breton Harbour 1893
Oil on canvas 40.6 × 50.3 cm
Mr and Mrs W. J. Holliday, Indianapolis,
Ind.

The Umbrella Pine 1897
Oil on canvas 65 × 81 cm
Musée de l'Annonciade, Saint-Tropez

The Yellow Sail, Venice 1904
Oil on canvas 72 × 91 cm
George Besson, Paris

127
Brig at Marseilles
Oil on canvas 81 × 65 cm
Mr and Mrs Josef Rosensaft, New York

Les Andelys
Oil on canvas 73 × 92 cm
Private collection

The Papal Palace at Avignon 1909
Oil on canvas 73.5 × 92 cm
Private collection, France

JAN TOOROP

183
Katwijk Harbour 1892
Oil on canvas 24 × 30 cm
M. and Mme Samuel Josefowitz, Lausanne

205
Shell-fish Gatherer on the Beach 1891
Oil on canvas 61.5 × 66 cm
Rijksmuseum Kröller-Müller, Otterlo

206
The Sea 1898
Oil on canvas 46 × 50.2 cm
Rijksmuseum Kröller-Müller, Otterlo

Guillaume Vogels
Oil on canvas
Musées Royaux des Beaux-Arts
de Belgique

The Middelburg Canal 1907
Oil on canvas 31 × 41 cm
Gemeentemuseum, The Hague

HENRY VAN DE VELDE

187
Woman in an Orchard 1888
Oil on canvas 66 × 89 cm
M. and Mme Samuel Josefowitz, Lausanne

209
Blankenberghe 1888
Oil on canvas 71 × 100 cm
Kunsthaus, Zurich

210
Woman at a Window 1889

Oil on canvas 111 × 125 cm
Koninklijk Museum, Antwerp

Henry van de Velde, *c.* 1896–1900
Photograph
Archives van de Velde, Bibliothèque Royale
de Belgique, Brussels

The Beach, Blankenberghe 1889
Oil on canvas 61 × 86 cm
Kunsthalle, Bremen

211
Père Biart reading in the Garden 1891
Oil on canvas 60.4 × 50.8 cm
Mr and Mrs W. J. Holliday, Indianapolis,
Ind.

Childish Landscape c. 1890
Oil on canvas 45 × 60 cm

Private collection

Winter Sunlight 1892
Oil on canvas 45.5 × 60.5 cm
Private collection

212
Wechel-der-zande Church c. 1900
Oil on canvas 45 × 60 cm
Private collection

GUILLAUME VOGELS

212
Twilight over the Pond
Oil on canvas
Musées Royaux des Beaux-Arts de Belgique,
Brussels

PHOTOGRAPH CREDITS

Albright-Knox Art Gallery, Buffalo; Art Institute of Chicago; Art Museum of the Ateneum, Helsinki; Ashmolean Museum, Oxford; Bianquis, Saint-Tropez; P. Bijtebier, Brussels; Brenwasser, New York; Courtauld Institute of Art, London; R. David, Paris; P. Eberhart, Paris; A. Faidherbe, Douai; R. Fine, Stamford, Conn; J.R. Freeman, London; Galerie Bernheim-Jeune, Paris; Galerie Robert Schmit, Paris; Galerie Wildenstein & Co, New York; Gemeente Musea, Amsterdam; Gemeentemuseum, The Hague; J. Gilbert, Paris; Giraudon, Paris; Hammer Galleries, New York; H. Edelstein, Northampton, Mass; W. J. Holliday, Indianapolis; J.N. Jacobson, New York; P. Katz, New York; Kunsthaus, Zurich; Rijksmuseum Kröller-Müller, Otterlo; N. Mandel, Paris; J. Messian, Tournai; Metropolitan Museum of Art, New York; Minneapolis Institute of Arts; J. Pénot, Paris; Petit-Palais, Geneva; M. Poplin, Paris; M. Queste, Versailles; Réunion des Musées nationaux, service de documentation photographique, Versailles; J. Rodrigues-Henriques, Paris; J.D. Schiff, New York; Smith College Museum of Art, Northampton, Mass; Solomon R. Guggenheim Museum, New York; Staatsgalerie, Stuttgart; Stickelmann, Bremen; M. Varon, New York; Vizzavona, Paris; J. Willemin, Paris.

Printed in offset by Paul Attinger, Neuchâtel
Switzerland